Gertrude Stein

In Words and Pictures

Gertrude Stein
In Words and Pictures

A PHOTOBIOGRAPHY

 Edited by Renate Stendhal

Algonquin Books of Chapel Hill ▣ 1994

Published by
ALGONQUIN BOOKS OF CHAPEL HILL
Post Office Box 2225
Chapel Hill, North Carolina 27515-2225

a division of
WORKMAN PUBLISHING COMPANY, INC.
708 Broadway
New York, New York 10003

First published in German under the title
*Gertrude Stein: Ein Leben in Bildern und
Texten.* © 1989 by Arche Verlag AG,
Raabe + Vitali, Zürich.

LIBRARY OF CONGRESS
CATALOGING-IN-PUBLICATION DATA
Gertrude Stein. English ed.
 Gertrude Stein : in words and pictures /
edited by Renate Stendhal.—1st ed.
 p. cm.
 Translated from : Gertrude Stein : ein
Leben in Bildern und Texten.
 Includes bibliographical references
and index.
 ISBN 0-945575-99-8
 1. Stein, Gertrude, 1874–1946—
Biography—Pictorial works.
 2. Women authors, American—20th
century—Biography—Pictorial works.
 3. Americans—France—History—
20th century—Pictorial works.
 I. Stein, Gertrude, 1874–1946.
 II. Stendhal, Renate.
 PS3537.T323Z65 1994
 818'.5209—dc20 94–28925
 CIP

10 9 8 7 6 5 4 3 2 1
First Edition

To Kim Chernin

CONTENTS

A Lifelong Passion for Sentences: Introductory Thoughts on Gertrude Stein

She was small and of voluminous proportions. She reminded Ernest Hemingway of an "Italian peasant woman." Her style of dress reminded him of "strange steerage clothes." The owner of the hotel in Belley where Gertrude Stein used to summer thought she looked like a gypsy as she stepped into the hotel, her skirt flapping around her, her feet naked in sandals. Her companion, Alice B. Toklas, kept herself one step behind the massive Gertrude. With her scant figure and slight stoop, she appeared to the hotelier as "the other one's maid."

Gertrude Stein's unconventional appearance fit well with the salon she held in Paris, first with her brother Leo, then with Alice B. Toklas. Their studio and apartment at 27, rue de Fleurus was the meeting place for the young artistic and literary rebels of the new century: Picasso, Matisse, Braque, Apollinaire, Juan Gris, Mina Loy; later Djuna Barnes, Ernest Hemingway, and many others. The Stein siblings were among the first to collect the scandalous paintings of the Fauvists and Cubists. Their salon at the rue de Fleurus, with its picture-paved walls, was, as Hemingway wrote, "one of the best rooms in the finest museum."

This, in itself, made Gertrude Stein a legend even while she was alive. The world saw her as a patroness, a muse, the "Mother of Modernism" who assisted young artists with the *accouchement* of their works and nourished the creativity of the Lost Generation. Her own writing seemed accessory. It disturbed the picture, except when she wrote about those (increasingly famous) friends.

The revolutionary spark struck by Picasso in painting was kindled by Gertrude Stein in writing. She wrote the way the Cubists painted, moving beyond the spatial limitations of the three-dimensional perspective. Her early "word portraits," for example, were verbal still lifes capturing the salon guests from different angles simultaneously, in a single "cubist" plane. Her writing and theories about writing liberated language from the nineteenth century, from all romantic, naturalistic, and symbolic overtones. With her most famous words—"A rose is a rose is a rose is a rose"—the nonrepresentational rose of the twentieth century was created.

Yet, in her own time, recognition of Gertrude Stein's language revolution was slow to come. From a traditional perspective, there was "no there there": the words of a woman could not possibly be at the beginning of modernism. The American Gertrude Stein gave her contemporaries a lot to swallow. She was not only a woman, she was an independent woman. She came from a well-to-do German-Jewish family and had her own income (a family allowance). At age fourteen, she had lost her not particularly beloved mother; at eighteen, her much detested father. She had studied psychology and medicine before coming to Paris. She would not toler-

ate the domination of a man and replaced her brotherly companion with a woman. With all this, the female language pioneer was a step ahead of her time.

Readers of the monumental work of Gertrude Stein (about six hundred titles) are sentenced to a challenge. The author had a "lifelong passion for sentences." Endless sentences. Stenographically short sentences. Constantly repeated, minutely changed sentences. Sentences that refuse to move anything on, that do not move toward any end of a story, any aim or future. Sentences insisting on the continuous present, i.e., "continuous presence." Sentences consisting of word play, double entendres, and seemingly nonsensical linguistic hide-and-seek games.

The works of the male avant-garde—Joyce, the Futurists, Dadaists, Expressionists, Surrealists—were auscultated word for word. Not so the works of the female avant-garde. Gertrude Stein had to wait for her first success until she was fifty-nine years old. Until then, she hardly managed to publish anything unless she paid for it herself. Her freeing of language from its grammatical and emotional traditions was considered absurd, not to be taken seriously. Together with Picasso, she liked to speculate: "Braque and Joyce, they are the incomprehensibles whom anybody can understand. Les incompréhensibles que tout le monde peut comprendre."

Nonetheless, during the early years, Gertrude Stein, flanked by Alice B. Toklas, held court each Saturday night at 27, rue de Fleurus. The American in Paris who was an outsider in so many ways was, at the same time, the hub of the "moveable feast." Chosen friends

and visitors were served a French *dîner*. "We had just hung all the pictures and we asked all the painters," Gertrude Stein wrote in *The Autobiography of Alice B. Toklas*. "You know how painters are, I wanted to make them happy so I placed each one opposite his own picture, and they were happy so happy that we had to send out twice for more bread, when you know France you will know that that means that they were happy, because they cannot eat and drink without bread and we had to send out twice for more bread so they were happy."

Strict rules applied in Gertrude Stein's salon. "If you brought up Joyce twice, you would not be invited back," Hemingway reported in his Parisian memoirs. "It was like mentioning one general favorably to another general. You learned not to do it the first time you made the mistake. You could always mention a general, though, that the general you were talking to had beaten. The general you were talking to would praise the beaten general greatly and go happily into detail on how he had beaten him."

The so-called Mother of Modernism defended her battlefield with the will of a sovereign and the energy of a tyrant. Only those useful to her were granted entrance; only those who had praised her were praised in turn. She liked to talk and give young, ambitious writers like Hemingway "fatherly" advice: "Remarks are not literature." Her self-confidence was unshaken by criticism, rejection, or ridicule.

She showed the same obstinacy in her daily living. In 1928, she discovered the summer house of her dreams in Bilignin, a village near Belley in the

Rhône Valley. When the tenant, a French lieutenant, refused to leave the house, she used her American connections to get him transferred to the Middle East. For the next fifteen years, the house with the romantic garden towers was hers.

"She had such a personality," Hemingway wrote, "that when she wished to win anyone over to her side she would not be resisted." Quite a number of both men and women found her sexually irresistable as well. In the cases of Hemingway and the American patroness Mabel Dodge, for example, Alice B. Toklas had to step in and occasionally even make a scene in order to render Gertrude resistable. People were particularly attracted by her full, melodious voice, her elemental laughter, her taking space in an obvious, physical way; by her humor, her curiosity, her sensuous appetite for everything in life—which lasted to the very end of her life.

As death approached, she asked Alice the now legendary question, "What is the answer?" And, when there was no reply, said, "In that case, what is the question?"

The legend still holds. Everybody knows of Gertrude Stein, even if only a few have read her. "A rose is a rose is a rose is a rose" is an evergreen, self-sufficient and satisfying to the point where inquiring further into her writing might seem unnecessary. Here, the idea and practice of modernism are captured in a single line, a magical "Open, Sesame" that promises access to the avant-garde literature of the twentieth century. Here, at the literary threshold, one can linger and weigh with a pleasant shudder how far the experiment of language has moved out into impassable terrain. In Stein's

phrase, the rose is still recognizable as what it had been for centuries in the Western lyrical tradition. Yet, it has gained a concreteness of irreducible presence and, at the same time, awakens an intimation of strangeness, the estrangement of a new era. The line is a literary "invitation to the dance": we, the readers, are invited to create the well-worn rose anew.

Familiar and strange. The photographic image of Stein's beautiful, massive head with the Caesar haircut belongs to the culture of our century as solidly as Picasso's 1906 portrait of her. A modern equivalent to archetypal Western images of women—the Mona Lisa for example—Stein's head raises the timeless question of identity. "I want to be historical," "In my generation I am the only one," "I am a genius"—the pronouncements of a woman who stepped onto the world stage at a time when other women were just beginning to demand egalitarian treatment.

Who was this woman?

THE IDEA of a book combining texts and pictures grew naturally out of Stein's life and work. Gertrude Stein was an author for whom being seen was as important as being read. Being portrayed by painters and sculptors pleased her, as it pleased her to have her photo taken by the great and "small" photographers of her time. (Her companion Alice B. Toklas, by contrast, seems to betray a growing fatigue with posing over the course of years.) The resulting wealth of photographic images that inspired this "picture-reader" invites a new view, a visual as well as literary reading of Stein's personality, life, and work.

The most immediate, striking effect of Gertrude Stein's photographic portraits is the impression they give a viewer that Stein took the same freedom with her appearance she took with her writing. Shortly after her arrival in Paris, at the beginning of the century, she removed her stays, literally stepping out of the corset of convention.

Appearance is a question of style, as telling as a style of writing. Stein insisted all her life that her writing had nothing to do with automatic writing. Her appearance, too, was not the product of happenstance. On the contrary, her readiness, at any moment, to establish her bodily presence has the quality of a deliberate statement. She faces the camera and posterity with the nonchalance of a woman for whom it is natural to be fully herself.

Generations later, such a posture still looks avant-garde, even though our *fin de siècle* may be catching up with Gertrude Stein. We have grown accustomed to abstract, conceptual, repetitive, and minimal art. In the context of performance art and new forms of writing, Stein's work seems less and less alien. If we were to see her today, sitting at the Coupole in Paris, dressed in her army coat and leopard hat, how seamlessly she would fit into the contemporary artists' scene. That "cool" look of hers wouldn't easily be matched by her own contemporaries, Joyce, Proust, or Pound. Her androgyny might still amaze: the challenging gaze of a general, the inviting body of a wet nurse, the lust for life of a child tyrant. "Literary Einstein of the century," "Mother of Modernism," and *enfant terrible* in one and the same person.

Stein's personality caused as much dissent as her writing. She had as many enemies as friends (some of whom changed fronts several times over the course of the years). Opinions about her clashed as long as she lived, and they continued to do so after her death. Was she a genius, as she claimed? As gifted with words as her soul-friend Picasso was with paints? Or was she a "clinical case of megalomania" as Tristan Tzara declared? Did her language possess the "exactitude, austerity, absence of variety in light and shade" of a Bach fugue, as the French critic Marcel Brion attested? Or was her writing a "cold suet-roll of fabulously reptilian length . . . all fat, without nerve," a "sausage, by-the-yard-variety," as Wyndham Lewis claimed? Was she self-assured or self-obsessed? Was it artistic rigor and integrity that compelled her to set limits on others ("We are not amused"), or was it narcissistic arrogance? Was she a "dictator of art," as Man Ray saw her, or, in Sylvia Beach's view, an "infant prodigy"?

Gertrude Stein, born in Allegheny, Pennsylvania, to parents of German–Jewish descent, learned English at the age of five. Her first language was German. She spent her early years in Vienna and Paris before her family moved back to America. From that time on, and for the rest of her life, she knew how to remain the five-year-old child who discovers the English language for the first time, tries it out without prejudice, endlessly repeating, wantonly changing, destroying, and recreating it. She played with every possible literary genre, from nursery rhymes to opera libretti. No matter how difficult her texts appear, she always insisted they were perfectly simple. And many are disarmingly simple and playful:

If you hear her snore
It is not before you love her
You love her so that to be her beau is very
lovely
She is sweetly there and her curly hair is very
lovely.
She is sweetly here and I am very near and
that is very lovely.
She is my tender sweet and her little feet are
stretched out well which is a treat and very
lovely.
Her little tender nose is between her little
eyes
which close and are very lovely.
She is very lovely and mine which is very
lovely.
—*Portraits and Prayers*

Having come into the world as the spoiled youngest of five siblings, Gertrude Stein described her childlike quality as freedom from "sentimental feeling" and as "aggressive liveliness" ("that is the way I was and that is the way I still am, and any one who is like that necessarily liked it. I did and I do"). The "child within man," as the German language has it, in this case survived within a woman.

FOR ME, composing Gertrude Stein's life story in pictures and quotations was giving in to the temptation of a riddle. There was not only the question, Who was Gertrude Stein? There was the unavoidable challenge of the question, How to read Gertrude Stein?

The riddle fascinated me from the moment when, as a schoolgirl, I heard how a comma is "holding your coat for you" ("Poetry and Grammar"). The fascination lasted even when it turned into avoidance: whenever I advanced from her more accessible theoretical and autobiographical texts into the hermetic fields of her "Cubist" writing,

my courage would desert me. Her continuous present tense seemed to have left the past, the literary tradition of the fathers, so far behind that the literary connection between them was cut. I would find myself face to face with a sphinx holding up a mirror to my incapacity. Is she making fun of language? I would ask myself. Is she intentionally fooling us?

I sensed that there was something else at play. If one could only find the rules of the game one would be able to play along with her and share the fun. With an excluded reader's agony, I would look for the "useful knowledge" my author had promised (in a book of that title, in 1928). I would go back and forth between my possible sources of understanding, puzzling over her cryptic words, her personality, her psychology, her life story, then trying to read her face, the foxy but good-natured, serious fun it radiates. I sensed that if this sphinx had hidden the answers to her questions, well, she must have also left sufficient clues about how to find them. "If there is no answer, what is the question?" My hunch proved right. My lack of courage would be countered to the extent that pieces of the verbal puzzle kept falling into my hands.

I remember the night when I first tried my teeth on Stein's famous portrait-poem "Susie Asado," written in 1913. The portrait begins:

Sweet sweet sweet sweet sweet tea.
 Susie Asado.
Sweet sweet sweet sweet sweet tea.
 Susie Asado.
Susie Asado which is a told tray sure.
A lean on the shoe this means slips slips
 hers. . . .

Reportedly the portrait had been inspired by the flamenco dancer La Argentina, whom Stein and Toklas had admired when they were in Spain in 1913. How then could the first evocation of the dancer be dominated by the highly un-Spanish association of tea on a tray? I did not find poetic peace that night. I continued hearing the staccato rhythm of flamenco shoes in these lines, but I fell out of rhythm every time I came to the "sweet tea." The turnoff or cutoff at the end of these lines seemed so jarring that I sensed a purpose behind it. Did the abrupt shift from Spanish "sweet" to English "tea" capture a dislocation Stein herself had experienced? I literally had no clue. I felt duped and slighted. I decidedly did not like Susie Asado, that fake Spanish dancer with a half-English name.

The next morning, however, when sweet Susie had become an annoying "earworm" (a German notion), I suddenly heard it. "Sweet tea": sweetie. It was a revelation that changed the entire portrait for me. Stein's sound play suddenly pulled the rapid dance of "Sweet sweet sweet sweet sweet . . ." over the end of the line—and over the edge of proper British manners—into a rapturous calling of "sweetie Susie Asado." Now the whole beginning sounded like the beginning of a lover's plea, with "tray sure" melting into "treasure," another tenderness. "Told" seemed to speak of "bold," of something risqué having been communicated between the adorer and the adored. On the sound stage that had suddenly opened before me, I could take the liberty of playing with associations. The passionate context of flamenco music, song, and dance held another, private, and

perhaps secret, passion—a passion involving an author who spoke English (and who had just been in England before coming to Spain) and whose communication of her admiration may not have been as easy as she had desired. Movements of desire may have run into obstacles (broken-off lines) because of different languages—English and Spanish, perhaps even French ("tray sure" can be read as "très sûre," the French feminine version of "very sure"). Desire may also have run into invisible lines of manners, drawn by Alice's presence as a guardian of tea on a tray, the virtues of the home. The dancer's mysterious English name, Susie, may point to the French word for worry, "souci." Any too-passionate leanings ("lean on the shoe") might have caused slippings, a loss of balance, especially if the dancer's movements ("slips slips hers") had conveyed too bold a message (with her slippers, her lips, or revealing her slip) as the sounds seem to suggest.

I felt bold myself in this speculative reading, but encouraged by the fact that my playing with Stein's text never seemed to leave the text. I rather felt that I was finally playing inside her own playfulness, dancing along with her own verbal dance. I was fortunate to know some of the bilingual "steps" of that dance. To read "Susie Asado," knowing French as well as English seemed a precondition. In other cases, I soon noticed, a knowledge of German and Yiddish also helped in keeping up with Stein. (My first language, as it was for Stein, is German; I learned English at age ten, French at sixteen, and Yiddish at twenty, shortly before leaving Germany to live in Paris as my chosen place of "exile.")

"Susie Asado" made me aware that biographical knowledge can be useful indeed for reading Gertrude Stein. I am not sure I would have found access to her text had I not known about the multilingual context of her writing and taken a few hints from what I knew about the erotic side of her life. Then, by reading and repeating the words (in the way Stein liked to call "caressing"), the "abstract" portrait had revealed itself as equally evocative, risqué, and rich in color as the portraits Picasso had painted at the same time.

In the past two decades, feminist scholars have confirmed my own tentative reading. Linda Simon, Gloria Orenstein, and others have clearly established the eroticism that crosses through Stein's work, partly in disguise, partly with surprising explicitness. The discovery led scholars to a new hypothesis: perhaps more than erotic deviance was hidden in Stein's texts. Perhaps even her most experimental work was not altogether abstract, but strategically coded. The coding, in Orenstein's view, was a device to disguise anything that would have hindered Stein's literary success. In order to hold her own against her male rivals, the female author had to veil the disturbing elements of her identity: being female, Jewish, and lesbian. According to this thesis, Stein over(p)layed these disturbing elements with the less provocative identity of an American in Paris. Hidden in the text, she played out her true identity in word games, sound associations, false abstractions, maskings, and masquerades.

Stein's "Susie Asado" can be read as a perfect example of such a masked homoerotic subtext. Another example

is "Caesar," an image that appears repeatedly in her work. "I say lifting belly and then I say lifting belly and Caesars. I say lifting belly gently and Caesars gently. I say lifting belly again and Caesars again. I say lifting belly and I say Caesars and I say lifting belly and Caesars and cow come out." ("Lifting Belly"). "What are Caesars. Caesars are round a little longer than wide but not oval. They are picturesque and useful" ("Today We Have a Vacation"). Or, "A fig an apple and some grapes make a cow. How. The Caesars know how. Now" ("A Sonatina Followed by Another"). The name Caesar contains a sound play on "sees her" and "seize her," as well as an allusion to Stein herself, the author with a claim to literary authority and with the haircut of an emperor famous for his homosexual leanings. Again the ear decodes what is partly hidden to the eyes.

It has been argued, however, that Stein's way of loading a word/sound/name/image with complex associations does not necessarily indicate coding. "Opaqueness" is characteristic of the entire modernist avant-garde. Instead of being a special case, Stein can be read simply as a prototype of modernism. Indeed, if she wrote in code, we would have to explain an obvious contradiction: she, whose language insistently abstracts itself from the personal and representational, presents her physical self with such shocking liberality.

No Oedipus will once and for all unriddle this sphinx. The most enticing riddle is precisely the one that promises and, at the same time, withholds its solution. Continuously tempting, it stays continuously present.

THE GUESSING game of reading Stein demands patience and sufficient motivation to listen to and around her words, to feel them out, let them roll over one's tongue, and read them aloud (or listen to Stein's recorded voice). Aloud and, I would add, administered in the right dose, in a rhythm similar to that in which she wrote: every day a bit. In my experience, this practice best brings out the unity of sound, rhythm, sense, and ambiguity in her writing. Even the most seemingly absurd statements do, after all, make sense.

Take a line from one of her hermetic texts, *Tender Buttons* (1912–14): "A little called anything shows shudders." What are we to make of it? Does anything show shudders when called "little," or when called only a little bit? The sentence is evocative without evoking anything clearly recognizable. It stays abstract, pure "Steinese."

The mystery, in this case, happens to have been solved by Gertrude Stein herself. She revealed in an interview, in 1946, that the sentence referred to her car, to "the movement of one of those old-fashioned automobiles, an old Ford . . . [a] movement that is not always successful." The "absurd" sentence instantly fills with life. There is tenderness, worry, a hint at nicknames for a beloved car. Every word vibrates with associations, with the "peaceful and exciting" certitude of meaning. Readers who are not satisfied with Stein's practical explanation, however, may seek further inspiration from the intriguing title of the book, *Tender Buttons*. "Button" is a slang word for clitoris. Read with this in mind, "a little" and its "shudders" radically change meaning. One and the same sentence can be abstract on one level, realistic on another, and a double entendre on a third. With her own interpretation the author has pointed toward a possible *explication de texte*, in the sense of a personal, creative relation to language in which meaning and interpretation are necessarily private and consistently in flux. Commenting about her sentences, Stein once evoked "the intense feeling that they made sense, then the doubt and then each time over again the intense feeling that they did make sense."

Stein's strategy is obviously different from the "female voice" (*écriture de différence*) celebrated by recent feminist authors. The "Mother of Modernism" was not particularly interested in being a woman. On the contrary, she used every possibility of the English language to neither reveal nor conceal her gender. She chose to leave the question open. She, the outsider, wrote about herself as "he," "one," "someone," "nobody," and "everybody." She called the second part of her autobiography *Everybody's Autobiography*. As she considered her writing self-explanatory, she never commented on what she intended with this tactical move. We are left to speculate. Did she intend to proclaim the universality of her—female—person?

Intended or not, Gertrude Stein's use of language was not her only gender-bending strategy. The American in Paris with the "lifelong passion for sentences" also subverted the European salon tradition. After the departure of her brother Leo from the rue de Fleurus, she herself took the role of the male genius in her salon, while Alice B. Toklas played the indispensible role of hostess. Alice B. Toklas took care not only of the guests' well-being, serving them *eau-de-vies* and *petits fours*, she also maintained protocol. As an intellectual "bodyguard," she made sure that the genius stayed unbothered by undesirable or useless conversation.

Gertrude Stein's ways of writing and surviving—her chutzpah, cunning, her playful "aggressive liveliness"—may explain her ability to play with dignity the lifelong role of an outsider. Another explanation, I surmise, is her lifelong relationship with Alice B. Toklas.

THE RELATIONSHIP between these two women piqued onlookers from the start. It has been (and is still) seen by some as an exploitive arrangement, profitable to only one partner. According to this view, it was a "marriage" based on patriarchal "authority and submission patterns" (Shari Benstock), with Alice B. Toklas in the thankless role of the wife/domestic. In 1938, in a letter to the painter Romaine Brooks, salon patroness and writer Natalie Barney expressed her concern about Alice's "stress": "I am afraid 'the bigger one,' who gets fatter and fatter and fatter, will sooner or later devour [Alice]. She looks so thin."

What do the photos reveal? Was Alice B. Toklas nothing but the servant-shadow of a genius? Or was Gertrude Stein a passion for Alice B. Toklas the way writing was for Stein? Was the radical background position that Toklas maintained (even after Stein's death) an expression of her passion? By contrast to most muses, mistresses, and wives of male writers, Alice B. Toklas is strikingly present,

both in the photos and in Stein's work.

There certainly is ample evidence in Stein's writing that she pleased herself in the sexual role of the "husband." But this is a husband whose "wife has a cow." A cow? Another example of "Steinese." Is there a question of a bucolic romance? Apparently not. The term "cow" covers a whole range of taboo topics ("sacred cows") of traditional writing: female sexual organs, desire, and above all orgasm. For example: "Cows are very nice. They are between legs" ("All Sunday"); "Yes tenderness grows and it grows where it grows. And do you like it. Yes you do. And does it fill a cow full of filling. Yes. And where does it come out of. It comes out of the way of the Caesars. . . . And the cow comes out of the door. Do you adore me. When this you see remember me" ("A Sonatina Followed by Another"). The romance clearly is of a bodily, orgasmic nature. Pleasing Alice seems to have been a prime concern of "husband" Stein: "Have Caesars a duty. Yes their duty is to a cow. Will they do their duty by the cow. Yes now and with pleasure" ("A Sonatina"). A line in "Lifting Belly" ironically demands, "Husband obey your wife." Role-play and role reversals (both partners took turns being "Baby," for example) should not be confused with fixed gender stereotypes. If patriarchal patterns are played out, they are played out with gusto, *ad absurdum*.

Alice B. Toklas's intellectual brilliance was admired by many contemporaries and by Stein herself. She was not just the secretary who typed up every word of Stein's for print. She was for years the only person who understood Stein's work, who validated and

discussed it with her and sometimes corrected it. Without her recognition and encouragement, Stein might have continued writing day after day and page after page about her "despairing," as she did in her early novel, *The Making of Americans*. She might have ended up paralyzed rather than inspired by the boldness and solitude of her vision of language. Without Alice B. Toklas there might not have been the female genius Gertrude Stein.

It was Alice B. Toklas who discovered the "rose" in Stein's writing, who recognized and propagated it as an emblem of Modernism. In 1930, she created her own publishing company, Plain Edition, to further Stein's work. Stein specialist Richard Bridgman seriously considers the possibility that manuscript passages in Alice's handwriting indicate her active participation. Others disagree. Ulla Dydo makes the distinction between Stein's private writing, which included "secret" messages and intimate "banter" between her and Alice, and her "literature." But the distinction may be strained. Numerous literary Stein pieces have the distinct ring of domestic dialogues. For example: "This must not be put in a book. / Why not. / Because it mustn't. / Yes sir" ("Bonne Année," from Stein's self-published collection *Geography and Plays*, 1922). Without calling this possible interchange a coauthorship, it is easy to imagine that Stein's joy in experimenting opened the door to occasional writing in two voices. (One example of such a duet with Alice is the poem written in two hands, on page 64.)

Years after Stein's death, Alice B. Toklas wrote two cookbooks (the first one garnished with anecdotes and

with a famous recipe for hashish cookies), and finally her own memoir, *What is Remembered* (1963). After Stein's *Autobiography of Alice B. Toklas*, Toklas's curt, sarcastic wit sounds familiar indeed. Whether or not some form of collaboration was part of the game, Gertrude Stein's most successful book is a monument to the equal spirit of her companion, a monument evidently true to nature.

MY CHOICE of pictures and texts is not intended to solve the mystery of Gertrude Stein's identity. My intention is to sow clues for the reader.

When I set out to do detective work on this obscure high priestess of Modernism, I was surprised to find that she herself had left a trail of clues. Apart from her extensive autobiographical and self-explanatory texts, I discovered the gigantic mass of pictorial "messages" that she had collected and left to posterity: an almost unbroken, year-by-year account of her life. The sheer size of this photo collection called my attention to the possibility that Stein's insistence on a visual record might have a meaning. She had left us two kinds of "texts" to read: her writing, and the photographic chronicle of her life, perhaps as a deliberate hint that these two kinds of texts can read each other.

Looking at her childhood pictures, I am struck by the early absence of any attempt to please the onlooker. To the contrary, "Gertie" is clearly not pleased and won't compromise with a smile. She sticks to her mood, her boredom or suspicious vigilance, simply pleasing herself. The same wilfullness can be read in the snapshot from Del Monte, in 1935, where she comes walking straight toward the camera.

She is a celebrity by then, a "lion," and shows the same unbending refusal to please anyone but herself. Her slightly crumpled, half-buttoned tweed costume, the half-tugged-away scarf, her childlike duck shoes, pay tribute to her comfort—not, however, in an aggressive way that would deny any sense of aesthetics or attractiveness. The fine silk blouse, the decorative brooch, the black velvet collar and matching cap setting off her graying hair bespeak an undeniable pleasure in her appearance. Her stride is grounded, filled with purpose. She does not smile. She looks at the inquisitive eye of the beholder with the intensity of one who is inquisitive herself, for whom it is crucial to know. Of course she knows that someone is looking at her, trying to capture her, read her, decode her, judge her. She must be aware of the situation: an author in fashion, returning from Hollywood, her star rising with every picture taken. It does not for a second distract her. Whatever is sought from her is already there, to be given, generously, in utter simplicity, without rancor about past ridicule, without speculation about future revenge. She looks, as in her childhood pictures, intensely involved in her very own, personal experience of the present. Her face has the same determination, as does her fist, to show herself, not in order to please, but to be—which clearly pleases her.

Stein's writing can be read with the same eyes. There, too, is her unbending refusal to satisfy any exterior demand, her uncompromising attitude of following her own command. She has made herself comfortable in language, puts on words that fit her like her tweeds. Linguistically, she walks in shoes made strictly for her own use. She wears the hats of every literary genre. She caresses the rhythms of words as her brooch caresses her throat. If her sentences give pleasure, it is because they are a pleasure to herself.

Reading Stein's photographs encourages us to approach the obscure genius as she, in the Del Monte picture, approaches us. The unflinching, no-nonsense authority of her gaze tells us to trust our own eyes, to trust what we see when we read her.

The repeated snapshots and studio photographs betray the same principle of ever-changing repetition Stein used in her writing. Similarly, Stein's continuous photographic self-presentation mirrors her literary use of the continuous present tense and perhaps interprets it as a celebration of being, a faculty of being present in the moment, in her body, herself, with the flow of life present at every moment.

Another important clue from the photographic con/text is Stein's good-humor. Whether she lets Carl Van Vechten wrap her in melodramatic curtains, lets Cecil Beaton dress her up as a Dalai Lama, whether she seats herself like Humpty Dumpty on her garden wall, singing, or dons her improbable hats: it is obvious that she always places herself on the same level as her spectators. There is no attitude of pious hauteur, of being above her readers, the genius unreachable by us, mere mortals.

The same message of equal standing is conveyed by her playfulness: giggling with her nephew as a teenager, dancing with her dog when already a woman well past her prime, Stein invites us to join in and play with her. Looking at her photos provides, I think, the best answer to the questions we have always asked: Is Stein making deliberate fun of us? Are we laughed at by an author who cynically plays tricks behind our backs, pulls our legs, and smirks at our falls? Seeing her face, I find the answer. She has fun and she makes puns, but she looks us in the eye with a wink that says we are both in the same place, we are wise and we are fools, we can laugh together.

Stein herself was aware of this democratic attitude. She considered it part of her American heritage, and she often commented on it. When she "entered the war," in 1917, driving her Ford truck with supplies for the American Fund for French Wounded, she had her share of mishaps, like any other driver. The difference, however, that "puzzled the other drivers of the organization" was that when she blew a tire, got lost, or got stuck in the snow, she would unfailingly get help. In *The Autobiography of Alice B. Toklas*, she explains why: ". . . the others looked so efficient, of course nobody would think of doing anything for them. Now as for [Gertrude Stein] she was not efficient, she was good humoured, she was democratic, one person was as good as another, and she knew what she wanted done. If you are like that she says, anybody will do anything for you. The important thing, she insists, is that you must have deep down as the deepest thing in you a sense of equality. Then anybody will do anything for you."

"Having deep down as the deepest thing in you a sense of equality," shines a light from the textual record back to the photographic record. Her words en/lighten her way of looking at the

camera, at us. She takes herself seriously, to say the least; her "democratic" rootedness, however, keeps her from taking herself too seriously. Taking oneself too seriously inevitably hampers one's creativity through lack of play. Her unusual balance explains why Stein, whose sense of equality did not stop her from knowing herself to be a genius, is a powerful inspiration for women readers today. I have often witnessed the effect of Stein's example on other women writers. I have observed the impact of her inspiration, leading from a first uncensored thought to a daring utterance, to rediscovering one's innate sense of play, to embracing the full peril and pleasure of one's creativity. After almost a century, Stein continues to be present as a role model, teacher, mentor, muse. Her two kinds of "texts," her eccentric story-telling photographs, the visionary composition of her words, continue to shock, challenge, ravish.

IT WOULD have been impossible, in a "picture-reader," to do justice to all facets of Stein's oeuvre. Her work, however, lends itself to fragmentation. One of her most masterful stylistic means is the aphorism, the line that "goes under the skin" as she herself knew so well:

"There is no there there."

"Pigeons on the grass alas."

"I am I because my little dog knows me."

"Before the flowers of friendship faded friendship faded."

"A rose is a rose is a rose is a rose."

Another of her significant stylistic traits is the anecdote. How could the story of her life be better told than through matching up her story-telling photographs with her own literary anecdotes, both with their ironic smile about the absurdity of life?

In order to create a synchronicity between quotes and photographs, I tried to follow the chronology of Stein's writing. I did not want to resist the temptation, however, to occasionally sacrifice synchronicity and enjoy a purely associative link between a quote and the expression of a picture.

Exact biographical timing was often impossible simply because dates were not established. The gigantic mass of Gertrude Stein's unpublished texts and photos, which had to be managed, after Stein's death, by Alice B. Toklas, her literary executor Carl Van Vechten, and Yale University, could not entirely be dated with precision. Some crucial events remained questionable. Stein specialists don't agree, for example, when exactly Gertrude and Leo Stein separated. Was it in 1911 (Leon Katz), 1912 (John Malcolm Brinnin), 1913 (Donald Gallup), or, in Gertrude Stein's memory, 1914?

Least well established were the photographic dates, sometimes even in pictures taken by famous, well-documented photographers. One and the same picture by Cecil Beaton, for example, can appear in different publications with dates that vary by as much as ten years. Whenever there were no established dates or when the existing biographies of Gertrude Stein contradicted one another too drastically, I chose to leave solid academic ground and play instead with a Steinian perspective of time-lags. Approaching the puzzle of Gertrude Stein always happens at one's own risk and peril. She knew how to avoid being categorized, and not only in her writing. Her lack of respect for traditional values, safe judgments, and solid categories forces one into creative guessing, subjectivity, and tolerance for the unavoidable error, the unpredictable, the unknown.

Occasionally a detail under the looking glass, a piece of clothing, a brooch, hat, or a painting in the background provided an indication about a possible time and place. In a view of Stein's head in front of a pigeon wallpaper, for example, the wallpaper served as evidence. Several pictures from rue Christine show rooms bedecked with the same pigeons, indicating that the earliest possible date for the photo had to be 1938, the year of the move to rue Christine. But the archival number of the photo indicated Carl Van Vechten as the photographer, and Van Vechten had taken his last pictures of Gertrude Stein in 1935, during her American lecture tour. The correspondence between Stein and Van Vechten finally rendered the solution: in the States, Gertrude Stein had fallen in love with the wallpaper and had her picture taken in front of a piece of it, in 1935. By 1938, Carl Van Vechten had sent her a sufficient supply of rolls across the Atlantic to cover the walls of her new apartment in rue Christine.

An early photographic series shows Gertrude Stein enthroned on her Renaissance chair and working at her desk. Her face, hair, her velvet gown indicate a time before the 1920s. But what is the actual date? The arrangement of the paintings on the walls can't serve as a safe indication, since they were constantly rearranged. One hint, however, is provided by Picasso's *Architect's Table*, recognizable in a corner. The date of this painting, 1912, places the photos in a period after that time. To me, the series seems to symbolize perfectly the time when

Gertrude Stein reigned over the rue de Fleurus for the first time alone, without her brother, and established herself as a literary genius with Alice B. Toklas's support. I further assumed that some, if not all of the photos belong to a series taken by the American photographer Alvin Langdon Coburn, whom Gertrude Stein had mentioned (without giving a date) as the first photographer who came to her to take her photo "as a famous woman." I therefore used the series to illustrate the period of her growing fame, after Leo's departure in 1913, after the publication of *Tender Buttons* in 1914, and before Stein's "entering the war" in 1917.

For Gertrude Stein's lecture tour through the United States, in 1934–35, there was a choice of several photo series by Carl Van Vechten, taken at his New York studio. Van Vechten had organized a good part of the tour, welcomed Stein and Toklas at their arrival, and waved them good-bye. I chose to make an exception in this case and break the chronology of Van Vechten's photo series for the purpose of recreating the effect of his building a caring frame around the whole tour.

This limited "photo-poetic" license seemed justified by my goal to make Gertrude Stein's story not only as precise, but also as entertaining as possible. Her story is told on three different levels, one visual, one strictly biographical, and one literary-anecdotal, in her own words. My aim was to find the right dosage for a "picture-reader," for browsing, choosing, repeating, remembering. The interplay of the parts will, I hope, highlight a particularly modern aspect of Gertrude Stein's work: its wholeness, its nonhierarchical unity of high-flying thoughts and everyday trivia, spirituality and common sense, philosophy and erotics. The juxtaposition of words and images may also shine a light on the paradox of Gertrude Stein's personality, embracing the legendary and the down-to-earth, the female and the male, the self-enthroning and the self-ironic, the word-dictator and the fool at the court of world literature.

—R. S.
Berkeley, 1994

The First
Sixteen Years
1874–1890

When I was then I liked revolutions I liked to eat I liked to eat I liked to cry not in real life but in books in real life there was nothing much to cry about but in books oh dear me, it was wonderful there was so much to cry about and then there was evolution. Evolution was all over my childhood, walks abroad with an evolutionist and the world was full of evolution, biological and botanical evolution, with music as a background for emotion and books as a reality, and a great deal of fresh air as a necessity, and a great deal of eating as an excitement and as an orgy, and now well just then there was no war no actual war anywhere.

—*Wars I Have Seen*

1864 Daniel Stein and Amelia ("Milly") Keyser marry in Baltimore. They are both of German–Jewish descent, and English is their second language. They plan to have five children, no more, no less.

1865 Birth of Michael Stein.

1867 Birth of Simon Stein.

1870 Birth of Bertha Stein.

1872 Birth of Leo Stein.

1874 On Feb. 3, at 8:00 A.M., Gertrude Stein is born in Allegheny, a suburb of Pittsburgh, Pennsylvania. Both Leo and Gertrude owe their life to the fact that two other siblings (names unknown) have previously died. Daniel Stein and his brother have been partners in a small wholesale textile business since 1862, with stores in Pittsburgh and Baltimore.

1875 (?) After constant disagreements between the brothers, Daniel Stein takes his family and part of his business to Vienna, accompanied by Amelia's unmarried sister, Rachel Keyser. (In *Wars I Have Seen*, Gertrude Stein remembers having arrived in Vienna eight months after her birth.) Daniel Stein keeps shuttling between Europe and America.

1878 At the end of the year, Amelia Stein and the children move to France, to Passy (which will later become the sixteenth Arondissement of Paris).

1879 Gertrude Stein turns five in Paris. The family returns to America and stays with her maternal grandparents (the Keysers) in Baltimore. After speaking first German, then French, English becomes, for Gertrude Stein, the language in which "emotions began to feel themselves" (*Wars I Have Seen*).

1880 Daniel Stein and his family move to California. Their first year is spent at Tubb's Hotel, in Oakland. Daniel Stein invests in real estate, stocks, and cable cars (he will later become vice president of the Omnibus Cable Car Company in San Francisco).

1881 The family moves to a first home on East Twelfth Street in Oakland, then finds the "old Stratton house" on Twenty-fifth Street and Thirteenth Avenue in East Oakland, a place that comes with ten acres of land and a Eucalyptus alley and soon acquires servants, a cook, a German governess, a cow, and a piano. As adults, the Stein siblings will learn that the neighbor children who stole their apples were Raymond and Isadora Duncan. In Gertrude Stein's novel *The Making of Americans*, her family in East Oakland appears as the "Hersland family" in "Gossols."

1885 Amelia Stein is diagnosed with cancer. The family moves to a smaller place, Herrington House, at 1324 Tenth Avenue in Oakland. On November 5, 1885, Amelia Stein reports in her diary that Gertrude is "unwell for the first time."

1886 Entry in Amelia Stein's diary, on January 14: "Gertrude weighs 135 pounds."

1888 Amelia Stein dies. Gertrude and Leo attend Oakwood High School for a year. (Apart from elementary school and occasional Sabbath School, their education had been provided by private tutors.) Daniel Stein is listed in the Oakland directory first as "capitalist," then as "stock broker."

NOTE: In the biographical tables and throughout the book, the dating of the genesis and composition of Gertrude Stein's works follows the *Yale Catalogue* (New Haven, Conn.: Yale University Press, 1941), reprinted in Richard Bridgman's *Gertrude Stein in Pieces* (New York: Oxford University Press, 1970).

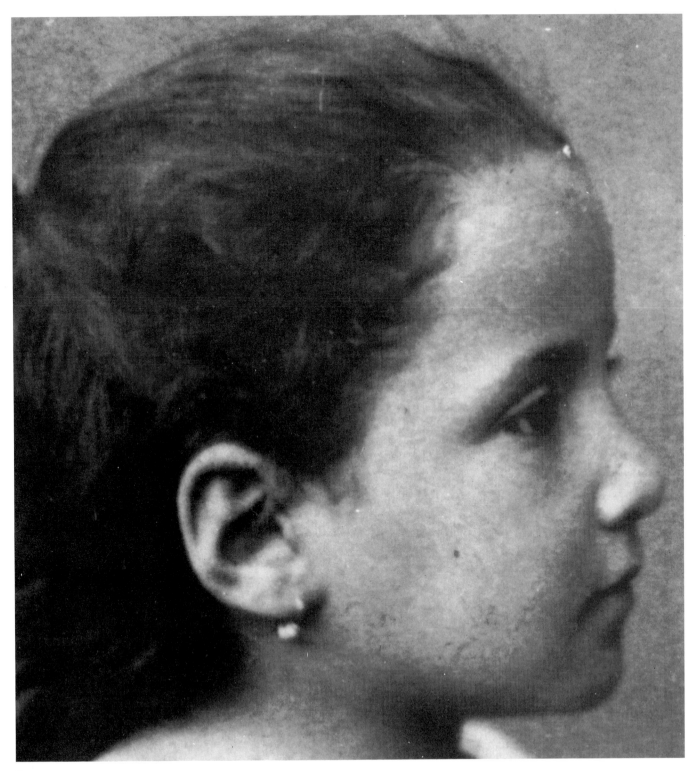

3

She was a sweet contented little woman who lived in her husband and her children, who could only know well to do middle class living, who never knew what it was her husband and her children were working out inside them and around them. She had strongly inside her the sense of being mistress of the household, the wife of a wealthy and good man and the mother of nice children.

—*The Making of Americans*

He was strong in fighting he was not so strong in winning, more and more then at the ending of his middle living fighting in him turned to impatient feeling inside him, more and more then fighting in him in his late living broke down into weakness inside him.

—*The Making of Americans*

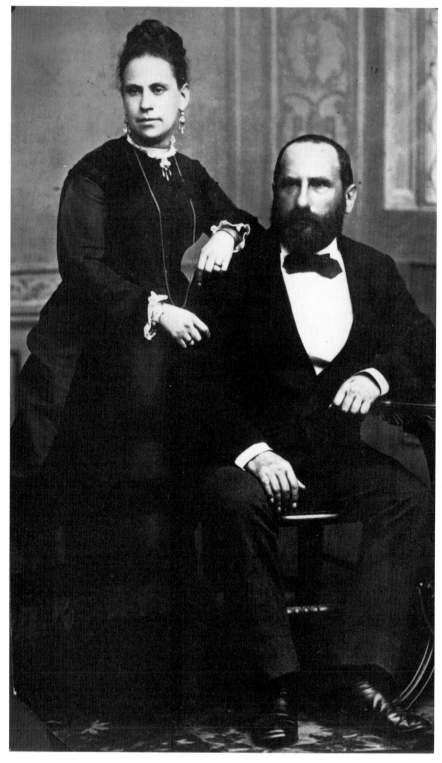

⊠ Gertrude Stein's parents, Amelia ("Milly") and Daniel Stein.

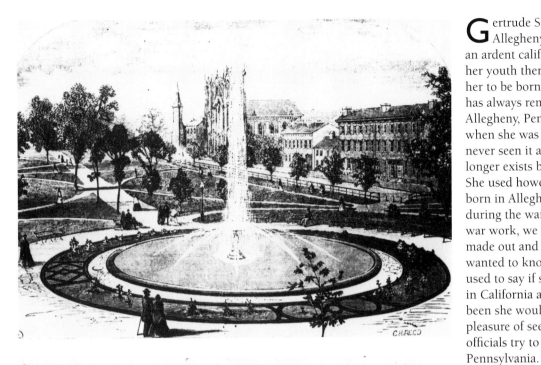

Gertrude Stein was born in Allegheny, Pennsylvania. As I am an ardent californian and as she spent her youth there I have often begged her to be born in California but she has always remained firmly born in Allegheny, Pennsylvania. She left it when she was six months old and has never seen it again and now it no longer exists being all of it Pittsburgh. She used however to delight in being born in Allegheny, Pennsylvania when during the war, in connection with war work, we used to have papers made out and they always immediately wanted to know one's birth-place. She used to say if she had been really born in California as I wanted her to have been she would never have had the pleasure of seeing the various french officials try to write, Allegheny, Pennsylvania.

—*The Autobiography of Alice B. Toklas*

⊞ Two views of Allegheny, near Pittsburgh, in 1874, the year of Gertrude Stein's birth.

Bottom: The market hall.

5

To begin with I was born, that I do not remember but I was told about it quite often, I was not born during the night but about eight o'clock in the morning and my father whenever I had anything the matter with me always reproached me by telling me that I had been born a perfect baby. I do not know whether the four living and the two dead older children had not been born equally perfect babies at any rate my father never reproached them with it when there was anything the matter with them.

—*Wars I Have Seen*

Dan in the city the children at school, swept the bedrooms and cleaned out the pantry and also washed some rags and at home all day a beautiful day all day.

—Amelia Stein's diary, 1884

The mother . . . was very loving in her feeling to all of her children, but they had been always . . . after they had stopped being very little children, too big for her ever to control them. She could not lead them nor could she know what they needed inside them. She could not help them, she could only be hurt not angry when any bad thing happened to them.

—*The Making of Americans*

▧ Above: Daniel and Amelia Stein. Right: "Gertie" at the age of three, in Vienna. Her first language was German. Right page: The Stein siblings with their Hungarian governess and Czech tutor, Vienna 1877. From left: Gertrude, Bertha, Simon, Michael; front, Leo.

Our little Gertie is a little Schnatterer. She talks all day long and so plainly. *She outdoes them all.* She is such a round little pudding, toddles around the whole day & repeats everything that is said or done.

—Rachel Keyser, Gertrude Stein's aunt, to Daniel Stein, Vienna, November 28, 1875

One should always be the youngest member of the family. It saves you a lot of bother everybody takes care of you.

I was the youngest member of my family and there were five of us and this my brother was only two years older. Naturally everybody always took care of me and naturally he always took care of me and I had a great deal of care taken of me and that left me with a great deal of time altogether. Well I suppose you have to do that if you are going to.

—*Everybody's Autobiography*

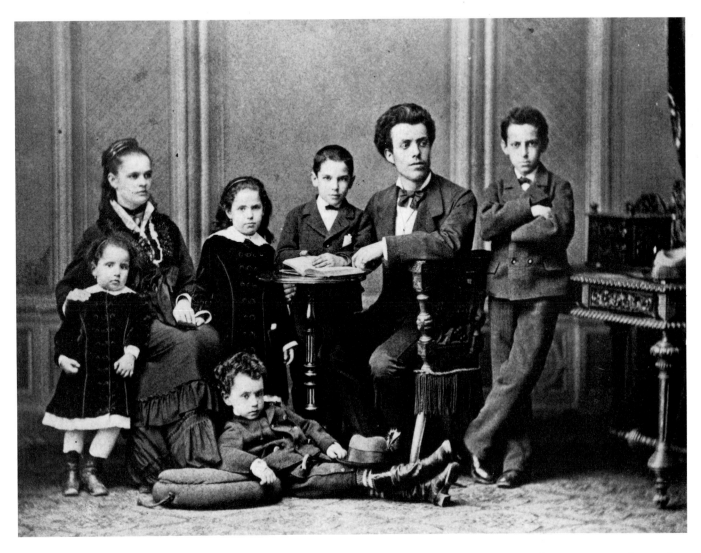

And so we were in Vienna and I have never seen it again but it has always remained for me something very real. It was there that I first came to be and so of course it was real and then there were really things, there was a public garden, a formal garden and in a kind of a way a formal garden pleases a child's fancy more than a natural garden. It is more like a garden that you would make yourself. And there was music and there was the old emperor who was a natural figure to have in a formal garden and there was his national anthem and then there were the salt caves and then there were birds and butterflies and insects in the woods and there was the catching of them and there was good eating and on my third birthday a taste of Vienna beer. And there were my mother and my brothers on horseback and there was a Czech tutor, one did not realise how important all these nationalities were going to be to every one then and a Hungarian governess, and there was the first contact with books, picture books but books all the same since pictures in picture books are narrative.

—*Wars I Have Seen*

7

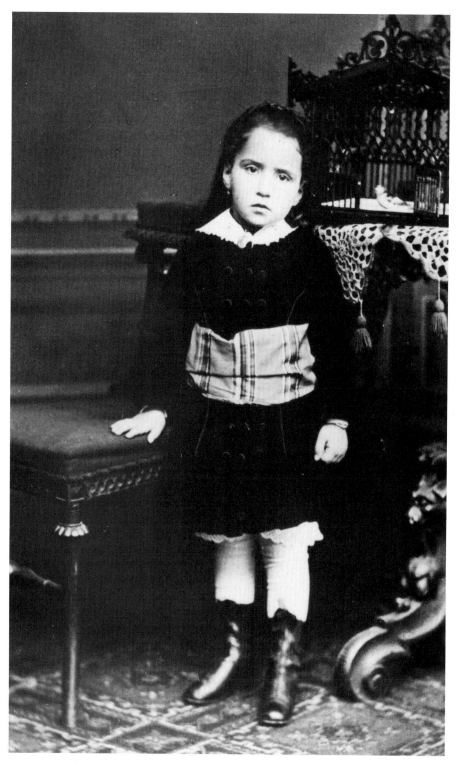

The little mother was not very important to them. They were good enough children in their daily living but they were never very loving to her inside them. They had it too strongly in them to win their own freedom.

—*The Making of Americans*

⊠ In Vienna, at the age of four.

My sister four years older simply existed for me because I had to sleep in the same room with her. It is natural not to care about a sister certainly not when she is four years older and grinds her teeth at night. My sister Bertha did. She was a little simple minded so was my brother Simon that is to say they would have been natural enough if no one had worried about it but Simon was very funny. He was always very funny. He never could learn anything not that it mattered except to my father. He naturally did not like it. My sister Bertha could not learn anything and that annoyed him even more.

—*Everybody's Autobiography*

Her father having taken his children to Europe so that they might have the benefit of a european education now insisted that they should forget their french and german so that their american english would be pure. Gertrude Stein had prattled in german and then in french but she had never read until she read english. As she says eyes to her were more important than ears and it happened then as always that english was her only language.

—*The Autobiography of Alice B. Toklas*

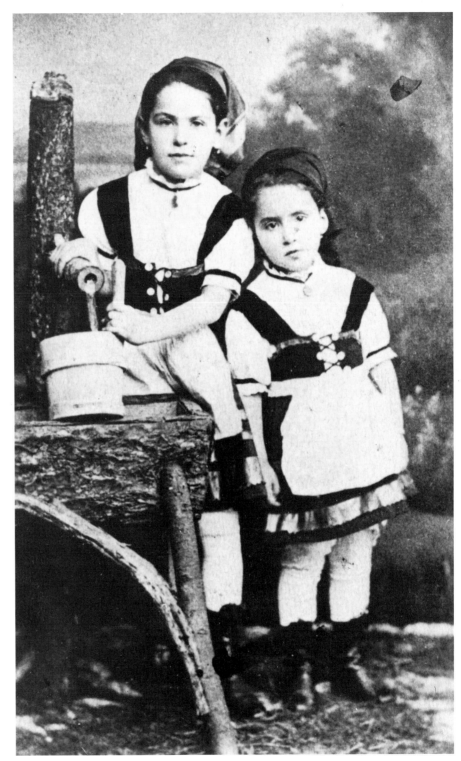

▣ The sisters Bertha and Gertrude Stein dressed as village girls.

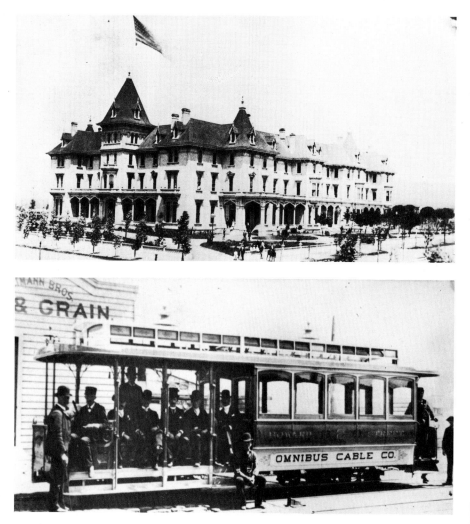

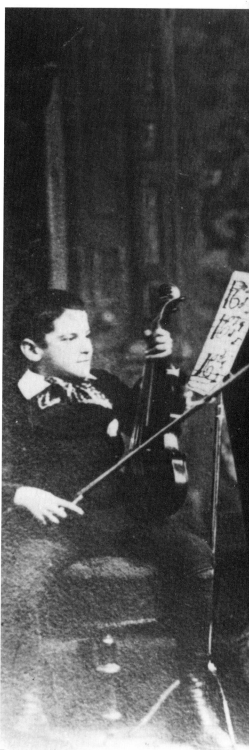

And so I was a little girl in East Oakland California and of course one did have to find out that life although it was life there was death although there was death, and you had to find out that stars were worlds and moved around and that there were comets and that there was wind and rain, grass and flowers and birds and butterflies were less exciting in California, but most of all there were books and food, food and books, both excellent things.

—*Wars I Have Seen*

Top: Tubbs Hotel in Oakland, California, where the Stein family resided after their return from Vienna, from 1880 until 1881.
Bottom: A San Francisco cable car, in the mid-eighties. Daniel Stein was vice president of the Omnibus Cable Car Company.
Right: Family idyll in East Oakland, ca. 1881. From the left: Simon, Father, Michael, Mother, Leo, Bertha; front, Gertrude.

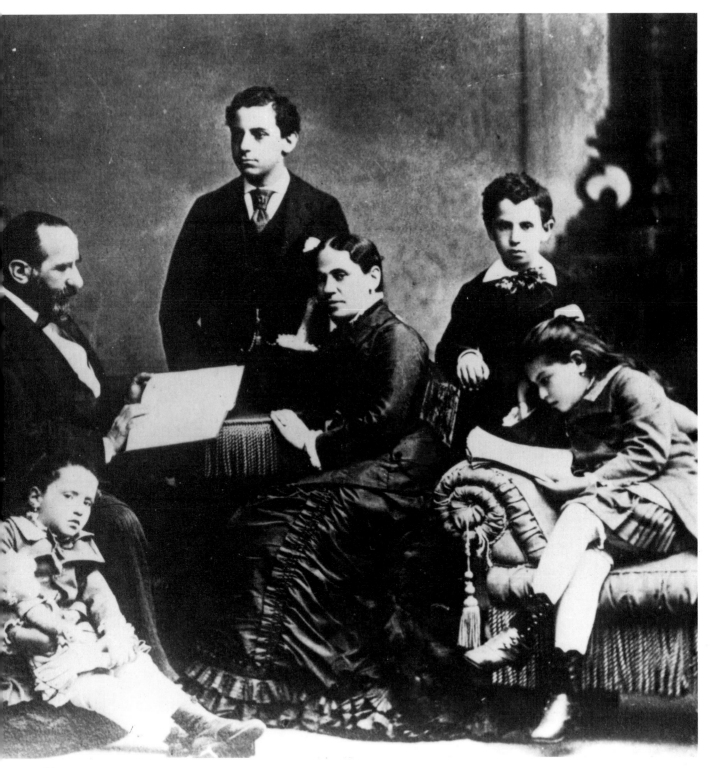

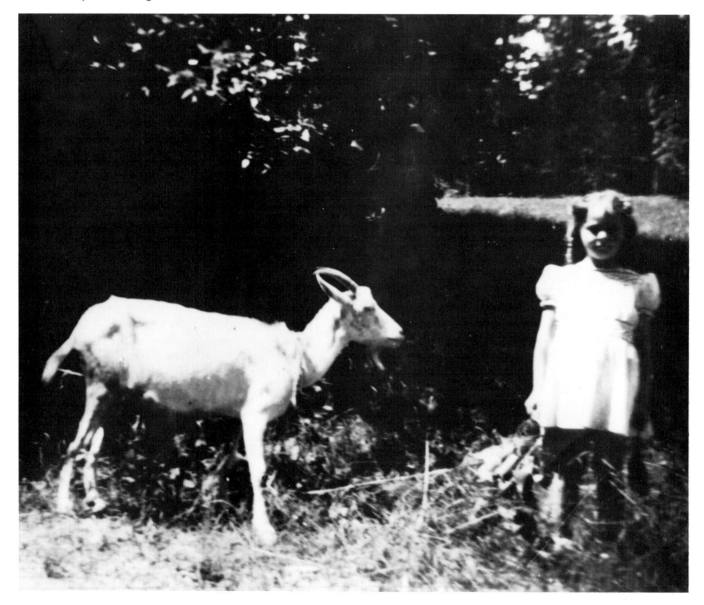

▨ "Gertie" in the garden with her first goat. About five decades later, in wartime France, couturier Pierre Balmain would spot Gertrude in her garden at Culoz, walking her "ghost," as he mistakenly called her goat.

It was a very good kind of living the Hersland children had in their beginning, and their freedom in the ten acres where all kinds of things were growing, where they could have all anybody could want of joyous sweating, of rain and wind, of hunting, of cows and dogs and horses, of chopping wood, of making hay, of dreaming, of lying in a hollow all warm with the sun shining while the wind was howling, of knowing all queer poor kinds of people that lived in this part of Gossols where the Herslands were living and where no other rich people were living. And so they grew up with this kind of living, such kind of queer poor, for them, people around them, such uncertain ways of getting educa-tion that they had from the father's passion for all kinds of educating, from his strong love of starting and the uncertain things he had inside him.

— *The Making of Americans*

▦ Lake Merrit, in the immediate neigh-borhood of the "old Stratton house," the Stein family home in East Oakland, in the 1880s.

. . . my first enthusiastic pleasure was a sunset in East Oakland, the sun setting in a cavern of clouds and my first writing when I was 8 years old was a description of it, which pleased the teacher and it was to be carefully copied on to a specially prepared paper it was to be exhibited . . . as the xample of our class in the Franklin School, but alas, after several efforts at copying, the teacher was discouraged, and it was my composition but another little girl was set to copy it whose hand writing was more certain. I can still see that enormous parch-ment piece of paper with a sort of red border.

— Gertrude Stein to Robert Bartlett Haas, 1940

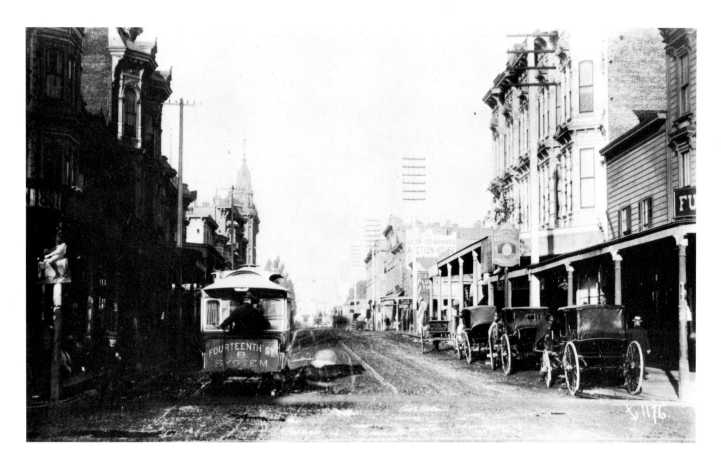

⊞ Downtown Oakland, Washington
Street, around 1885.

Youth and Student Years 1891–1903

. . . in those days in California I was interested in everlasting and I wondered so much about everything that I was almost alone and if you are almost alone well all that there is is almost alone.

—*Everybody's Autobiography*

1891 Daniel Stein dies. Michael ("Mike") Stein breaks off his studies at Johns Hopkins University and begins to manage his father's estate with considerable success. For many years, Gertrude and Leo receive monthly allowances from him. The siblings move to 834 Turk Street in San Francisco. Gertrude Stein has dropped out of school and, together with Leo, pursues her own education by browsing through San Francisco bookstores for days on end. She is seventeen years old.

1892 Gertrude and Bertha go to live with their maternal aunt Fanny Bachrach and her family, in Baltimore. Leo, who has managed "doing three years' high school work in seven months," studies philosophy at Harvard.

1893 Gertrude Stein registers at Harvard Annex, the college for women that in 1894 becomes Radcliffe College. Even though she never finished high school, she is accepted as a special student for the winter semester. She studies philosophy and takes classes in English composition with the poet William Vaughn Moody. ("Your vehemence runs away with your syntax," he comments.) Her compositions, "The Radcliffe Manuscripts," are her first serious attempt at writing.

1894 Gertrude Stein studies philosophy and psychology with William James, the brother of Henry James, and works with the German professor Hugo Münsterberg at Harvard Psychological Laboratory.

1895 Michael Stein marries Sarah ("Sally") Samuels. Leo graduates and goes on a world trip with his cousin Fred Stein.

1896 First publication: Gertrude Stein's investigation of automatic writing, "Normal Motor Automatism" (coauthored with her colleague Leon Solomons), appears in *Psychological Review* in September. In the summer, Gertrude returns to Europe for the first time as an adult and meets up with Leo in Antwerp.

1897 Gertrude flunks her Latin entrance exam and cannot graduate. She pursues her interest in psychology by entering Johns Hopkins School of Medicine in Baltimore. She sets up house with Leo, who studies biology at Johns Hopkins University, and Lena, the first of two housekeepers she will later describe in *Three Lives*. Proud of being "born Bohemians," the two siblings hold their first salon for relatives and friends of the Jewish intelligentsia (among them, the sisters Claribel and Etta Cone).

1898 B.A. in medicine.

1899 Summer with Michael, Sarah, and Allan Stein in San Francisco. As part of her medical studies, Gertrude Stein does casework, delivering babies in the black neighborhoods of Baltimore.

1900 Summer in Italy and France with Leo and their friend Mabel Weeks. Leo goes to Florence, where he has met the art historian Bernard Berenson, to study art and aesthetics. After her return to Baltimore, Gertrude's interest in medicine lags. To her friend Marion Walker's admonishments—"Gertrude, Gertrude, remember the cause of women"—she replies, "You don't know what it is to be bored." Her first love affair, with student May Bookstaver, is an unhappy triangle involving another female student. Worried about her health, Gertrude engages a boxer as her personal trainer. She does an independent study on human brain development, dissecting embryo brains and reconstructing them in plastic models.

1901 Gertrude Stein fails four courses in the final term. She summers with Leo in Tangiers, Granada, and Paris before returning to Baltimore. She continues the research project on her plastic landscapes of the brain, possibly in the hope of making up for her failed courses.

1902 Having given up on medicine for good and fleeing from her unhappy love affair, Gertrude joins Leo in Italy, then follows him to London. They settle for several months at 20 Bloomsbury Square. Paying a summer visit to Bernard Berenson in Surrey, they meet the philosopher Bertrand Russell. At Christmas, Leo departs for Paris, while Gertrude stays in Bloomsbury. In a serious depression, she begins to write in the notebooks that she will later use as source material for *The Making of Americans*.

1903 In February, Gertrude Stein returns to America. She shares rooms with her friend Mabel Weeks at the "White House," on One Hundredth Street and Riverside Drive in New York. The love affair with May Bookstaver ends. Gertrude begins *Q.E.D.* (*Quod Erat Demonstrandum*), a veiled description of her affair, and a first version of her novel *The Making of Americans*. In the spring, she visits Leo in Paris. They go to Rome, Florence, and Siena. In Rome, she runs into May Bookstaver. After her return to New York and futile attempts at reconciliation, Gertrude decides to join Leo in Paris. In the fall, she moves in with him at 27, rue de Fleurus, in the artists' *quartier* Montparnasse. Here, she finishes *Q.E.D.* (published four years after her death and later reissued under the title, *Things as They Are*). She is twenty-nine years old. Michael Stein and his family also move to Paris.

17

. . . a girl rather stout, fair ((,))* and with a singularly attractive face, attractive largely because puzzling. Her mouth is just saved from complete severity by a slight fullness of the lower lip which seems rather an after-thought of her Creator. Her chin does its best to make up for this slip by hard lines of determination. Her nose just escapes being beautiful for at the last moment it drooped and spoiled its perfect shape. Still in spite of these features she is distinctly lovable and if you will watch her carefully you will notice how her hard lines are success-fully contradicted. See just then the music pleased her and her eyes creased and wrinkled an in (minatl) nimitable charm.

—"The Great Enigma"

*Gertrude Stein offered writing and punctuation alternatives, in single or double parentheses, in all her college compositions.

"Then our life without a father began a very pleasant one." Turk Street in San Francisco, where the orphaned Stein siblings lived before Gertrude and Bertha moved to Baltimore in 1892. Gertrude Stein, high-school dropout, in Baltimore (left) and future student of psychology (right page) at Harvard University at the beginning of the 1890s.

Life in California came to its end when Gertrude Stein was about seventeen years old. The last few years had been lonesome ones and had been passed in an agony of adolescence. After the death of first her mother and then her father she and her sister and one brother left California for the East. They came to Baltimore and stayed with her mother's people. There she began to lose her lonesomeness. She has often described to me how strange it was to her coming from the rather desperate inner life that she had been living for the last few years to the cheerful life of all her aunts and uncles. When later she went to Radcliffe she described this experience in the first thing she ever wrote. Not quite the first thing she ever wrote. She remembers having written twice before. Once when she was about eight and she tried to write a Shakespearean drama in which she got as far as a stage direction, the courtiers making witty remarks. And then as she could not think of any witty remarks gave it up.

—*The Autobiography of Alice B. Toklas*

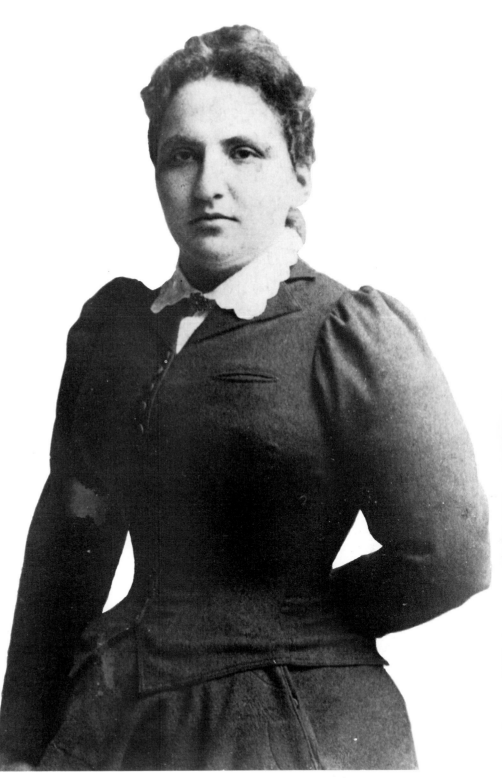

It is better if you are the youngest girl in a family to have a brother two years older, because that makes everything a pleasure to you, you go everywhere and do everything while he does it all for and with you which is a pleasant way to have everything happen to you.

—*Everybody's Autobiography*

⊠ "Born Bohemians" Gertrude and Leo during their student years, Cambridge, Massachusetts, ca. 1897.

. . . an exceedingly attractive buxom young woman, quick-thinking and speaking, original in ideas and manner, with a capacity of humor so deep, kindly and embracing that you found yourself laughing at everything she found extremely amusing, even yourself. Leo made you uncomfortable, you always felt he thought you were ridiculous. . . . Everybody was attracted to Gertrude—men, women, and children, our German maids, the negro laundresses, even casual aquaintances she talked to on the long walks we used to take into the country.

—Helen Bachrach, Gertrude Stein's cousin

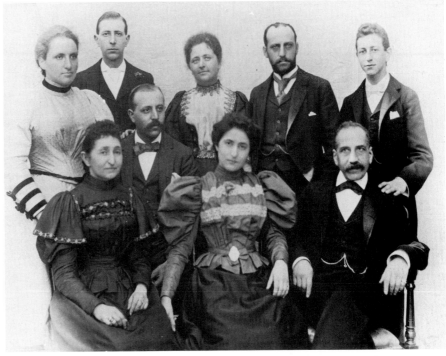

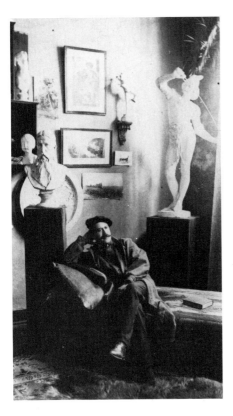

I remember we were once arguing my brother and I which one of us talked more and we finally asked our little uncle Ephraim Keyser which one of us did talk and argue more and he looked very carefully first at one and then at the other one and he said well I think you do certainly do both do your share.

As I say we were almost always together.

—*Everybody's Autobiography*

Left: The family artist, uncle Ephraim Keyser, in his studio.
Above: Gertrude Stein (left, standing) with relatives in Baltimore. (Michael Stein and his wife, Sarah, are standing at center.)

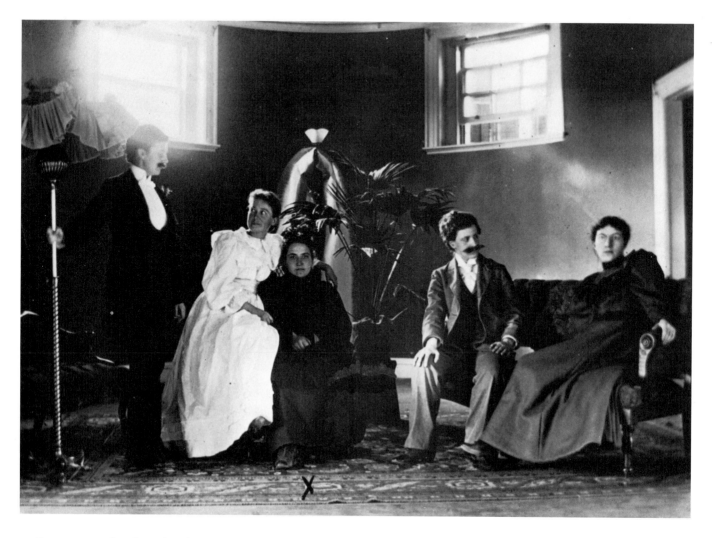

It was a very lovely spring day, Gertrude Stein had been going to the opera every night and going also to the opera in the afternoon and had been otherwise engrossed and it was the period of the final examinations, and there was the examination in William James' course. She sat down with the examination paper before her and she just could not. Dear Professor James, she wrote at the top of her paper. I am so sorry but really I do not feel a bit like an examination paper in philosophy to-day, and left.

The next day she had a postal card from William James saying, Dear Miss Stein, I understand perfectly how you feel I often feel like that myself. And underneath it he gave her work the highest mark in his course.

—*The Autobiography of Alice B. Toklas*

▨ Theater performance by the Idler Club, at Harvard University; Gertrude Stein is under the palm tree.

Solomons reported what he called his and my automatic writing but I did not think that we either of us had been doing automatic writing, we always knew what we were doing how could we not when every minute in the laboratory we were doing what we were watching others doing, that was our training.

—*Everybody's Autobiography*

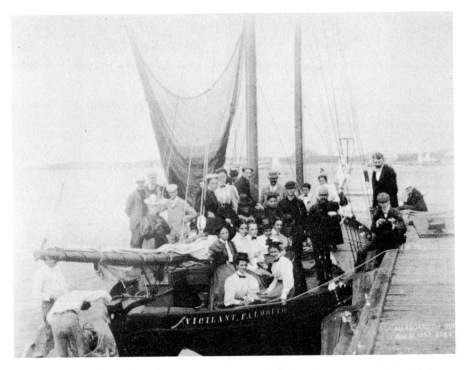

⊠ Left: A student outing by boat. Leo is at the mast, Gertrude at the stern (under the x).
Below: Gertrude Stein's professor, philosopher and psychologist William James, who said, "There are no other differences than gradual differences between different grades of difference and no difference."

I like a thing simple, but it must be simple through complication. Everything must come into your scheme, otherwise you cannot achieve real simplicity. A great deal of this I owe to a great teacher, William James. He said, "Never reject anything. Nothing has been proved. If you reject anything, that is the beginning of the end as an intellectual." He was my big influence when I was at college. He was a man who always said, "Complicate your life as much as you please, it has got to simplify."

—"A Transatlantic Interview"

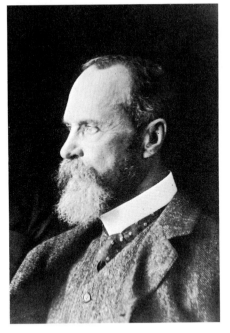

She had not noticed this man before, she did not look at him now, but he ((,)) taking advantage of the position ((,)) leaned toward her rather heavily. She felt his touch. At first she was *(oblivious to)* only half-aware of it, but soon she became conscious of his presence. The sensuous impressions (had done their work only too well. The magic charm of a human touch was on her) was in her and she (could) did not stir. She loathed herself but still she did not move.

Now she became conscious that possibly her friends would notice her proximity to this fellow. Even that did not stir her. Her busy brain was active in weaving excuses. She remembered her well-known tendency to absent-mindedness. "I can tell them I was unconscious and grow indignant if they accuse me."

The voice of the preacher continued off in the distance but the words did not penetrate her brain. At last she became unconscious of the voice and of the crowd, she only felt the human touch and thought of the reasons she should give for her position.

At last she noticed her (aunt) friend motioning to her. "Not yet," she said to herself, "I won't see her." Then with a quick revulsion she continued fiercely, "Liar and coward," will you continue this, have you no sense of shame?" and all the while her eyes were fixed on the preacher and she looked the embodiment of intelligent interest.*

—"The Temptation"

*Comment by her teacher, the poet W. V. Moody: "I wish that you might overcome your disdain for the more necessary marks of punctuation."

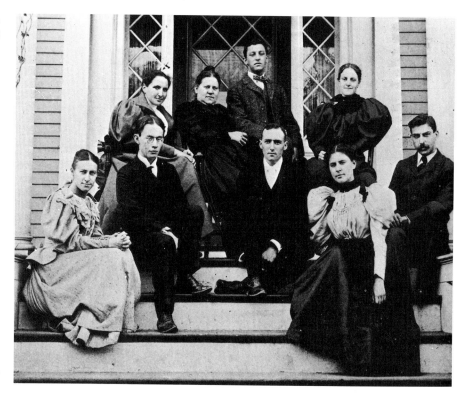

She had always been accustomed to rule ((and)) ((H)) (h) er family had been afraid of her and all men had bowed before her. She had a glorious ideal of generosity but for the most part was thoroughly selfish. She was intolerant in the pride of her strength but no one could have had theoretically, a broader out-look. She was tremendously moral, riding with great vigor all those hobbies that belong to the women known in current phrase as advanced. She was painfully self-righteous in the midst of most violent denunciation of self-righteousness. So far the promise of her mouth and chin had not been belied but her eyes crinkled and creased in vain, that part of her nature was still hidden.

—"The Great Enigma"

With fellow students from Harvard University and Radcliffe College (among them Leon Solomons?), mid-1890s.

24

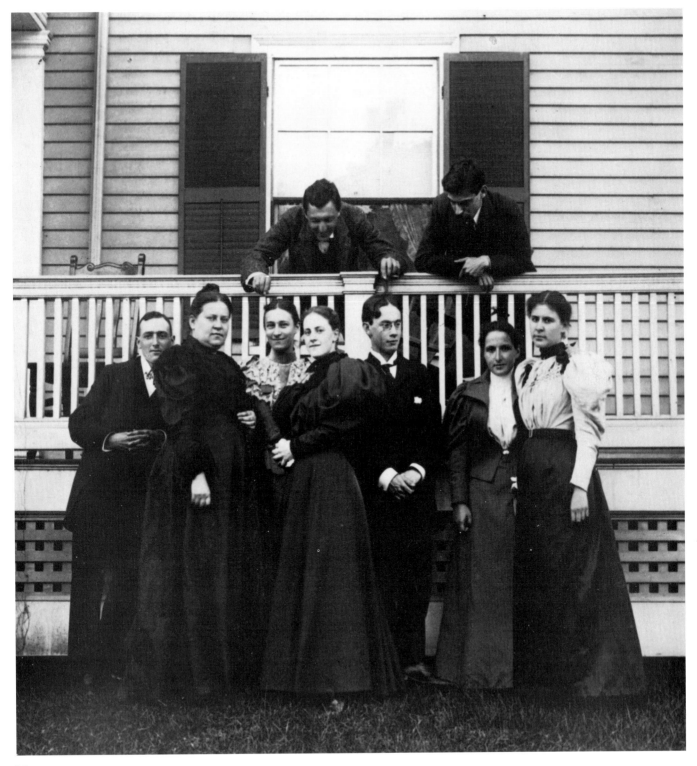

◼ "Loving alone is very simple." The medical student at Johns Hopkins School of Medicine in Baltimore, at the end of the 1890s.

. . . her deepest interest was in the varieties of human experience and her constant desire was to partake of all human relations but by some quality of her nature she never succeeded in really touching any human creature she knew. Her transfigured innocence too was not an ignorance of the facts of life nor a puritan's instinct indeed her desire was to experience the extreme forms of sensuous life and to make even immoral experience her own. Her detachment was due to an abstracted spirit that could not do what it would and which was evident in the reserved body her shy eyes and gentle face. A passionate desire for worldly experience filled her entirely and she was still waiting for the hand that could tear down the walls that enclosed her and let her escape into a world of humans.

—"Fernhurst"

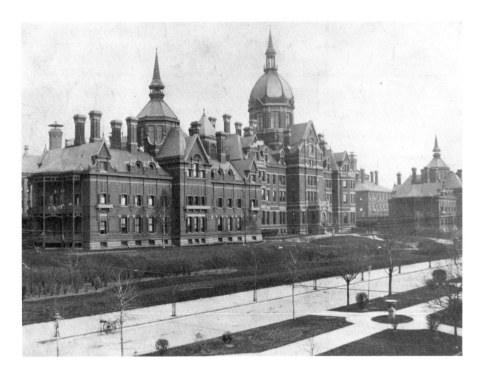

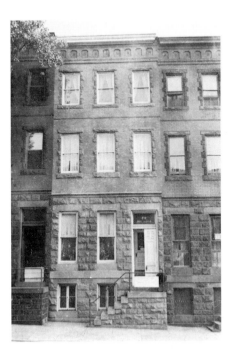

Then one day when I was at college at Radcliffe in Cambridge Massachusetts, I was on a train and sitting next to me was a frenchman. I recognised him as a visiting lecturer and I spoke to him. We talked about American college women. Very wonderful he said and very interesting but and he looked at me earnestly, really not one of them, now you must admit that, not one of them could feel with Alfred de Musset that le seul bien qui me reste au monde c'est d'avoir quelque fois pleuré. I was young then but I knew what he meant that they would not feel like that.

—Paris France

She always says she dislikes the abnormal, it is so obvious. She says the normal is so much more simply complicated and interesting.

— The Autobiography of Alice B. Toklas

✶ Above: The University Hospital in Baltimore where Gertrude Stein did some of her required practical work. Left: East Biddle Street in Baltimore. Across from these houses, Leo and Gertrude Stein hosted their first salon.

27

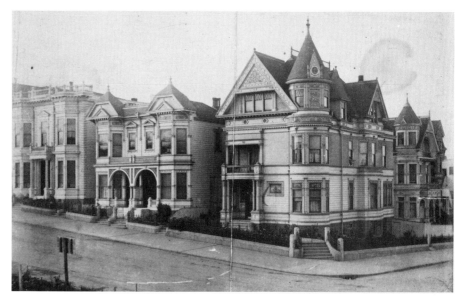

Just as everybody has the vote, including the women, I think children should, because as soon as a child is conscious of itself, then it has to me an existence and has a stake in what happens.

—"A Transatlantic Interview"

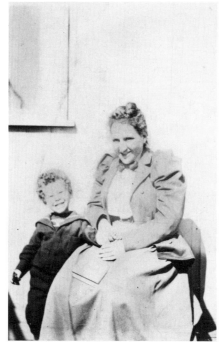

With her nephew Allan, Sarah and Michael Stein's son, 1899.
Above right: The corner house in Pierce Street, San Francisco, where Allan was born in 1896 and where Gertrude Stein used to spend part of her summer vacations.

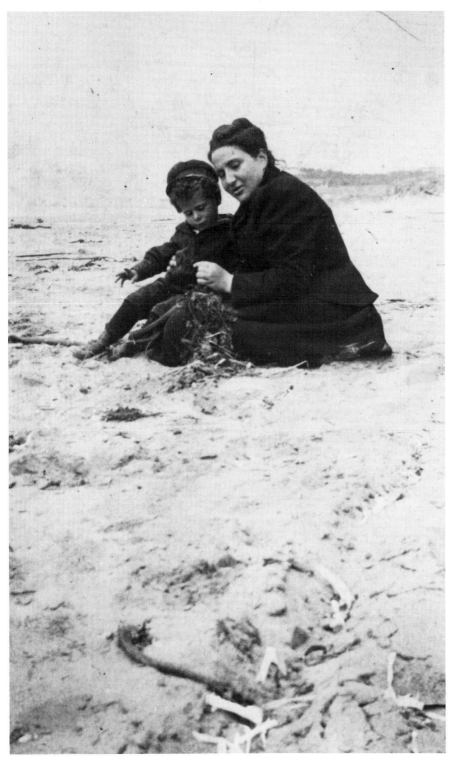

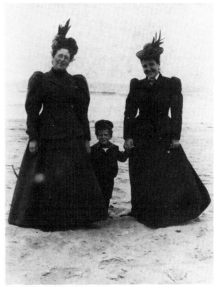

Loving repeating is one way of being. This is now a description of such being. Loving repeating is always in children. Loving repeating is in a way earth feeling. Some children have loving repeating for little things and story-telling, some have it as a more bottom being. Slowly this comes out in them in all their children being, in their eating, playing, crying, and laughing. Loving repeating is then in a way earth feeling. This is very strong in many, in children and in old age being. This is very strong in many in all ways of humorous being, this is very strong in some from their beginning to their ending.

—*The Making of Americans*

▦ Summer with Sarah and Allan Stein on a San Francisco beach.

The professor who had flunked her asked her to come to see him. She did. He said, of course Miss Stein all you have to do is to take a summer course here and in the fall naturally you will take your degree. But not at all, said Gertrude Stein, you have no idea how grateful I am to you. I have so much inertia and so little initiative that very possibly if you had not kept me from taking my degree I would have, well, not taken to the practice of medicine, but at any rate to pathological psychology and you don't know how little I like pathological psychology, and how all medicine bores me. The professor was competely taken aback and that was the end of the medical education of Gertrude Stein.

—*The Autobiography of Alice B. Toklas*

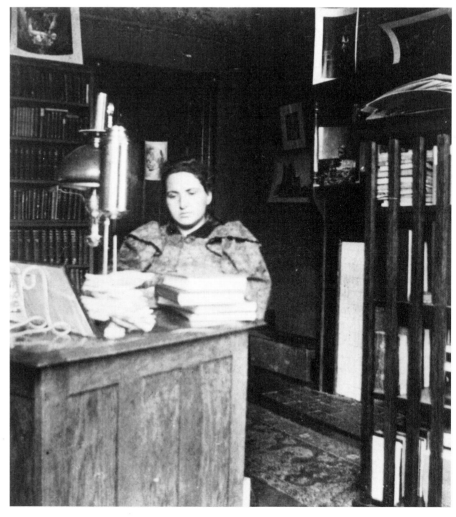

"Books, books" she muttered, "is there no end to it. Nothing but myself to feed my own eager nature, nothing given me but dusty books."

—"The Radcliffe Manuscripts"

▨ Above and right page, near right: Studying at Johns Hopkins School of Medicine, late 1890s.
Left and far right: In love for the first time? Photographs taken shortly before Gertrude Stein broke off her studies.

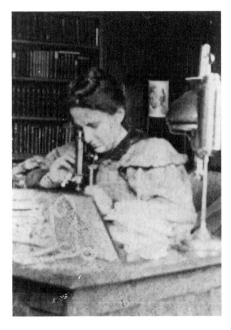

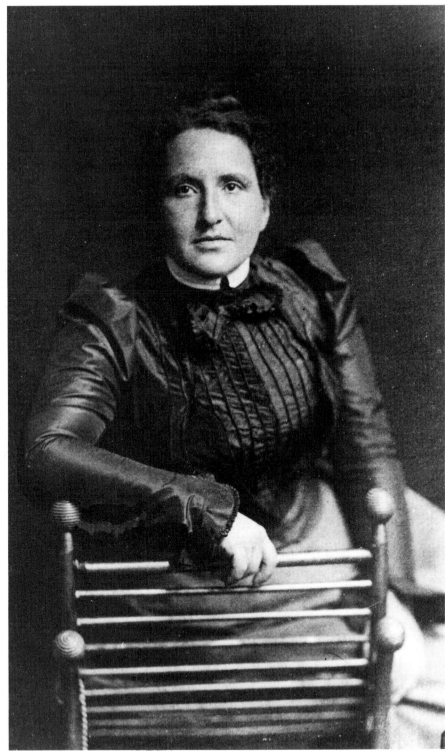

It was a very real oblivion. Adele was aroused from it by a kiss that seemed to scale the very walls of chastity. She flung away on the instant filled with battle and revulsion. Utterly regardless of Helen she lay her face buried in her hands. "I never dreamed that after all that has come I was still such a virgin soul" she said to herself, "and that like Parsifal a kiss could make me frantic with realisation" and then she lost herself in the full tide of her fierce disgust.

—*Q.E.D.*

Honesty is a selfish virtue. Yes I am honest enough.

—*Q.E.D.*

🔲 "I want to be historical."

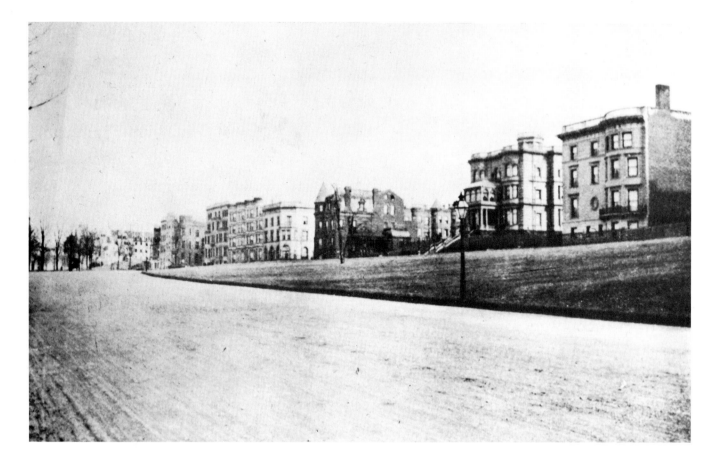

North One Hundredth Street, New York, Gertrude Stein's last address in the United States, at the turn of the century. This is where she wrote *Q.E.D.*, the story of her first love.

First Years with Leo at the rue de Fleurus 1904–1907

It happens often in the twenty-ninth year of a life that all the forces that have been engaged through the years of childhood, adolescence and youth in confused and ferocious combat range themselves in ordered ranks—one is uncertain of one's aims, meaning and power during these years of tumultuous growth when aspiration has no relation to fulfillment and one plunges here and there with energy and misdirection during the storm and stress of the making of a personality until at last we reach the twenty-ninth year the straight and narrow gate-way of maturity and life which was all uproar and confusion narrows down to form and purpose and we exchange a great dim possibility for a small hard reality.

Also in our American life where there is no coercion in custom and it is our right to change our vocation so often as we have desire and opportunity, it is a common experience that our youth extends through the whole first twenty-nine years of our life and it is not until we reach thirty that we find at last that vocation for which we feel ourselves fit and to which we willingly devote continued labor.

—*The Making of Americans*

1904 At the beginning of the year, Gertrude Stein visits America; she will not return for the next thirty years. She travels back to Paris in June, accompanied by Etta Cone, then spends the first of several summers with Leo in Fiesole, above Florence. She and Leo receive an eight-thousand-dollar dividend from the family estate. In Paris, they begin purchasing paintings at Ambroise Vollard's gallery in Montmartre. Gertrude Stein writes "Fernhurst," another account of a love triangle, this time involving two women and a man.

1905 Seated across from Cézanne's *Portrait de Mme. Cézanne* (*Madame Cézanne with a Fan*), Gertrude Stein begins *Three Lives*, three stories about three different women—two German servants and a young black woman in Baltimore. Scandal of the Fauvist painters at the Paris Salon d'Automne. Leo and Gertrude Stein buy their first Matisse, *Woman with a Hat*. Shortly thereafter, they acquire their first Picasso, *Girl with a Basket of Flowers*, from the art dealer Clovis Sagot. Sagot arranges their meeting with Picasso, in November. The Saturday night salon at 27, rue de Fleurus begins.

1906 Gertrude Stein sits for Picasso's portrait of her. In February, she finishes *Three Lives*. She continues working on her first novel, *The Making of Americans*, a fictionalized history of her own extended family and, in Stein's words, a "history of the whole world." Sarah and Michael Stein, who have also begun to collect art, travel to San Francisco after the earthquake to look after the family estate. They take some of their paintings with them—the first Matisse paintings ever shown in America. Alice B. Toklas (born on April 30, 1877) sees the paintings, meets Sarah and Michael Stein, and plans to go to Paris. (Alice B. Toklas had studied music in order to become a concert pianist. After the death of her mother, however, she had abandoned that plan and devoted herself to her family.)

1907 Picasso's African period peaks with *Les Demoiselles d'Avignon,* the first announcement of abstract painting. Leo Stein fails to recognize this development in painting, just as he fails to recognize Gertrude's literary development. Picasso becomes Gertrude Stein's soulmate and "brother in arts." The gradual separation of the siblings begins.

I am all unhappy in this writing. I know very much of the meaning of the being in men and women. I know it and feel it and I am always learning more of it and now I am telling it and I am nervous and driving and unhappy in it.

Sometimes I will be all happy in it.

— *The Making of Americans*

I am writing for myself and strangers. This is the only way that I can do it. Everybody is a real one for me, everybody is like some one else too to me. No one of them that I know can want to know it and so I write for myself and strangers.

— *The Making of Americans*

▣ Above: Following in Leo's footsteps. With Dr. Claribel Cone (left) and Etta Cone in Florence, June 1903.
Right: Meditation over a lunch basket. With the sisters Cone in Vallombrosa, July 1903.

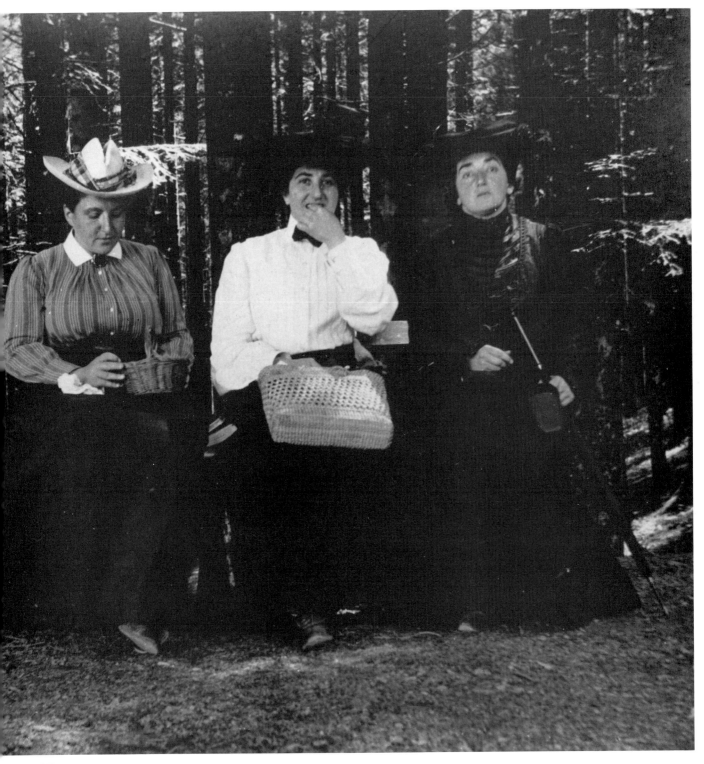

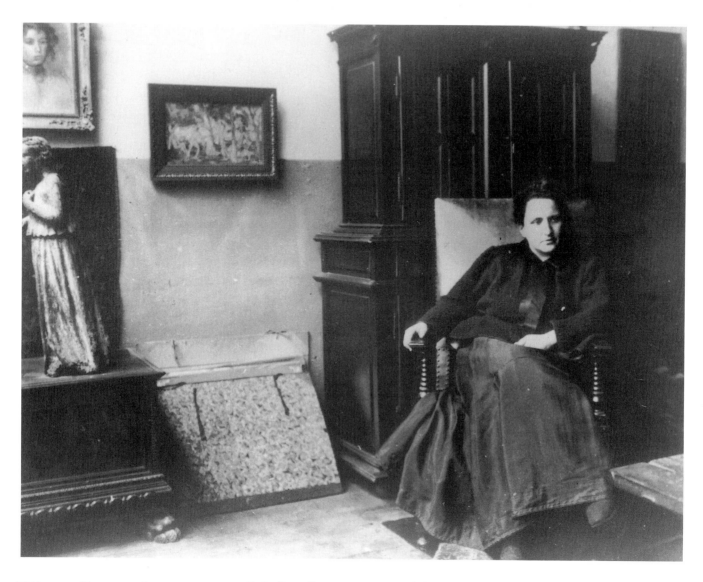

⊠ Above and bottom right, opposite page: Brother and sister at 27, rue de Fleurus, ca. 1905. He paints, she writes: he talks, she is silent.

Stieglitz tells a strange story of the early days when we were living in Paris and I had begun writing and my brother was painting and we had begun everything. According to Stieglitz, and I very well remember his being there he was there for several hours and my brother was talking and according to Stieglitz I was not saying anything and he went away with the greatest admiration and said he had never known any woman well perhaps anybody to sit still so long without talking.

—*Everybody's Autobiography*

Right: Montparnasse, the Paris artists'
quartier, around 1900.
Below right: Leo Stein.
Below left: Leo Stein in the courtyard
of 27, rue de Fleurus, ca. 1905. To
the left, the studio; to the right, the
apartment.

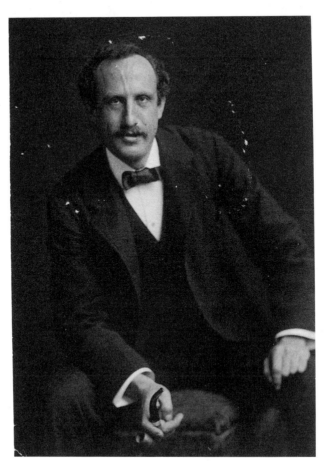

She used to wear a sort of kimono made of brown corduroy in the hot Tuscan summertime, and arrive just sweating, her face parboiled. And when she sat down, fanning herself with her broad-brimmed hat with its wilted, dark brown ribbon, she exhaled a vivid steam all around her. When she got up she frankly used to pull her clothes off from where they stuck to her great legs. Yet with all this she was not at all repulsive. On the contrary, she was positively, richly attractive in her grand *ampleur*. She always seemed to like her own fat anyway and that usually helps other people to accept it. She had none of the funny embarrassment Anglo-Saxons have about flesh. She gloried in hers.

—Mabel Dodge Luhan,
European Experiences

She went flopping around the place—other girls wore corsets then . . .—big and floppy and sandalled and not caring a damn.

—Husband of one of Gertrude Stein's cousins

Family vacation in the country, in Fiesole, 1905:
Gertrude Stein bursts out of the corset of convention.
Right page: Gertrude, Leo, and two unknown friends (in back); front, Michael, Sarah, and Allan Stein.

I began to get enormously interested in hearing how everybody said the same thing over and over again with infinite variations but over and over again until finally if you listened with great intensity you could hear it rise and fall and tell all that that there was inside them, not so much by the actual words they said or the thoughts they had but the movement of their thoughts and words endlessly the same and endlessly different.

—*Lectures in America*

41

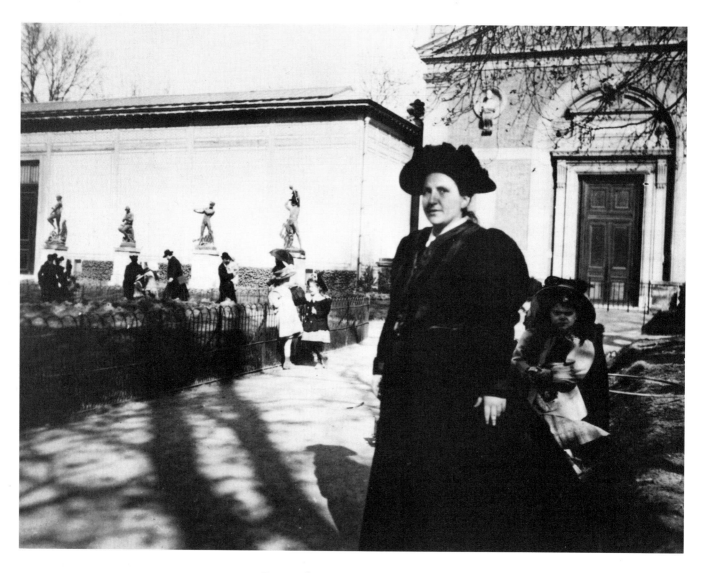

⊠ In the Luxembourg Gardens in Paris,
ca. 1905.

Gertrude Stein tried to copy Three Lives on the typewriter but it was no use, it made her nervous, so Etta Cone came to the rescue. The Miss Etta Cones as Pablo Picasso used to call her and her sister. Etta Cone was a Baltimore connection of Gertrude Stein's and she was spending a winter in Paris. . . .

Etta Cone offered to typewrite Three Lives and she began. Baltimore is famous for the delicate sensibilities and conscientiousness of its inhabitants. It suddenly occurred to Gertrude Stein that she had not told Etta Cone to read the manuscript before beginning to typewrite it. She went to see her and there indeed was Etta Cone faithfully copying the manuscript letter by letter so that she might not by any indiscretion become conscious of the meaning.

—*The Autobiography of Alice B. Toklas*

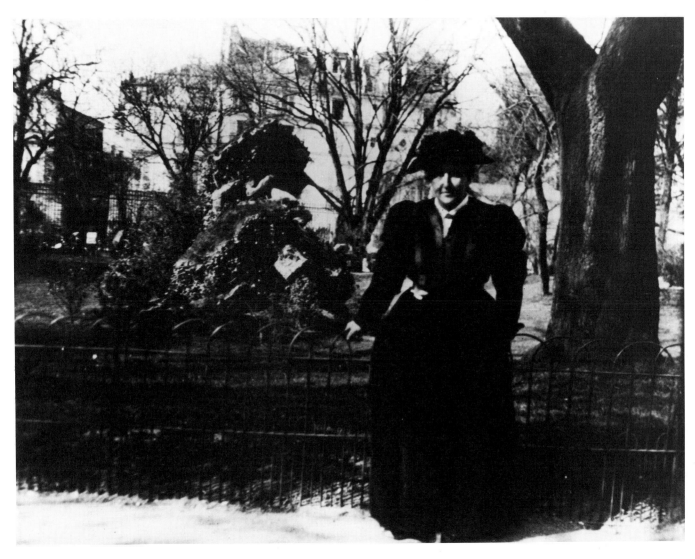

Melanctha sat at Jane's feet for many hours in these days and felt Jane's wisdom. She learned to love Jane and to have this feeling very deeply. She learned a little in these days to know joy, and she was taught too how very keenly she could suffer. It was very different this suffering from that Melanctha sometimes had from her mother and from her very unendurable black father. Then she was fighting and she could be strong and valiant in her suffering, but there with Jane Harden she was longing and she bent and pleaded with her suffering.

It was a very tumultuous, very mingled year, this time for Melanctha, but she certainly did begin to really understand.

—*Three Lives*

It was about this time that Gertrude Stein's brother happened one day to find the picture gallery of Sagot, an ex–circus clown who had a picture shop further up the rue Lafitte. Here he, Gertrude Stein's brother, found the paintings of two young spaniards, one, whose name everbody has forgotten, the other one, Picasso. The work of both of them interested him and he bought a water colour by the forgotten one, a café scene. Sagot also sent him to a little furniture store where there were some paintings being shown by Picasso. Gertrude Stein's brother was interested and wanted to buy one and asked the price but the price asked was almost as expensive as Cézanne. He went back to Sagot and told him. Sagot laughed. He said, that is alright, come back in a few days and I will have a big one. In a few days he did have a big one and it was very cheap. When Gertrude Stein and Picasso tell about those days they are not always in agreement as to what happened but I think in this case they agree that the price asked was a hundred and fifty francs. The picture was the now well known painting of a nude girl with a basket of red flowers.

Gertrude Stein did not like the picture, she found something rather appalling in the drawing of the legs and feet, something that repelled and shocked her. She and her brother almost quarrelled about this picture. He wanted it and she did not want it in the house. Sagot gathering a little of the discussion said, but that is alright if you do not like the legs and feet it is very easy to guillotine her and only take the head. No that would not do, everybody agreed, and nothing was decided.

Gertrude Stein and her brother continued to be very divided in this

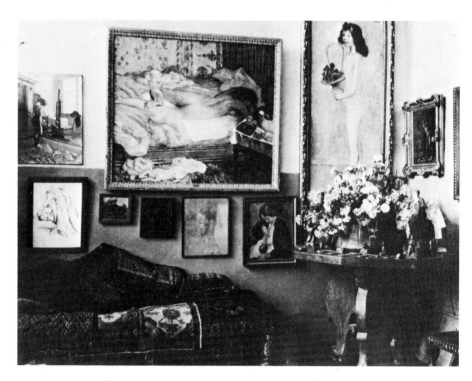

matter and they were very angry with each other. Finally it was agreed that since he, the brother, wanted it so badly they would buy it, and in this way the first Picasso was brought into the rue de Fleurus.

—*The Autobiography of Alice B. Toklas*

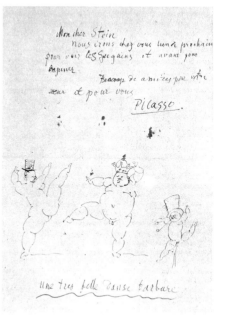

▓ *Girl with a Basket of Flowers,* the first Picasso at rue de Fleurus, end of 1905. Flowers cover the girl's "shocking" feet. Right: Reply to a dinner invitation for Picasso and Fernande Olivier, issued by Leo (not dated, probably around 1905): "My dear Stein / we will be there next Monday to look at the Gauguins, and before, to dine. / Kindest greetings to your sister and yourself. / Picasso. / A marvellous barbaric danse."

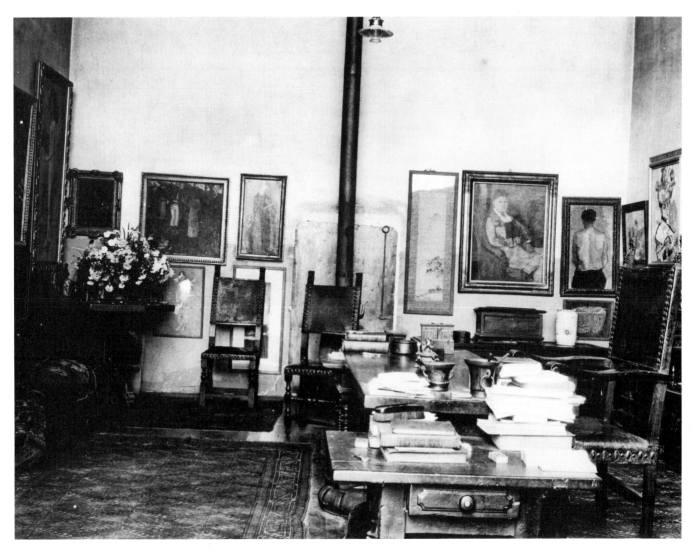

Against the walls were several pieces of large italian renaissance furniture and in the middle of the room was a big renaissance table, on it a lovely inkstand, and at one end of it note-books neatly arranged, the kind of note-books french children use, with pictures of earthquakes and explorations on the outside of them. And on all the walls right up to the ceiling were pictures. At one end of the room was a big cast iron stove that Hélène came in and filled with a rattle, and in one corner of the room was a large table on which were horseshoe nails and pebbles and little pipe cigarette holders which one looked at curiously but did not touch, but which turned out later to be accumulations from the pockets of Picasso and Gertrude Stein. But to return to the pictures. The pictures were so strange that one quite instinctively looked at anything rather than at them just at first. . . . The chairs in the room were also all italian renaissance, not very comfortable for short-legged people and one got the habit of sitting on one's legs. Miss Stein sat near the stove in a lovely high-backed one and she peacefully let her legs hang, which was a matter of habit, and when any one of the many visitors came to ask her a question she lifted herself up out of this chair and usually replied in french, not just now.

—*The Autobiography of Alice B. Toklas*

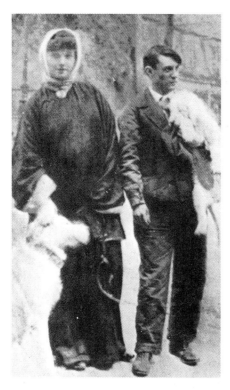

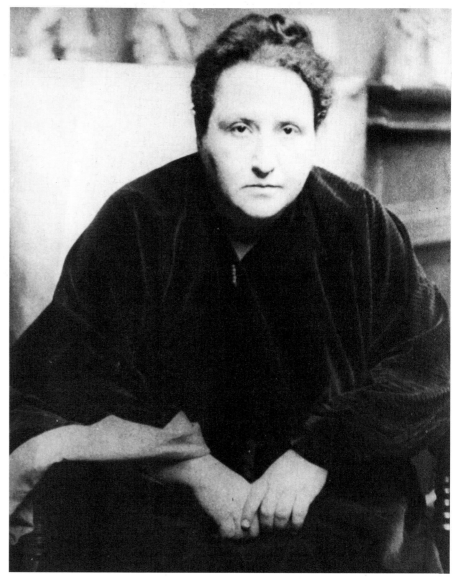

Picasso and Fernande came to dinner, Picasso in those days was, what a dear friend and schoolmate of mine, Nellie Jacot, called, a good-looking bootblack. He was thin dark, alive with big pools of eyes and a violent but not rough way. He was sitting next to Gertrude Stein at dinner and she took up a piece of bread. This, said Picasso, snatching it back with violence, this piece of bread is mine. She laughed and he looked sheepish. That was the beginning of their intimacy.

That evening Gertrude Stein's brother took out portfolio after portfolio of japanese prints to show Picasso, Gertrude Stein's brother was fond of japanese prints. Picasso solemnly and obediently looked at print after print and listened to the descriptions. He said under his breath to Gertrude Stein, he is very nice, your brother, but like all americans, like Haviland, he shows you japanese prints. Moi j'aime pas ça, no I don't care for it. As I say Gertrude Stein and Pablo Picasso immediately understood each other.

— *The Autobiography of Alice B. Toklas*

▨ A genius takes her place in the twenti-eth century. Portrait by Picasso, 1906 (right page), and a later photo of Gertrude Stein by Alvin Langdon Coburn (above). Above left: Pablo Picasso and Fernande Olivier in Paris, ca. 1906. Far right: Photograph of the Bâteau Lavoir, with inscriptions by Picasso indi-cating the location of his studio.

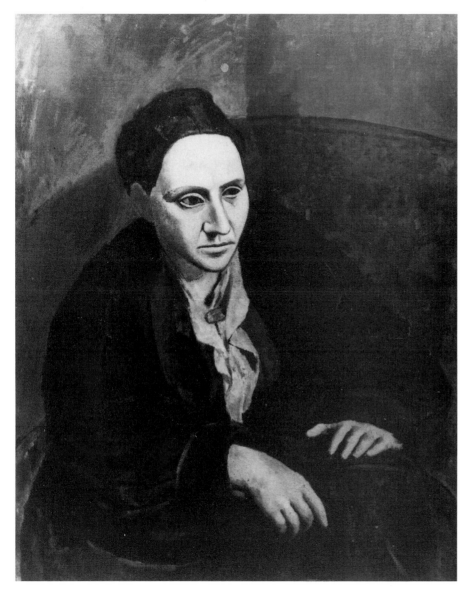

Anyway it did and she posed to him for this portrait ninety times and a great deal happened during that time.

—The Autobiography of Alice B. Toklas

Practically every afternoon Gertrude Stein went to Montmartre, posed and then later wandered down the hill usually walking across Paris to the rue de Fleurus. She then formed the habit which has never left her of walking around Paris, now accompanied by the dog, in those days alone. And Saturday evenings the Picassos walked home with her and dined and then there was Saturday evening.

During these long poses and these long walks Gertrude Stein meditated and made sentences.

—The Autobiography of Alice B. Toklas

. . . he gave me the picture and I was and I still am satisfied with my portrait; for me, it is I, and it is the only reproduction of me which is always I, for me.

—Picasso

After a little while I murmured to Picasso that I liked his portrait of Gertrude Stein. Yes, he said, everybody says that she does not look like it but that does not make any difference, she will, he said.

—The Autobiography of Alice B. Toklas

It was only a very short time after this that Picasso began the portrait of Gertrude Stein, now so widely known, but just how that came about is a little vague in everybody's mind. I have heard Picasso and Gertrude Stein talk about it often and they neither of them can remember. They can remember the first time that Picasso dined at the rue de Fleurus and they can remember the first time Gertrude Stein posed for her portrait at rue Ravignan but in between there is a blank. How it came about they do not know. Picasso had never had anybody pose for him since he was sixteen years old, he was then twenty-four and Gertrude Stein had never thought of having her portrait painted, and they do not either of them know how it came about.

47

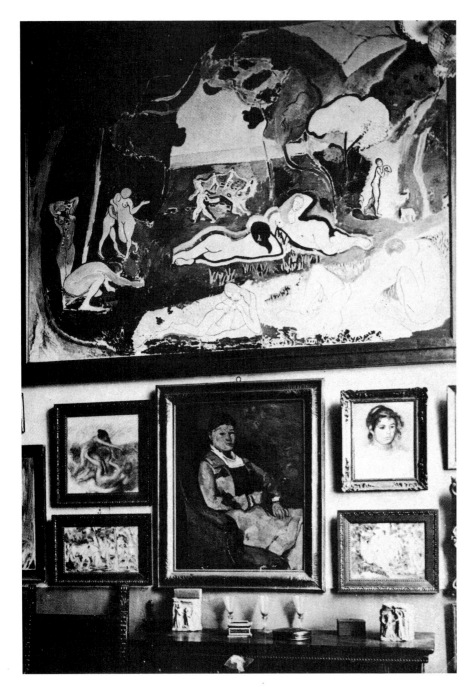

This was the year 1907. Gertrude Stein was just seeing through the press Three Lives which she was having privately printed, and she was deep in the Making of Americans, her thousand page book. Picasso had just finished his portrait of her which nobody at that time liked except the painter and the painted and which is now so famous, and he had just begun his strange complicated picture of three women, Matisse had just finished his Bonheur de Vivre, his first big composition which gave him the name of fauve or a zoo. It was the moment Max Jacob has since called the heroic age of cubism. I remember not long ago hearing Picasso and Gertrude Stein talking about various things that had happened at that time, one of them said but all that could not have happened in that one year, oh said the other, my dear you forget we were young then and we did a great deal in a year.

— *The Autobiography of Alice B. Toklas*

⊞ On the studio wall, *Le bonheur de vivre* by Matisse. Below, the *Portrait de Mme. Cézanne* by Cézanne. Facing this portrait, Gertrude Stein wrote *Three Lives*.

Little by little people began to come to the rue de Fleurus to see the Matisses and the Cézannes, Matisse brought people, everybody brought somebody, and they came at any time and it began to be a nuisance, and it was in this way that Saturday evenings began. It was also at this time that Gertrude Stein got into the habit of writing at night. It was only after eleven o'clock that she could be sure that no one would knock at the studio door. She was at that time planning her long book, The Making of Americans, she was struggling with her sentences, those long sentences that had to be so exactly carried out. Sentences not only words but sentences and always sentences have been Gertrude Stein's life long passion. And so she had then and indeed it lasted pretty well to the war, which broke down so many habits, she had then the habit of beginning her work at eleven o'clock at night and working until the dawn. She said she always tried to stop before the dawn was too clear and the birds were too lively because it is a disagreeable sensation to go to bed then. There were birds in many trees behind high walls in those days, now there are fewer. But often the birds and the dawn caught her and she stood in the court waiting to get used to it before she went to bed. She had the habit then of sleeping until noon and the beating of rugs into the court, because everybody did that in those days, even her household did, was one of her most poignant irritations.

— *The Autobiography of Alice B. Toklas*

⊞ Ceremony of welcome at the studio door, 1907.
Above right: Henri Matisse, at the turn of the century.

I wanted to find out if you could make a history of the whole world, if you could know the whole life history of everyone in the world, their slight resemblances and lack of resemblances. I made enormous charts, and I tried to carry these charts out. . . . I got to the place where I didn't know whether I knew people or not. I made so many charts that when I used to go down the streets of Paris I wondered whether they were people I knew or ones I didn't. That is what *The Making of Americans* was intended to be. I was to make a description of every kind of human being until I could know by these variations how everybody was to be known. Then I got very much interested in this thing, and I wrote about nine hundred pages, and I came to a logical conclusion that this thing could

⊞ The first page of the thousand-page novel *The Making of Americans*: "Once an angry man dragged his father along the ground through his own orchard. 'Stop!' cried the groaning old man at last, 'Stop! I did not drag my father beyond this tree.'

It is hard work living down the tempers we are born with. We begin well, for in our youth there is nothing we are more intolerant of . . ."
Right: Character diagram for *The Making of Americans.*

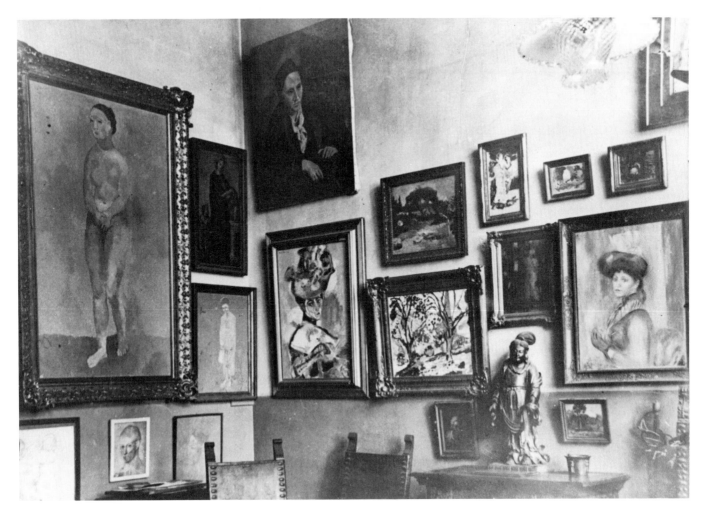

be done. Anybody who has patience enough could literally and entirely make of the whole world a history of human nature. When I found it could be done, I lost interest in it.

—*How Writing Is Written*

We had just hung all the pictures and we asked all the painters. You know how painters are, I wanted to make them happy so I placed each one opposite his own picture, and they were happy so happy that we had to send out twice for more bread, when you know France you will know that that means that they were happy, because they cannot eat and drink without bread and we had to send out twice for bread so they were happy.

—*The Autobiography of Alice B. Toklas*

⊠ Rue de Fleurus in 1907. Pictures by Picasso (in the corner his portrait of Gertrude Stein; on the left, *Standing Nude (Fernande)*, et al.); Matisse (*Woman with a Hat*, et al.); Manet; Renoir; and Daumier.

51

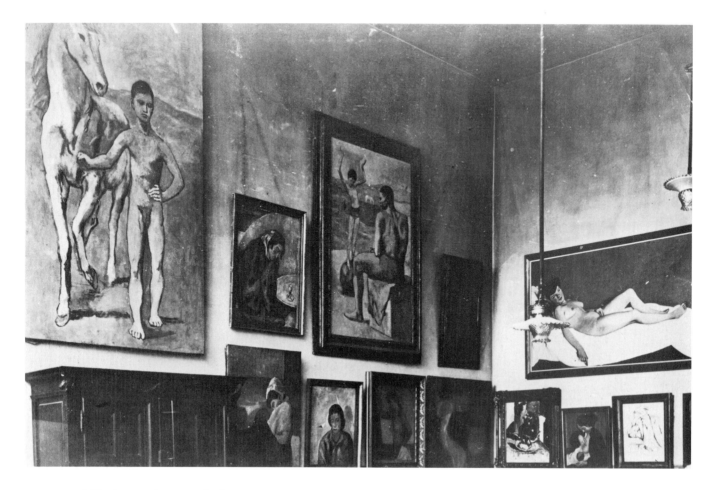

It is very difficult now that everybody is accustomed to everything to give some idea of the kind of uneasiness one felt when one first looked at all these pictures on these walls. In those days there were pictures of all kinds there, the time had not yet come when there were only Cézannes, Renoirs, Matisses and Picassos, nor as it was even later only Cézannes and Picassos. At that time there was a great deal of Matisse, Picasso, Renoir, Cézanne but there were also a great many other things. There were two Gauguins, there were Manguins, there was a big nude by Valloton that felt like only it was not like the Odalisque of Manet, there was a Toulouse-Lautrec. Once about this time Picasso looking at this and greatly daring said, but all the same I do paint better than he did. Toulouse-Lautrec had been the most important of his early influences. I later bought a little tiny picture by Picasso of that epoch. There was a portrait of Gertrude Stein by Valloton that might have been a David but was not, there was a Maurice Denis, a little Daumier, many Cézanne water colours, there was in short everything, there was even a little Delacroix and a moderate sized Greco. There were enormous Picassos of the Harlequin period, there were two rows of Matisses, there was a big portrait of a woman by Cézanne and some little Cézannes, all these pictures had a history and I will soon tell them.

— *The Autobiography of Alice B. Toklas*

52

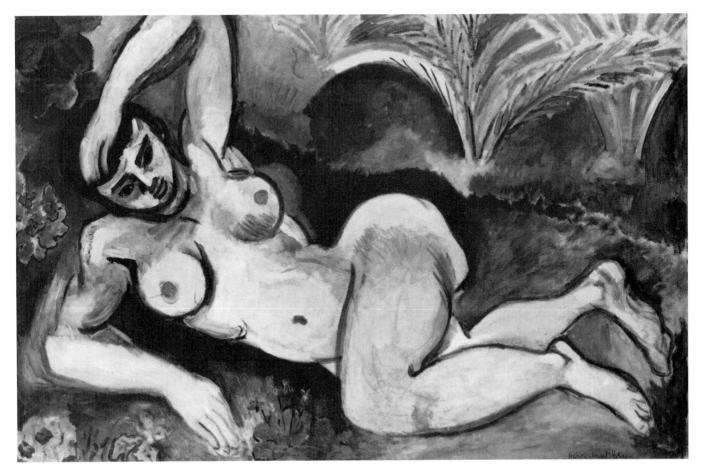

"Pablo & Matisse have a maleness that belongs to genius. Moi ausi [*sic*] perhaps." Left page, top row, from the left: Picasso, *Boy Leading a Horse, Dozing Absinthe Drinker, Young Acrobat on a Ball*; painting by Leo Stein(?); Felix Vallotton, *Reclining Nude*. Bottom row: Picasso, *Seated Woman in a Hood, Woman with Bangs*; unidentified painting; Picasso, *Two Women at a Bar*; Matisse, *Yellow Pottery from Provence*; Maurice Denis, *Mother in Black*; Cézanne, study for *The Smoker*. Above: *Blue Nude* by Matisse.

We knew a Matisse when we saw it, knew at once and enjoyed it and knew that it was great art and beautiful. It was a big figure of a woman lying in among some cactuses. A picture which was after the show to be at the rue de Fleurus. There one day the five year old little boy of the janitor who often used to visit Gertrude Stein who was fond of him, jumped into her arms as she was standing at the open door of the atelier and looking over her shoulder and seeing the picture cried out in rapture, oh là là what a body of a woman. Miss Stein used always to tell this story when the casual stranger in the aggressive way of the casual stranger said, looking at this picture, and what is that supposed to represent.

— *The Autobiography of Alice B. Toklas*

They did not look at all alike.
Gertrude Stein looked like her
father's family. The two brothers
looked like each other. Like Gertrude
Stein, Leo was golden, he had a golden
beard. . . . Leo had a beautiful spring-
ing step and carried his tall body with
incomparable grace. He at this time
was amiable. But later, when he and
Gertrude Stein disagreed about
Picasso's pictures and her writing, he
became unreasonable and unbearable.

—Alice B. Toklas,
What Is Remembered

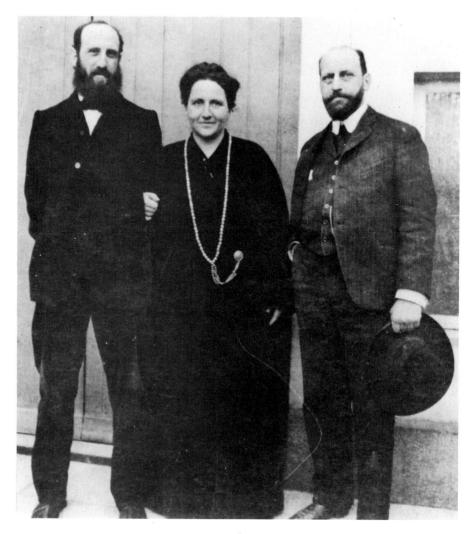

🖾 "Springing step." Leo Stein drawn by
Picasso, 1905.
Above right: The art collectors, Leo,
Gertrude, and Michael Stein, 1907.

Disillusionment in living is the
finding out nobody agrees with
you not those that are and were fight-
ing with you. Disillusionment in living
is the finding out nobody agrees with
you not those that are fighting for you.
Complete disillusionment is when you
realise that no one can for they can't
change. The amount they agree is
important to you until the amount
they do not agree with you is
completely realised by you. Then you
say you will write for yourself and
strangers, you will be for yourself and
strangers and this then makes an old
man or an old woman of you.

—*The Making of Americans*

54

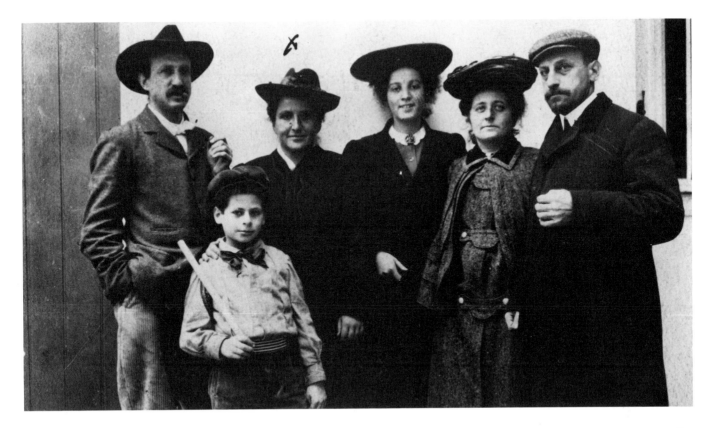

Two knowing each other very well being living might be thinking they are not knowing what the other one is thinking about the other one. Two knowing each other very well in living might be telling each one of them to some one what they are thinking of the other one. Two knowing each other very well in living might not be telling any one what they are each one of them thinking about the other one.

—*The Making of Americans*

▣ "That is what makes a family, . . . that concentration of isolation." From the left: Leo, Gertrude, unknown woman, Sarah, Michael, Allan (in front), in the courtyard of rue de Fleurus, 1907.

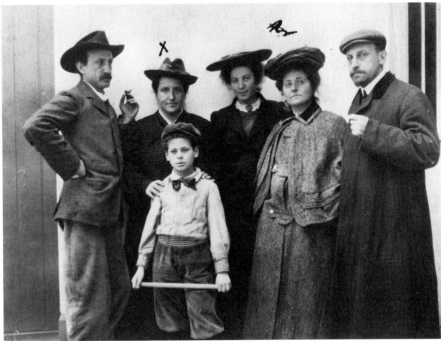

G ertrude and I are just the contrary. She's basically stupid and I'm basically intelligent.

—Leo Stein,
Journey into the Self

I was writing in the way I was writing. I did not show what I was doing to my brother, he looked at it and he did not say anything. Why not. Well there was nothing to say about it and really I had nothing to say about it. Gradually he had something to say about it. I did not hear him say it. Slowly we were not saying anything about it that is we never had said anything about it.

—*Everybody's Autobiography*

✳ Above: Picasso's gouache (1906) of the brother who was not a genius.

I t is funny this thing of being a genius, there is no reason for it, there is not reason that it should be you and should not have been him, no reason at all that it should have been you, no no reason at all.

That is the way he felt about it and it was a natural thing, because he understood everything and if you understand everything and besides that are leading and besides that do do what you do there is no reason why it should not be creating, and that is he was that and had always been and I had not been that but I had been it enough to be following, now why should it come to be that it should be something else now just why should it. Well well just why should it. The only thing about it was that it was I who was the genius, there was no reason for it but I was, and he was not there was a reason for it but he was not and that was the beginning of the ending and we always had been together and now we were never at all together. Little by little we never met again.

—*Everybody's Autobiography*

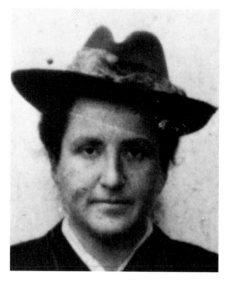

I am really almost despairing, I have really in me a very very melancholy feeling, a very melancholy being, I am really then despairing.

—*The Making of Americans*

First Years with Alice B. Toklas Until the End of World War I 1907–1919

She came to be happier than anybody else who was living then. It is easy to believe this thing. She was telling some one, who was loving every story that was charming. Some one who was living was almost always listening. Some one who was loving was almost always listening. That one who was loving was almost always listening. That one who was loving was telling about being one then listening. That one being loving was then telling stories having a beginning and a middle and an ending. That one was then one always completely listening. Ada was then one and all her living then one completely telling stories that were charming, completely listening to stories having a beginning and a middle and an ending. Trembling was all living, living was all loving, some one was then the other one. Certainly this one was loving this Ada then. And certainly Ada all her living then was happier in living than any one else who ever could, who was, who is, who ever will be living.

—"Ada"

1907 In September, Alice B. Toklas arrives in Paris with her friend Harriet Levy and meets Gertrude Stein. The mutual interest is immediate.

1908 Gertrude, Leo, Sarah, Michael, and Allan Stein spend the summer in Fiesole, at Villa Bardi; Alice B. Toklas and Harriet Levy stay at Casa Ricci. Gertrude and Alice secretly "marry." Gertrude Stein is thirty-four, Alice B. Toklas thirty-one years old. They explore Tuscany (Assisi) and take a trip to Venice. Back in Paris, Alice learns to type and begins transcribing the manuscript of *The Making of Americans*, while Gertrude Stein continues writing and rewriting the book. At the same time, Stein writes her first "Cubist" word portraits, which achieve in writing the revolution going on in painting. One of these texts ("Ada") is a portrait of Alice B. Toklas.

1909 Alice B. Toklas spends most of her days at the rue de Fleurus. Gertrude Stein's *Three Lives* is published at her own expense by Grafton Press in New York, with the help of May Bookstaver's husband. It is her first book publication. Picasso returns from Spain with his first Cubist paintings, among them *Maisons sur la colline, Horta de Ebro*.

1910 At the beginning of the year, Alice B. Toklas moves in with Gertrude and Leo Stein. Leo, who has taken up painting, falls in love with his model Nina Auzias, who later becomes his wife.

1911 Gertrude Stein finishes *The Making of Americans*. She and Alice B. Toklas visit the American patroness Mabel Dodge at her Medici palace at Arcetri, near Florence, where Stein writes her "Portrait of Mabel Dodge at the Villa Curonia."

1912 Alfred Stieglitz publishes Gertrude Stein's 1909 portraits "Picasso" and "Matisse" in *Camera Work*, the first English texts on these painters. Gertrude Stein and Alice B. Toklas travel for several months through Spain and to Tangiers.

1913 In January, Gertrude Stein and Alice B. Toklas go to England on a search for publishers. In New York, the Armory Show opens with the first Fauvist and Cubist paintings exhibited in America, some of which belong to the Stein siblings. At her famous New York salon, Mabel Dodge includes Stein's "Portrait of Mabel Dodge at the Villa Curonia" in her campaign to publicize Cubism. Gertrude and Leo Stein separate after almost forty years. Leo goes to Italy, Gertrude stays at the rue de Fleurus. They share the paintings: Leo gets the Renoirs and Cézanne's *Apples* (Picasso comforts Gertrude by promising to paint an apple for her); Gertrude keeps all the Picassos. Brother and sister never meet again. Second trip with Alice B. Toklas to Spain (Granada). Gertrude Stein writes rhythmical sound poems and portraits, such as "Susie Asado." In Paris, she makes friends with the American writer and photographer Carl Van Vechten, who will later became her agent and literary executor. Together they invent the story of having originally met at the tumultuous opening night of Stravinsky's *Le Sacre du Printemps*, performed by Diaghilev's *Ballets Russes*.

1914 Gertrude Stein acquires her first paintings by Juan Gris. *Tender Buttons*, the peak of her "Cubist" writing, is published in London. She and Alice B. Toklas pay a summer visit to the mathematician and philosopher Alfred Whitehead. Trapped in England by the outbreak of World War I, they cannot return to Paris until the fall. A five-year period of migrations begins.

1915 Fleeing zeppelin raids on Paris, Gertrude Stein and Alice B. Toklas travel to Barcelona and Mallorca. A short trip to Spain follows (bullfights in Valencia). They winter in Mallorca. As a result of her isolation and concentration on the relationship with Alice, Gertrude Stein develops her specific language mixture of inner monologues and dialogues, her poetic "plays," and her blatant, if often disguised, eroticism (the omnipresent "cow" is an apparent cover word for "orgasm").

1916 Encouraged by the outcome of the Battle of Verdun, Stein and Toklas return to Paris. They stop over at Huiry, at the Marne, to visit their friend, the author Mildred Aldrich (*Hilltop on the Marne*).

1917 Gertrude Stein obtains her first car from America, a Ford van, named "Auntie" (after her aunt Pauline Stein). She learns to drive and, together with Alice, drives the car as a supply truck for the American Fund for French Wounded, supplying hospitals in Perpignan and Nîmes. Meetings with the first "doughboys" (among them W. G. Rogers, "the Kiddie"), whom they "adopt" as godsons and friends.

1918 After the cease-fire, Stein and Toklas drive from Nîmes to Mulhouse, in Alsace, to distribute clothes and blankets to the civilian population. After the war, their active duty is rewarded by the French government with the *Médaille de la Reconnaissance Française*.

1919 Definitive return to Paris, in May.

The San Franciso earthquake, 1906.

. . . my life was reasonably full and I enjoyed it but I was not very ardent in it. This brings me to the San Francisco fire which had as a consequence that the elder brother of Gertrude Stein and his wife came back from Paris to San Francisco and this led to a complete change in my life. . . .

Mrs. Stein brought with her three little Matisse paintings, the first modern things to cross the Atlantic. I made her acquaintance at this time of general upset and she showed them to me, she also told me many stories of her life in Paris. Gradually I told my father that perhaps I would leave San Francisco. He was not disturbed by this, after all there was at that time a great deal of going and coming and there were many friends of mine going. Within a year I also had gone and I had come to Paris. There I went to see Mrs. Stein who had in the meantime returned to Paris, and there at her house I met Gertrude Stein. I was impressed by the coral brooch she wore and by her voice. I may say that only three times in my life have I met a genius and each time a bell within me rang and I was not mistaken, and I may say in each case it was before there was any general recognition of the quality of genius in them. The three geniuses of whom I wish to speak are Gertrude Stein, Pablo Picasso and Alfred Whitehead. I have met many important people, I have met several great people but I have only known three first class geniuses and in each case on sight within me something rang. In no one of the three cases have I been mistaken. In this way my new full life began.

—*The Autobiography of Alice B. Toklas*

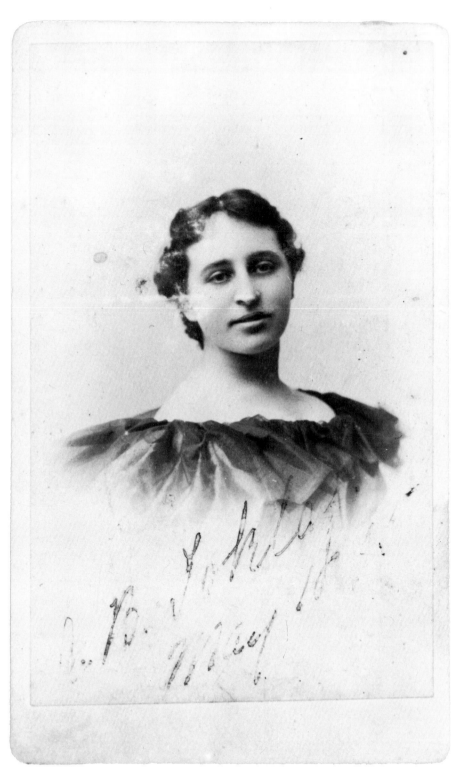

RECITAL

OF THE

Saturday Morning
String Orchestra
Class ✦ ✦ ✦ ✦

WITH THE CO-OPERATION OF

Miss Alice B. Toklas

Thursday, April 25th, 1901
At 8:30 p. m.

✦ Alice Babette Toklas, Gertrude Stein's future "Ada," in San Francisco, before her acquaintance with the Steins. Above: Announcement of a Saturday morning concert in San Francisco with pianist Alice B. Toklas, 1901.

Gertrude Stein was prodigious. Pounds and pounds and pounds piled up on her skeleton—not the billowing kind, but massive, heavy fat. She wore some covering of corduroy or velvet and her crinkly hair was brushed back and twisted up high behind her jolly, intelligent face. She intellectualized her fat, and her body seemed to be the large machine that her large nature required to carry it.

Gertrude was hearty. She used to roar with laughter, out loud. She had a laugh like a beefsteak. She loved beef, and I used to like to see her sit down in front of five pounds of rare meat three inches thick and, with strong wrists wielding knife and fork, finish it with gusto, while Alice ate a little slice daintily, like a cat.

Alice Toklas had just come to stay with Gertrude when I first met them. She was slight and dark, with beautiful gray eyes hung with black lashes— and she had a drooping, Jewish nose, and her eyelids drooped, and the corner of her red mouth and the lobes of her ears dropped under the black, folded Hebraic hair, weighted down, as they were, with long, heavy Oriental earrings.

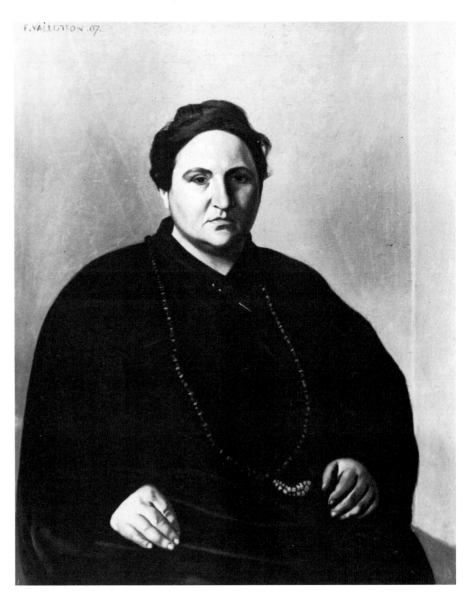

⊠ Gertrude Stein, painted by Felix Vallotton in the year of her meeting with Alice B. Toklas, 1907.

Alice wore straight dresses made of Javanese prints—they are called batiks nowadays. She looked like Leah, out of the Old Testament, in her half-Oriental get-up—her blues and browns and oyster whites—her black hair—her barbaric chains and jewels—and her melancholy nose. Artistic.

She was forever manicuring her nails. Her hands were small and fine and with the almond-shaped, painted, glistening nails they looked like the hands of a courtesan. Every morning, for an hour, Alice polished her nails— they had become a fetish with her. She loved her hands.

—Mabel Dodge Luhan,
European Experiences

⌗ Above: Portrait of Alice B. Toklas (painter unknown).
Right: Alice B. Toklas shortly before she went to Paris; photo by Arnold Genthe.

I did not realise then how completely and entirely american was Gertrude Stein. Later I often teased her, calling her a general, a civil war general of either or both sides.

—*The Autobiography of Alice B. Toklas*

Above: The Stein siblings at Villa Bardi, Fiesole, 1908.
Right: Alice, the secret bride, and her friend Harriet Levy (with hat) in Fiesole, 1908.
Above right: Love poem in two voices, written alternately by Gertrude Stein and Alice B. Toklas (not dated):
"Baby has her husband here to give her good cheer. (G.S.)
And likes it / Baby has a cheerful husband? (A.B.T.)
A question mark is not admitted by us moderns. (G.S.)
Then you'll have to learn to read (A.B.T.)
She is a wonderful mind reader. She is a wonderful mine reader. (G.S.)"

I said go home if you like.
I said I was an authority.
I said I could be angry.
I said nothing.
We went on terrorising.
Then we came to a hill.
We settled on the hill.
I said is it likely that I am stubborn.
An answer.
Not such as would be given.
There came to be then a time when answering was everything. Yes.

—"Farragut or A Husband's Recompense"

But by the time the buttercups were in bloom, the old maid mermaid had gone into oblivion and I had been gathering wild violets.

—Alice B. Toklas,
What Is Remembered

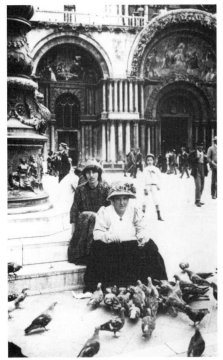

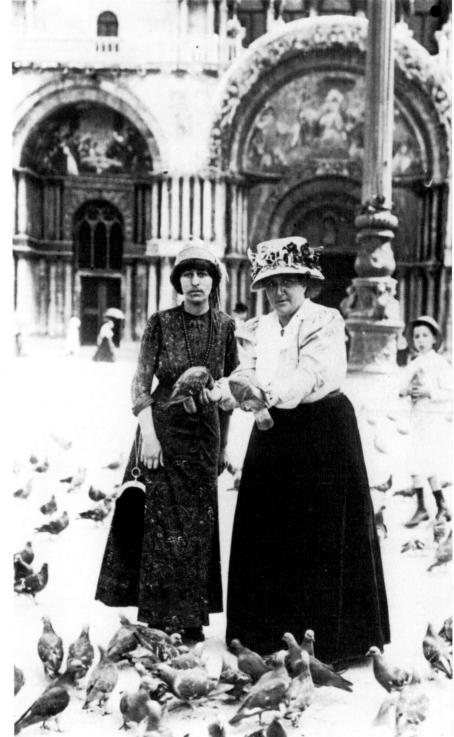

S he came and saw and seeing cried I am your bride.

—"Didn't Nelly and Lilly Love You"

L oving is something. Anything is something. Babies are something. Being a baby is something. Not being a baby is something.

Coming to be anything is something. Not coming to be anything is something. Loving is something. Not loving is something. Loving is loving. Something is something. Anything is something.

Anything is something. Not coming to anything is something. Loving is something. Needing coming to something is something. Not needing coming to something is something. Loving is something. Anything is something.

—"A Long Gay Book"

▨ "Honeymoon" trip to Venice, 1908.

. . . it was during that summer that she first felt a desire to express the rhythm of the visible world.

It was a long tormenting process, she looked, listened and described. She always was, she always is, tormented by the problem of the external and the internal. One of the things that always worries her about painting is the difficulty that the artist feels and which sends him to painting still lifes, that after all the human being essentially is not paintable.

—*The Autobiography of Alice B. Toklas*

⚙ Above: The beginning of Cubism: Picasso's *Maisons sur la colline, Horta de Ebro*, summer 1909.

As I said when I became an habitual visitor at the rue de Fleurus the Picassos were once more together, Pablo and Fernande. That summer they went again to Spain and he came back with some spanish landscapes and one may say that these landscapes, two of them still at the rue de Fleurus . . . were the beginning of cubism. In these there was no african sculpture influence. There was very evidently a strong Cézanne influence, particularly the influence of the late Cézanne water colours, the cutting up the sky not in cubes but in spaces.

But the essential thing, the treatment of the houses was essentially spanish and therefore essentially Picasso. In these pictures he first emphasized the way of building in spanish villages, the line of the houses not following the landscape but cutting across and into the landscape, becoming undistinguishable in the landscape by cutting across the landscape. It was the principle of the camouflage of the guns and the ships in the war. . . .

But to go back to the three landscapes. When they were first put up on the wall naturally everybody objected. As it happened he and Fernande had taken some photographs of the villages which he had painted and he had given copies of these photographs to Gertrude Stein. When people said that the few cubes in the landscapes looked like nothing but cubes, Gertrude Stein would laugh. . . .

—*The Autobiography of Alice B. Toklas*

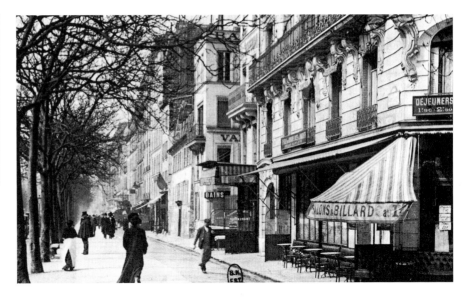

Then commenced the long period which Max Jacob has called the Heroic Age of Cubism, and it was an heroic age. All ages are heroic, that is to say there are heroes in all ages who do things because they cannot do otherwise and neither they nor the others understand how and why these things happen. One does not ever understand, before they are completely created, what is happening and one does not at all understand what one has done until the moment when it is all done. Picasso said once that he who created a thing is forced to make it ugly. In the effort to create the intensity and the struggle to create this intensity, the result always produces a certain ugliness, those who follow can make of this thing a beautiful thing because they know what they are doing, the thing having already been invented, but the inventor because he does not know what he is going to invent inevitably the thing he makes must have its ugliness.

—*Picasso*

I was ignorant then about the rue de Fleurus. I did not know the great glamour it held for artists, for the great and famous, for above all the inquisitive and interesting young, the wild, the violent and the creative who had crossed its threshold, drunk Alice's wonderful tea and eaten her exotic petit fours. I came to it as to just a new house; the street was just a most ordinary Paris street, not one of the beautiful ones of the rive gauche. We went through a porte cochère with a shabby concierge's loge in which sat an old concierge wearing a postière's cap and blue workman's trousers . . . the small flagged courtyard we crossed was shabbier and facing us was a large lockup studio, which might have been a garage or a workshop. . . .

—Francis Rose,
"Memories of Gertrude Stein"

Both he and Gertrude are using their intellects, which they ain't got, to do what would need the finest critical tact, which they ain't got neither, and they are in my belief turning out the most Godalmighty rubbish that is to be found.

—Leo Stein to Mabel Weeks, 1913

. . . if you see what I mean she was too good a bourgeoise and too good a bohemian for café life. It wasn't café conversation at the rue de Fleurus so there was no need to continue it at cafés.

—Alice B. Toklas,
What Is Remembered

▨ Above left: Picasso's *Homage to Gertrude* (1909) was supposed to be suspended from the ceiling over her bed.
Above right: Boulevard Montmartre at the time of the Cubist revolution.
Over: "One of the best rooms in the finest museum" (Hemingway), ca. 1912.

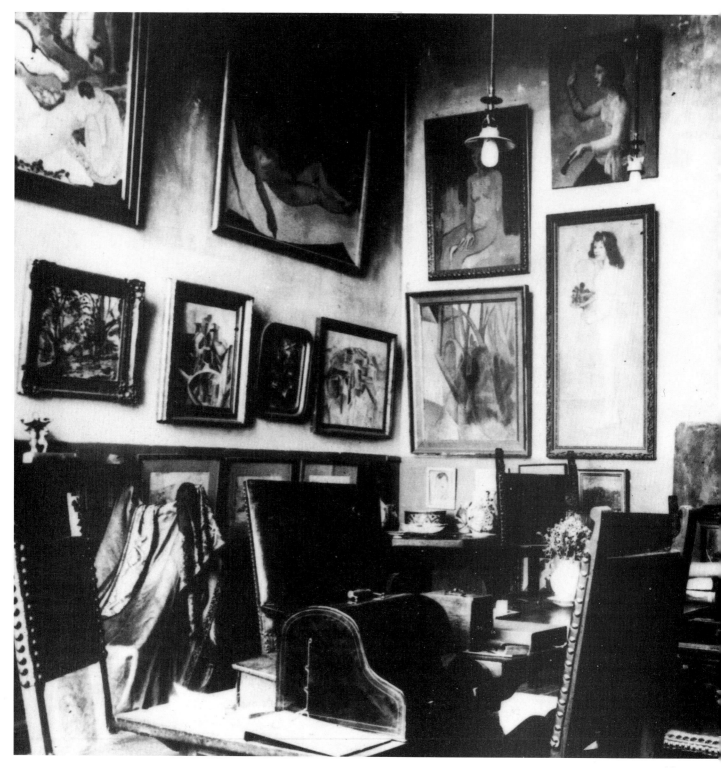

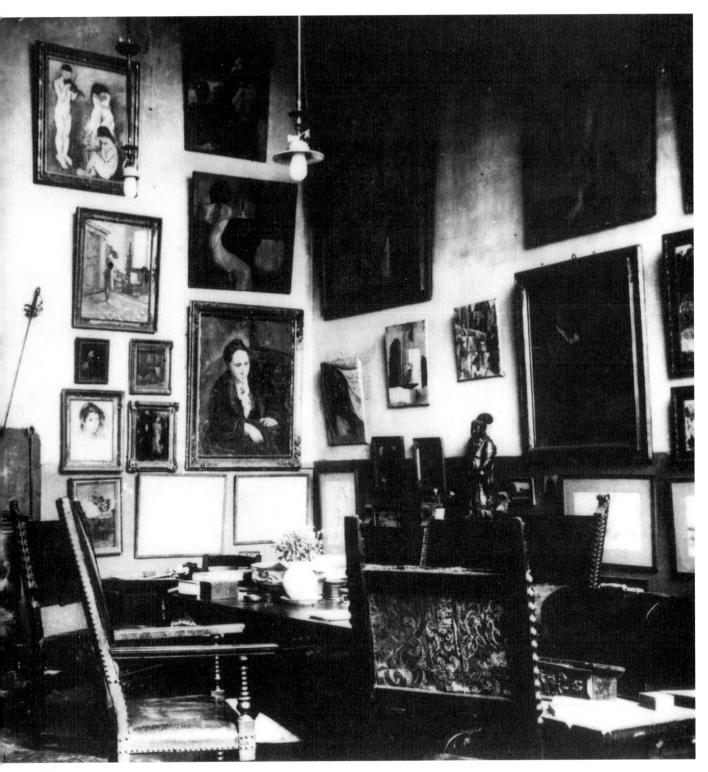

Gertrude's mind is about as little nimble as a mind can be.

—Leo Stein to Mabel Weeks, 1913

One of the greatest changes that has become decisive in recent times is the fairly definite "disaggregation" of Gertrude and myself. The presence of Alice was a godsend, as it enabled the thing to happen without any explosion.

—Leo Stein to Mabel Weeks, 1913

▨ Below: Gertrude Stein's first literary magazine publication: Her word portraits "Picasso" and "Matisse" appeared in Alfred Stieglitz's *Camera Work*, 1912. Right: Artists at rue de Fleurus, between 1905 and World War I (top to bottom): Henri Rousseau, Georges Braque, Marie Laurencin, Guillaume Apollinaire, Marcel Duchamp.

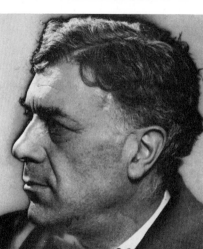

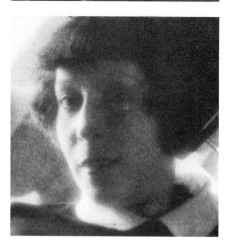

CAMERA WORK°°

A PHOTOGRAPHIC QUARTERLY
· EDITED AND PUBLISHED BY·
ALFRED STIEGLITZ NEW YORK

SPECIAL NUMBER
MDCCCCXII

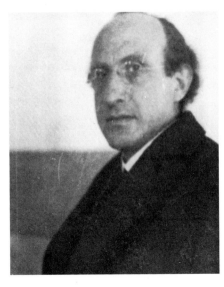

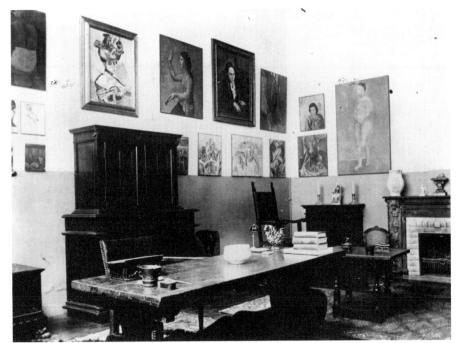

Brother brother go away and stay.

—"Names of Flowers"

⊞ Top left: Leo Stein after his departure
from rue de Fleurus.
Bottom left: Picasso painted this apple
in order to comfort Gertrude Stein for
the loss of Cézanne's still life *Apples*,
which had gone to her brother.
Inscription on the back of the painting:
"Souvenir for Gertrude and Alice /
Picasso / Christmas / 1914."
Right: Rue de Fleurus after the parti-
tion of the paintings, 1913. Leo got
Renoir, Gertrude kept Picasso; Cézanne
was split in two.

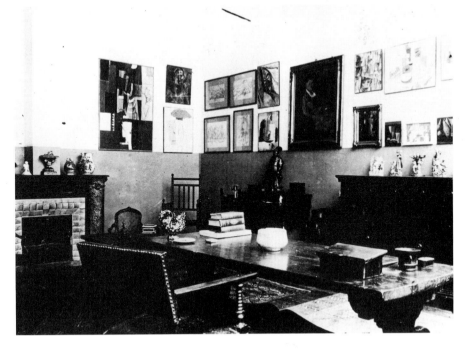

We went early to the russian ballet, these were the early great days of the russian ballet with Nijinsky as the great dancer. . . .

We arrived in the box and sat down in the three front chairs leaving one chair behind. Just in front of us in the seats below was Guillaume Apollinaire. He was dressed in evening clothes and he was industriously kissing various important looking ladies' hands. He was the first one of his crowd to come into the great world wearing evening clothes and kissing hands. We were very amused and very pleased to see him do it. It was the first time we had seen him doing it. After the war they all did these things but he was the only one to commence before the war.

Just before the performance began the fourth chair in our box was occupied. We looked around and there was a tall well-built young man, he might have been a dutchman, a scandinavian or an american and he wore a soft evening shirt with the tiniest pleats all over the front of it. It was impressive, we had never even heard that they were wearing evening shirts like that. That evening when we got home Gertrude Stein did a portrait of the unknown called a Portrait of One.

—*The Autobiography of Alice B. Toklas*

One.
In the ample checked fur in the back and in the house, in the by next cloth and inner, in the chest, in mean wind.
One.
In the best most silk and water much, in the best most silk.
One.
In the best might last and wind that.

In the best might last and wind in the best might last.
Ages, ages, all what sat.
One.
In the gold presently, in the gold presently unsuddenly and decapsized and dewalking.
In the gold coming in.
ONE.
One.
None in stable, none at ghosts, none in the latter spot.
ONE.
One.
An oil in a can, an oil and a vial with a thousand stems. An oil in a cup and a steel sofa.
One.
An oil in a cup and a woolen coin, a woolen card and a best satin.
A water house and a hut to speak, a water house and entirely water, water and water.
TWO.
Two.

A touching white shining sash and a touching white green undercoat and a touching white colored orange and a touching piece of elastic. A touching piece of elastic suddenly.
A touching white inlined ruddy hurry, a touching research in all may day. A touching research is an over show. . . .

—"One. Carl Van Vechten"

⌗ The stranger in the "evening shirt": Carl Van Vechten. Photo by Elizabeth Buehrmann, 1906.

When I first knew Gertrude Stein in Paris I was surprised never to see a french book on her table, although there were always plenty of english ones, there were even no french newspapers. But do you never read french, I as well as many other people asked her. No, she replied, you see I feel with my eyes and it does not make any difference to me what language I hear, I don't hear a language, I hear tones of voice and rhythms, but with my eyes I see words and sentences and there is for me only one language and that is english. One of the things I have liked all these years is to be surrounded by people who know no english. It has left me more intensely alone with my eyes and my english. I do not know if it would have been possible to have english be so all in all to me otherwise. And they none of them could read a word I wrote, most of them did not even know that I did write. No, I like living with so very many people and being all alone with english and myself.

—*The Autobiography of Alice B. Toklas*

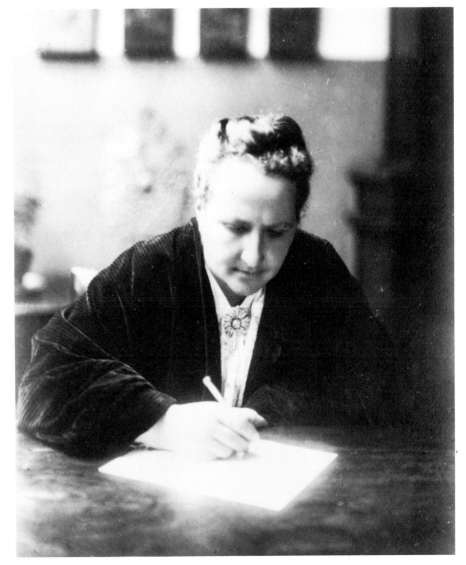 A desk of one's own. Photo by Alvin Langdon Coburn, 1914 (?).

13, Clifford's Inn
London, E.C.
Apr 19, 1912

Dear Madam,
I am only one, only one, only one. Only one being, one at the same time. Not two, not three, only one. Only one life to live, only sixty minutes in one hour. Only one pair of eyes. Only one brain. Only one being. Being only one, having only one pair of eyes, having only one time, having only one life, I cannot read your M.S. three or four times. Not even one time. Only one look, only one look is enough. Hardly one copy would sell here. Hardly one. Hardly one.
Many thanks. I am returning the M.S. by registered post. Only one M.S. by one post.

Sincerely yours,
A. C. Fifield

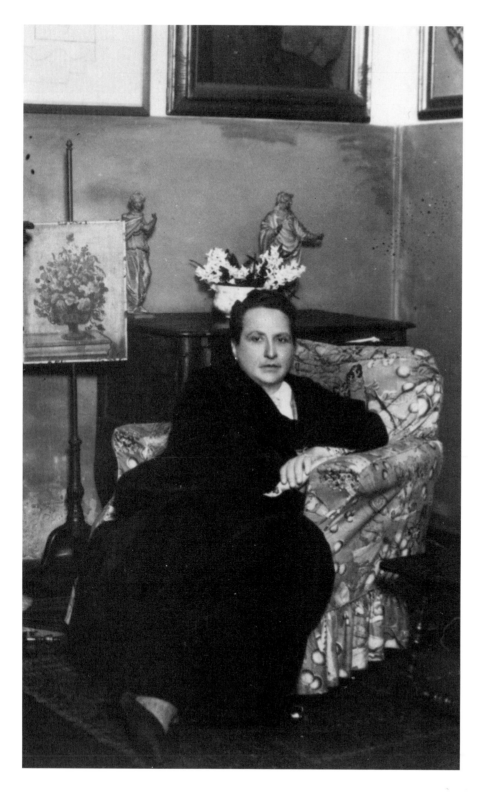

All the pudding has the same flow and the sauce is painful, the tunes are played, the crinkling paper is burning, the pot has a cover and the standard is excellence.

—"A Long Gay Book"

And then, something happened and I began to discover the names of things, that is not discover the names but discover the things the things to see the things to look at and in so doing I had of course to name them not to give them new names but to see that I could find out how to know that they were there by their names or by replacing their names. And how was I to do so. They had their names and naturally I called them by the names they had and in doing so having begun looking at them I called them by their names with passion and that made poetry, I did not mean it to make poetry but it did, it made the Tender Buttons, and the Tender Buttons was very good poetry it made a lot more poetry, and I will now more and more tell about that and how it happened.

I discovered everything then and its name, discovered it and its name. I had always known it and its name but all the same I did discover it.

—"Poetry and Grammar"

The avant-gardist: "Why do something if it can be done." From the photo series by Alvin Langdon Coburn, 1914(?).

Below: First edition of Gertrude Stein's *Tender Buttons*, Cubist "still lifes" in words.
Right: *Still Life with Calling Card*, Picasso, 1914. Gertrude Stein and Alice B. Toklas had left a calling card with a turned-down edge (indicating they had personally been there) at Picasso's doorstep. Picasso used it for a collage that he, in turn, left as a calling card at rue de Fleurus when nobody was home.

GERTRUDE STEIN

TENDER BUTTONS

Objects ∴ Food ∴ Rooms

CLAIRE MARIE ∴ 1914 ∴ NEW YORK

They were the beginning, as Gertrude Stein would say, of mixing the outside with the inside. Hitherto she had been concerned with seriousness and the inside of things, in these studies she began to describe the inside as seen from the outside. She was awfully pleased at the idea of these three things being published, and immediately consented, and suggested the title of Tender Buttons. Donald Evans called his firm the Claire Marie and he sent over a contract just like any other contract. We took it for granted that there was a Claire Marie but there evidently was not. There were printed of this edition I forget whether it was seven hundred and fifty or a thousand copies but at any rate it was a very charming little book and Gertrude Stein was enormously pleased, and it, as every one knows, had an enormous influence on all young writers and started off columnists in the newspapers of the whole country on their long campaign of ridicule. I must say that when the columnists are really funny, and they quite often are, Gertrude Stein chuckles and reads them aloud to me.

—*The Autobiography of Alice B. Toklas*

Suppose it is within a gate which open is open at the hour of closing summer that is to say it is so.

All the seats are needing blackening. A white dress is in sign. A soldier a real soldier has a worn lace a worn lace of different sizes that is to say if he can read, if he can read he is a size to show shutting up twenty-four.

Go red go red, laugh white.

Suppose a collapse in rubbed purr, in rubbed purr get.

Little sales ladies little sales ladies little saddles of mutton.

Little sales of leather and such beautiful beautiful, beautiful beautiful.

—*Tender Buttons*

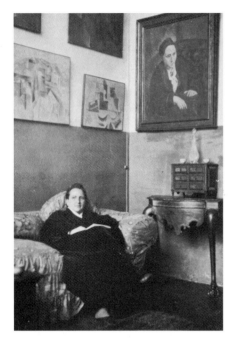

Stirred by the publication of Tender Buttons many newspapers had taken up the amusement of imitating Gertrude Stein's work and making fun of it. Life began a series that were called after Gertrude Stein.

Gertrude Stein suddenly one day wrote a letter to Masson who was then editor of Life and said to him that the real Gertrude Stein was as Henry McBride had pointed out funnier in every way than the imitations, not to say much more interesting, and why did they not print the original. To her astonishment she received a very nice letter from Mr. Masson saying that he would be glad to do so. And they did.

—*The Autobiography of Alice B. Toklas*

One whom some were certainly following was one working and certainly was one bringing something out of himself then and was one who had been all his living had been one having something come out of him.

Something had been coming out of him, certainly it has been coming out of him, certainly it was something, certainly it had been coming out of him and it had meaning, a charming meaning, a solid meaning, a struggling meaning, a clear meaning.

—"Picasso"

And so I am trying to tell you what doing portraits meant to me, I had to find out what it was inside any one, and by any one I mean every one I had to find out inside every one what was in them that was intrinsically exciting and I had to find out not by what they said not by what they did not by how much or how little they resembled any other one but I had to find it out by the intensity of movement that there was inside in any one of them.

—"Portraits and Repetition"

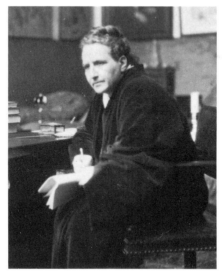

⊠ "A special word for careless is caress." At 27, rue de Fleurus, about 1914. Photo series by Alvin Langdon Coburn.

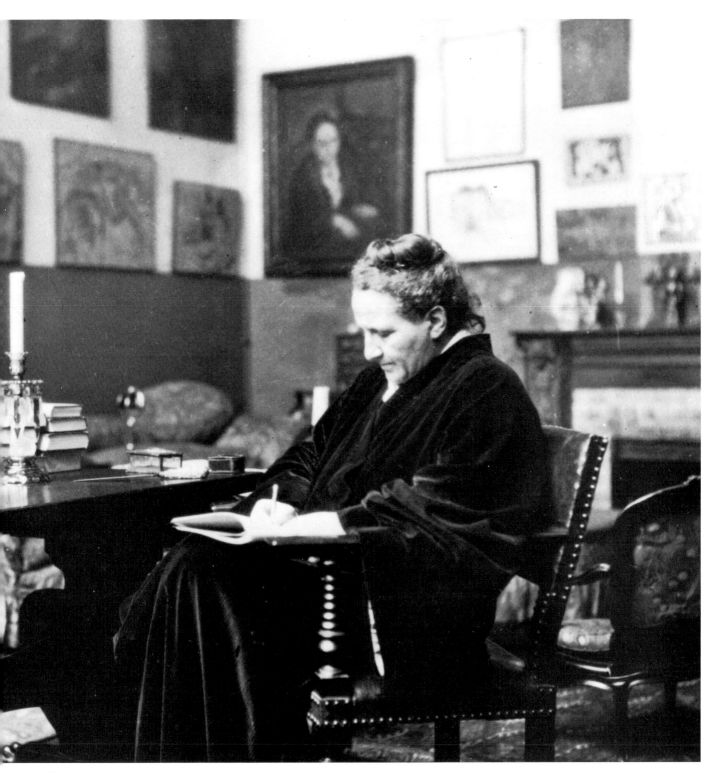

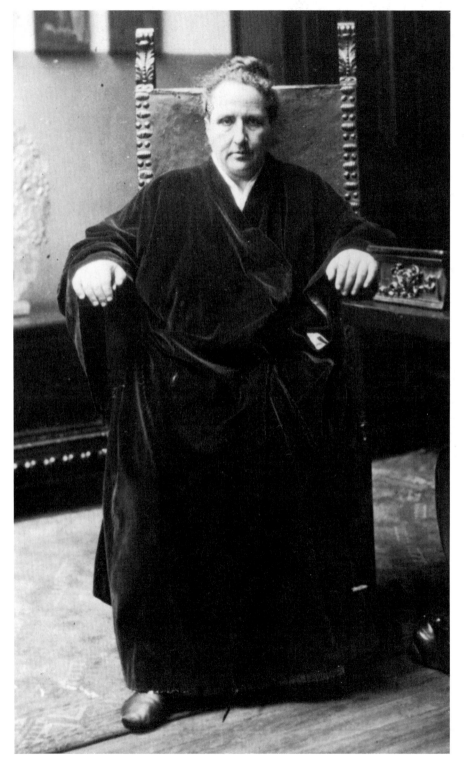

For most of those Saturday evenings, Gertrude Stein would sit straight in a magnificent high-backed Renaissance chair, attentively observing everything and everyone around her. More often than not, during her first years at the rue de Fleurus, she was silent, speaking only formal phrases to those who approached her. Every once in a while, and seemingly without reason, she would burst into laughter, a hearty, infectious, engaging laugh.

As the years went by and her self-confidence grew, she spoke more, strongly dominating the salon. People came not out of curiosity, but to pay homage to this woman with the squat figure—shaped as if she were wearing a hoopskirt from neck to knees. Her chair came to resemble a throne. Gertrude Stein had become world famous, but, ironically, many people did not know why.

—Howard Greenfield,
Gertrude Stein. A Biography

Photographs are small. They reproduce well. I enlarge better. . . .

—"Photograph. A Play in Five Acts"

▨ "Any copy is a bad copy." From the photo series of Alvin Langdon Coburn.

The germans were getting nearer and nearer Paris and the last day Gertrude Stein could not leave her room, she sat and mourned. She loved Paris, she thought neither of manuscripts nor of pictures, she thought only of Paris and she was desolate. I came up to her room, I called out, it is alright Paris is saved, the germans are in retreat. She turned away and said, don't tell me these things. But it's true, I said, it is true. And then we wept together.

—*The Autobiography of Alice B. Toklas*

When in the beginning of the war, she and I having been in England and there having been caught by the outbreak of the war and so not returning until October, were back in Paris, the first day we went out Gertrude Stein said, it is strange, Paris is so different but so familiar. And then reflectively, I see what it is, there is nobody here but the french (there were no soldiers or allies there yet), you can see the little children in their black aprons, you can see the streets because there is nobody on them, it is just like my memory of Paris when I was three years old. The pavements smell like they used (horses had come back into use), the smell of french streets and french public gardens that I remember so well.

—*The Autobiography of Alice B. Toklas*

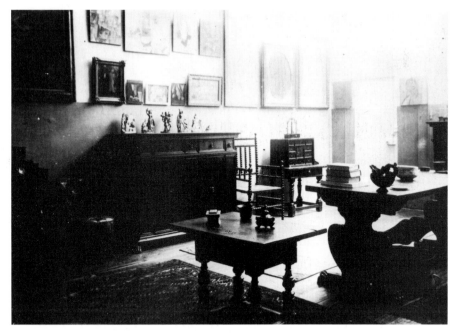

▨ Top: Paris around 1914.
Bottom: The apartment was temporarily abandoned when Gertrude Stein and Alice B. Toklas were trapped in England by the outbreak of World War I.

Gertrude Stein and myself were doing war work for the American Fund for French Wounded and I had often to wake her up very early. She and Cook used to write the most lugubrious letters to each other about the unpleasantness of sunrises met suddenly. Sunrises were, they contended, alright when approached slowly from the night before, but when faced abruptly from the same morning they were awful. It was William Cook too who later on taught Gertrude Stein how to drive a car by teaching her on one of the old battle of the Marne taxis. Cook being hard up had become a taxi driver in Paris, that was in sixteen and Gertrude Stein was to drive a car for the American Fund for French Wounded. So on dark nights they went out beyond the fortifications and the two of them sitting solemnly on the driving seat of one of those two-cylinder before-the-war Renault taxis, William Cook taught Gertrude Stein how to drive.

—*The Autobiography of Alice B. Toklas*

Our little ford was almost ready. She was later to be called Auntie after Gertrude Stein's aunt Pauline who always behaved admirably in emergencies and behaved fairly well most times if she was properly flattered.

—*The Autobiography of Alice B. Toklas*

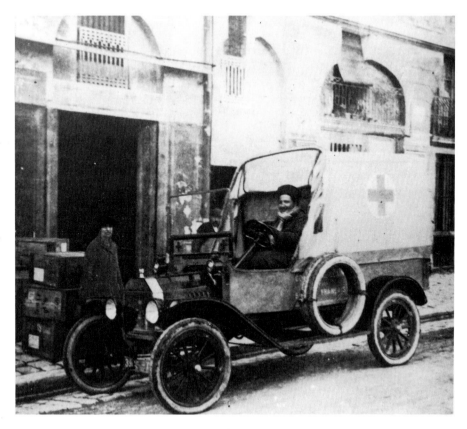

We had a few adventures, we were caught in the snow and I was sure that we were on the wrong road and wanted to turn back. Wrong or right, said Gertrude Stein, we are going on. She could not back the car very successfully and indeed I may say even to this day when she can drive any kind of a car anywhere she still does not back a car very well. She goes forward admirably, she does not go backwards successfully. The only violent discussions that we have had in connection with her driving a car have been on the subject of backing.

—*The Autobiography of Alice B. Toklas*

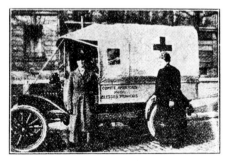

⊠ On duty for the American Fund for French Wounded, with "Auntie", the first Ford.
Below: Photo from a newspaper report on the American Fund for French Wounded.

80

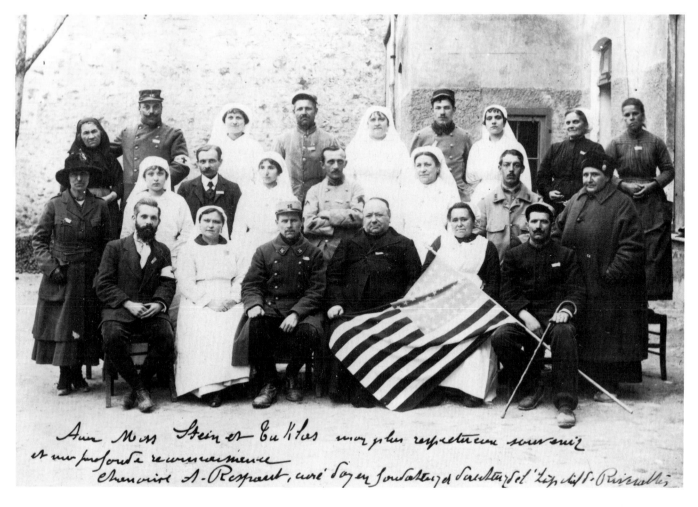

Aux Miss Stein et Tocklas mon plus respectueux souvenir et une profonde reconnaissance Chevoisier A. Respaut, ancé [?] Sergent [?] Seculten [?] l'Hôp. [?] de [?] Rivesaltes

Gertrude Stein always said the war was so much better than just going to America. Here you were with America in a kind of way that if you only went to America you could not possibly be. Every now and then one of the american soldiers would get into the hospital at Nîmes and as Doctor Fabre knew that Gertrude Stein had had a medical education he always wanted her present with the doughboy on these occasions. One of them fell off the train. He did not believe that the little french trains could go fast but they did, fast enough to kill him. . . .

81

. . . I often wonder, I have often wondered if any of all these dough-boys who knew Gertrude Stein so well in those days ever connected her with the Gertrude Stein of the newspapers.

—*The Autobiography of Alice B. Toklas*

This faculty of Gertrude Stein of having everybody do anything for her puzzled the other drivers of the organisation. . . . Gertrude Stein said that the others looked so efficient, of course nobody would think of doing anything for them. Now as for herself she was not efficient, she was good

humoured, she was democratic, one person was as good as another, and she knew what she wanted done. If you are like that she says, anybody will do anything for you. The important thing, she insists, is that you must have deep down as the deepest thing in you a sense of equality. Then anybody will do anything for you.

—*The Autobiography of Alice B. Toklas*

⊠ Members of the American Fund for French Wounded, Rivesaltes, 1917. Alice B. Toklas (left front, standing) and Gertrude Stein (right front, standing). "For Miss Stein and Toklas with fondest memories and deepest gratitude . . ."

Birth Place of Marechal JOFFRE at Rivesaltes april 1917

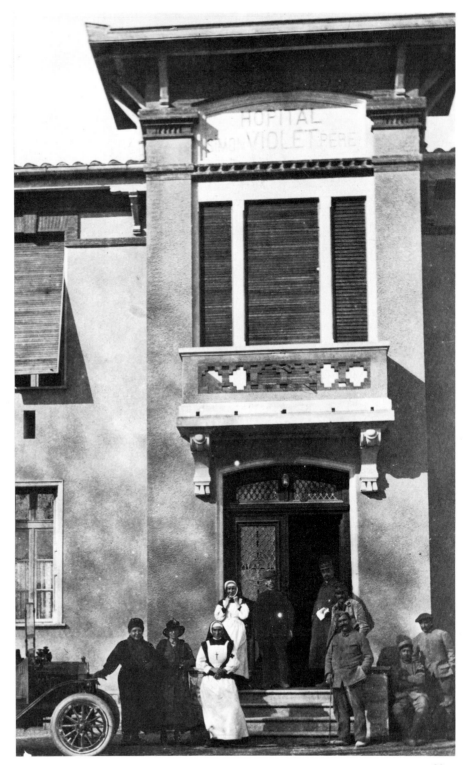

We had a very busy life. There were all the americans, there were a great many in the small hospitals round about as well as in the regiment in Nîmes and we had to find them all and be good to them, then there were all the french in the hospitals, we had them to visit as this was really our business, and then later came the spanish grippe and Gertrude Stein and one of the military doctors from Nîmes used to go to all the villages miles around to bring into Nîmes the sick soldiers and officers who had fallen ill in their homes while on leave.

It was during these long trips that she began writing a great deal again. The landscape, the strange life stimulated her. It was then that she began to love the valley of the Rhône, the landscape that of all landscapes means the most to her.

—*The Autobiography of Alice B. Toklas*

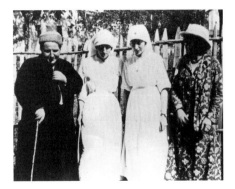

In these days Gertrude Stein wore a brown corduroy suit, jacket and skirt, a small straw cap, always crocheted for her by a woman in Fiesole, sandals, and she often carried a cane. That summer the head of the cane was of amber. It is more or less this costume without the cap and the cane that Picasso has painted in his portrait of her. This costume was ideal for Spain, they all thought of her as belonging to some religious order and we were always treated with the most absolute respect. I remember once a nun was showing us the treasures in a convent church in Toledo. We were near the steps of the altar. All of a sudden there was a crash, Gertrude Stein had dropped her cane. The nun paled, the worshippers startled. Gertrude Stein picked up her cane and turning to the frightened nun said reassuringly, no it is not broken.

—*The Autobiography of Alice B. Toklas*

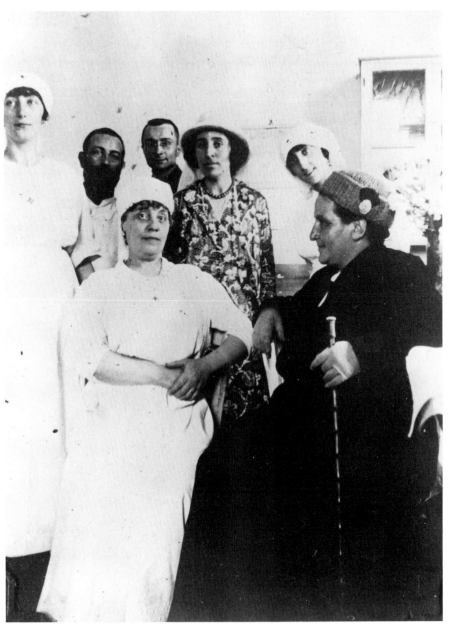

▦ Left page, far left: With "Auntie" in Rivesaltes. Postcard for friends in America, 1917.
Near left: Stationed in Nîmes, 1917.
Above: War work in Spanish garb, ca. 1918.

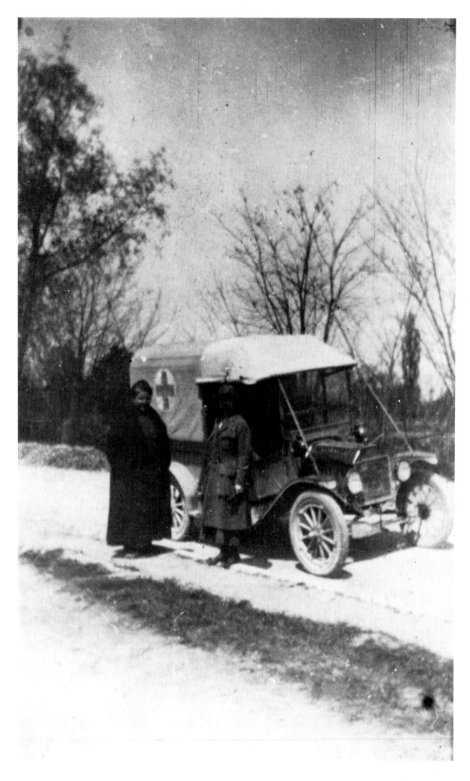

Any time is the time to make a poem. The snow and sun below.

—*Everybody's Autobiography*

Letting me see.
Come together when you can.
Have it higher. You mean that lake.
What was that funny thing you said.
I am learning to say a break.
I am learning to say a clutch.
I am learning to say it in french. A house or lions.
A young lion looks like a dog. We laugh. I am not satisfied.
You have to feel what you write. . . .

PAGE XXIV.

There was a little apple eat.
By a little baby that is wet.
Wet from kisses.
There was a good big cow came out.
Out of a little baby which is called stout.
Stout with kisses.
There will be a good cow come out.
Out of a little baby I don't doubt.
Neither does she covered with kisses.
She is misses.
That's it.

—"The King or Something
(The Public Is Invited to Dance)"

▨ "Able sweet and in a seat." On the way to their last active duty, in Alsace(?).

Years of the "Lost Generation" 1920-1927

It was this hotel keeper who said what it is said I said that the war generation was a lost generation. And he said it in this way. He said that every man becomes civilized between the ages of eighteen and twenty-five. If he does not go through a civilizing experience at that time in his life he will not be a civilized man. And the men who went to the war at eighteen missed the period of civilizing, and they could never be civilized. They were a lost generation. Naturally if they are at war they do not have the influences of women of parents and of preparation.

—*Everybody's Autobiography*

1920 Gertrude Stein becomes the first American subscriber to the circulating library connected to Sylvia Beach's Latin Quarter bookstore, Shakespeare and Company. The group of Cubists at Stein's salon has dispersed after the war and after Apollinaire's death (1918). They are replaced by young Americans ("During the next two or three years all the young men were twenty-six years old"). Stein herself is forty-six. The Saturday nights are suspended for economic reasons. Stein and Toklas go out and even attend other salons, invited, for example, by the American writer Natalie Clifford Barney and the French writer Elisabeth de Gramont, i.e., the Duchesse de Clermont-Tonnerre (who had been a model for Proust's Duchesse de Guermantes). Toward the end of the year, Gertrude Stein buys a new Ford, a sports car, named "Godiva" because of its "naked" interior.

1921 Sylvia Beach introduces Gertrude Stein to the writer Sherwood Anderson, who becomes a friend. Gertrude Stein secretly undergoes surgery to remove a lump from her breast.

1922 Gertrude Stein's meeting with Man Ray triggers the first of many photo sessions at his Montparnasse studio. Through Sherwood Anderson, she meets Ernest Hemingway, who also becomes a friend. She becomes temporarily estranged from Sylvia Beach when Beach publishes *Ulysses* by James Joyce. (The rapprochement occurs years later, after the definitive estrangement of Beach and Joyce.) Gertrude Stein self-publishes *Geography and Plays*, a collection of poems and prose from the prewar and war years, with a foreword by Sherwood Anderson. (Among the texts is "Sacred Emily," 1913, with Stein's probably first mention of "Rose is a rose is a rose is a rose." A year later, in "An Elucidation," the rose will acquire its indefinite article: " . . . a rose is a rose is a rose is a rose.") Trip through the Rhône Valley to Saint-Rémy.

1923 Return to Paris. Gertrude Stein and Alice B. Toklas become godmothers of Hemingway's first son, John Hadley ("Bumby"). Meeting and friendship with Jane Heap and Margaret Anderson, the publishers of *Little Review*, who regularly include texts by Gertrude Stein. First summer in Belley, in the Rhône Valley, southeast of Paris. For many years, the Hotel Pernollet in Belley is the summer meeting place for the circle of friends.

1924 Gertrude Stein writes *A Birthday Book* for Picasso's son Paolo, whose birthday also falls in the month of January, in the sign of Aquarius, one day from Stein's. Daniel-Henry Kahnweiler's plan to publish the book fails. Hemingway arranges the serialized publication of a part of *The Making of Americans* in Ford Madox Ford's *Transatlantic Review* (from April to December). Meeting and friendship with the British writer Edith Sitwell.

1925 Publication of *The Making of Americans* in Robert McAlmon's Contact Editions, in Paris. Through Hemingway, Stein makes friends with Zelda and F. Scott Fitzgerald.

1926 First estrangement from Hemingway. Gertrude Stein's *A Book Concluding With As a Wife Has a Cow a Love Story* is published by the art dealer Daniel-Henry Kahnweiler and illustrated with lithographs by Juan Gris. Edith Sitwell, who tries in vain to get Leonard and Virginia Woolf to publish *The Making of Americans*, arranges invitations for Gertrude Stein at the Oxford and Cambridge literary societies. Stein uses the occasion to explain her writing for the first time. Her lecture, "Composition as Explanation," is published in the same year by the Woolfs' Hogarth Press. Summer in Belley, at the Hotel Pernollet. Gertrude Stein and Alice B. Toklas discover "the house of our dreams" in the nearby village of Bilignin. Two new friends are the French historian Bernard Faÿ and the American composer Virgil Thomson, who sets Stein's portrait "Susie Asado" to music and presents it to her as a Christmas gift.

1927 After the death of Juan Gris, Stein's "The Life and Death of Juan Gris" is published in Eugene Jolas's and Elliot Paul's *transition*. Paintings by Picasso have become unaffordable for Gertrude Stein; she is now interested in young painters, the Russian exile Pavel Tchelitchev and the English aristocrat Francis Rose among others. She follows the example of her friend, the Duchesse de Clermont-Tonnerre, and has her hair cut. The cut is executed by Alice. Gertrude Stein is fifty-three years old.

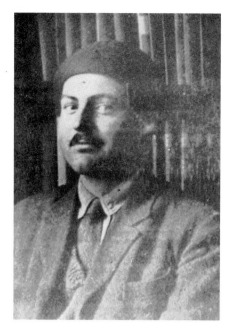

So Hemingway was twenty-three, rather foreign looking, with passionately interested, rather than interesting eyes. He sat in front of Gertrude Stein and listened and looked.

—*The Autobiography of Alice B. Toklas*

If you brought up Joyce twice, you would not be invited back. It was like mentioning one general favorably to another general. You learned not to do it the first time you made the mistake. You could always mention a general, though, that the general you were talking to had beaten. The general you were talking to would praise the beaten general greatly and go happily into detail on how he had beaten him.

—Ernest Hemingway,
A Moveable Feast

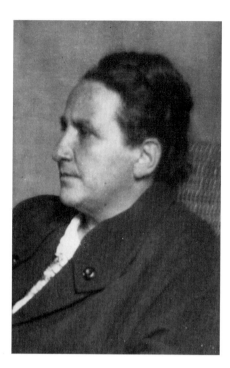

The first thing that happened when we were back in Paris was Hemingway with a letter of introduction from Sherwood Anderson.

I remember very well the impression I had of Hemingway that first afternoon. He was an extraordinarily good-looking young man, twenty-three years old. It was not long after that that everybody was twenty-six. It became the period of being twenty-six. During the next two or three years all the young men were twenty-six years old. It was the right age apparently for that time and place. There were one or two under twenty, for example George Lynes but they did not count as Gertrude Stein carefully explained to them. If they were young men they were twenty-six. Later on, much later on they were twenty-one and twenty-two.

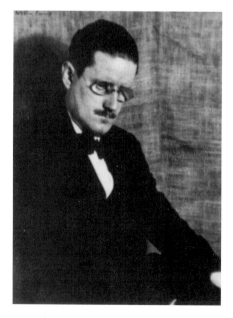

⌗ Above: The "mother" of the Lost Generation. Photo by Man Ray, 1922.
Above left: Her "pupil" Ernest Hemingway, early 1920s.
Left: Her rival James Joyce. Photo by Man Ray, 1922.

Miss Stein was very big but not tall and was heavily built like a peasant woman. She had beautiful eyes and a strong German-Jewish face that also could have been Friulano and she reminded me of a northern Italian peasant woman with her clothes, her mobile face and her lovely, thick, alive immigrant hair which she wore put up in the same way she had probably worn it in college. She talked all the time and at first it was about people and places.

Her companion had a very pleasant voice, was small, very dark, with her hair cut like Joan of Arc in the Boutet de Monvel illustrations and had a very hooked nose. She was working on a piece of needlepoint when we first met them and she worked on this and saw to the food and drink and talked to my wife. She made one conversation and listened to two and often interrupted the one she was not making.

Afterwards she explained to me that she always talked to the wives. The wives, my wife and I felt, were tolerated. But we liked Miss Stein and her friend, although the friend was frightening. . . .

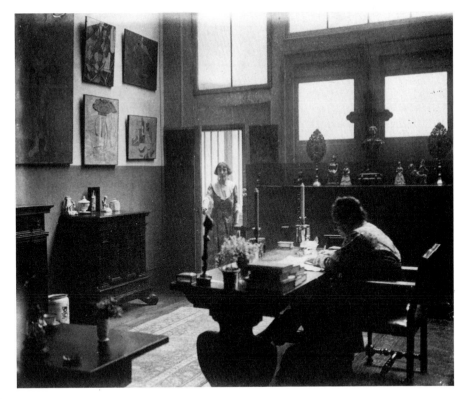

⊞ "Joan of Arc" and "peasant woman." Photo by Man Ray, 1922.

. . . That afternoon she told us, too, how to buy pictures.

"You can either buy clothes or buy pictures," she said. "It's that simple. No one who is not very rich can do both. Pay no attention to your clothes and no attention at all to the mode, and buy your clothes for comfort and durability, and you will have the clothes money to buy pictures."

"But even if I never bought any more clothing ever," I said, "I wouldn't have enough money to buy the Picassos that I want."

"No. He's out of your range. You have to buy the people of your own age—of your own military service group. You'll know them. You'll meet them around the quarter. There are always good new serious painters. But it's not you buying clothes so much.

It's your wife always. It's women's clothes that are expensive."

I saw my wife trying not to look at the strange, steerage clothes that Miss Stein wore and she was successful. When they left we were still popular, I thought, and we were asked to come again to 27 rue de Fleurus.

—Ernest Hemingway,
A Moveable Feast

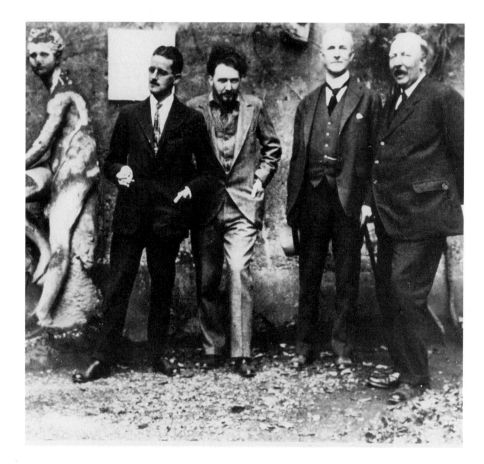

⊞ Men and Muse. Above: James Joyce, Ezra Pound, American patron John Quinn who financed *The Transatlantic Review,* and Ford Madox Ford, the founder of the review, in Paris, 1923. Below: John Hadley ("Bumby") Hemingway and his godmother.

They wanted Gertrude Stein and myself to be god-mothers and an english war comrade of Hemingway was to be god-father. We were all born of different religions and most of us were not practising any, so it was rather difficult to know in what church the baby could be baptised. We spent a great deal of time that winter, all of us, discussing the matter. Finally it was decided that it should be baptised episcopalian and episcopalian it was. Just how it was managed with the assortment of godparents I am sure I do not know, but it was baptised in the episcopalian chapel.

—*The Autobiography of Alice B. Toklas*

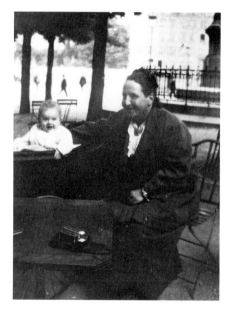

Hemingway came in then very excited and said that Ford wanted something of Gertrude Stein's for the next number and he, Hemingway, wanted The Making of Americans to be run in it as a serial and he had to have the first fifty pages at once. Gertrude Stein was of course quite overcome with her excitement at this idea, but there was no copy of the manuscript except the one that we had had bound. That makes no difference, said Hemingway, I will copy it. And he and I between us did copy it and it was printed in the next number of the Transatlantic. So for the first time a piece of the monumental work which was the beginning, really the beginning of modern writing, was printed, and we were very happy. Later on when things were difficult between Gertrude Stein and Hemingway, she always remembered with gratitude that after all it was Hemingway who first caused to be printed a piece of The Making of Americans. She always says, yes sure I have a weakness for Hemingway. After all he was the first of the young men to knock at my door and he did make Ford print the first piece of The Making of Americans.

—*The Autobiography of Alice B. Toklas*

The Transatlantic Review

EDITED IN PARIS BY
FORD MADOX FORD
(Ford Madox Hueffer)

CONTRIBUTORS

Joseph Conrad	Thomas Hardy	A. E. Coppard
E. E. Cummings	Ezra Pound	Mary Butts
Luke Ionides	R. Descharmes	Jean Cassou
D. Chaucer	Philippe Soupault	V. Larbaud
T. S. Eliot	Jeanne Foster	R. McAlmon
H. G. Wells	Ford Madox Ford	James Joyce

PARIS **NEW YORK** **LONDON**

. . . incidentally he brought the manuscript he intended sending to America. He handed it to Gertrude Stein. He had added to his stories a little story of meditations and in these he said that The Enormous Room was the greatest book he had ever read. It was then that Gertrude Stein said, Hemingway, remarks are not literature. . . .

For some years after this Gertrude Stein and Hemingway did not meet. And then we heard that he was back in Paris and telling a number of people how much he wanted to see her. Don't you come home with Hemingway on your arm, I used to say when she went out for a walk. Sure enough one day she did come back bringing him with her.

They sat and talked a long time. Finally I heard her say, Hemingway, after all you are ninety percent Rotarian. Can't you, he said, make it eighty percent. No, said she regretfully, I can't.

—*The Autobiography of Alice B. Toklas*

"Remarks are not literature."
Above: Drawing by Djuna Barnes, undated.
Below: *The Transatlantic Review* ran Stein's *The Making of Americans* as a series, from April to December 1924.

Gertrude Stein and Sherwood Anderson are very funny on the subject of Hemingway. The last time that Sherwood was in Paris they often talked about him. Hemingway had been formed by the two of them and they were both a little proud and a little ashamed of the work of their minds. . . .

. . . They admitted that Hemingway was yellow, he is, Gertrude Stein insisted, just like the flat-boat men on the Mississippi river as described by Mark Twain. But what a book, they both agreed, would be thereal story of Hemingway, not those he writes but the confessions of the real Ernest Hemingway. It would be for another audience than the audience Hemingway now has but it would be very wonderful. And then they both agreed that they have a weakness for Hemingway because he is such a good pupil. He is a rotten pupil, I protested. You don't understand, they both said, it is so flattering to have a pupil who does it without understanding it, in other words he takes training and

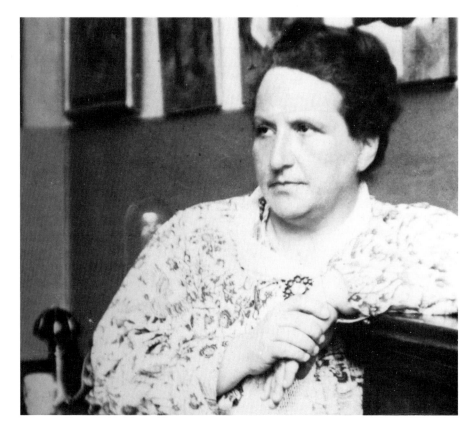

anybody who takes training is a favourite pupil. They both admit it to be a weakness.

—*The Autobiography of Alice B. Toklas*

A Very Valentine
Very fine is my valetine.
Very fine and very mine.
Very mine is my valentine very mine and very fine.
Very fine is my valetine and mine, very fine very mine and mine is my valentine.

—"A Valentine for Sherwood Anderson"

He began to develop, as a shield, a big Kansas-City-boy brutality . . . and so he was "tough" because he was really sensitive and ashamed that he was. Then it happened. I saw it happening and tried to save what was fine there, but it was too late. He went the way so many other Americans have gone before, the way they are still going. He became obsessed by sex and violent death.

—Gertrude Stein to John Hyde Preston, "A Conversation with Gertrude Stein"

▓ Above: Solid center of the Paris moveable feast. Photo by Man Ray, 1922.
Left: Sherwood Anderson. Photo by Alfred Stieglitz, 1925.

She is passionately addicted to what the french call métier and she contends that one can only have one métier as one can only have one language. Her métier is writing and her language is english.

Observation and construction make imagination, that is granting the possession of imagination, is what she has taught many young writers. Once when Hemingway wrote in one of his stories that Gertrude Stein always knew what was good in a Cézanne, she looked at him and said, Hemingway, remarks are not literature.

—*The Autobiography of Alice B. Toklas*

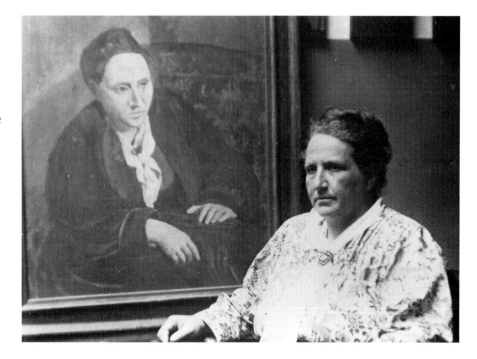

We all three went to Man Ray's hotel. It was one of the little, tiny hotels in the rue Delambre and Man Ray had one of the small rooms, but I have never seen any space, not even a ship's cabin, with so many things in it and the things so admirably disposed. He had a bed, he had three large cameras, he had several kinds of lighting, he had a window screen, and in a little closet he did all his developing. He showed us pictures of Marcel Duchamp and a lot of other people and he asked if he might come and take photographs of the studio and of Gertrude Stein. He did and he also took some of me and we were very pleased with the result.

—*The Autobiography of Alice B. Toklas*

It is quite true what is known as work is something that I cannot do it makes me nervous, I can read and write and I can wander around and I can drive an automobile and I can talk and that is almost all, doing anything else makes me nervous.

—*Everybody's Autobiography*

▓ Above: Portrait and model, sixteen years later. Photo by Man Ray, 1922. Left: Man Ray, self-portrait, 1922.

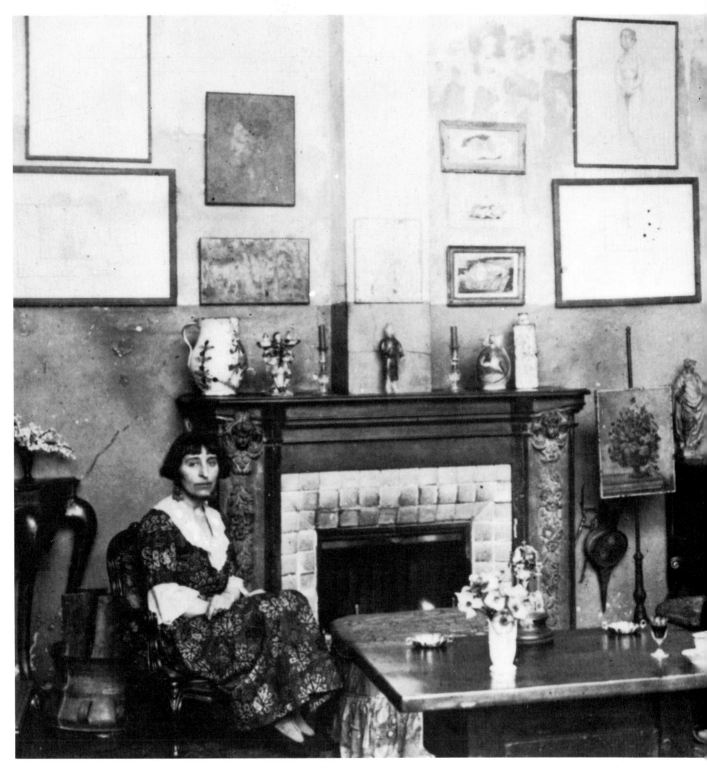

Between the two women, one seemingly stronger and the other more frail, one affirming her genius and the other venerating it, one speaking and the other listening, only a blind man could ignore that the most vigorous one was Alice, and that Gertrude, for her behavior as much as for her work, and publications, leaned on her, used her and followed her advice.

—Bernard Faÿ, *Les Précieux*

. . . though I could not remember it from the beginning there was no doubt that I was the youngest of the children and as such naturally I had privileges the privilege of petting the privilege of being the youngest one. If that does happen it is not lost all the rest of one's life, there you are you are privileged, nobody can do anything but take care of you, that is the way I was and that is the way I still am, and any one who is like that necessarily liked it. I did and do.

—*Wars I Have Seen*

⊠ Intimate privilege. Photos by Man Ray, 1922.

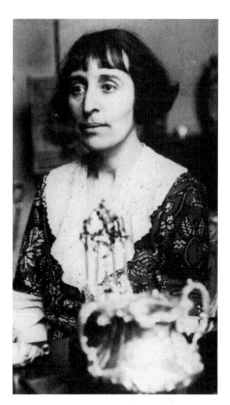

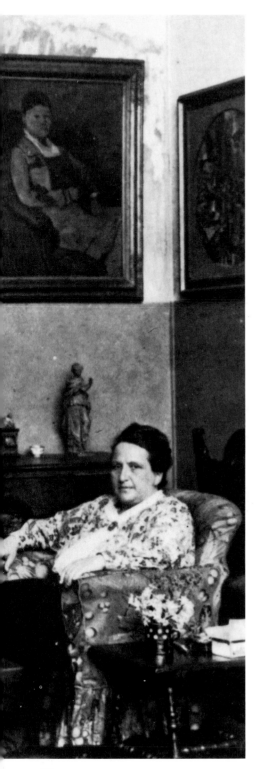

The geniuses came and talked to Gertrude Stein and the wives sat with me. How they unroll, an endless vista through the years. I began with Fernande and then there were Madame Matisse and Marcelle Braque and Josette Gris and Eve Picasso and Bridget Gibb and Marjory Gibb and Hadley and Pauline Hemingway and Mrs. Sherwood Anderson and Mrs. Bravig Imbs and the Mrs. Ford Madox Ford and endless others, geniuses, near geniuses and might be geniuses, all having wives, and I have sat and talked with them all all the wives and later on, well later on too, I have sat and talked with all. But I began with Fernande.

—*The Autobiography of Alice B. Toklas*

Speaking of the device of rose is a rose is a rose is a rose, it was I who found it in one of Gertrude Stein's manuscripts and insisted upon putting it as a device on the letter paper, on the table linen and anywhere that she would permit that I would put it. I am very pleased with myself for having done so.

—*The Autobiography of Alice B. Toklas*

27 RUE DE FLEURUS

GERTRUDE STEIN

First Example.

How pleasantly I feel contented with that. Contented with the example, content with the example.

As if one example was meant to be succeeded by an example. I remember that he said they can prepare to have it here and to have it there to have it here and there. We have said there to have it there.

First Example:

Suppose, to suppose, suppose a rose is a rose is a rose is a rose.

To suppose, we suppose that there arose here and there that here and there there arose an instance of knowing that there are here and there that there are there that they will prepare, that they do care to come again. Are they to come again.

In this way I have explained that to them and for them that for them alone that to them alone that to them and for them we have no depression. The law covers this, if you say made of fruit or if you say made by the aid of or made with the aid of fruit, or made by using fruit or made with fruit, for the fruit, you see how suddenly if there is in question if there can be any question, what would them compare with their description, with the description of this description. I describe all the time.

The second example is an example of action.

What action.

If you arrange the door, if you arrange the door and the floor. I have lost most of my interest in politics, still it is more interesting than the theater. Brenner says that.

In action.

In every action we can take he knows that if the hair is there and the ears hear and the Caesars share and they

— 75 —

⊞ Right: A letter from Gertrude Stein with the rose emblem, 1923.
Above: One of the texts in which Alice B. Toklas discovered the rose: "An Elucidation," 1923, published in *transition* in 1927.

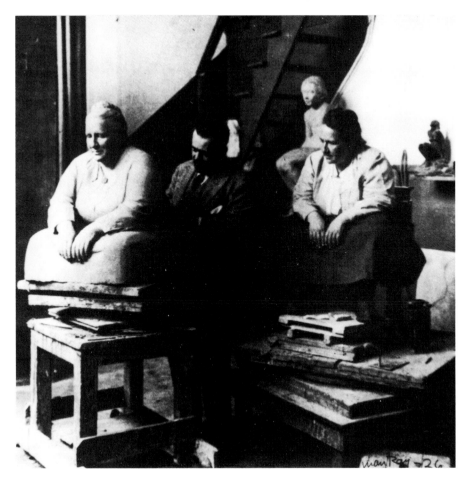

the description of inner and outer reality. She has produced a simplification by this concentration, and as a result the destruction of associational emotion in poetry and prose. She knows that beauty, music, decoration, the result of emotion should never be the cause, even events should not be the cause of emotion nor should they be the material of poetry and prose. Nor should emotion itself be the cause of poetry or prose. They should consist of an exact reproduction of either an outer or an inner reality.

It was this conception of exactitude that made the close understanding between Gertrude Stein and Juan Gris.

Juan Gris also conceived exactitude but in him exactitude had a mystical basis. As a mystic it was necessary for him to be exact. In Gertrude Stein the necessity was intellectual, a pure passion for exactitude. It is because of this that her work has often been compared to that of mathematicians and by a certain french critic to the work of Bach.

—*The Autobiography of Alice B. Toklas*

Sculpture is made with two instruments and some supports and pretty air.

—*A Novel of Thank You*

▨ Above: Jo Davidson and his model. Photo by Man Ray, 1923.
Near right: *The Clown*, drawing by Juan Gris with the dedication, "For Gertrude Stein / in friendship / Juan Gris / 1924."
Far right: *Roses* for Gertrude Stein, by Juan Gris, 1924.

Gertrude Stein, in her work, has always been possessed by the intellectual passion for exactitude in

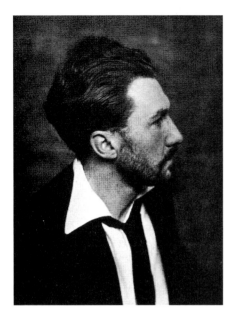

We met Ezra Pound at Grace Lounsbery's house, he came home to dinner with us and he stayed and he talked about japanese prints among other things. Gertrude Stein liked him but did not find him amusing. She said he was a village explainer, excellent if you were a village, but if you were not, not. . . .

. . . Ezra did come back and he came back with the editor of The Dial. This time it was worse than japanese prints, it was much more violent. In his surprise at the violence Ezra fell out of Gertrude Stein's favourite little armchair, the one I have since tapestried with Picasso designs, and Gertrude Stein was furious. Finally Ezra and the editor of The Dial left, nobody too well pleased. Gertrude Stein did not want to see Ezra again. Ezra did not quite see why. He met Gertrude Stein one day near the Luxembourg gardens and said, but I do want to come to see you. I am so sorry, answered Gertrude Stein, but

Miss Toklas has a bad tooth and beside we are busy picking wild flowers. All of which was literally true, like all of Gertrude Stein's literature, but it upset Ezra, and we never saw him again.

—*The Autobiography of Alice B. Toklas*

FISH
Can fish be wives and wives and wives and have as many as that. Can fish be wives and have as many as that.
Ten o'clock or earlier.

—*A Book Concluding with As a Wife Has a Cow a Love Story*

⊞ Far left page: Ezra Pound, about 1923. Photo by Man Ray.
Center: Ezra Pound's bad-luck chair and its mate.
Above: "Cows are very nice. They are between legs." Illustration by Juan Gris (ca. 1925) for Gertrude Stein's, *A Book Concluding with As a Wife Has a Cow a Love Story*.

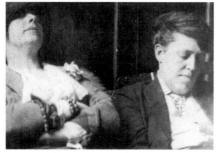

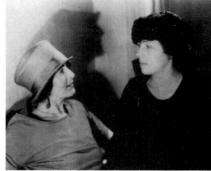

⊠ Above: 27, rue de Fleurus with the new doorway leading from the apartment to the studio, in the 1920s.
Right: Guests of Gertrude Stein and Alice B. Toklas in the 1920s:
From top to bottom: Margaret Anderson and Jane Heap, editors of *The Little Review*; Mina Loy and Djuna Barnes; e. e. cummings; Man Ray.
Right page, top: Scott and Zelda Fitzgerald with their daughter Scottie, Paris, Christmas 1925; Jean Cocteau; Janet Flanner.
Bottom: Louis Bromfield; Bryher and Robert McAlmon; T. S. Eliot.

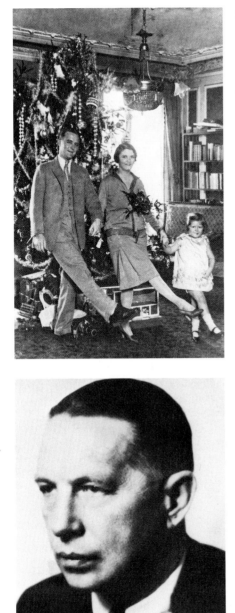

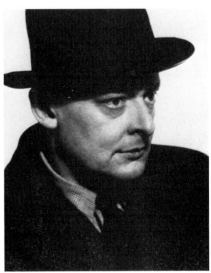

Very shortly after [Auntie] went its honourable way and was succeeded by Godiva, a two-seated runabout, also a little ford. She was called Godiva because she had come naked into the world and each of our friends gave us something with which to bedeck her.

—*The Autobiography of Alice B. Toklas*

When I began writing I was always writing about beginning again and again. In The Making of Americans I was making a continuous present a continuous beginning again and again, the way they do in making automobiles or anything, each one has to be begun, but now everything having been begun nothing had to be begun again.

—*Everybody's Autobiography*

THE
MAKING
OF
AMERICANS

BEING
A HISTORY OF
A FAMILY'S PROGRESS

*WRITTEN
BY GERTRUDE STEIN
1906-1908*

 First edition of the one-thousand-page novel *The Making of Americans*, published by Robert McAlmon's Contact Editions in 1925.

"I do love Tubbs hotel very well with Eucalyptus and palms and Godiva and a mistress." Driving her second Ford, "Godiva," in the 1920s.

The only thing she did, to my knowledge, to which her French friends could have objected morally and maybe legally was to seem often to be about to run them down with her car. Though possessed with lightning-fast reactions and a knowledge of how to handle a Ford, she felt she owned the road. She spent a good deal of time driving for visits, on errands, or just for the pleasure of being at the wheel. But she regarded a corner as something to cut, and another car as something to pass, and she could scare the daylights out of all concerned.

—W. G. Rogers,
When This You See Remember Me

During these early restless years after the war Gertrude Stein worked a great deal. Not as in the old days, night after night, but anywhere, in between visits, in the automobile while she was waiting in the street while I did errands, while posing. She was particularly fond of these days of working in the automobile while it stood in the crowded streets.

It was then that she wrote Finer Than Melanctha as a joke. Harold Loeb, at that time editing Broom all by himself, said he would like to have something of hers that would be as fine as Melanctha, her early negro story in Three Lives.

She was much influenced by the sound of the streets and the movement of the automobiles. She also liked then to set a sentence for herself as a sort of tuning fork and metronome and then write to that time and tune.

—*The Autobiography of Alice B. Toklas*

One cold dark afternoon she went out to sit with her ford car and while she sat on the steps of another battered ford watching her own being taken to pieces and put together again, she began to write. She stayed there several hours and when she came back chilled, with the ford repaired, she had written the whole of Composition As Explanation.

Once the lecture written the next trouble was the reading of it. Everybody gave her advice. She read it to anybody who came to the house and some of them read it to her. Prichard happened to be in Paris just then and he and Emily Chadbourne between them gave advice and were an audience. Prichard showed her how to read it in the english manner but Emily Chadbourne was all for the american manner and Gertrude Stein was too worried to have any manner. We went one afternoon to Natalie Barney's. There there was a very aged and a very charming french professor of history. Natalie Barney asked him to tell Gertrude Stein how to lecture. Talk as quickly as you can and never look up, was his advice. Prichard had said talk as slowly as possible and never look down. At any rate I ordered a new dress and a new hat for Gertrude Stein and early in the spring we went to London.

—*The Autobiography of Alice B. Toklas*

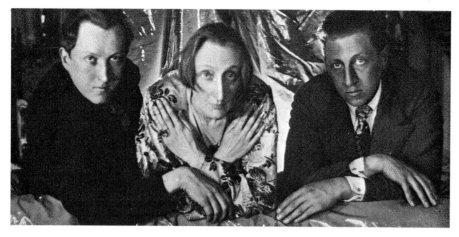

The Sitwell siblings, ca. 1926. Photo by Cecil Beaton.
Right page: A new hat for London? Photo by Man Ray, 1926.

Edith, Osbert and Sacheverell Sitwell accompanied Gertrude as well as Miss Alice Toklas, her inseparable companion, who looked like a Spanish gipsy and talked like a Bostonian. Gertrude had left all her nervousness at Cambridge: it was a fine summer day and she was ready to enjoy herself. Her audience was even larger than I had anticipated and many had to stand. Owing to the critics, the popular conception of Gertrude Stein was of an eccentric visionary, a literary Madame Blavatsky in fabulous clothes, the triumph of the dream and escape from life personified, with bells on her fingers as well as on her toes, or a mermaid swathed in tinsel, smoking drugged cigarettes through an exaggerated cigarette holder, or a Gioconda who had had her face lifted so often that it was fixed in a smile beyond the nightmares of Leonardo da Vinci. One was aware of the rapid deflation of these conceptions, as Gertrude surpassed them by her appearance, a squat Aztec figure in obsidian, growing more monumental as soon as she sat down. With her tall bodyguard of Sitwells and the gipsy acolyte, she made a memorable entry.

Nobody was prepared for what followed, a placid reading of *Composition as Explanation* and several word portraits, including one of Edith Sitwell, who sat so near that the portrait could be compared with the original. The litany of an Aztec priestess, I thought, uttered in a friendly American voice that made everybody feel at home until they pondered the subject matter. What a contrast between manner and matter, between voice and written page! I could not suppress a nervous chuckle at the possible developments of the situation which flashed in front of my eyes. Though we had heard dozens of lectures, nobody had heard anything like this before. There was no nonsense about her manner, which was in deep American earnest, as natural as could be. Hers was the only possible way of reading those flat sentences, entirely matter of fact. But it was difficult not to fall into a trance.

—Harold Acton,
Memoirs of an Aesthete

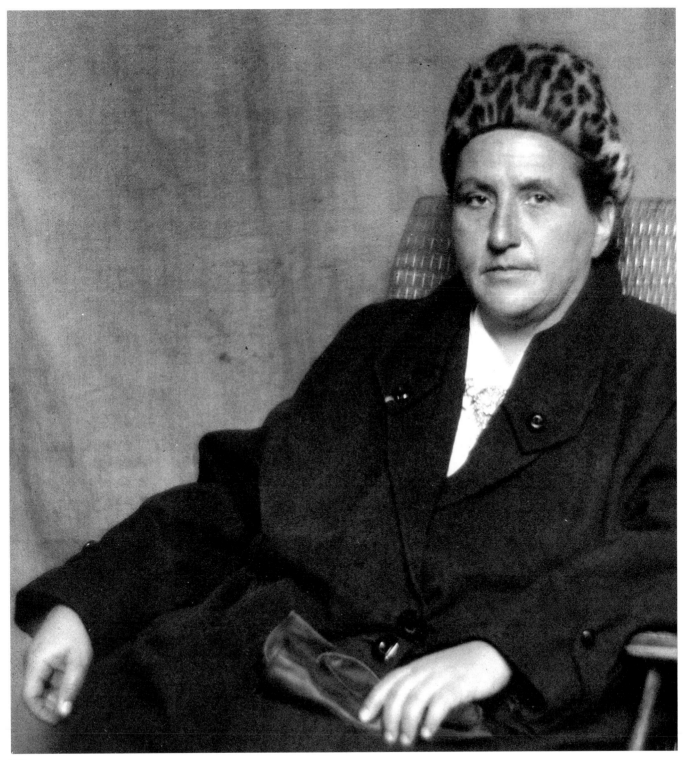

⊞ Cambridge (top) and Oxford in the 1920s.

The day after we went to Oxford. There we lunched with young Acton and then went in to the lecture. Gertrude Stein was feeling more comfortable as a lecturer and this time she had a wonderful time. As she remarked afterwards, I felt just like a prima donna.

The lecture room was full, many standing in the back, and the discussion, after the lecture, lasted over an hour and no one left. It was very exciting. They asked all sorts of questions, they wanted to know most often why Gertrude Stein thought she was right in doing the kind of writing she did. She answered that it was not a question of what any one thought but after all she had been doing as she did for about twenty years and now they wanted to hear her lecture. This did not mean of course that they were coming t think that her way was a possible way, it proved nothing, but on the other hand it did possibly indicate something. They laughed. Then up jumped one man, it turned out afterwards that he was a dean, and he said that in the Saints in Seven he had been very interested in the sentence about the ring around the moon, about the ring following the moon. He admitted that the sentence was one of the most beautifully balanced sentences he had ever heard, but still did the ring follow the moon. Gertrude Stein said, when you look at the moon and there is a ring around the moon and the moon moves does not the ring follow the moon. Perhaps it seems to, he replied. Well, in that case how, she said, do you know that is does not; he sat down. Another man, a don, next to him jumped up and asked something else. They did this several times, the two of them, jumping up one after the

106

other. Then the first man jumped up and said, you say that everything being the same everything is always different, how can that be so. Consider, she replied, the two of you, you jump up one after the other, that is the same thing and surely you admit that the two of you are always different. Touché, he said and the meeting was over. One of the men was so moved that he confided to me as we went out that the lecture had been his greatest experience since he had read Kant's Critique of Pure Reason.

—*The Autobiography of Alice B. Toklas*

The next day we returned to Paris. . . . Gertrude Stein felt that she had had enough of glory and excitement. Not, as she always explains, that she could ever have enough of glory. After all, as she always contends, no artist needs criticism, he only needs appreciation. If he needs criticism he is no artist.

—*The Autobiography of Alice B. Toklas*

In the days when the friendship between Gertrude Stein and Picasso had become if possible closer than before, (it was for his little boy, born February fourth to her February third, that she wrote her birthday book with a line for each day in the year) in those days her intimacy with Juan Gris displeased him. Once after a show of Juan's pictures at the Gallérie Simon he said to her with violence, tell me why you stand up for his work, you know you do not like it; and she did not answer him.

Later when Juan died and Gertrude Stein was heart broken Picasso came to the house and spent all day there. I do not know what was said but I do know that at one time Gertrude Stein said to him bitterly, you have no right to mourn, and he said, you have no right to say that to me. You never realised his meaning because you did not have it, she said angrily. You know very well I did, he replied.

The most moving thing Gertrude Stein has ever written is The Life and Death of Juan Gris.

—*The Autobiography of Alice B. Toklas*

⊠ Gertrude Stein's friend Juan Gris. Photo by Man Ray, 1922.

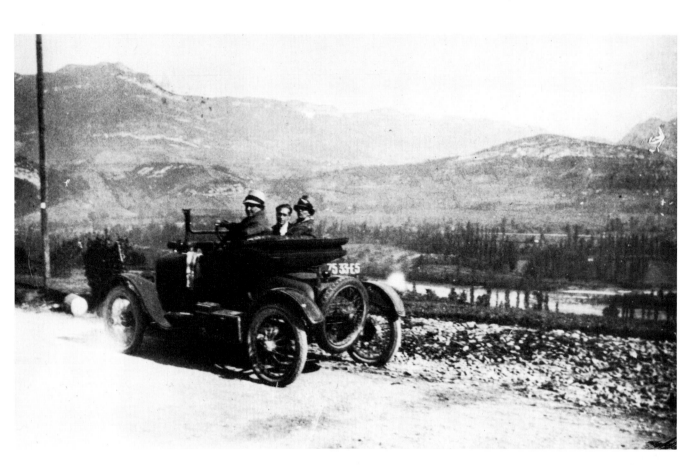

She liked to take a chair and sit in a person's life.

—Pavel Tchelitchev, author's journal

▨ Trip to Belley, in the Rhône Valley, with the painter Pavel Tchelitchev, 1926(?).

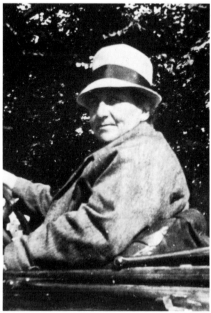

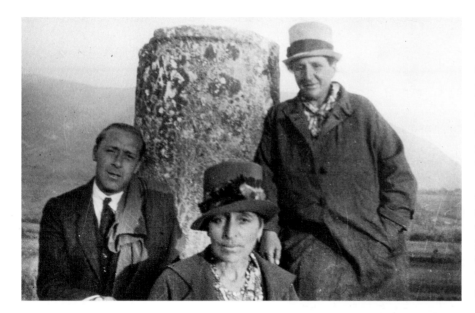

I always remember Pavlick Tchelitcheff writing to us the first time he was ever on shipboard and saying how bored he was with the ocean because it was just like the Russian revolution it just kept going up and down and being unpleasant and annoying and upsetting but it never went forward and back it just went up and down. . . .

I am also fond of saying that a war or fighting is like a dance because it is all going forward and back, and that is what everybody likes they like that forward and back movement, that is the reason that revolutions and Utopias are discouraging they are up and down and not forward and back.

—*Everybody's Autobiography*

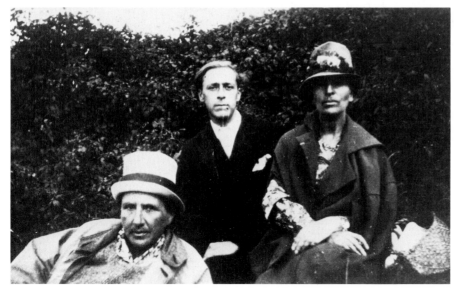

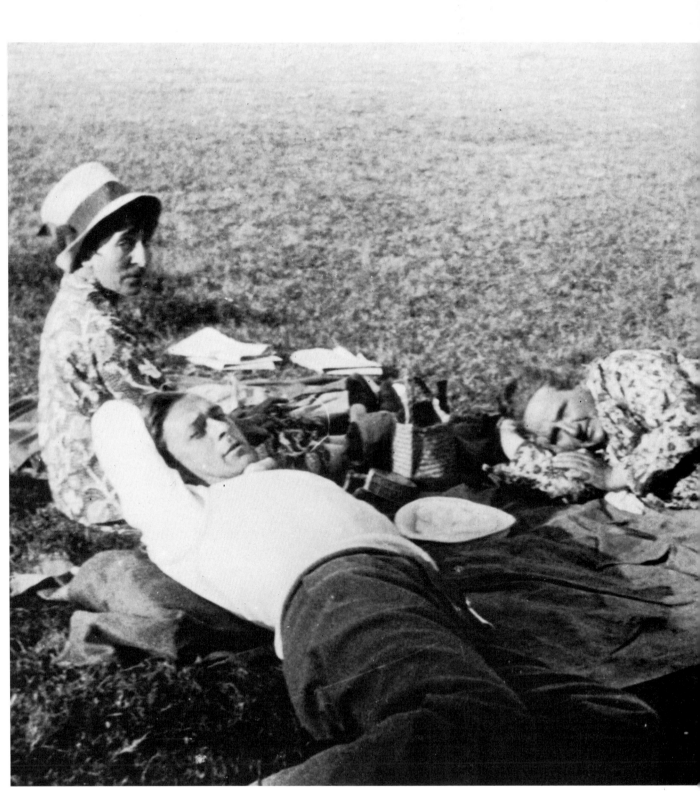

Gertrude Stein adored heat and sunshine although she always says that Paris winter is an ideal climate. In those days it was always at noon that she preferred to walk. I, who have and had no fondness for a summer sun, often accompanied her. Sometimes later in Spain I sat under a tree and wept but she in the sun was indefatigable. She could even lie in the sun and look straight up into a summer noon sun, she said it rested her eyes and head.

—*The Autobiography of Alice B. Toklas*

⊞ Top right: "Group photography of all kinds of marriages."

Who is it, said Gertrude Stein with a never failing curiosity. Sir Francis Rose, they said. Alright, we'll come, said Gertrude Stein. By this time she no longer objected to meeting Francis Rose. We met then and he of course immediately came back to the house with her. He was, as may be imagined, quite pink with emotion. And what, said he, did Picasso say when he saw my paintings. When he first saw them, Gertrude Stein answered, he said, at least they are less bêtes than the others. And since, he asked. And since he always goes into the corner and turns the canvas over to look at them but he says nothing.

—*The Autobiography of Alice B. Toklas*

She began at this time to describe landscape as if anything she saw was a natural phenomenon, a thing existent in itself, and she found it, this exercise, very interesting and it finally led her to the later series of Operas and Plays. I am trying to be as commonplace as I can be, she used to say to me. And then sometimes a little worried, it is not too commonplace. The last thing that she had finished, Stanzas of Meditation, and which I am now typewriting, she considered her real achievement of the commonplace.

—*The Autobiography of Alice B. Toklas*

But she always says some day they, anybody, will find out that she is of interest to them, she and her writing. And she always consoles herself that the newspapers are always interested. They always say, she says, that my writing is appalling but they always quote it and what is more, they quote it correctly, and those they say they admire they do not quote. This at some of her most better moments has been a consolation. My sentences do get under their skin, only they do not know that they do, she has often said.

—*The Autobiography of Alice B. Toklas*

Above: Sir Francis Rose.
Right: "How can language alter. It does not it is an altar." In the neighborhood of Bilignin.

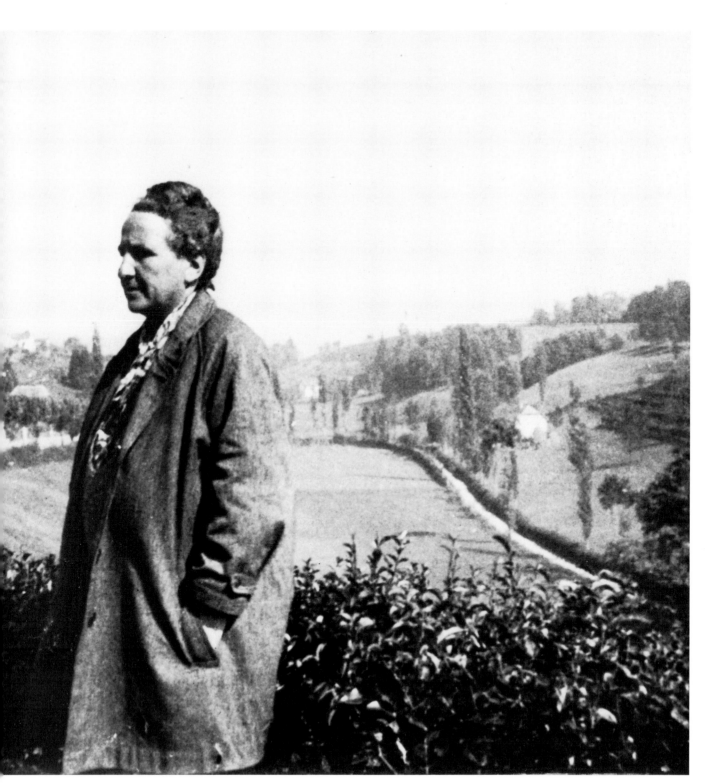

There was never anything equivocal about Gertrude's hats; they were either excessively mannish, Napoleonic and severe, or of a dowdy, blousy, flower-bedecked femininity which was disconcerting to behold. The same tendency was marked in her dress. She could be very handsome, indeed, in austere brown monastic gowns—there was one made out of some Egyptian cloth that I liked very much, falling straight from the shoulder to foot and giving her the height she needed, for she was rather small in stature. But Gertrude also had a penchant for brightly coloured clothes, bearing patterns of tiny flowers, and for blouses, both of which should have been forbidden, because they made her look dumpy and old.

Alice on the contrary, never made an error in dress, and always looked exceedingly smart. She had adopted the Frenchwoman's restraint, and seldom wore anything but greys and blacks.

—Bravig Imbs,
Confessions of Another Young Man

Gertrude Stein and Alice B. Toklas. Studio photo.
Right page: Summer, in Aix-les-Bains, undated.

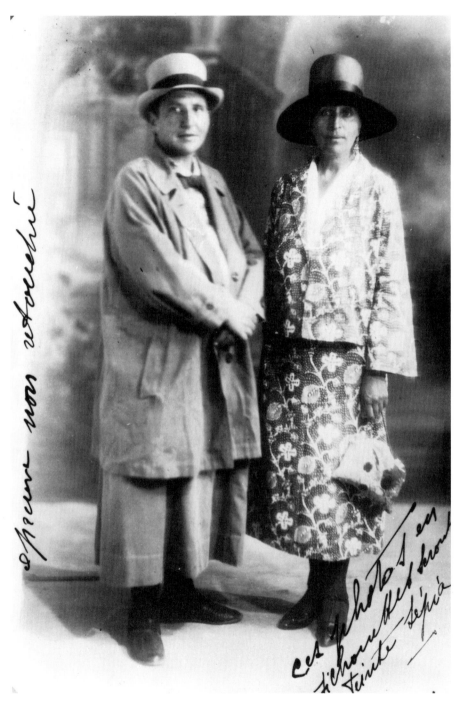

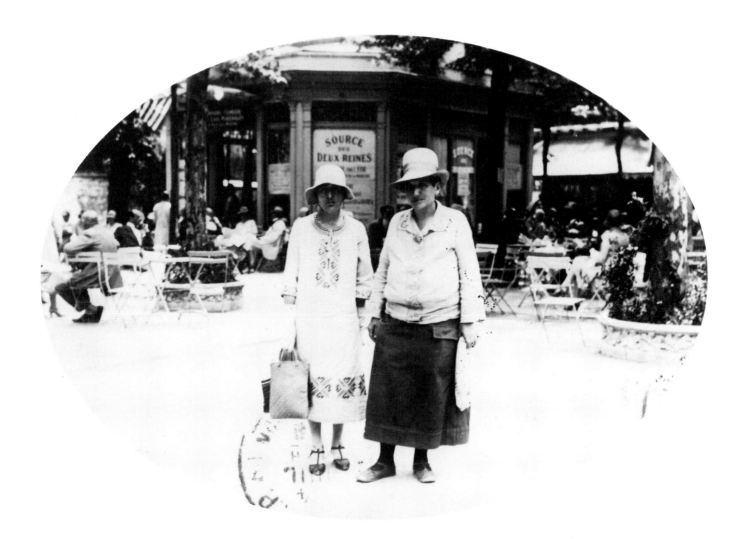

We did give a great many parties in those days and the Duchess of Clermont-Tonnerre came very often.

She and Gertrude Stein pleased one another. They were entirely different in life education and interests but they delighted in each other's understanding. They were also the only two women whom they met who still had long hair. Gertrude Stein had always worn hers well on top of her head, an ancient fashion that she had never changed.

Madame de Clermont-Tonnerre came in very late to one of the parties, almost every one had gone, and her hair was cut. Do you like it, said Madame de Clermont-Tonnerre. I do, said Gertrude Stein. Well, said Madame de Clermont-Tonnerre, if you like it and my daughter likes it and she does like it I am satisfied. That night Gertrude Stein said to me, I guess I will have to too. Cut it off she said and I did.

I was still cutting the next evening, I had been cutting a little more all day and by this time it was only a cap of hair when Sherwood Anderson came in. Well, how do you like it, said I rather fearfully. I like it, he said, it makes her look like a monk.

As I have said, Picasso seeing it, was for a moment angry and said, and my portrait, but very soon added, after all it is all there.

—*The Autobiography of Alice B. Toklas*

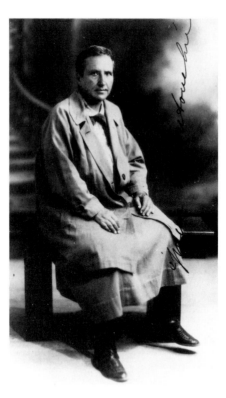

"Cut it off she said . . ." Gertrude Stein after the haircut, early 1927.

Summers in Bilignin— The First Success 1927–1934

I like the feeling of words doing as they want to do and as they have to do when they live where they have to live that is where they have come to live which of course they do do.

—*Narration*

1927 Gertrude Stein writes *Lucy Church Amiably*, a lyrical account of life in the country around Belley, and *Four Saints in Three Acts*, her first opera libretto for Virgil Thomson. In November, Virgil Thomson presents the first act of the opera to Gertrude Stein and her friends, among them Tristan Tzara and Georges Hugnet. At a masked ball at the house of the Duchesse de Clermont-Tonnerre, Thomson performs his composition of Stein's "Capital Capitals." Natalie Clifford Barney organizes a Gertrude Stein *soirée* at her "Académie des Femmes": Barney reads translated passages from *The Making of Americans*, the futurist poet Mina Loy reads poems, Virgil Thomson plays and sings Stein's portraits "Susie Asado" and "Preciosilla."

1928 Purchase of a new (unnamed) Ford sports car and a poodle named Basket. Gertrude Stein self-publishes a second collection of short texts, *Useful Knowledge*. She writes *How to Write*, reflections on language, grammar, sentences, and paragraphs. Daniel-Henry Kahnweiler publishes Stein's *A Village. Are You Ready Not Yet.*

1929 Gertrude Stein and Alice B. Toklas rent the house of their dreams in Bilignin as their summer residence. Extracts from *The Making of Americans* appear in French, translated by Georges Hugnet in his Editions de la Montagne. Stein writes stanzas, ballads, and her first French text, a film script: *"Film deux soeurs qui ne sont pas soeurs"* ("Film Two Sisters Who Aren't Sisters"). Her American college friend Marion Walker visits her in Bilignin.

1930 The first and only meeting with James Joyce, arranged by Sylvia Beach, at Jo Davidson's studio.

Gertrude Stein promises Georges Hugnet the English translation of his long poem "Enfances" but, instead, writes her own "mirror" version of his text. When this causes a breach in their friendship, she titles her version "Before the Flowers of Friendship Faded Friendship Faded." She sells Picasso's *Woman with a Fan* in order to finance a publishing company, Plain Edition, that Alice B. Toklas directs in order to further Stein's work. Their first volume is *Lucy Church Amiably*, in an edition of one thousand copies. Meeting and friendship with the painter Sir Francis Rose.

1931 Plain Edition publishes *Before the Flowers of Friendship Faded Friendship Faded*. The critic Edmund Wilson (in *Axel's Castle*) places Stein at the same level with Joyce, Proust, Yeats, and T. S. Eliot.

1932 The painter Francis Picabia gives Gertrude Stein a dog, a Mexican Chihuahua, named Byron because "he was to have as a wife his sister or mother." Byron is succeeded by the (identical) Pépé, named after Picabia. In Paris, *The Making of Americans* appears in a complete translation by Bernard Faÿ. Plain Edition publishes *Operas and Plays*. It takes Gertrude Stein six weeks, at Bilignin, to write *The Autobiography of Alice B. Toklas*. At the same time, in *Stanzas in Meditation and Other Poems*, she reflects on writing her first accessible book, a "real achievement of the commonplace."

1933 *The Autobiography of Alice B. Toklas* appears and is a bestseller, Gertrude Stein's first success. She is fifty-nine years old. She is temporarily estranged from Picasso (because of Olga Picasso's dislike of the book) and her friendship with Hemingway ends. She enjoys having money for the first time, aquires a new Ford, and, in a severe identity crisis, experiences her first writing block. Plain Edition brings out *Matisse, Picasso and Gertrude Stein with Two Shorter Stories*. In New York, *Three Lives* goes into its second edition.

1934 The mystery that writing, for the first time, "has not happened" inspires Gertrude Stein's first and only detective novel, *Blood on the Dining-Room Floor*. On February 8, John Houseman directs the world premiere of *Fours Saints in Three Acts* in Hartford, Connecticut, with choreography by Frederick Ashton, stage sets by Florine Stettheimer, and a libretto by Maurice Grosser. The Broadway premiere follows on February 20. Gertrude Stein prepares for a lecture tour in the United States, encouraged by visits from W. G. Rogers ("the Kiddie") and Carl Van Vechten. Writing her lectures (published as *Lectures in America*), she enters the most active theoretical phase in her writing. Her collection of hermetic texts *Portraits and Prayers* appears in New York.

119

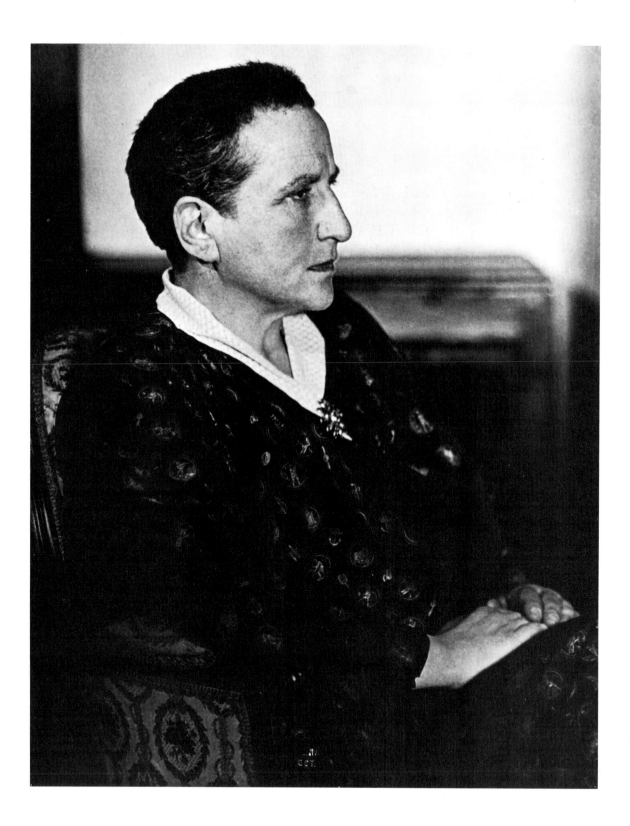

Every one began at this time to be very occupied with their own affairs. Virgil Thomson had asked Gertrude Stein to write an opera for him. Among the saints there were two saints whom she had always liked better than any others, Saint Theresa of Avila and Ignatius Loyola, and she said she would write him an opera about these two saints. She began this and worked very hard at it all that spring and finally finished Four Saints and gave it to Virgil Thomson to put to music. He did. And it is a completely interesting opera both as to words and music.

—*The Autobiography of Alice B. Toklas*

A saint a real saint never does anything, a martyr does something but a really good saint does nothing, and so I wanted to have Four Saints who did nothing and I wrote the Four Saints In Three Acts and they did nothing and that was everything.

Generally speaking anybody is more interesting doing nothing than doing something.

—*Everybody's Autobiography*

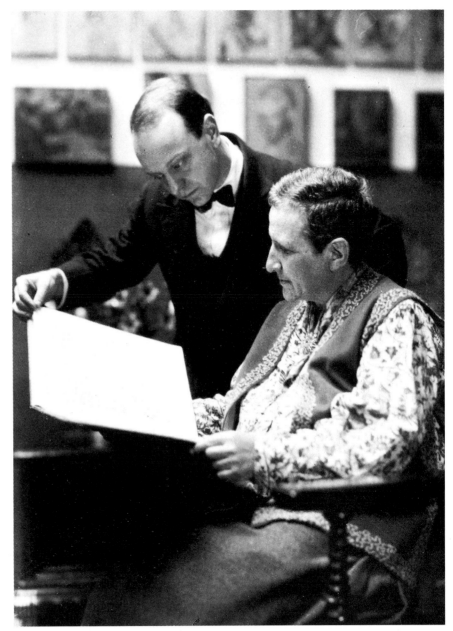

⊠ Left page: Portrait of a "dictator of art" (Man Ray). Photo by Man Ray, ca. 1927.
Right: With Virgil Thomson, her first composer, working on her first opera, *Four Saints in Three Acts*, 1927.

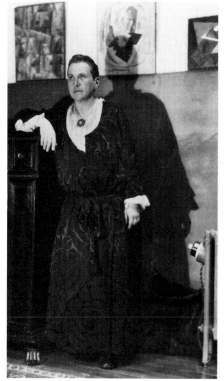

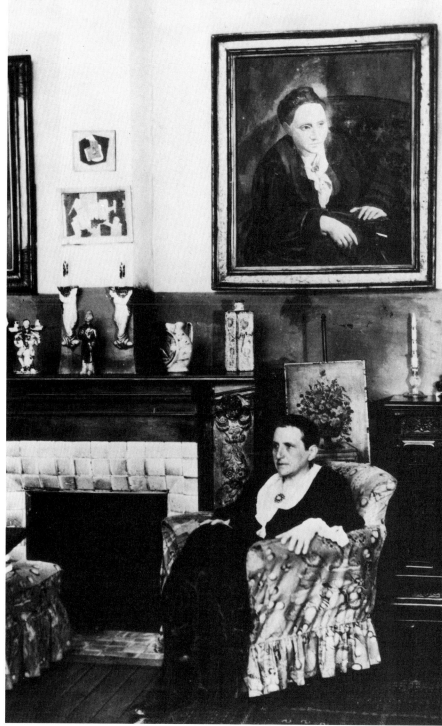

We had installed electric radiators in the studio, we were as our finnish servant would say getting modern. She finds it difficult to understand why we are not more modern. Gertrude Stein says that if you are way ahead with your head you naturally are old fashioned and regular in your daily life. And Picasso adds, do you suppose Michael Angelo would have been grateful for a gift of a piece of renaissance furniture, no he wanted a greek coin.

—*The Autobiography of Alice B. Toklas*

▨ At the end of the 1920s. Photos possibly by Man Ray.

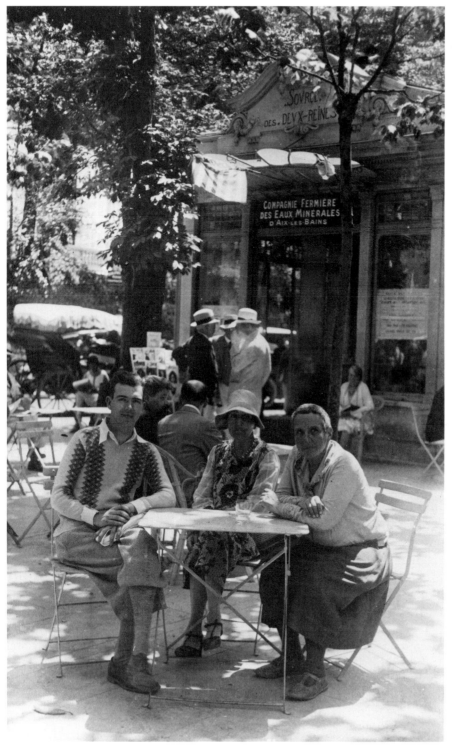

Among the other young men who came to the house at the time when they came in such numbers was Bravig Imbs. We liked Bravig, even though as Gertrude Stein said, his aim was to please.

— *The Autobiography of Alice B. Toklas*

After a little while there is a difference between rain and wind. After a little while there is a difference between wind rain and wind rain and paper and between rain wind and paper and there is after a while there is a difference between rain wind and paper.

— *An Acquaintance with Description*

▨ "When one goes three go and when three go two go." Looking for a country house in the Rhône Valley.
Left: With the writer Bravig Imbs in Aix-les Bains, ca. 1927.
Right: A snapshot near Belley, published in *transition*, no. 14, Fall 1928.

All these summers we had continued to go to the hotel in Belley. We now had become so fond of this country, always the valley of the Rhône, and of the people of the country, and the trees of the country, and the oxen of the country, that we began looking for a house. One day we saw the house of our dreams across a valley. Go and ask the farmer there whose house that is, Gertrude Stein said to me. I said, nonsense it is an important house and it is occupied. Go and ask him, she said. Very reluctantly I did. He said, well yes, perhaps it is for rent, it belongs to a little girl, all her people are dead and I think there is a lieutenant of the regiment stationed in Belley living there now, but I understand they were to leave. You might go and see the agent of the property. We did. He was a kindly old farmer who always told us allez doucement, go slowly. We did. We had the promise of the house, which we never saw any nearer than across the valley, as soon as the lieutenant should leave. Finally three years ago the lieutenant went to Morocco and we took the house still only having seen it from across the valley and we have liked it always more.

— *The Autobiography of Alice B. Toklas*

We now had our country house,
the one we had only seen
across the valley and just before leav-
ing we found the white poodle, Basket.
He was a little puppy in a little neigh-
bourhood dog-show and he had blue
eyes, a pink nose and white hair and
he jumped up into Gertrude Stein's
arms. A new puppy and a new ford we
went off to our new house and we
were thoroughly pleased with all three.

— *The Autobiography of Alice B. Toklas*

▣ "A house in the country is not the
same as a country house." Left page,
above: The *manoir* in Bilignin, seen from
across the valley, 1929. Above and
right: Entrance gate and entrance door
of the house. Both photos by Samuel M.
Steward.
Left page, below: Hotel Pernollet in
nearby Belley, postcard.

We named him Basket because I had said he should carry a basket of flowers in his mouth. Which he never did.

—Alice B. Toklas,
What Is Remembered

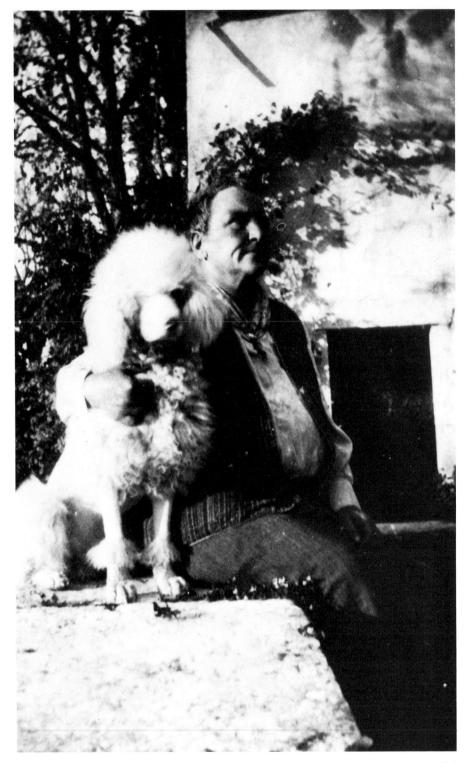 With Basket, the new poodle, in the new house. Undated.

It was only a few years ago that
Marion Walker, Gertrude Stein's old
friend, came to see her at Bilignin
where we spend the summer. She and
Gertrude Stein had not met since
those old days nor had they corre-
sponded but they were as fond of each
other and disagreed as violently about
the cause of women as they did then.
Not, as Gertrude Stein explained to
Marion Walker, that she at all minds
the cause of women or any other
cause but it does not happen to be
her business.

—*The Autobiography of Alice B. Toklas*

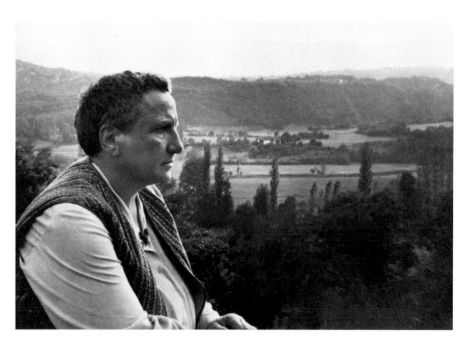

Their origin and their history patri-
archal poetry their origin and their
history patriarchal poetry their origin
and their history. . . .
 Patriarchal poetry makes no
mistake. . . .
 Patriarchal Poetry is the same as
Patriotic poetry is the same as patriar-
chal poetry is the same as Patriotic
poetry is the same as patriarchal
poetry is the same.
 Patriarchal poetry is the same.

—"Patriarchal Poetry"

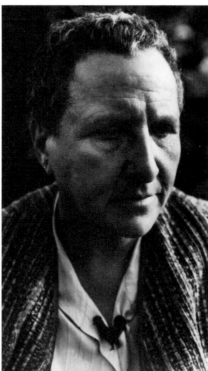

There were many Gertrudes, the
neighbour Gertrude, a homely
pleasant countrywoman, the Dr.
Johnson Gertrude, laying down the
law, the *homme de lettres, homme* not
femme, the *salonière,* giving her opin-
ion on everything, and Gertrude the
hermetic poet, hard-working, humble
. . . Not humble before the views of
other people on her work, but humble
before a piece of paper. And even more
so before ideas of grammar, of compo-
sition. Hers was a work of method
more than of communication. She
would work at composition, at

description, at narration, in a way in
which no other writers have. One can
compare this with Bach working at
fugal technique as he wrote.

—Virgil Thomson,
author's journal

▨ View from the garden across the
valley. Photos by G. P. Lynes, 1929.

And then there was a historic
moment the other day that will
amuse you, you know in all these
years Joyce and I had never met, well
the other day Jo Davidson gave a party
for his Walt Whitman [sculpture] and
Sylvia Beach was there and she came
up to me and said Joyce is here, he
wants to meet you but he cannot move
around on account of his eyes will
you come, so of course I did, and I
said we have never met and he said
no although our names are always
together, and then we talked Paris and
where we lived and why we lived
where we lived and that was all, but
I thought it would interest you. . . .

—Letter to W. G. Rogers

QUESTIONNAIRE FROM LITTLE REVIEW
[Jane Heap]

1. What should you most like to do, to
know, to be? (In case you are not satis-
fied.)
2. Why wouldn't you change places
with any other human being?
3. What do you look forward to?
4. What do you fear most from the
future?
5. What has been the happiest
moment of your life? The unhappiest?
(If you care to tell.)
6. What do you consider your weakest
characteristics? Your strongest? What
do you like most about yourself?
Dislike most?
7. What things do you really like?
Dislike? (Nature, people, ideas,
objects, etc. Answer in a phrase or a
page, as you will.)
8. What is your attitude toward art
today?
9. What is your world view? (Are you
a reasonable being in a reasonable
scheme?)
10. Why do you go on living?

Left: James Joyce, early 1930s.
Above right: Jane Heap, 1929.

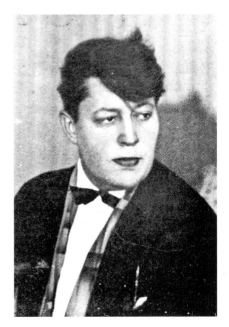

ANSWERS TO JANE HEAP

Good luck to your last number. I
would much rather have written about
Jane because I do appreciate Jane but
since this is what you want here are
my answers.
1. But I am.
2. Because I am I.
3. More of the same.
4. Anything.
5. Birthday.
6. 1. Weakness. 2. Nothing. 3.
Everything. 4. Almost anything.
7. 1. What I like. 2. Hardly anything.
8. I like to look at it.
9. Not very likely or often.
10. I am.

—*The Little Review*, May 1929

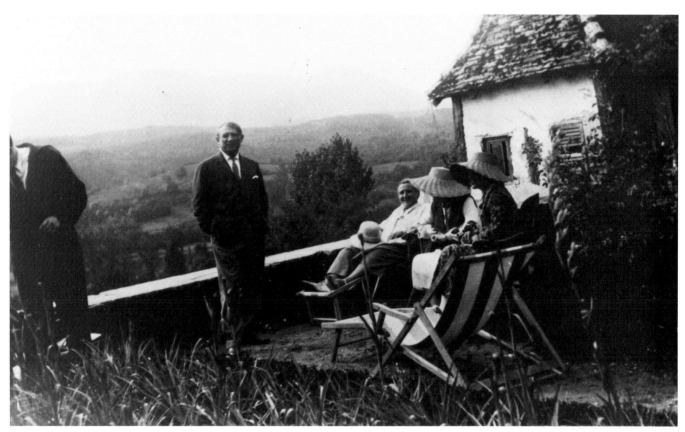

Picasso and I used to dream of the pleasure if a burglar came to steal something he would steal his painting or my writing in place of silver and money. They might now they certainly would not have then and after all if a work of art has existed then somehow every one can feel that it has been and so that makes the few geniuses there are a continuous line even if what they did is not there any more. Of course one always does want one's own to be left perhaps not so much now as in the beginning and so perhaps after all they are right the Americans in being more interested in you than in the work you have done although they would not be interested in you if you had not done the work you had done.

—*Everybody's Autobiography*

Above: Summer visit by the Picassos. Bilignin, ca. 1930.

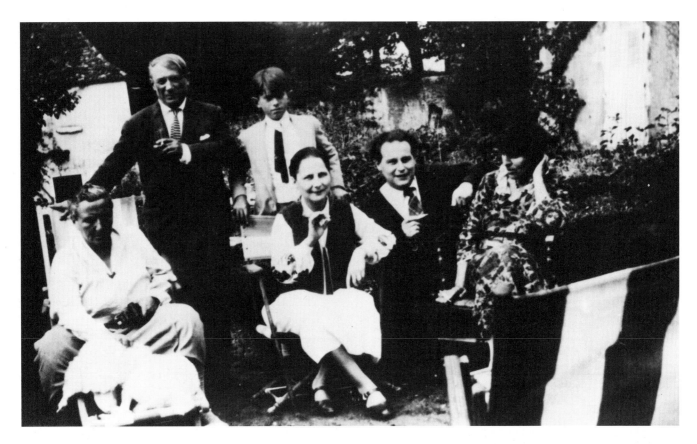

She understands very well the basis of creation and therefore her advice and criticism is invaluable to all her friends. How often have I heard Picasso say to her when she has said something about a picture of his and then illustrated by something she was trying to do, racontez-moi cela. In other words tell me about it. These two even to-day have long solitary conversations. They sit in two little low chairs up in his apartment studio, knee to knee and Picasso says, expliquez-moi cela. And they explain to each other. They talk about everything, about pictures, about dogs, about death, about unhappiness. Because Picasso is a spaniard and life is tragic and bitter and unhappy.

Gertrude Stein often comes down to me and says, Pablo has been persuading me that I am as unhappy as he is. He insists that I am and with as much cause. But are you, I ask. Well I don't think I look it, do I, and she laughs. He says, she says, that I don't look it because I have more courage, but I don't think I am, she says, no I don't think I am.

—*The Autobiography of Alice B. Toklas*

✠ Above: With Pablo and Paolo Picasso, Alice B. Toklas, and probably neighbors.
Right: Olga Picasso (left), Paolo Picasso, and Gertrude Stein; behind them Alice B. Toklas and Picasso.
Right page: With Olga and Pablo Picasso in the garden.

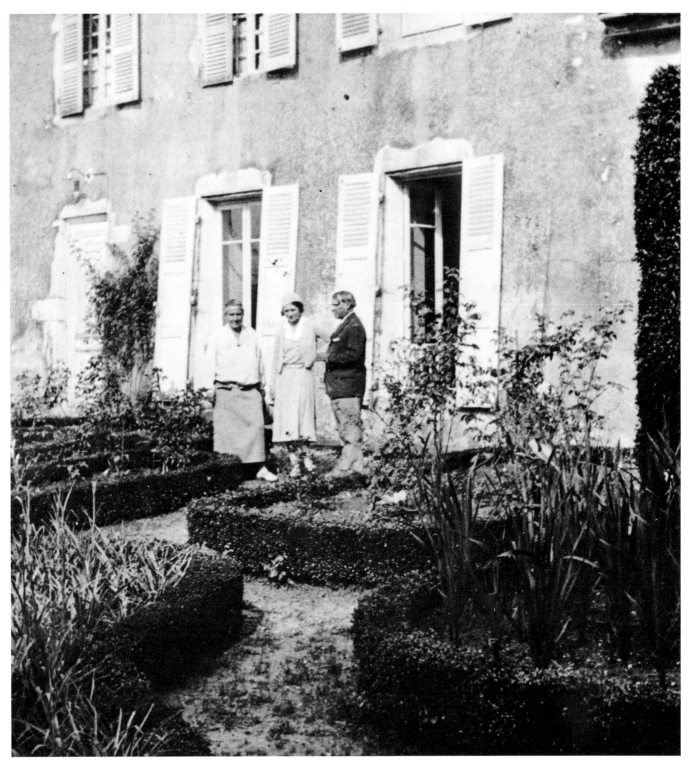

There are many Paris picture dealers who like adventure in their business, there are no publishers in America who like adventure in theirs. In Paris there are picture dealers like Durand-Ruel who went broke twice supporting the impressionists, Vollard for Cézanne, Sagot for Picasso and Kahnweiler for all the cubists. They make their money as they can and they keep on buying something for which there is no present sale and they do so persistently until they create its public. And these adventurers are adventurous because that is the way they feel about it. There are others who have not chosen as well and have gone entirely broke. It is the tradition among the more adventurous Paris picture dealers to adventure. I suppose there are a great many reasons why publishers do not.

— *The Autobiography of Alice B. Toklas*

I now myself began to think about publishing the work of Gertrude Stein. I asked her to invent a name for my edition and she laughed and said, call in Plain Edition. And Plain Edition it is.

— *The Autobiography of Alice B. Toklas*

Our first Plain Edition volume, *Lucy Church Amiably,* was badly printed in Paris. It would not stay closed and its back broke. So for a second volume, *How to Write*, we went down to Dijon. Gertrude wanted it to look like an eighteenth-century copy of Sterne which she had found once in London, bound in blue and white paper on board. But this was not very successful and I complained bitterly saying, Look how badly the pages fit each other. The printer said to me, What can you expect, madame? It is machine made, it is not done by hand. Which remained a classic answer for Gertrude and me.

— Alice B. Toklas,
What is Remembered

The distribution in Paris was at once easier and more difficult. It was easy to get the book put in the window of all the booksellers in Paris that sold english books. This event gave Gertrude Stein a childish delight amounting almost to ecstasy. She had never seen a book of hers in a bookstore window before, except a french translation of The Ten Portraits, and she spent all her time in her wanderings about Paris looking at the copies of Lucy Church Amiably in the windows and coming back and telling me about it.

— *The Autobiography of Alice B. Toklas*

❖ "A Novel of Romantic beauty and nature and which Looks Like an Engraving." *Lucy Church Amiably,* the first self-published edition, January 1931.

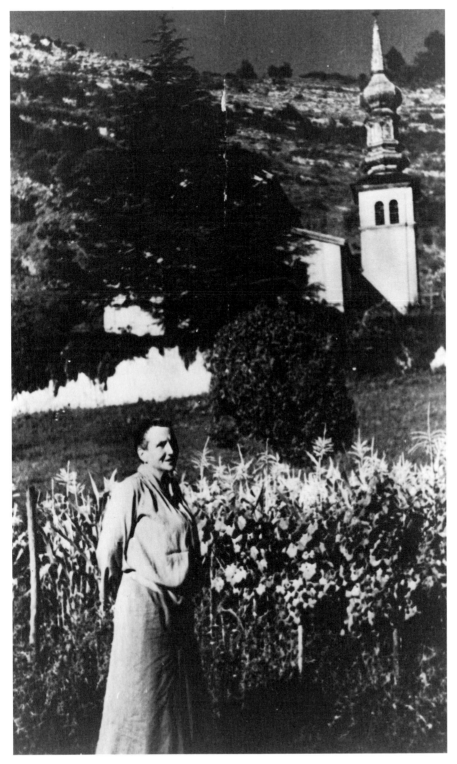

The scene took place in a field, its enactors being Gertrude, Alice, and a cow. Alice, by means of a stick, would drive the cow around the field. Then, at a sign from Gertrude, the cow would be stopped; and Gertrude would write in her copybook. After a bit, she would pick up her folding stool and progress to another spot, whereupon Alice would again start the cow moving around the field till Gertrude signaled she was ready to write again.

—Virgil Thomson, *Virgil Thomson*

⌗ At the church of Lucey, near Bilignin, 1930.

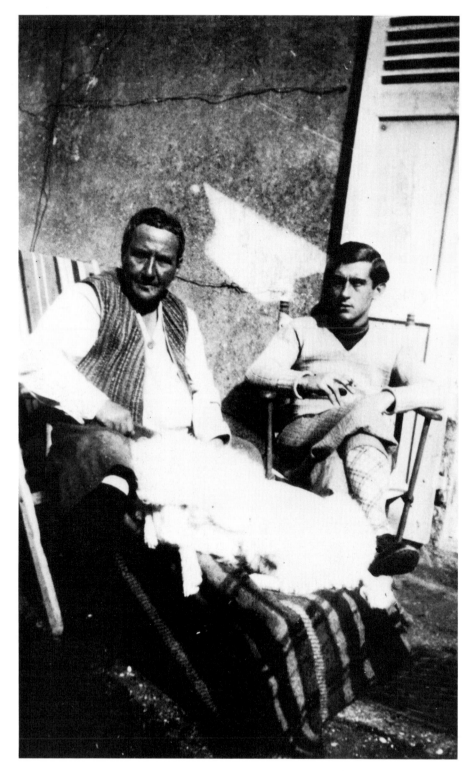

In the meantime, through Virgil Thomson, she had met a young frenchman named Georges Hugnet. He and Gertrude Stein became very devoted to one another. He liked the sound of her writing and then he liked the sense and he liked the sentences.

— *The Autobiography of Alice B. Toklas*

In the meantime Georges Hugnet wrote a poem called Enfance. Gertrude Stein offered to translate it for him but instead she wrote a poem about it. This at first pleased Georges Hugnet too much and then did not please him at all. Gertrude Stein then called the poem Before The Flowers Of Friendship Faded Friendship Faded.

— *The Autobiography of Alice B. Toklas*

Getting reviews was a difficulty, there are always plenty of humorous references to Gertrude Stein's work, as Gertrude Stein always says to comfort herself, they do quote me, that means that my words and my sentences get under their skins although they do not know it. It was difficult to get serious reviews. There are many writers who write her letters of admiration but even when they are in a position to do so they do not write themselves down in book reviews. Gertrude Stein likes to quote Browning who at a dinner party met a famous literary man and this man came up to Browning and spoke to him at length and in a very laudatory way about his poems. Browning listened and then said, and are you going to print what you have just said. There was naturally no answer. In Gertrude Stein's case there have been some notable exceptions, Sherwood

Anderson, Edith Sitwell, Benard Faÿ and Louis Bromfield.

I also printed an edition of one hundred copies, very beautifully done at Chartres, of the poem of Gertrude Stein Before The Flowers Of Friendship Faded Friendship Faded. These one hundred copies sold very easily.

— *The Autobiography of Alice B. Toklas*

PLAIN EDITION

Lucy Church Amiably
1931

Before The Flowers of Friendship Faded Friendship Faded
1931

How To Write
1932

OPERAS AND PLAYS
BY
GERTRUDE STEIN

PLAIN EDITION
27 - *rue de Fleurus* - 27
PARIS

BEFORE THE FLOWERS OF FRIENDSHIP
FADED FRIENDSHIP FADED

WRITTEN ON A POEM BY GEORGES HUGNET

GERTRUDE STEIN

PLAIN EDITION 27 RUE DE FLEURUS PARIS

⬚ Left page: With the poet Georges Hugnet in Bilignin, early 1930s.
Above: The second self-published edition, *Before the Flowers of Friendship Faded Friendship Faded,* May 1932.
Top right: *Operas and Plays*, the fourth self-published book, following *How to Write* in 1932.
Bottom right: With the historian Bernard Faÿ.

Bernard Faÿ came and stayed with us that summer. Gertrude Stein and he talked out in the garden about everything, about life, and America, and themselves and friendship. They then cemented the friendship that is one of the four permanent friendships of Gertrude Stein's life.

— *The Autobiography of Alice B. Toklas*

I remember once coming into the room and hearing Bernard Faÿ say that the three people of first rate importance that he had met in his life were Picasso, Gertrude Stein and André Gide and Gertrude Stein inquired quite simply, that is quite right but why include Gide. A year or so later in referring to this conversation he said to her, and I am not sure you were not right.

— *The Autobiography of Alice B. Toklas*

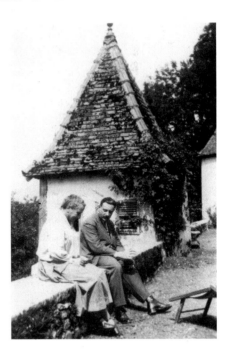

Picabia was in Paris and he said we should have another one immediately have another one, and Basket was happy that Byron was dead and gone and then we had Pépé and as he had feared and dreaded Byron Basket loved Pépé. Pépé was named after Francis Picabia and perhaps that made the difference anyway Pépé was and is a nice little dog but not at all like Byron although in a picture of him you can never tell which one is which one.

—*Everybody's Autobiography*

Basket although now he is a large unwieldy poodle, still will get up on Gertrude Stein's lap and stay there. She says that listening to the rhythm of his water drinking made her recognize the difference between sentences and paragraphs, that paragraphs are emotional and that sentences are not.

—*The Autobiography of Alice B. Toklas*

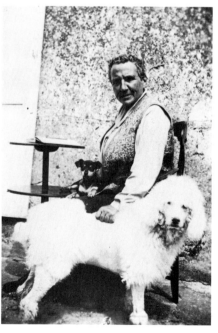

⊞ With her dogs, Pépé and Basket, in Bilignin. Undated.

Byron was a little Mexican dog given to us by Picabia. . . . We called him Byron because he was to have as a wife his sister or his mother and so we called him Byron. Poor little Byron his name gave him a strange and feverish nature, he was very fierce and tender and he danced strange little war dances and frightened Basket. Basket was always frightened of Byron. And then Byron died suddenly one night of typhus.

A sentence is inside itself by its internal balancing, think how a sentence is made by its parts of speech and you will see that it is not dependent upon a beginning a middle and an ending but by each part needing its own place to make its own balancing, and because of this in a sentence there is no emotion, a sentence does not give off emotion. But one sentence coming after another sentence makes a succession and the succession if it has a beginning a middle and an ending as a paragraph has does form create and limit an emotion. . . .

When I first began writing really just began writing, I was tremendously impressed by anything by everything having a beginning a middle and an ending. I think one naturally is impressed by anything having a beginning a middle and an ending when one is beginning writing and that is a natural thing because when one is emerging from adolescence, which is really when one first begins writing one feels that one would not have been one emerging from adolescence if there had not been a beginning and a middle and an ending to anything. So paragraphing is a thing then any one is enjoying and sentences are less fascinating, but then gradually well if you are an American gradually you find that really it is not necessary not really necessary that anything that everything has a beginning and a middle and an ending and so you struggling with anything as anything has begun and begun and began does not really mean that thing does not really mean beginning or begun.

—*Narration*

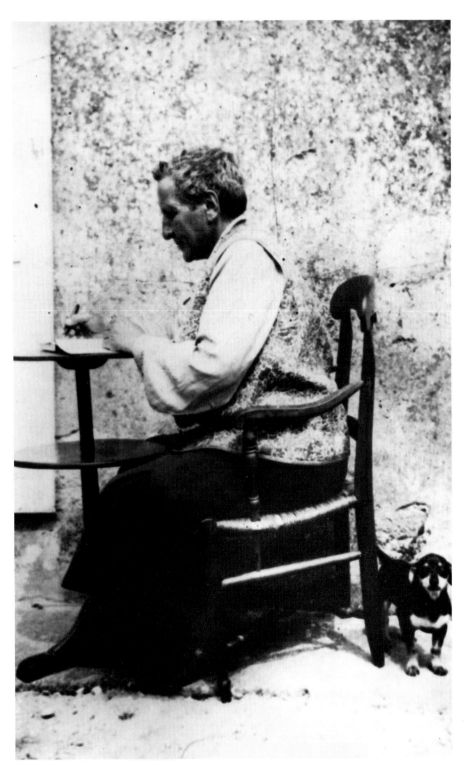

What is a genius. Picasso and I used to talk about that a lot. Really inside you if you are a genius there is nothing inside you that makes you really different to yourself inside you than those are to themselves inside them who are not a genius. That is so.

And so what is it that makes you a genius. Well yes what is it.

—*Everybody's Autobiography*

It takes a lot of time to be a genius, you have to sit around so much doing nothing, really doing nothing. If a bird or birds fly into the room is it good luck or bad luck we will say it is good luck.

—*Everybody's Autobiography*

She acted like a shadow behind Gertrude and was really the power behind the throne. It was she who always made the final decisions; whether it was concerning the dismissal of friends . . . or their rein-statement, but her real devotion was for Gertrude Stein's mind and this almost amounted to adoration.

—Francis Rose, "Memories of Gertrude Stein"

I do not care about anybody's painting if I know what the next painting they are painting looks like. I am like any dog out walking, I want it to be the same and I want it to be completely unalike.

The painting anybody was painting just then was not the same and it was completely alike. Except Picabia.

—*Everybody's Autobiography*

▣ "Beauty is beauty even when it is irritating." Portrait by Francis Picabia, 1933. Right: With the publisher Charles Henri Ford in Bilignin. Undated. Right page: Literary accomplices. Undated.

138

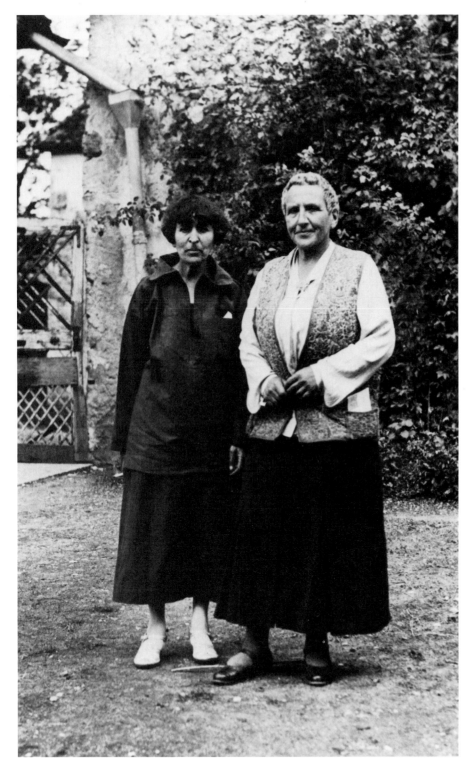

For some time now many people, and publishers, have been asking Gertrude Stein to write her autobiography and she had always replied, not possibly.

She began to tease me and say that I should write my autobiography. Just think, she would say, what a lot of money you would make. She then began to invent titles for my autobiography. My Life With The Great, Wives of Geniuses I Have Sat With, My Twenty-five Years With Gertrude Stein.

Then she began to get serious and say, but really seriously you ought to write your autobiography. Finally I promised that if during the summer I could find time I would write my autobiography.

When Ford Madox Ford was editing the Transatlantic Review he once said to Gertrude Stein, I am a pretty good writer and a pretty good editor and a pretty good business man but I find it very difficult to be all three at once.

I am a pretty good housekeeper and a pretty good gardener and a pretty good needlewoman and a pretty good secretary and a pretty good editor and a pretty good vet for dogs and I have to do them all at once and I found it difficult to add being a pretty good author.

About six weeks ago Gertrude Stein said, it does not look to me as if you were ever going to write that autobiography. You know what I am going to do. I am going to write it for you. I am going to write it as simply as Defoe did the autobiography of Robinson Crusoe. And she has and this is it.

— *The Autobiography of Alice B. Toklas*

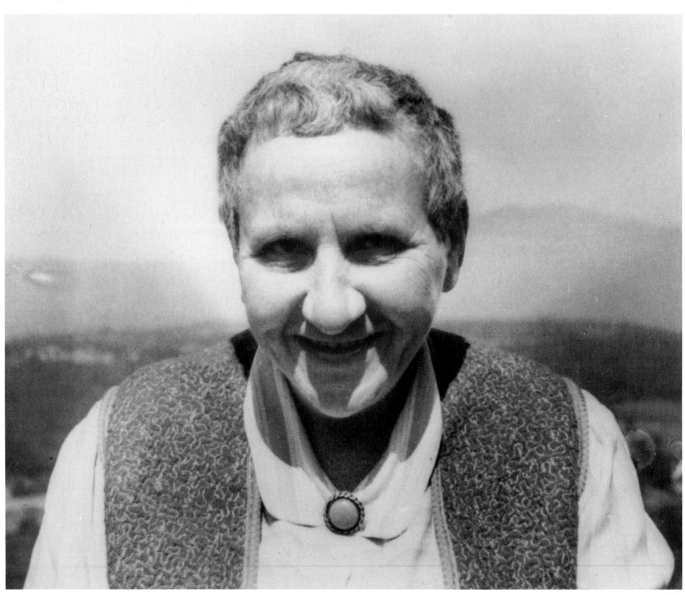

A "real achievement of the commonplace." The author of a bestseller, sixty years old. Photo by Carl Van Vechten, 1934.

The worst possible judgement one could make about this work would be to claim one hadn't expected the ending. It appears to us as the witty signature under a painting because the author's mystifying smile had all along drawn our attention to the true nature of the text. One also can't say that this attitude of the writer has a monotonous effect. One should notice how the smile turns malicious when "Alice Toklas" harshly judges herself, how it turns soothing, however, when she puts the most diabolical opinions on Gertrude Stein's work into Gertrude Stein's own mouth. It is precisely in this game of mirror reflections—Gertrude Stein speaking through the mouth of the garrulous Alice Toklas—that one finds the delicious secret of this prose.

—Cesare Pavese,
foreword to the Italian edition of
Autobiografia di Alice Toklas

Gertrude Stein and Her Fords

by Donald Hall

illustrations by Max Altekruse

Well anyway it was a beautiful autumn in Bilignin and in six weeks I wrote The Autobiography of Alice B. Toklas and it was published and it became a best seller and first it was printed in the Atlantic Monthly and there is a nice story about that but first I bought myself a new eight cylinder Ford car and the most expensive coat made to order by Hermes and fitted by the man who makes horse covers for the race horses for Basket the white poodle and two collars studded for Basket. I had never made any money before in my life and I was most excited.

—Everybody's Autobiography

▨ A lifelong passion for Fords.
Above: Ad campaign with Gertrude Stein. A Ford brochure.
Left: The new Matford. Undated.

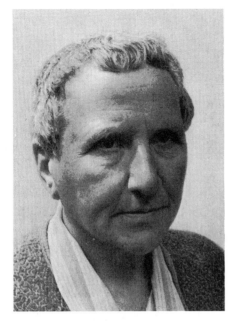

I am I because my little dog knows me, but perhaps he does not and if he did I would not be I. Oh no oh no. . . .

 I am I yes sir I am I.
 I am I yes madame am I I.
 When I am I am I I.

—"The Question of Identity. A Play."

Not enough can be enough and being enough quite enough is enough and being enough enough is enough and being enough it is that. Quite all that can be what it is and all of it being that, quite all of it is all there is of it.

—"A Long Gay Book"

Love and success: Photos by Carl Van Vechten, 1934.
Right page: "I am I because my little dog knows me." Undated.

My sweet dear does hear her dear here saying little and big coming and true discern and firmly coming out softly shoving out singly coming out all of the cow that has been registered as a round now. . . .

 Navigation sub-marine of the cow come out of queen my queen. That is what the cow does it sinks and a little it sinks so sweetly, my own cow out of my own queen is now seen.

—"A Lyrical Opera Made by Two to Be Sung"

Thank you very much, how often I have thanked you, how often I have cause to thank you. How often I do thank you.

 Thank you very much.

 And what would you have me do.

 I would have you sing songs to your little Jew.

Not in the form of games not in the way of repetitions. Repetitions are in your first manner and now we are in the South and the South is not in the North. In the North we resist even when we are kissed and in the South we are kissed on the mouth. No sonatina can make me frown.

 I love my love with a g because she is so faithful. I love her with a p because she is my pearl.

 Can you subsist on butter, oil and edibles and rosebuds and weddings. Can you have weddings in many countries. How do each how does each mountain have a hill a steep hill, and I, I am always good.

 Coo-coo, Mona. Plan away.

 Have you seen a mixed dream. I dreamed of dances and guesses and cooing. How did you guess that.

—"A Sonatina Followed by Another"

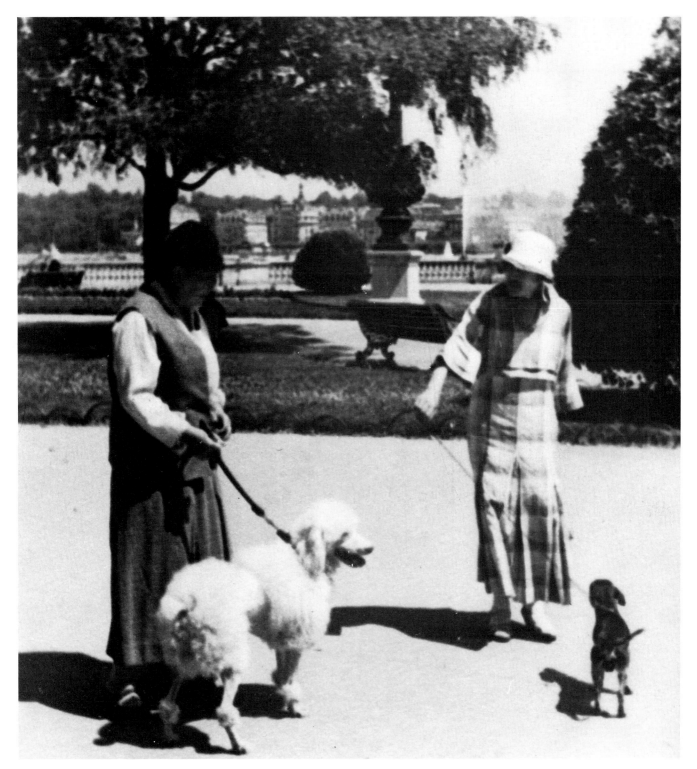

143

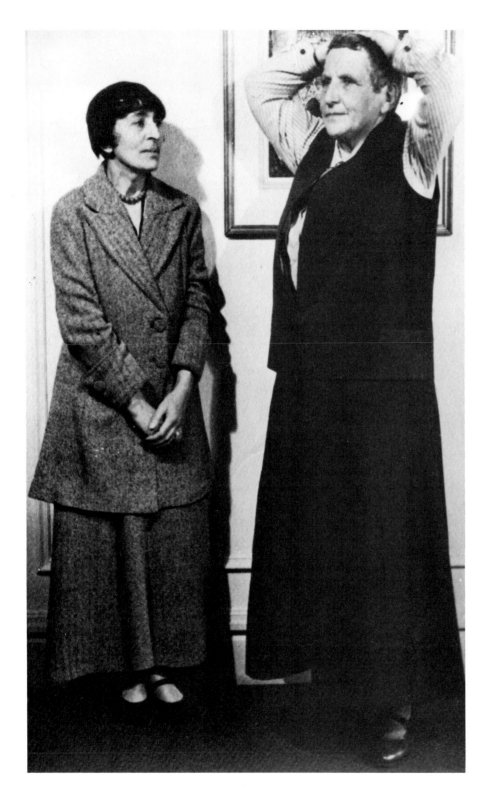

I have always quarreled with a great many young men and one of the principal things that I have quarreled with them about was that once they had made a success they became sterile, they could not go on. And I blamed them. I said it was their fault. I said success is all right but if there is anything in you it ought not to cut off the flow not if there is anything in you. Now I know better. . . .

What happened to me was this. When the success began and it was a success I got lost completely lost. You know the nursery rhyme, I am I because my little dog knows me. Well you see I did not know myself, I lost my personality. It has always been completely included in myself my personality as any personality naturally is, and here all of a sudden, I was not just I because so many people did know me.

—"And Now"

The thing is like this, it is all the question of identity. It is all a question of the outside being outside and the inside being inside. As long as the outside does not put a value on you it remains outside but when it does put a value on you then it gets inside or rather if the outside puts a value on you then all your inside gets to be outside. I used to tell all the men who were being successful young how bad this was for them and then I who was no longer young was having it happen.

But there was the spending of money and there is no doubt about it there is no pleasure like it, the sudden splendid spending of money and we spent it.

—*Everybody's Autobiography*

▨ After the first success, the time when writing was "not happening."
Photos by Carl Van Vechten, 1934.

144

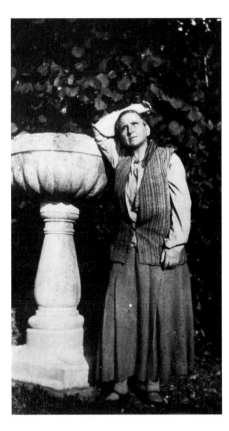

All this time I did no writing. I had written and was writing nothing. Nothing inside me needed to be written. Nothing needed any word and there was no word inside me that could not be spoken and so there was no word inside me. And I was not writing. I began to worry about identity. I had always been I because I had words that had to be written inside me and now any word I had inside could be spoken it did not need to be written.

—*Everybody's Autobiography*

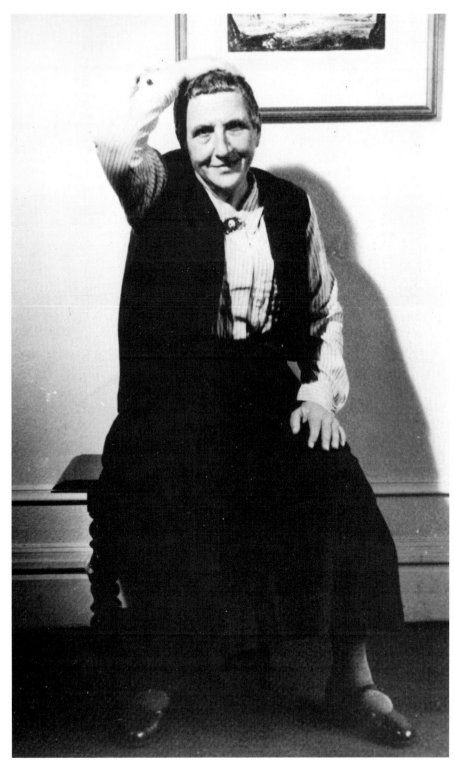

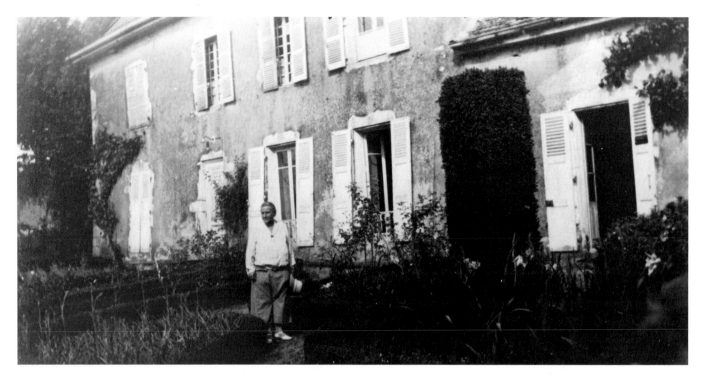

Since the Autobiography I had not done any writing, I began writing something, I called it Blood on the Dining-room Floor but somehow if my writing was worth money then it was not what it had been, if it had always been worth money then it would have been used to being that thing but if anything changes then there is no identity and if it completely changes then there is no sense in its being what it has been. Anyway that was the way it was.

—*Everybody's Autobiography*

So this winter it was a very different winter, Picasso used to be fond of saying that when everybody knew about you and admired your work there were just about the same two or three who were really interested as when nobody knew about you, but does it make any difference. In writing the Making of Americans I said I write for myself and strangers and then later now I know these strangers, are they still strangers, well anyway that too does not really bother me, the only thing that really bothers me is that the earth now is all covered over with people and that hearing anybody is not of any particular importance because anybody can know anybody.

That is really why the only novels possible these days are detective stories, where the only person of any importance is dead.

—*Everybody's Autobiography*

⊠ Identity angst in Bilignin. 1934?

146

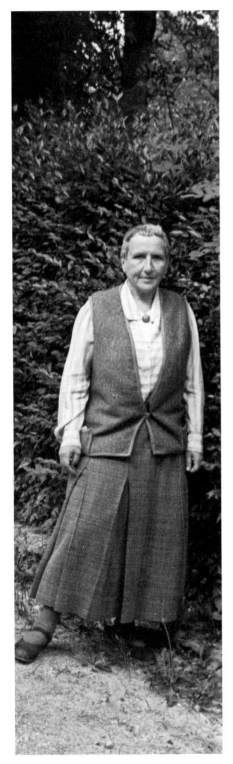

You will say to me it has not happened and I will answer yes of course it has not happened and you will dream and I will dream and cream.

It has not happened. She slept and it has not happened. He will have been unhappy and it has not happened. They will be dogs dogs and it has not happened.

Shut forty more up and it has not happened.

Prepare sunsets and it has not happened.

Finally decry all arrangement and still, it has not happened.

This where I alone finish finally fairly well, I exchange it has not happened for it has not happened and it gives me peace of mind.

Like that.

—*Blood on the Dining-Room Floor*

Posing in anticipation of the lecture tour through the United States. Photos by Carl Van Vechten, June 1934.

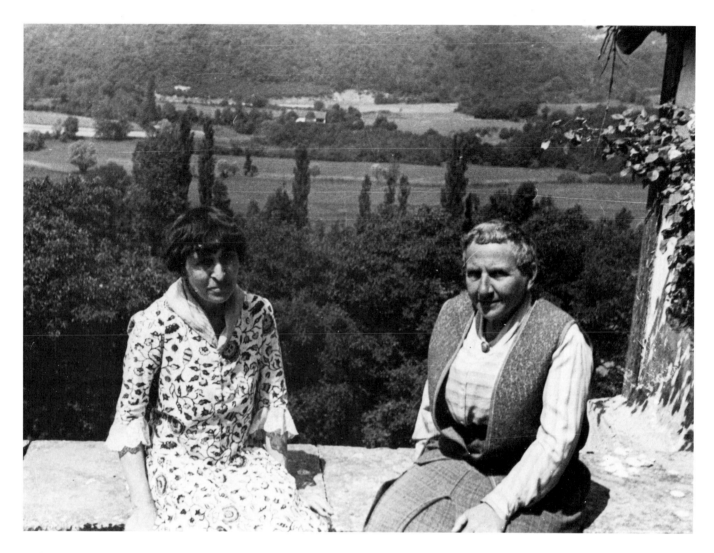

⊠ On the garden wall in Bilignin. Photo
by Carl Van Vechten, 1934.

Lecturing in the United States 1934–1935

Everybody invited me to meet somebody, and I went. I always will go anywhere once and I rather liked doing what I had never done before, going everywhere. It was pleasant being a lion, and meeting the people who make it pleasant to you to be a lion.

—*Everybody's Autobiography*

1934 On October 17, Gertrude Stein and Alice B. Toklas depart from Le Havre, on board the SS *Champlain*. They arrive in New York on October 24, welcomed by Carl Van Vechten, W. G. Rogers and a swarm of reporters. They stay at the Hotel Algonquin. Carl Van Vechten throws a number of parties for Gertrude, one of them exclusively with black artists and intellectuals. Pathé produces a newsreel on Gertrude Stein (she quotes, "Pigeons on the grass alas"). First radio broadcast at the NBC studio. On November 1, Stein gives her first lecture at the Colony Club to members of the Museum of Modern Art. A headline of the *New York Times* reads, "Miss Stein Speaks to Bewildered 500." Alice B. Toklas takes over the tour management. Stein begins lecturing throughout the east, first at Columbia University, Princeton, Philadelphia, and Bryn Mawr College.

Also in November, first trip by air, to Chicago, where Gertrude Stein attends a performance of *Four Saints in Three Acts* (conducted by Virgil Thomson). Her lecture at the University of Chicago is so successful that she is invited back. After lectures at Harvard, Radcliffe, and again in New York, she returns to Chicago (Drake Hotel), Gertrude Stein's favorite city in the States. There follows an invitation to stay with Bobsy Goodspeed, the head of the Chicago Arts Association. At her house, Stein meets Thornton Wilder, who becomes a friend. Accompanied by Carl Van Vechten, Stein lectures in Wisconsin, Minnesota, Michigan, Indiana, Ohio, and throughout the Midwest.

Christmas with the family of Stein's cousin Julian, her uncle Ephraim Kayser, and aunt Fanny Bachrach, near Baltimore. Gertrude Stein pays a Christmas visit to Zelda and Scott Fitzgerald in Baltimore. On December 30, she attends a reception given by Eleanor Roosevelt at the White House.

1935 Visit with W. G. Rogers in Springfield, Massachusetts; further lectures along the East Coast. Stein gives a special lecture, "How Writing Is Written," at Choate School in Wallingford, later published in *How Writing Is Written*. Further lectures follow in the South, in Richmond, Charlottesville, Charleston, Atlanta, New Orleans, St. Louis, and other cities. In New Orleans, Stein renews her friendship with Sherwood Anderson. She returns to Chicago, staying at Thornton Wilder's apartment on Drexel Avenue. Gertrude Stein's lecture at the University of Chicago, written during her tour, is published in the same year as *Narration*. In Chicago, she learns about hostile French reactions to *The Autobiography of Alice B. Toklas*. *Lectures in America* is published in New York.

Flight to Los Angeles, via Austin and Houston. In Los Angeles, Stein meets Upton Sinclair. Lecture in Pasadena and meeting with William Saroyan. At a party in Beverly Hills arranged by Carl Van Vechten, Gertrude Stein meets Dashiell Hammett, Lillian Hellman, Charlie Chaplin, Paulette Goddard, and Anita Loos. She declines a movie offer by Warner Brothers because she is not interested in movies. With a brand new Ford rental car, she and Alice drive through the Yosemite Valley, Carmel, Del Monte, and Monterey (Stein meets with Lincoln Steffens but refuses to meet with her one-time friend Mabel Dodge) to San Francisco. Lectures in San Francisco (sponsored by Gertrude Atherton), in Berkeley where a huge peace rally takes place on the day of her first appearance, April 12, and in Oakland (Mills College) where, on April 13, she revisits the places of her childhood ("There is no there there.") After spending a few final days in New York, on May 4 she and Alice return to Europe on the SS *Champlain*.

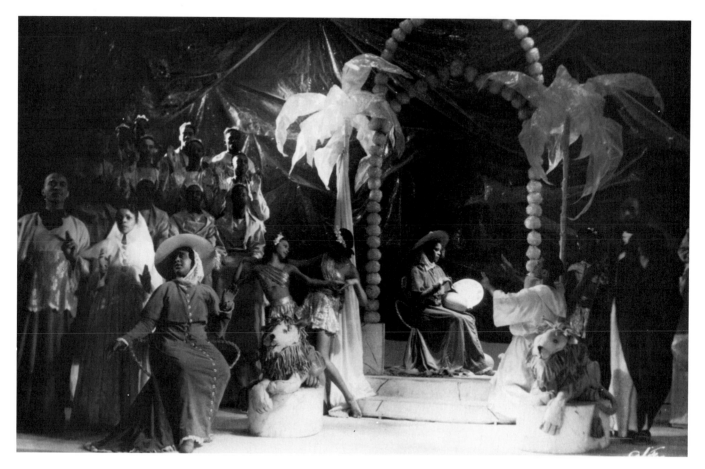

Now although I never do think anything is going to happen things were happening. Roosevelt was being elected, the opera was going to be given, the Autobiography was selling, everybody wanted to meet me, and I began lecturing. All this happened that winter the winter before the summer that I went to America.

—*Everybody's Autobiography*

But now it was getting a little exciting. Carl Van Vechten sent me photos with my name in electric lights on Broadway and that was very exciting.

—*Everybody's Autobiography*

The cast of the opera is hired and rehearsal is begun. I have a chorus of 32 & six soloists, very, very fine ones indeed. Miss Stettheimer's sets are of a beauty incredible, with trees made out of feathers and a sea-wall at Barcelona made out of shells and for the procession a baldachino of black chiffon & bunches of black ostrich plumes just like a Spanish funeral. St. Teresa comes to the picnic in the 2nd Act in a cart drawn by a real white donkey & brings her tent with her and sets it up & sits in the door-way of it. It is made of white gauze with gold fringe and has a most elegant shape. My singers, as I have wanted, are Negroes, & you can't imagine how

beautifully they sing. Frederick Ashton is arriving from London this week to make choreography for us. . . . Everything about the opera is shaping up so beautifully, even the raising of money (it's going to cost $10,000), that the press is chomping at the bit and the New York ladies already ordering dresses & engaging hotel rooms. . . . Rumors of your arrival are floating about . . . and your presence would be all we need to make the opera perfect in every way.

—Virgil Thomson to Gertrude Stein, December 6, 1933

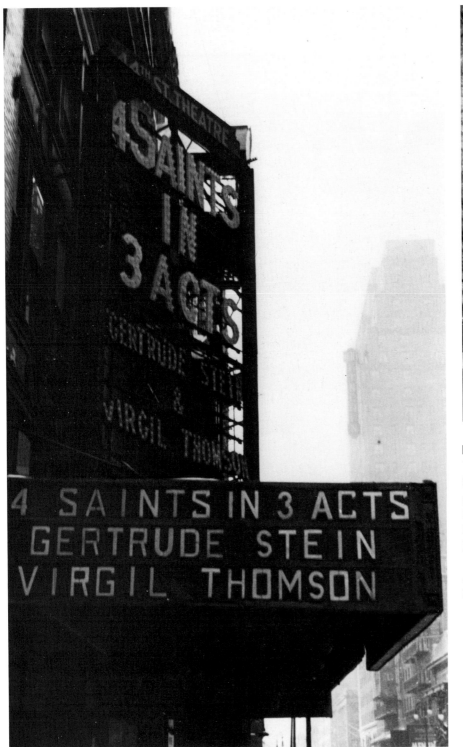

⊞ Left page: A scene from *Four Saints in Three Acts*. Stage sets by Florine Stettheimer. Photo from the world premiere in Hartford, Connecticut, February 8, 1934, by White Studios. Left: The opera on Broadway, at the Forty-fourth Street Theater, March 1934. Photo by Carl Van Vechten. Above: *Portrait of Virgil Thomson*, painting by Florine Stettheimer.

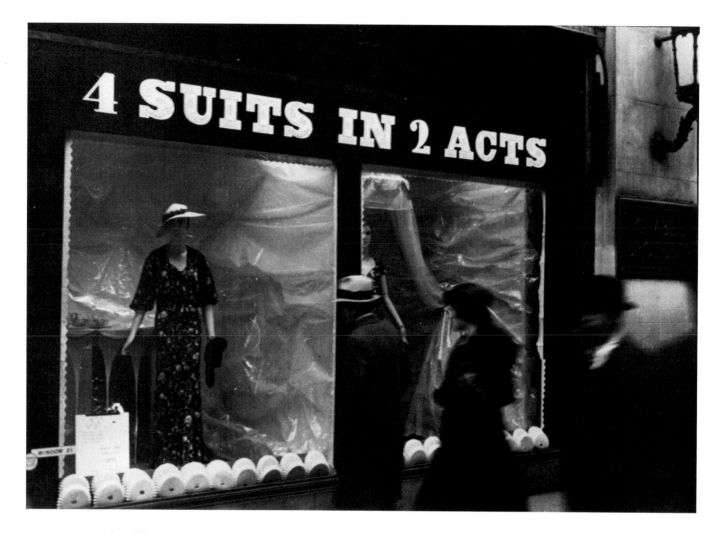

PART IV.
ACT I.
Come to sing and sit.
ACT II.
Repeat it.
ACT III.
I repeat it.
PART V.
ACT I.
Can you speak quickly.
ACT II.
Can you cough.
ACT III.
Remember me to him.

ACT IV.
Remember that I want a cloak.
PART VI.
ACT I.
I know what I want to say. How do you do I forgive you everything and there is nothing to forgive.
PART VII.
ACT I.
The dog. You mean pale.
ACT II.
No we want dark brown.
ACT III.
I am tired of blue.

PART VIII.
ACT I.
Shall I wear my blue.
ACT II.
Do.
PART IX.
ACT I.
Thank you for the cow.
Thank you for the cow. . . .

—"Counting Her Dresses"

New York shop window, 1934. Photo by Carl Van Vechten.

And so we were on the Champlain. Being a celebrity we paid less than the full price of a small room and we had a very luxurious one. That was a very pleasant thing. People always had been nice to me because I am pleasing but now this was going to be a different thing. We were on the Champlain and we were coming.

I used to say that was long ago in between I never had thought of going, I used to say that I would not go to America until I was a real lion a real celebrity at that time of course I did not really think I was going to be one. But now we were coming and I was going to be one.

In America everybody is but some are more than others. I was more than others.

—*Everybody's Autobiography*

I will be well welcome when I come.
Because I am coming.
Certainly I come having come.

—*Stanzas in Meditation and Other Poems*

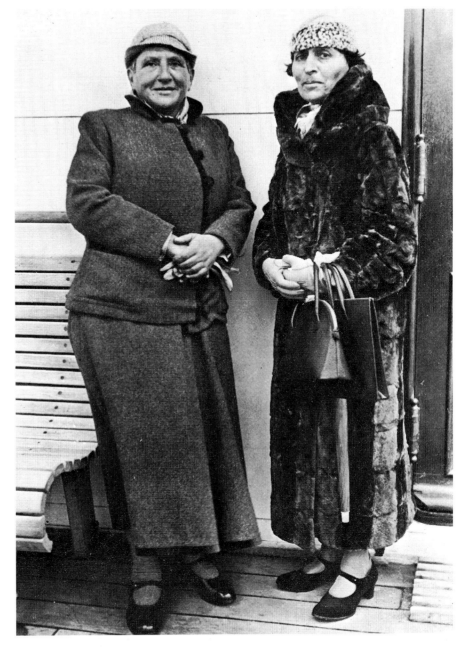

Arrival in New York, on the SS *Champlain*, October 24, 1934. Press photo.

The main encounter, match or bout, took place in a lounge, with ten or fifteen men and a couple of women, notebooks open and pencils aimed.

"Why don't you write the way you talk?" they demanded, and she retorted: "Why don't you read the way I write?" There wasn't a sign of stage fright, a second of hesitation, a slightest hint of confusion. She had met the enemy and he was hers.

She had returned to this country to "tell very plainly and simply and directly, as is my fashion, what literature is." That incited them to questions as to how plain, simple and direct were *As a Wife Has a Cow a Love Story* and certain passages from *The Making of Americans* and *Four Saints*.

"You see and you hear and you have got to know the difference," she lectured them. "It's very difficult to know how much you hear when you see and see when you hear. The business of writing is to find the balance in your own inside. . . .

. . . Think of how you talk when you are not writing. You reporters don't talk as you write. As for the repetition in my writing, you repeat a great deal, but in repeating change the words just enough."

She avoided politics with the claim that her business was writing, and slyly left her questioners uncertain whether she had confused Franklin D. Roosevelt with Theodore Roosevelt, . . . She identified Miss Toklas as her secretary and the one who "makes life comfortable for me," reaffirmed her affection for Ernest Hemingway, said that Shakespeare, Trollope and Flaubert had influenced her and that she herself could not understand why she had waited thirty-one years to revisit her native land.

"No one enjoyed that interview more than Miss Stein, unless it might have been Miss Toklas," in the opinion of one reporter, but others reacted differently to the "constant companion," "secretary and companion," "somewhat submerged heroine of *The Autobiography*," Miss Stein's "Girl Friday" and "enigmatic bodyguard and typist." . . .

Miss Toklas' "Cossack-type" cap and black fur coat "gave her a less unusual appearance than her companion's," it was conceded. "Tiny, thin-faced, mouselike . . . sitting quietly in a corner . . . watching, listening, grinning occasionally," she "hovered in the background." She was "rather nervous," said another paper, and then clinched the point by calling her "thin, dark, nervous-appearing." She was "worried but gracious," "dark and small," she "gazed raptly at Miss Stein." She "shrank" in the background. She was Miss Stein's "queer, birdlike shadow" and when she could be persuaded to speak at all, she "twittered."

She may have cawed and on that memorable day she would have had a right to crow, but she never in her life "twittered." . . .

"Gerty Gerty Stein Stein
Is Back Home Home Back"

"Gertrude Stein Barges In
With A Stein Song to Stein"

"Gertrude Stein, Stein
Is Back, Back, and It's
Still All Black, Black"

Set in thirty-six or forty-eight point bold type, they were not very funny, though they were imitated in many of the cities Miss Stein visited. . . . As one newsman admitted:

"Miss Toklas was afraid, she said, that the reporters would frighten Miss Stein, but after a few minutes Miss Stein had the reporters frightened.". . .

The descriptions of what Miss Stein wore, by the male band of reporters, where sometimes more extreme than the clothes themselves. While the men were troubled by this phase of their duty, not a one of them shirked. Her hat was called variously a braumeister's cap, a jockey's cap, a deerstalker's cap and a grouse-hunter's cap. It was a small gray tweed, it was mannish, its brim turned down "visor-like so that it gave a squirrel-like appearance to her face." One observer explained:

"A strange article, apparently a compromise between feminine toque and male cap; black and white tweed, with visor in front and coy upcurl at rear."

Another . . . : "A Stein hat, a hat as persistent as the repetitions which are a feature of her abstruse writings. . . . Peaked in front . . . it roamed backward tightly . . . to fold at the rear; a gay hat which gave her the appearance of having just sprung from Robin Hood's forest." . . .

. . . the hat which attracted so much attention was old. It was especially modeled for Miss Stein after a Louis XIII, that is, thirteenth-century, hat which Miss Toklas saw and liked in the Cluny Museum. In answer to a question, Miss Stein said:

"It's just a hat."

—W. G. Rogers,
When This You See Remember Me

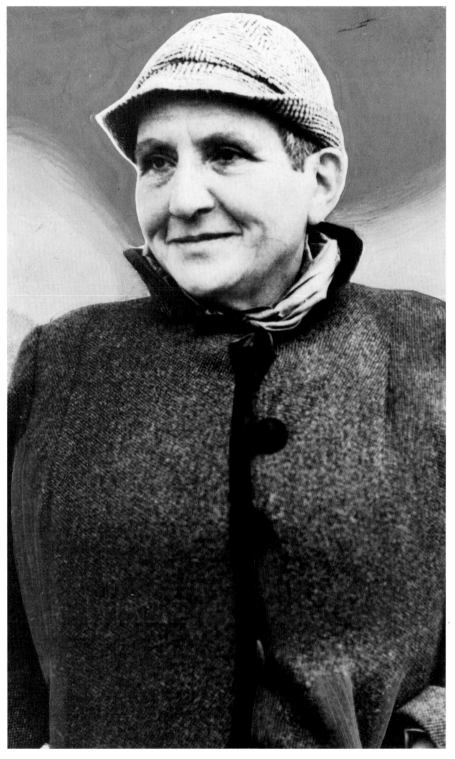

A HAT.

It is as pleasant as that to have a hat, to have a hat and it is as pleasant as that. It is as pleasant as that to have a hat. It is as pleasant as that. To have a hat. To have a hat it is as pleasant as that to have a hat. To have had a hat it is as pleasant as that to have a hat.

—*A Book Concluding with As a Wife Has a Cow a Love Story*

"It begins like this: 'gertrude says four hats is a hat is a hat.' What the hell can you make out of a declaration like that, chief?"

▥ Left: "Benevolent Viking" (The Nation). Press photo.
Above: "It begins like this: 'gertrude says four hats is a hat is a hat.' What the hell can you make out of a declaration like that, chief?" Cartoon by Alan Dunn in *The New Yorker*, 1934.

157

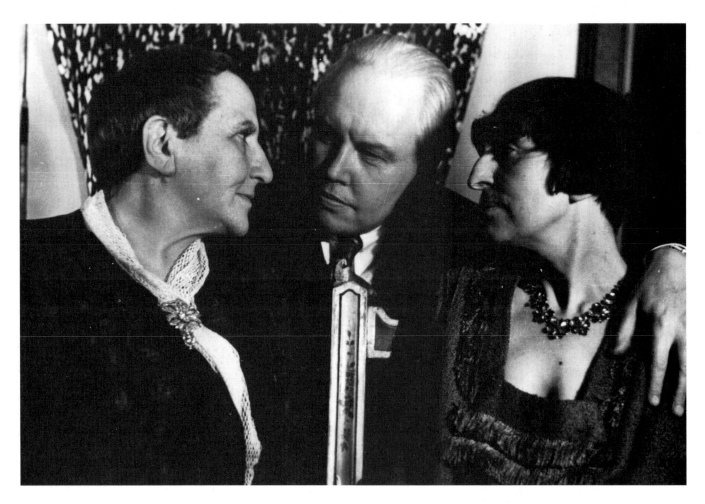

⊞ Untied friendship. At Carl Van Vechten's studio, in New York. Photo by Carl Van Vechten.

So now here we were and . . . the food was moist. The oysters are moist well of course tomato juice and all that is but even American bread certainly hot breads are more moist than French bread.

We liked that moist food. I suppose since American climate and certainly American heated houses are dry food has to be moist. On the contrary in France where there is always lots of humidity food has to be dry. That is natural enough. But anything is if it is.

So then we began and we liked it. It was foreign but also it was a memory and it was exciting. I then began to eat honeydew melon, most of the time I was in America I ate honeydew melon every morning and every evening and I ate oysters and I ate hot bread that is corn muffins, they were moist and I ate green apple pie and butterscotch pie, pumpkin pie not so good but twice superlative lemon pies. . . .

—*Everybody's Autobiography*

Twenty years after, as much as twenty years after in as much as twenty years after, after twenty years and so on. It is it is it is it is.

If it and as if it, if it or as if it, if it is as if it, and it is as if it and as if it. Or as if it. More as if it. As more. As more as if it. And if it. And for and as if it.

If it was to be a prize a surprise if it was to be a surprise to realise, if it was to be if it were to be, was it to be. What was it to be. It was to be what it was. And it was. So it was. As it was. As it is. Is it as it as. It is and as it is and as it is. And so and so as it was.

Keep it in sight all right.

Not to the future but to the fuchsia.

Tied and untied and that is all there is about it. And as tied and as beside, and as beside and tied. Tied and untied and beside and as beside and as untied and as tied and as untied and as beside.

—"Van or Twenty Years After. A Second Portrait of Carl Van Vechten."

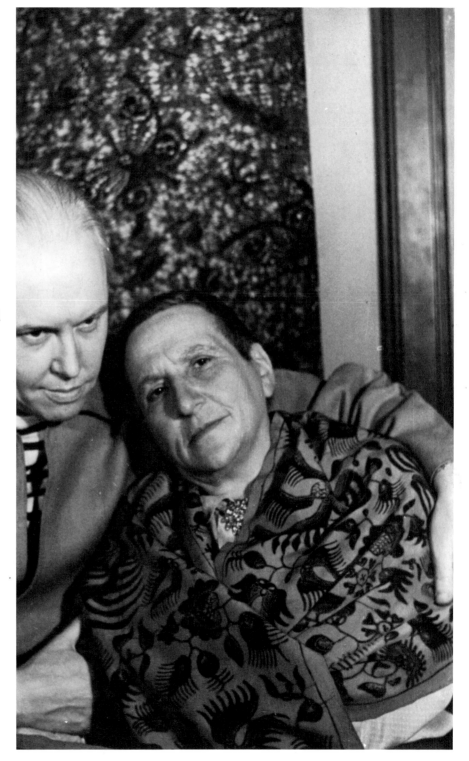

159

So then we went on and people said how do you do nicely and we said how do you do to them and we thought how pleasantly New York was like Bilignin where in the country everybody says how do you in passing the way they do in any country place in the country and then we saw a fruit store and we went in. How do you do Miss Stein, said the man, how do you do, I said, and how do you like it, he said, very much, I said, he said it must be pleasant coming back after thirty years, and I said it certainly was. He was so natural about knowing my name that it was not surprising and yet we had not expected anything like that to happen. If anything is natural enough it is not surprising and then we went out again on an avenue and the elevated railroad looked just like it had ever so long ago and then we saw an electric sign moving around a building and it said Gertrude Stein has come and that was upsetting. Anybody saying how do you do to you and knowing your name may be upsetting but on the whole it is natural enough but to suddenly see your name is always upsetting. Of course it has happened to me pretty often and I like it to happen just as often but always it does give me a little shock of recognition and nonrecognition. It is one of the things most worrying in the subject of identity.

—*Everybody's Autobiography*

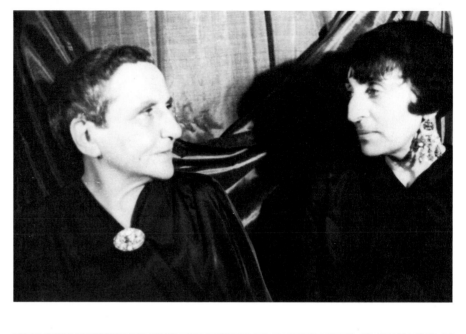

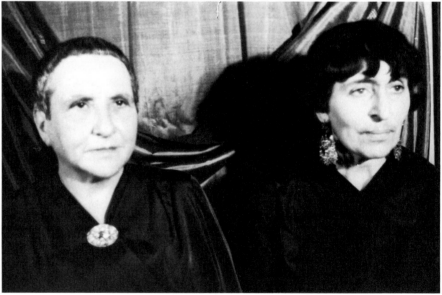

◈ "So then there we were and we were liking it ..." Portraits by Carl Van Vechten.

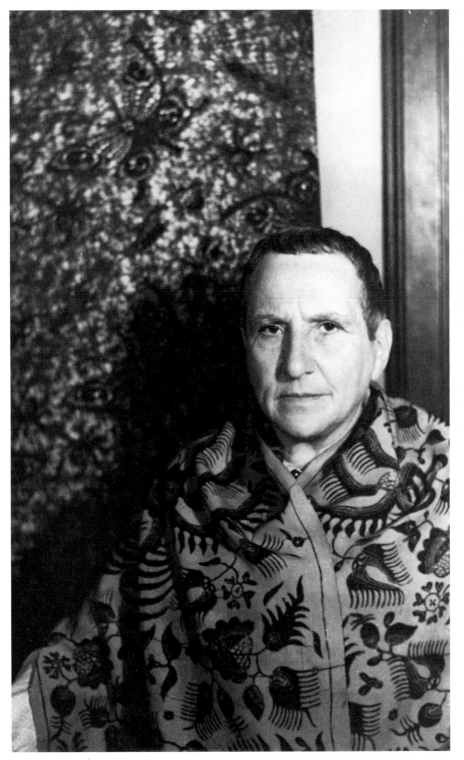

They ask me to tell why an author like myself can become popular. It is very easy everybody keeps saying and writing what anybody feels that they are understanding and so they get tired of that, anybody can get tired of anything everybody can get tired of something and so they do not know it but they get tired of feeling they are understanding and so they take pleasure in having something that they feel they are not understanding.

. . .That was almost as exciting as a spelling match.

That is all understanding is you know it is all in the feeling.

My writing is clear as mud, but mud settles and clear streams run on and disappear . . .

—*Everybody's Autobiography*

One cannot come back too often to the question what is knowledge and to the answer knowledge is what one knows.

—*Lectures in America*

<div style="text-align:center">ACT II.</div>

We saw a dress.

<div style="text-align:center">ACT III.</div>

We saw a man.

<div style="text-align:center">ACT IV.</div>

Sarcasm.

<div style="text-align:center">PART XXXV.</div>
<div style="text-align:center">ACT I.</div>

We can be proud of tomorrow.

<div style="text-align:center">ACT II.</div>

And the vests.

—"Counting Her Dresses"

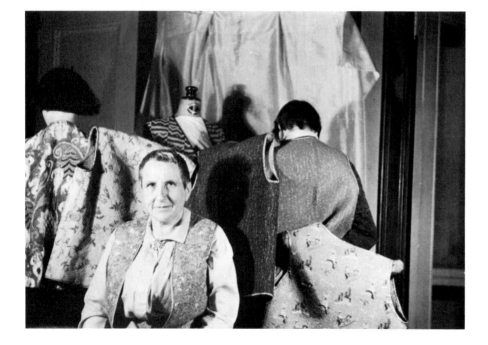

Gertrude Stein's collection of vests. Van Vechten's wife, actress Fania Marinoff (left) and Alice B. Toklas (right) pose as mannequins. Photos by Carl Van Vechten.

It is difficult to believe but it is true, I had never heard a broadcasting; that is I had never listened to one and I certainly had never thought of doing one, and this is the way the thing that I like best of all the things I have never done before, was done. They said would I and I of course said I would. I never say no, not in America.

The first thing they did was to photograph me doing it, not doing it but making believe doing it, this was easily done. There was nothing natural or unnatural about that.

And then we went into training. I liked that; I wrote out answers to questions and questions to answers and I liked that, and then one day the day had come, and it was to be done. . . .

Then we sat down one on either side of the little thing that was between us and I said something and they said that is all, and then suddenly it was all going on. It was it was really all going on, and it was, it really was, as if you were saying what you were saying and you knew, you really knew, not by what you knew but by what you felt, that everybody was listening. It is a very wonderful thing to do, I almost stopped and said it, I was so filled with it. And then it was over and I never had liked anything as I had liked it.

—"I Came and Here I Am"

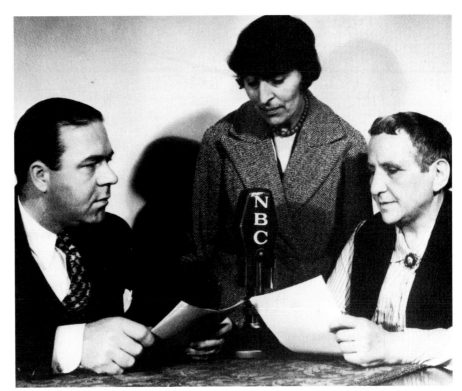

In the NBC studio in New York: Her first broadcast.

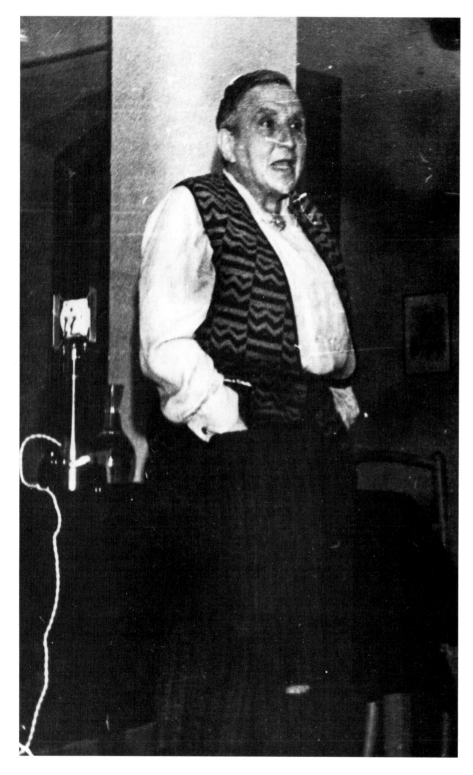

Now listen! Can't you see that when the language was new—as it was with Chaucer and Homer—the poet could use the name of a thing and the thing was really there? He could say "O moon," "O sea," "O love" and the moon and the sea and love were really there. And can't you see that after hundreds of years had gone by and thousands of poems had been written, he could call on those words and find that they were just wornout literary words? The excitingness of pure being had withdrawn from them; they were just rather stale literary words. Now the poet has to work in the excitingness of pure being; he has to get back that intensity into the language. We all know that it's hard to write poetry in a late age; and we know that you have to put some strangeness, something unexpected, into the structure of the sentence in order to bring back vitality to the noun. Now it's not enough to be bizarre; the strangeness in the sentence structure has to come from the poetic gift, too. That's why it's doubly hard to be a poet in a late age. Now you all have seen hundreds of poems about roses and you know in your bones that the rose is not there. All those songs that sopranos sing as encores about "I have a garden; oh, what a garden!" Now I don't want to put too much emphasis on that line, because it's just one line in a longer poem. But I notice that you all know it; you make fun of it, but you know it. Now listen! I'm no fool. I know that in daily life we don't go around saying "is a . . . is a . . . is a . . ." Yes, I'm no fool; but I think that in that line the rose is red for the first time in English poetry for a hundred years.

—*Four in America*

▒ "I am not a fool."

164

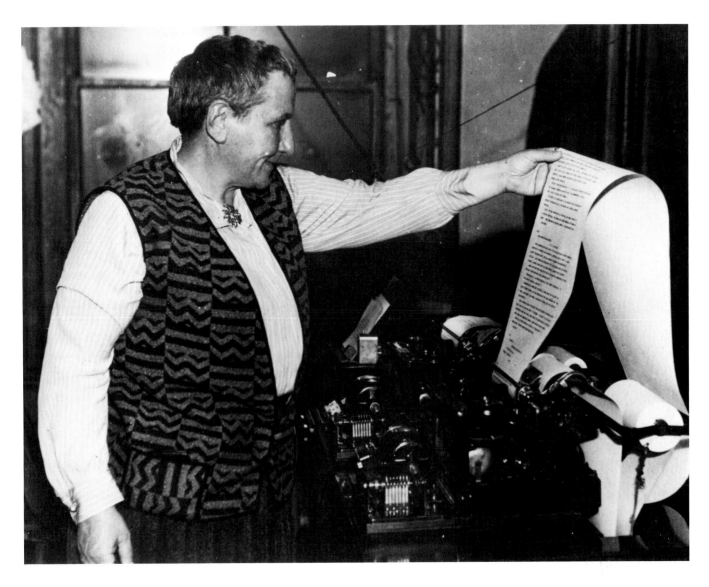

▥ "... even a slow catastrophe is rather
fast." News from a teletype machine.

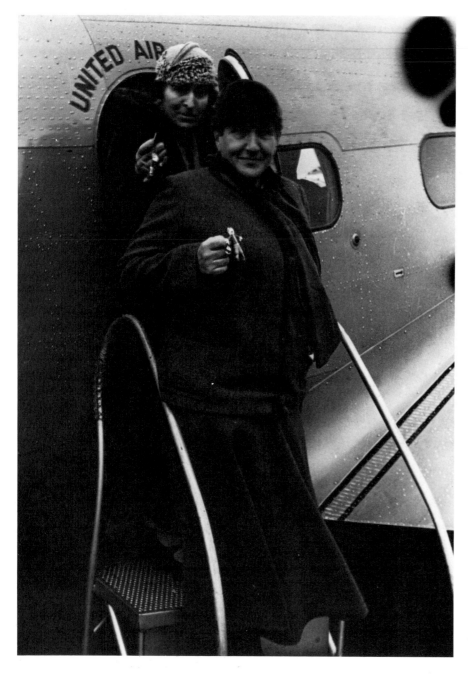

one got in and there we were in. That is one of the nice things about never going to the movies there are so many surprises. . . . Reading does not destroy surprise it is all a surprise that it happens as they say it will happen. But about the airplane we had known nothing and it was an extraordinarily natural and pleasant thing much more simple and natural than anything even than walking, perhaps as natural as talking but certainly more natural than doing any other thing. And so we liked it and whenever we could we did it. . . .

It was then in a kind of way that I really began to know what the ground looked like. Quarter sections make a picture and going over America like that made any one know why the post-cubist painting was what it was. The wandering line of Masson was there the mixed line of Picasso coming and coming again and following itself into a beginning was there, the simple solution of Braque was there and I suppose Leger might be there but I did not see it not over there. Particularly the track of a wagon making a perfect circle and then going back to the corner from where they had come and later in the South as finally we went everywhere by air and always wanted the front seat so I could look down and what is the use, the earth does look like that and even if none of them had seen it and they had not very likely had not but since everyone was going to see it they had to see it like that.

—*Everybody's Autobiography*

Happy landing—thanks to Carl Van Vechten's Indian fetishes—after their first flight. Chicago, November 7, 1934. Photos by Carl Van Vechten.

I know of nothing more pleasing more soothing more beguiling than the slow hum of the mounting. I had never even seen an airplane near before not near enough to know how

One must not forget that the earth seen from an airplane is more splendid than the earth seen from an automobile. The automobile is the end of progress on the earth, it goes quicker but essentially the landscapes seen from an automobile are the same as the landscapes seen from a carriage, a train, a waggon, or in walking. But the earth seen from an airplane is something else. So the twentieth century is not the same as the nineteenth century and it is very interesting knowing that Picasso has never seen the earth from an airplane, that being of the twentieth century he inevitably knew that the earth is not the same as in the nineteenth century, he knew it, he made it, inevitably he made it different and what he made is a thing that now all the world can see. When I was in America I for the first time travelled pretty much all the time in an airplane and when I looked at the earth I saw all the lines of cubism made at a time when not any painter had ever gone up in an airplane. I saw there on the earth the mingling lines of Picasso, coming and going, developing and destroying themselves. I saw the simple solutions of Braque, I saw the wandering lines of Masson, yes I saw and once more I knew that a creator is contemporary, he understands what is contemporary when the contemporaries do not yet know it, but he is contemporary and as the twentieth century is a century which sees the earth as no one has ever seen it, the earth has a splendor that it never has had, and as everything destroys itself in the twentieth century and nothing continues, so then the twentieth century has a splendor which is its own and Picasso is of this century, he has that strange quality of an earth that one has never seen and of things destroyed as they have never been destroyed. So then Picasso has his splendor.

—*Picasso*

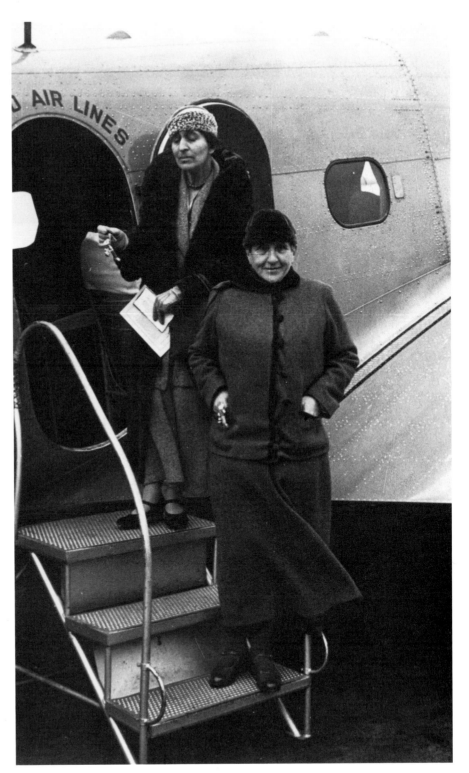

So we went on spending our two weeks in Chicago, the Hutchinses asking us to dinner. Bobsy and Barney Goodspeed were to be there and Thornton Wilder.

We went to dinner it was a good dinner. We were at dinner but Hutchins the president of Chicago University was not there later he came in with Mortimer Adler.

Hutchins was tired and we all sat down again together and then he began talking about what he had been doing. He and Adler were having special classes and in them they were talking over all the ideas that had been important in the world's history. Every week they took a new idea and the man who had written it and the class read it and then they had a conversation about it.

What are the ideas that are important I asked him. Here said he is the list of them I took the list and looked it over. Ah I said I notice that none of the books read at any time by them was originally written in English, was that intentional I asked him. No he said but in English there have really been no ideas expressed. Then I gather that to you there are no ideas which are not sociological or government ideas. Well are they he said, well yes I said. Government is the least interesting thing in human life, creation and the expression of that creation is a damn sight more interesting, yes I know and I began to get excited yes I know, naturally you are teachers and teaching is your occupation and naturally what you call ideas are easy to teach and so you are convinced that they are the only ideas but the real ideas are not the relation of human beings as groups but a human being to himself inside him and that is an idea that is more interesting than humanity in groups, after all the minute that there are a lot of them they do not do it for themselves but somebody does it for them and that is a darn sight less interesting. Then Adler began and I have forgotten what the detail of it was but we were saying violent things to each other and I was telling him that anybody could tell by looking that he was a man who would be singularly unsusceptible to ideas that are created within oneself that he would take to either inside or outside regulation but not to creation, and Hutchins was saying well if you can improve upon what we are doing I challenge you to do it take our class next week and I said of course I will and then Adler said something and I was standing next to him and violently telling him and everybody was excited and the maid came and said Madame the police.

—*Everybody's Autobiography*

A new friend: Thornton Wilder (right). Photo taken shortly after Gertrude Stein's lecture at the University of Chicago, at the house of the dean, Robert Hutchins. From the left: Mortimer Adler, Robert Hutchins, Gertrude Stein, Fanny Butcher, Mr. and Mrs. Goodspeed, Alice B. Toklas, Thornton Wilder.

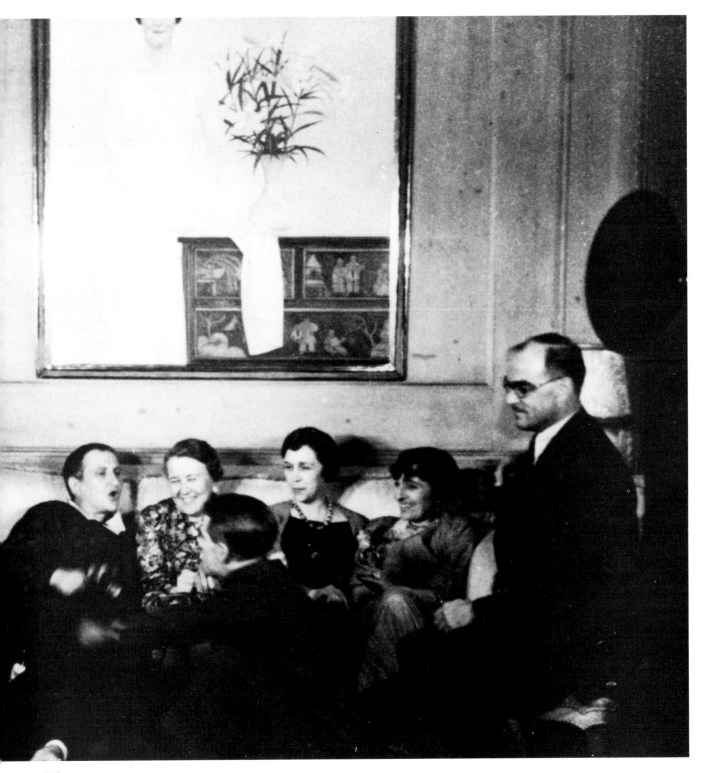

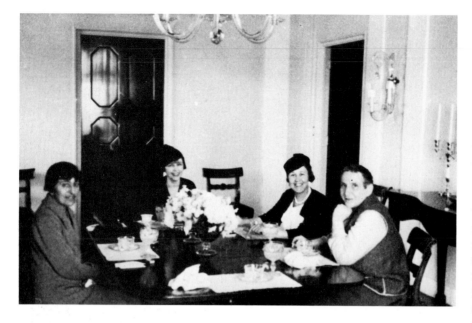

... they liked it and I liked it and Hutchins said to me as he and I were walking, you did make them all talk more than we can make them and a number of them talked who never talked before and it was very nice of him to say it and he added and if you will come back I will be glad to have you do some teaching and I said I would and he said he would let me know and then I said you see why they talk to me is that I am like them I do not know the answer, you say you do not know but you do know if you did not know the answer you could not spend your life in teaching but I I really do not know, I really do not, I do not even know whether there is a question let alone having an answer for a question. To me when a thing is really interesting it is when there is no question and no answer, if there is then already the subject is not interesting and it is so, that is the reason that anything for which there is a solution is not interesting, that is the trouble with governments and Utopias and teaching, the things that can not be learnt but that can be taught are not interesting.

—*Everybody's Autobiography*

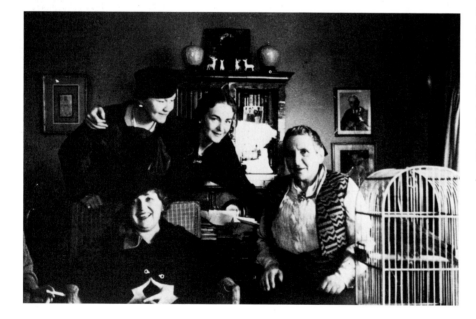

Top: "Any American is American." Guests of Elizabeth ("Bobsy") Goodspeed, president of the Chicago Arts Association, who probably took the photos. From the left: Alice B. Toklas, Alice Rouillier(?), Fanny Butcher from the *Chicago Tribune*, Gertrude Stein.
Bottom: With Claire Dux Swift (sitting).

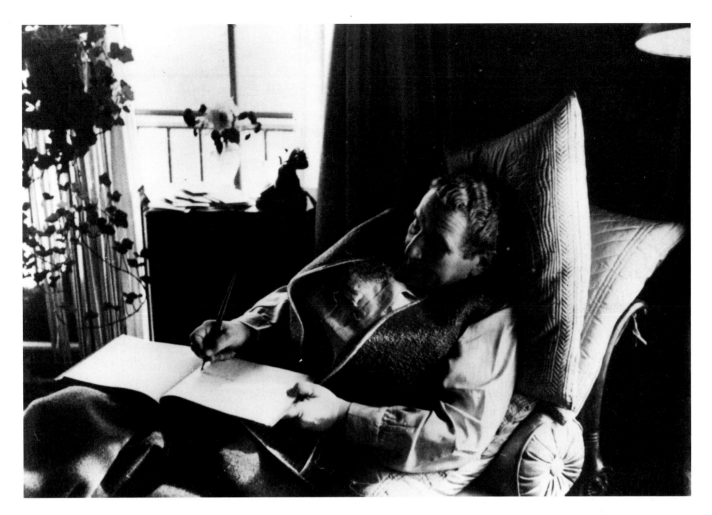

▦ "...I always have something to say and I like to say anything I say." Staying with Bobsy Goodspeed in Chicago.

A thing you all know is that in the three novels written in this generation that are the important things written in this generation, there is, in none of them a story. There is none in Proust in The Making of Americans or in Ulysses.

—"Portraits and Repetition"

. . . in the daytime it was the daytime and at night it was nightime and I never tired of seeing them, the sombre gray light on the buildings and the simple solemn mechanical figures dancing, there were other things I liked but I liked that the most.

Chicago may have thought of it first but New York has made it higher much higher. It was the Rockefeller Center building that pleased me the most and they were building the third piece of it when we left New York so quietly so thinly and so rapidly, and when we came back it was already so much higher that it did not take a minute to end it quickly.

It is not delicate it is not slender it is not thin but it is something that does make existence a non-existent real thing. Alice Toklas said it is not the way they go into the air but the way they come out of the ground that is the thing. European buildings sit on the ground but American ones come out of the ground. And then of course there is the air. And that air is everywhere, everywhere in America, there is no sky, there is air and that makes religion and wandering and architecture.

When I used to try to explain America to Frenchmen of course before I had gone over this time, I used to tell them you see there is no sky over there there is only air, when you look up at the tall buildings at that time I left America the Flatiron was the tallest one and now it is not one at all it is just a house like any house but at that time it was the tallest one and I said you see you look up and you see the cornice way on top clear in the air, but now in the new ones there is no cornice up there and that is right because why end anything, well anyway I always

172

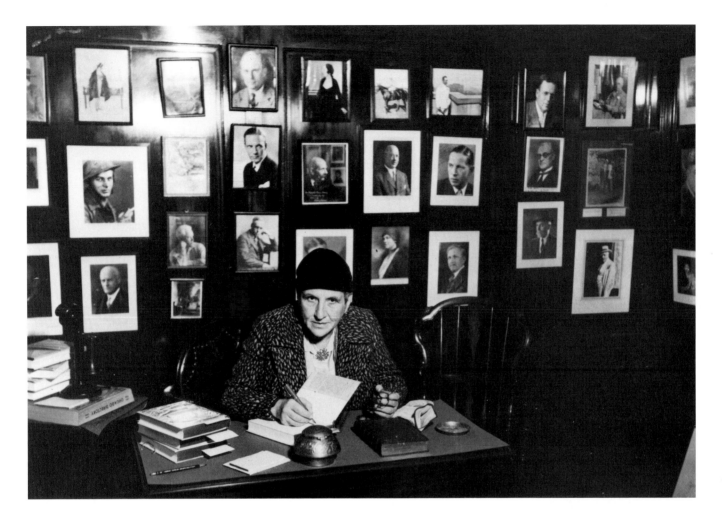

explained everything in America by this thing, the lack of passion that they call repression and gangsters, and savagery, and everybody being nice, and everybody not thinking because they had to drink and keep moving, in Europe when they drink they sit still but not in America no not in America and that is because there is no sky, there is no lid on top of them and so they move around or stand still and do not say anything. That makes that American language that says everything in two words and mostly in words of one syllable two words of one syllable and that makes all the conversation. That is the reason they like long books novels and things of a thousand pages it is to calm themselves from the need of two words and those words of one syllable that say everything.

—*Everybody's Autobiography*

▨ Left page: "I am violently ... devoted to the new." The Wrigley Building in Chicago, in the 1930s.
Above: Book-signing in a Chicago department store.

173

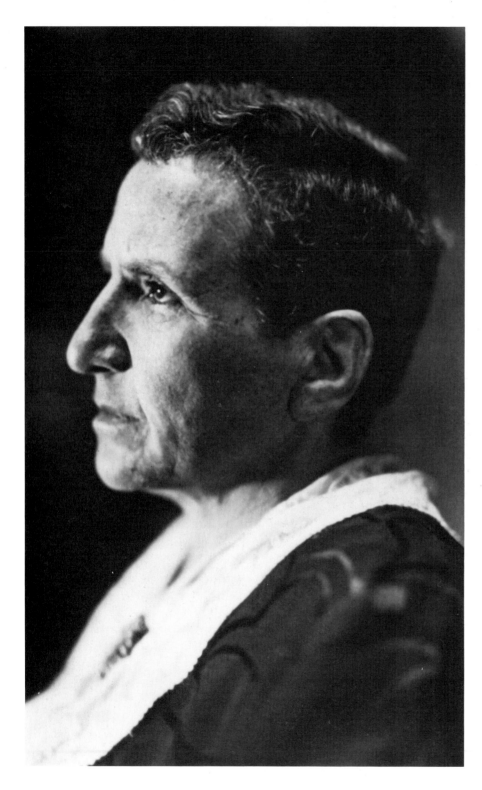

Her dress—it was a dress—not a gown, nor yet a frock—was of black taffeta shot with very dark blue, and cut after a pattern which was neither a cassock nor a man's lounging-robe, but combined the most comfortable features of both. The bit of white neckwear which adorned it suggested the linen bands of the Reformed clergy.

—*Pioneer Press*, December 9, 1934

Poetry is concerned with using with abusing, with losing with wanting, with denying with avoiding with adoring with replacing the noun. It is doing that always doing that, doing that and doing nothing but that. Poetry is doing nothing but using losing refusing and pleasing and betraying and caressing nouns. That is what poetry does, that is what poetry has to do no matter what kind of poetry it is. And there are a great many kinds of poetry.

When I said.

A rose is a rose is a rose is a rose.

And then later made that into a ring I made poetry and what did I do I caressed completely caressed and addressed a noun.

Now let us think of poetry any poetry all poetry and let us see if this is not so. Of course it is so anybody can know that. . . .

. . . Think what you do when you do do that when you love the name of anything really love its name. Inevitably you express yourself in that way, in the way poetry expresses itself that is in short lines in repeating what you began in order to do it again. Think of how you talk to anything whose name is new to you a lover a baby or a dog or a new land or any part of it. Do you not inevitably repeat

what you call out and is that calling
out not of necessity in short lines.
Think about it and you will see what I
mean by what you feel.

—*Lectures in America*

Before I left America I had visited
almost thirty universities and I
began to really only like that, there
were lots more of them where I would
have liked to have gone we only got to
know about some of them after we had
left where they were but it would be
fun to go to every one of them all over
the United States, I sometimes think it
would be fun to talk to students in
every university all over the world, it
would be interesting and they would
like it as well as I would because of
course they would like it, and
certainly I liked the thirty I did visit.

—*Everybody's Autobiography*

▨ On a lecture tour in the southern
states, February 1935.
Left page: Lecturing in a white tie.
Right: At the University of Virginia in
Charlottesville, after her lecture at the
Raven Society, Gertrude Stein received
the key to Edgar Allan Poe's reading
room. From this day forward, she
allegedly kept the key in her pocket.
Photos by Carl Van Vechten.

■ Center of attention. In front of William and Mary College, Williamsburg, Virginia. Photo by Carl Van Vechten(?).

. . . Amherst was awfully nice, the next morning the students went around collecting faculty opinions and the football coach said yes I'd like to have Gertrude for the tackles but I don't know whether she would be good to call the signals and then reflectively but I guess Alice B. would do that, and another one said, I was dead against her and I just went to see what she looked like and then she took the door of my mind right off its hinges and now it's wide open.

—Gertrude Stein to Carl Van Vechten

The roads in America were lovely, they move along alone the big ones the way the railroad tracks used to move with really no connection with the country. Of course in a way that is natural enough as I always like to tell a Frenchman and he listens but he does not believe the railroad did not follow the towns made by the road but it made a road followed by the towns and the country, there were no towns and no roads therefore no country until the railroad came along, and the new big roads in America still make you feel that way, air lines they call some of them and they are they have nothing really to do with the towns and the country.

—*Everybody's Autobiography*

▣ Horsing around in Richmond, Virginia. Photo by Carl Van Vechten.

I was fascinated with the way everybody did what they should. When I first began driving a car myself in Chicago and in California I was surprised at the slowness of the driving, in France you drive much faster, you are supposed not to have accidents but you drive as fast as you like and in America you drive very slowly forty-five miles an hour is slow, and when lights tell you to stop they all stop and they never pass each other going up a hill or around a curve and yet so many get hurt. It was a puzzle to me.

I was first struck with all this that first day.

In France you drive fifty-five or sixty miles an hour all the time, I am a very cautious driver from the standpoint of my French friends but I often do and why not, not very often does anybody get killed and in America everybody obeying the law and everybody driving slowly a great many get killed it was a puzzle to me.

—*Everybody's Autobiography*

⊠ Reunion with F. Scott Fitzgerald (top right) and Sherwood Anderson (right page).
Bottom right: Invited to have tea with Eleanor Roosevelt in December 1934.

I don't care to say whether I'm greater than Shakespeare, and he's dead and can't say whether he's greater than I am. Time will tell.

—Lecture at Wesleyan University, 1935

. . . I liked best Seventh Avenue, I bought a stylograph there for a dollar, it is a good one, I bought an American clock that was not so good but the stylo is an excellent one.

—*Everybody's Autobiography*

It is quite worth while to have a pen. And to look at all those that are for sale. Because each time there are different ones and it is actually always attractive. To possess them.

—"A Little Love of Life"

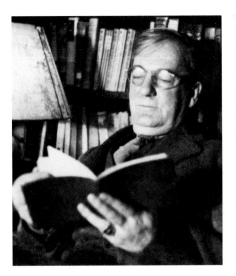

⊞ Signing with a stylograph. Inscription on the photo: "For Christopher who writes with his pen too. Gertrude Stein."

My dear Miss Crager,

Miss Gertrude Stein will very willingly autograph books some afternoon at the Basement Book Shop and Library, but she must decline to meet ##### any one. She finds meeting people very fatiguing and as she wishes to keep herself fresh for her lectures Miss Stein thanks you for your invitation but is anuable [sic] to accept it.

—Alice B. Toklas to Jess M. Crager, February 6, 1935

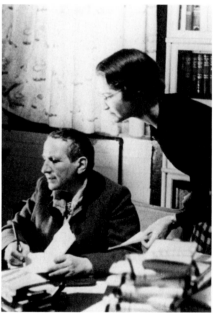

▨ At the Basement Bookshop, New Orleans.
Top left: With her "bodyguard" Alice.
Bottom left: Question by the photographer, "Well, what can you do?" "I can drink a glass of water."

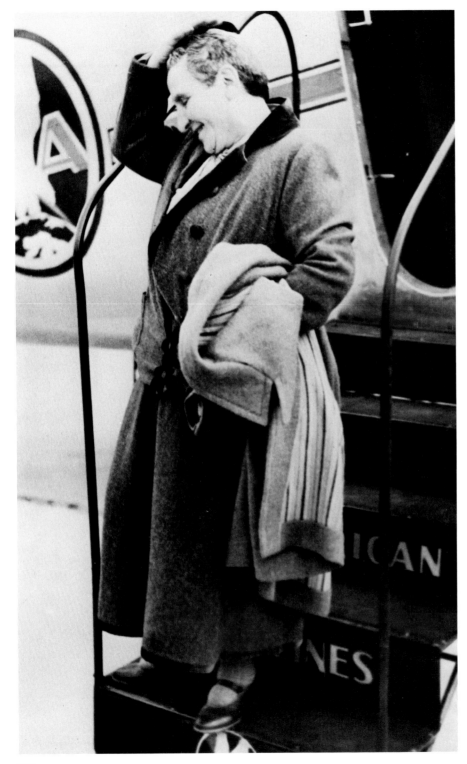

I liked the photographers, there is one who came in and said he was sent to do a layout of me. A layout, I said yes he said what is that I said oh he said it is four or five pictures of you doing anything. All right I said what do you want me to do. Why he said there is your airplane bag suppose you unpack it, oh I said Miss Toklas always does that oh no I could not do that, well he said there is the telephone suppose you telephone well I said yes but I never do Miss Toklas always does that, well he said what can you do, well I said I can put my hat on and take my hat off and I can put my coat on and I can take it off and I like water I can drink a glass of water all right he said do that so I did that and he photographed while I did that and the next morning there was the layout and I had done it.

—*Everybody's Autobiography*

It is very nice being a celebrity a real celebrity who can decide who they want to meet and say so and they come or do not come as you want them. I never imagined that would happen to me to be a celebrity like that but it did and when it did I liked it . . .

—*Everybody's Autobiography*

⊞ Return to California after thirty-one years. Arrival in Los Angeles, March 29, 1935. Press photo.

We were to go to dinner at
Beverly Hills which is the same
as Hollywood this I have said we were
to meet Dashiell Hammett and Charlie
Chaplin and Anita Loos and her
husband and Mamoulian who was
directing everything and we did. Of
course I liked Charlie Chaplin he is a
gentle person like any Spanish gypsy
bull-fighter he is very like my favorite
one Gallo who could not kill a bull but
he could make him move better than
any one ever could and he himself not
having any grace in person could
move one as no one else ever did, and
Charlie Chaplin was like Gallo. . . . We
talked a little about the Four Saints
and what my idea had been, I said that
what was most exciting was when
nothing was happening, I said that
saints should naturally do nothing if
you were a saint that was enough . . . ,
he said yes he could understand that,
. . . he wanted the sentiment of move-
ment invented by himself and I wanted
the sentiment of doing nothing in-
vented by myself, anyway we both
liked talking but each one had to stop
to be polite and let the other one say
something.

—*Everybody's Autobiography*

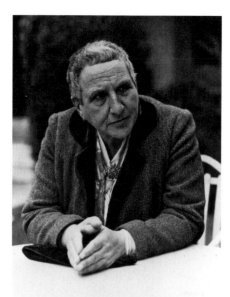

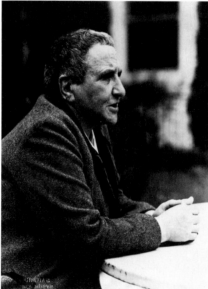

🔲 Lessons for Hollywood Stars. At the
Del Monte Hotel. Del Monte,
California.
Left: The hotel in the 1930s. Postcard.
Top right: Charlie Chaplin in the 1930s.
Bottom right: Script writer Anita Loos
(photo by Cecil Beaton).

Right page, top: American director
Rouben Mamoulian.
Right page, bottom: Dashiell Hammett.

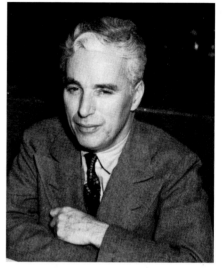

When I was at a dinner party at Beverly Hills in Hollywood, there were a great many of the big vedettes of the cinema. After the dinner all these people were seated in front of me, and I did not know what it was all about or what they wanted, and finally one blurted out, "What we want to know is how do you get so much publicity?" So I told them, "By having such a small audience. Begin with a small audience. If that small audience really believes, they make a big noise, and a big audience does not make a noise at all."

—"A Transatlantic Interview"

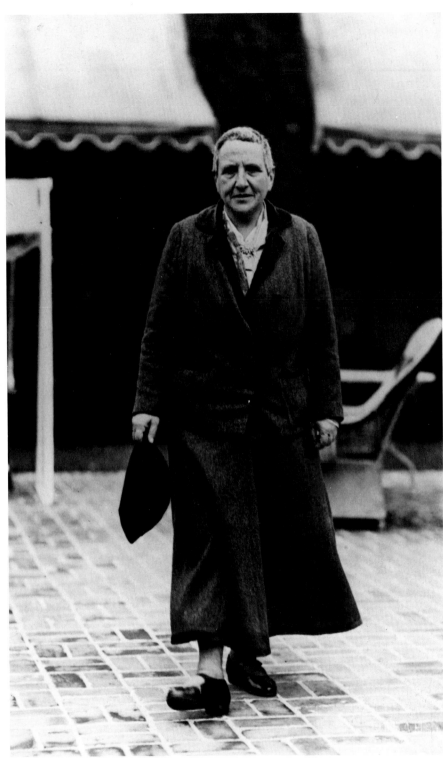

Alice Toklas wanted to come back to live there. She wants to come back to live not everywhere but in Avila and in New York and New Orleans and California, I preferred Chicago and Texas but I did not want to come back to live there. I like Paris and I like six months in the country but I like Paris. Everybody says it is not very nice now but I like Paris and I like to live there.

—*Everybody's Autobiography*

You have a feeling of being without roots. Something like that happened to me, too. I think I must have had a feeling that it had happened or I should not have come back. I went to California. I saw it and felt it and had a tenderness and a horror too. Roots are so small and dry when you have them and they are exposed to you. . . . You can go back to where they are and they can be less real to you than they were three thousand, six thousand miles away. . .

—John Hyde Preston,
"A Conversation with Gertrude Stein"

▨ "Alice loves it and so we like it."
Gertrude Stein to Sherwood Anderson,
April 1935.

So then we ate a great deal here and there on the beach and everywhere and then we left for San Francisco and Oakland there I was to be where I had come from, we went over the green rounded hills which are brown in summer with a very occasional live oak tree and otherwise empty and a fence that does not separate them but goes where the hill has come to come down, it was just like them geographically altogether the hills they had been and a great deal of them up and down we went among them and they made me feel funny, yes they were like that that is what they were and they did trouble me they made me very uncomfortable I do not know why but they did, it all made me uncomfortable it just did.

—*Everybody's Autobiography*

⊞ San Francisco. Hotel Mark Hopkins, where Gertrude Stein and Alice B. Toklas stayed in 1935.

. . . anyway what was the use of my having come from Oakland it was not natural to have come from there yes write about it if I like or anything if I like but not there, there is no there there.

—*Everybody's Autobiography*

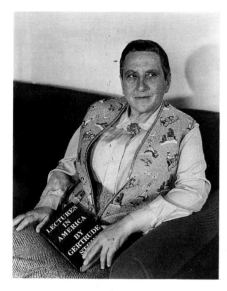

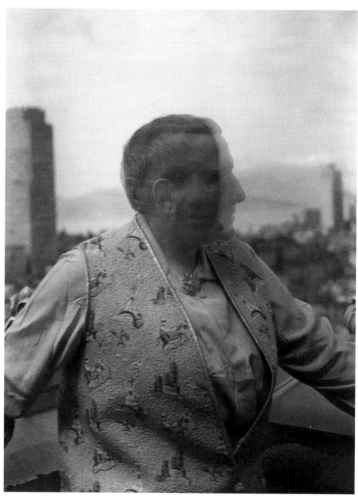

And what does a comma do, a comma does nothing but make easy a thing that if you like it enough is easy enough without the comma. A long complicated sentence would force itself upon you, make you know yourself knowing it and the comma, well at the most a comma is a poor period that it lets you stop and take a breath but if you want to take a breath you ought to know yourself that you want to take a breath. It is not like stopping altogether which is what a period does stopping altogether has something to do with going on, but taking a breath well you are always taking a breath and why emphasize one breath rather than another breath. Anyway that is the way I felt about it and I felt that about it very very strongly. And so I almost never use a comma. The longer, the more complicated the sentence the greater the number of the same kinds of words I had following one after another, the more the very many more I had of them the more I felt the passionate need of their taking care of themselves by themselves and not helping them, and thereby enfeebling them by putting in a comma.

—"Poetry and Grammar"

"[Gertrude Stein] will speak in Oakland on April 13, but only to an elect few—because more than 500 persons is 'an unpoetic mob.'"

—*Oakland Tribune*, February 19, 1935

"You," she said, running her fingers through her close cropped gray hair, "don't understand what I write. You don't understand what I write because you don't read. You don't read, therefore, you don't understand. You complain I don't punctuate. Punctuation is necessary only for the feeble-minded."

—*The Chronicle* (San Francisco), April 10, 1935

▧ In their room and on the balcony of the Hotel Mark Hopkins, photographed by Imogen Cunningham, April 1935.

186

International House, U. of C., Berkeley, Calif.
B-118

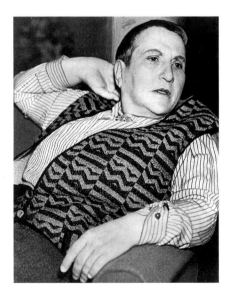

▨ The International House in Berkeley, situated off-campus, where Gertrude Stein gave her lecture. The university considered Gertrude Stein too "trivial." Postcard.
Right: Press photo.

We went to Berkeley and they had invited me I think it was the Phi Beta Kappa to lunch, and during the lunch there were a lot of them there everybody asked a question not everybody but a good many, they thought I answered them very well the only thing I remember is their asking why I do not write as I talk and I said to them if they had invited Keats for lunch and they asked him an ordinary question would they expect him to answer with the Ode to the Nightingale. It is funny everybody knows but of course everybody knows that writing poetry that writing anything is a private matter and of course if you do it in private then it is not what you do in public. We used to say when we were children if you do it in private you will do it in public and we did not then say if you do it in public you will do it in private. Well anyway when you say what you do say you say it in public but when you write what you do write you write it in private if not you do not write it, that is what writing is, and in private you are you and in public you are in public and everybody knows that, just read Briggs' Mr. and Mrs. everybody knows that but when they ask questions well then they are neither public nor private they are just fatheaded yes yes.

—*Everybody's Autobiography*

Miss Stein fails to see that language, in its art form, must be an interpretation of living experience rather than . . . a photograph of it.

—*Mills Quarterly* (Mills College)

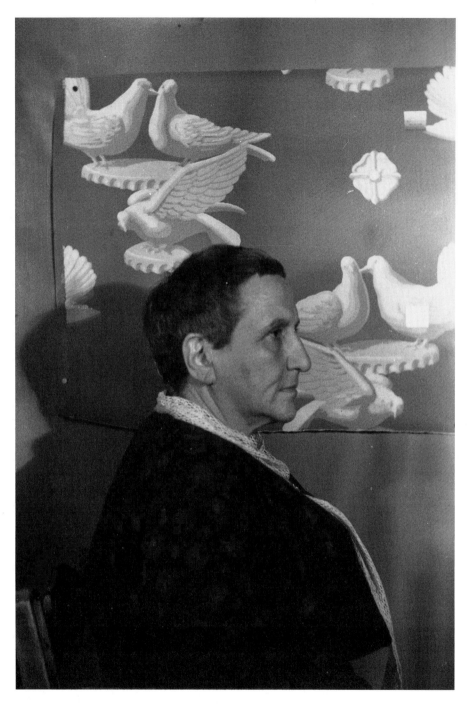

It always did bother me that the American public were more interested in me than in my work. And after all there is no sense in it because if it were not for my work they would not be interested in me so why should they not be more interested in my work than in me. That is one of the things one has to worry about in America, and later I learned a lot more about that.

—*Everybody's Autobiography*

I am always explaining to French people that Europeans do not know anything about disillusion, Americans have to have so much optimism because they do know what it is to have disillusion, the land goes away from them, the water goes away from them they go away from everything and it is all of it so endless and yet they have all been from one end to the other end of it. Yes they have all been.

—*Everybody's Autobiography*

▦ Photos by Carl Van Vechten. Left: the New York pigeon wallpaper that would later be used in the new apartment at 5, rue Christine.

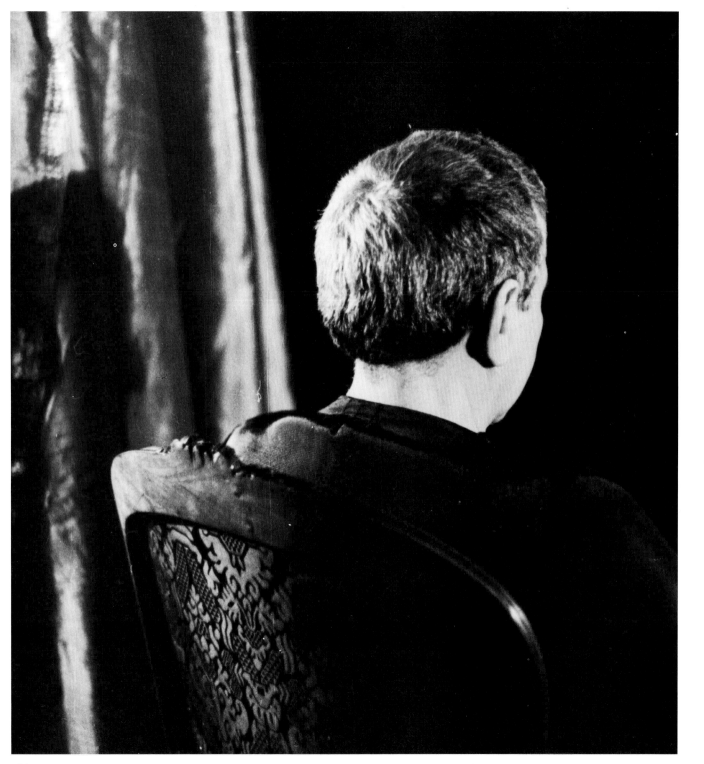

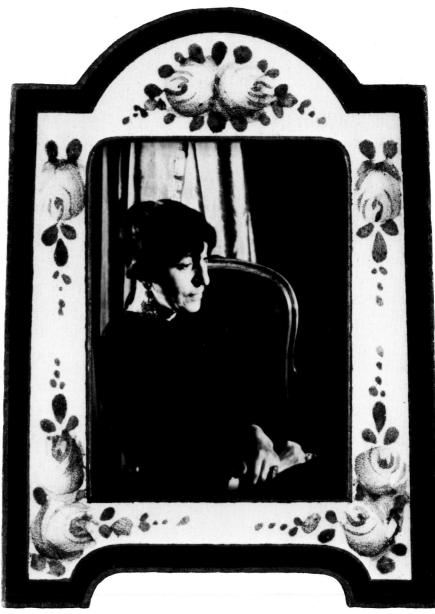

"America is my country and Paris is my home town . . ." Taking leave from Carl Van Vechten and America. Aboard the SS *Champlain*, May 4, 1935. Press photo.
Below and right page: Photos by Carl Van Vechten.

And then we came on to the shore and then into the train and then through to Paris. The cities we saw worried me, after all European cities the old parts have beautiful architecture but the new parts that is everything for almost a hundred years have not and as gradually European cities are having a larger and larger part new and as the new parts in America are more beautiful than the new parts in Europe perhaps the American cities are more beautiful than the European. Interesting if true.

—*Everybody's Autobiography*

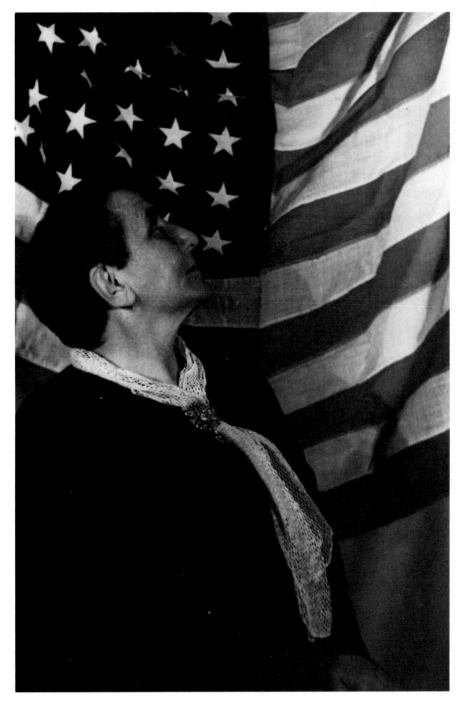

She told an Associated Press reporter in Paris: "Yes I am married; I mean I am married to America, it is so beautiful."

Still wearing the brown tweed and the braumeister's-deerstalker's cap, she continued:

"I am going back to America sometime, someday not too long. I am already homesick for America. I never knew it was so beautiful. It was like a bachelor who goes along fine for 25 years and then decides to get married. That is the way I feel, I mean about America."

—W. G. Rogers,
When This You See Remember Me

▓ Over: Paris at the end of the 1930s.

Back in France—The Years Before World War II 1935–1939

E instein was the creative philo-
sophic mind of the century and I
have been the creative literary mind of
the century. . . .

—*Everybody's Autobiography*

1935 Arrival in Paris, on May 12. Summer in Bilignin. Gertrude Stein continues explaining and justifying her writing, partly as a reaction to "Testimony Against Gertrude Stein," attacks by Matisse, Braque, Tzara, André Salmon, and Maria and Eugene Jolas, that had appeared in *transition*. Stein writes *The Geographical History of America or The Relation of Human Nature to the Human Mind* (published in 1936) and *What Are Masterpieces* (published in 1940). Both books are introduced by Thornton Wilder, who comes for the first of many visits to Paris and Bilignin. Temporary estrangement from Picasso, who, after separating from Olga, has begun writing poems. First indications of the war in which Stein refuses to believe: five hundred French soldiers are billeted in Bilignin. For safety reasons, Alice B. Toklas ships copies of Stein's works to America. Michael Stein and his family leave France and return to California.

1936 Gertrude Stein lectures again in Oxford and Cambridge ("What Are Masterpieces" and "An American and France"). Visit with the composer Lord Gerald Berners, who transforms Stein's "They Must Be Wedded. To Their Wife" into a ballet—a playful contemporary version of *Giselle*, titled *The Wedding Bouquet*. Meeting and friendship with the photographer Cecil Beaton who takes a series of photographs of Stein and Toklas at his studio. In March, Stein begins writing her second autobiographical account, *Everybody's Autobiography*. She is invited to join the World Exhibition jury in order to choose paintings for the Petit Palais, and obtains Picabia's participation in the exhibition.

1937 Gertrude Stein flies to London to attend the premiere of *The Wedding Bouquet* at Sadler's Wells Theatre (with Margot Fonteyn, Ninette de Valois, and Robert Helpman, choreographed by Frederick Ashton). In the summer, another visit from Thornton Wilder in Bilignin. Meeting and friendship with the writer Samuel M. Steward. "Sentimental journey" with W. G. Rogers ("the Kiddie") and his wife, the writer Mildred Weston, to Nîmes, the place of their first encounter. The lease at 27, rue de Fleurus runs out. In December, *Everybody's Autobiography* is published in New York.

1938 Move to 5, rue Christine, in the *quartier* St. Germain. Stein writes *Picasso* (first in French, then in English), the play *Doctor Faustus Lights the Lights,* and a children's book, *The World Is Round*. Visit from Cecil Beaton in Paris and Bilignin. Death of Basket and acquisition of a new poodle, Basket II. Michael Stein dies in San Francisco.

1939 After France declares war, Gertrude Stein and Alice B. Toklas close the apartment in Paris and decide to winter in the country. They take the Picasso portrait and the *Portrait of Mme. Cézanne* back to Bilignin. A visit from André Breton and family, among others.

195

As I told Picasso the egotism of a writer is not at all the same egotism as the egotism of a painter and all the painters felt that way about The Autobiography of Alice B. Toklas, Braque and Marie Laurencin and Matisse they did not like it and they did not get used to it.

The first to feel that way about it was Braque or Matisse or Marie Laurencin. Matisse had pieces translated to him so did Braque, Marie Laurencin had pieces translated to her but not by me. Matisse I never saw again but Braque yes twice and Marie Laurencin once. . . .

. . . Matisse said that Picasso was not the great painter of the period that his wife did not look like a horse and that he was certain that the omelette had been an omelette or something. Braque said that he had invented cubism, he did not say this but at any rate if what he said was so then that was so. And Marie Laurencin, Marie Laurencin is always Marie Laurencin, we had not met for many a year.

This was a long time after.

In later years perhaps it had to do with the Autobiography and how it affected me but anyway there has been a tendency to go out more and see different kinds of people. In the older days mostly they came to see me but then we began to go out to see them. I had never been to any literary salons in Paris, and now well I did not go to many of them but I did go to some.

—*Everybody's Autobiography*

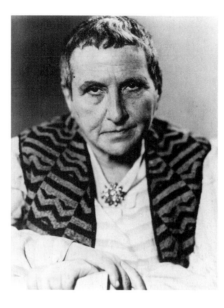

⊞ Focus of the feud over *The Autobiography of Alice B. Toklas*. (Photographer and date of photo unknown.)
Right page: A lion in London. This and the next three photos were taken by Cecil Beaton in his studio, in 1936.

The memories of Miss Toklas furnish us with an opportunity to appreciate how far the limits of indecency can be pushed. Underneath the "baby" style, which is pleasant enough when it is a question of simpering at the interstices of envy, it is easy to discern such a really coarse spirit, accustomed to the artifices of the lowest literary prostitution, that I cannot believe it necessary for me to insist on the presence of a clinical case of megalomania. . . .

Far be it from me to throw any doubt upon the fact that Miss Stein is a genius. We have seen plenty of those. Not that Miss Toklas is convinced of it. To tell the truth, all this would have no importance if it took place in the family circle between two maiden ladies greedy for fame and publicity.

—Tristan Tzara,
"Testimony Against Gertrude Stein"

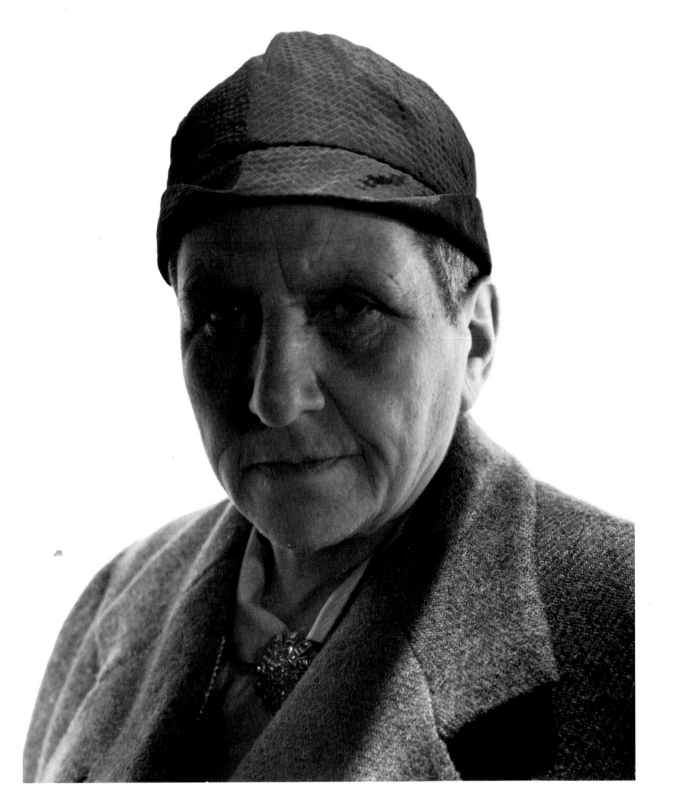

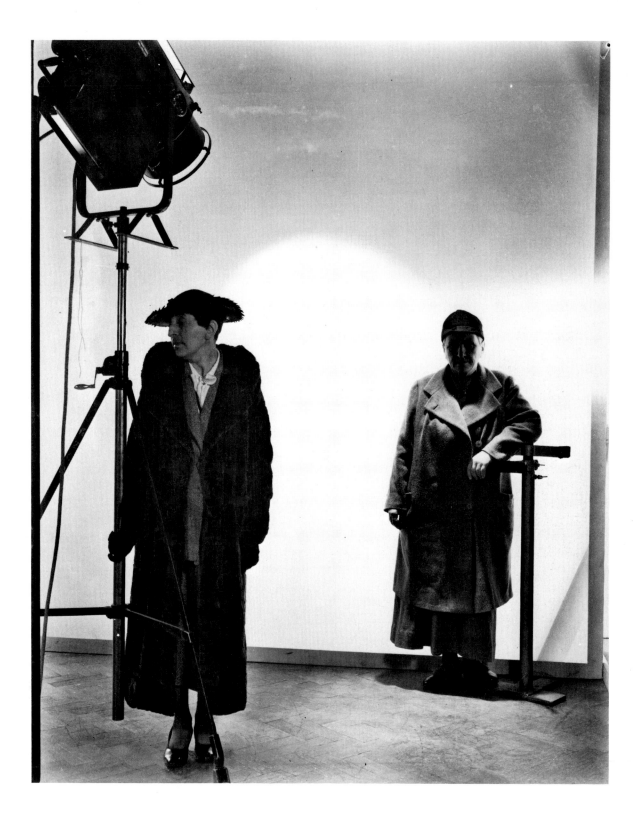

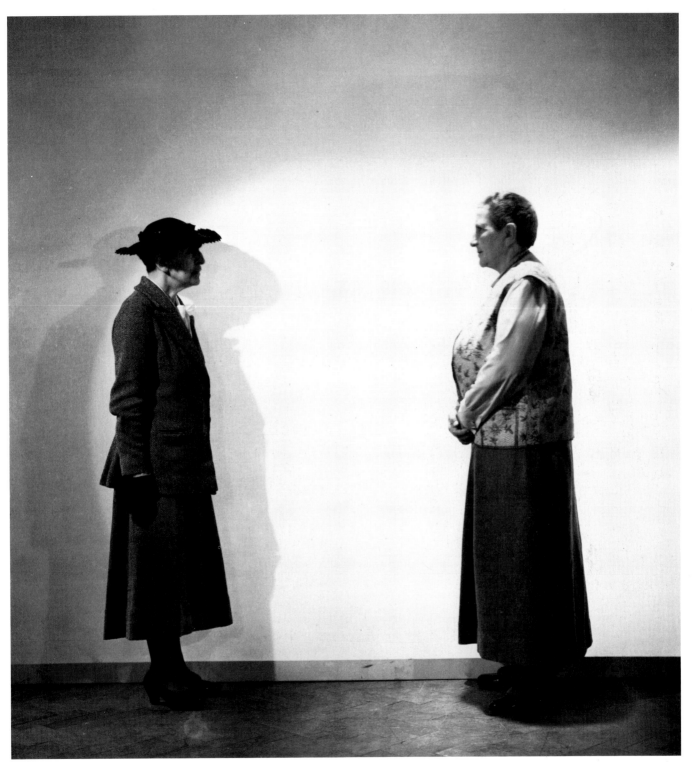

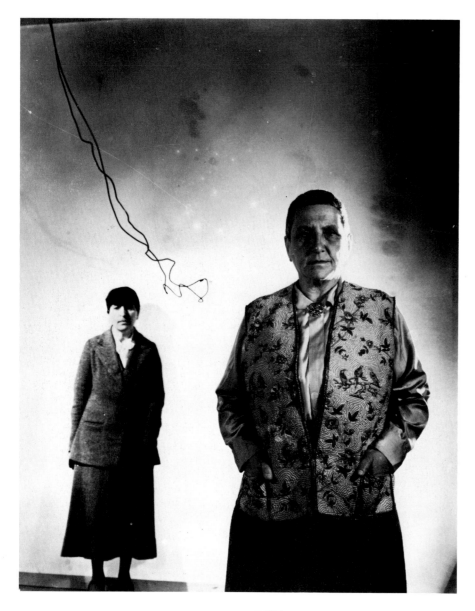

"If not then why not."

I tell you it is true that I do the literary thinking for you.

—*The Geographical History of America*

. . . I never get over being puzzled about it, best sellers are well written and they are moving and of course in the nineteenth century best sellers were things that go on being but the difference between one that is and one that is not writing that goes on being read, you do know the difference that is to say I know the difference when I can or cannot read it not that that has anything to do with it either, I can read things and be held by them and they are nothing that will go on being read and I do know the difference of course I know the difference but to describe the difference, it is not possible to describe the difference, I tried to in the lecture I gave last winter in Oxford and Cambridge What Are Masterpieces And Why Are There So Few Of Them, it is the same thing that knowing inside in one that one is a genius, what difference is there inside in one from the others inside in them who are not one, what is the difference, there is a difference what is the difference, oh yes it seems easy enough to say it and even if you know it although inside in yourself you do not know but there is one if there is one.

—*Everybody's Autobiography*

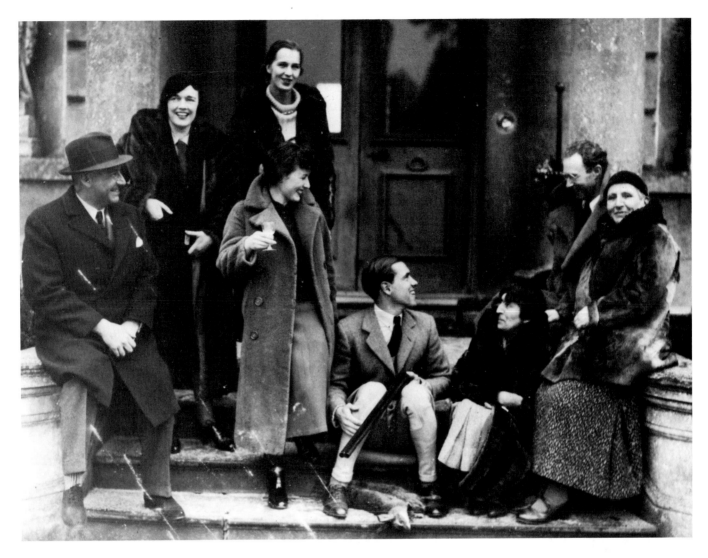

The word timely tells that master-pieces have nothing to do with time.

—*What Are Masterpieces*

※ Guests of the English aristocracy. From the left: the composer Lord Gerald Berners, Lady Roseberry, Lady Bridget-Parsons, the hosts—Lady Diana (center) and Sir Robert Abdy (far right)—and Robert Heber-Percy (center, with gun).

. . . just then the Spanish civil war began and that scared everybody really scared them, scared them because it was so near and so frightening and also anything foreign may cause foreign fighting and Frenchmen like fighting but they do not want a war again not now no they know that, they all know that, and so the Spanish civil war scared them. The women felt better than they had felt they felt the men seeing what was happening over the border and realizing what civil war was really like they would settle down and be just simply Frenchmen again. Well anyway that is what happened last spring.

—*Everybody's Autobiography*

He who could see did not need interpretation and in these years, 1927 to 1935, for the first time, the interpretations destroyed his own vision so that he made forms not seen but conceived. All this is difficult to put into words but the distinction is plain and clear, it is why he stopped working. The only way to purge himself of a vision which was not his was to cease to express it, so that as it was impossible for him to do nothing he made poetry, but of course it was his way of falling asleep during the operation of detaching himself from the souls of things which were not his concern. To see people as they have existed since they were created is not strange, it is direct, and Picasso's vision, his own vision, is a direct vision.

Finally war broke out in Spain.

First the revolution and then war.

It was not the events themselves that were happening in Spain which awoke Picasso but the fact that they

were happening in Spain, he had lost Spain and here was Spain not lost, she existed, the existence of Spain awakened Picasso, he too existed, everything that had been imposed upon him no longer existed, he and Spain, both of them existed, of course they existed, they exist, they are alive, Picasso commenced to work, he commenced to speak as he has spoken all his life, speaking with drawings and color, speaking with writing, the writing of Picasso.

—*Picasso*

⊠ Picasso shortly after the outbreak of the Spanish civil war and his return to painting. In the background— "Guernica," 1937. Photo by David "Chim" Seymour.

You see I said continuing to Pablo you can't stand looking at Jean Cocteau's drawings, it does something to you, they are more offensive than drawings that are just bad drawings now that's the way it is with your poetry it is more offensive than just bad poetry I do not know why but it just is, somebody who can really do something very well when he does something else which he cannot do and in which he cannot live it is particularly repellent, now you I said to him, you never read a book in your life that was not written by a friend and then not then and you never had any feelings about any words, words annoy you more than they do anything else so how can you write you know better you yourself know better, well he said getting truculent, you yourself always said I was an extraordinary person well then an extraordinary person can do anything, ah I said catching him by the lapels of his coat and shaking him, you are extraordinarily within your limits but your limits are extraordinarily there and I said shaking him hard, you know it, you know it as well as I know it, it is all right you are doing this to get rid of everything that has been too much for you all right all right go on doing it but don't go on trying to make me tell you it is poetry and I shook him again, well he said supposing I do know it, what will I do, what will you do said I and I kissed him, you will go on until you are more cheerful or less dismal and then you will, yes he said, and then you will paint a very beautiful picture and then more of them, and I kissed him again, yes said he.

—*Everybody's Autobiography*

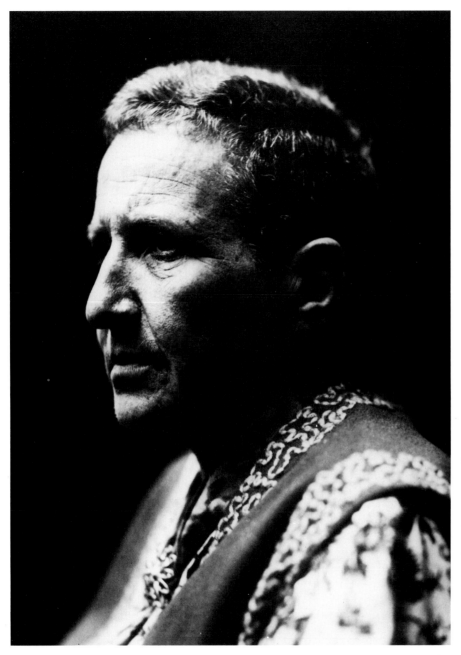

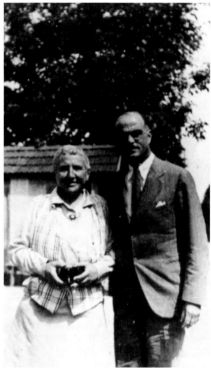

▣ "Fathers are depressing." Undated.
Above right: Visit by Thornton Wilder
to Bilignin, 1936.

Thornton Wilder writes to us these days and says he is shamelessly happy, and now he has no father.

—*Everybody's Autobiography*

There is too much fathering going on just now and there is no doubt about it fathers are depressing. Everybody nowadays is a father, there is father Mussolini and father Hitler and father Roosevelt and father Stalin and father Lewis and father Blum and father Franco and just commencing now and there are ever so many more ready to be one. Fathers are depressing. England is the only country now that has not got one and so they are more cheerful there than anywhere. It is a long time now that they have not had any fathering and so their cheerfulness is increasing.

—*Everybody's Autobiography*

. . . when I write a play then it is something that is inside of me but if I could see it then it would not be. And so I do write a lot of plays and they are things for somebody to see and somebody does see them, sometimes there will be lots more of them given. They are doing one in London Lord Berners has put music to it and Pépé the little Mexican dog is going to be on the stage not in person of course but a little girl to play him but even the littlest little girl is going to be a very large little Mexican.

—*Everybody's Autobiography*

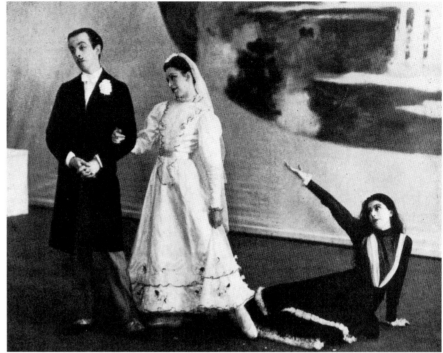

🎗 *The Wedding Bouquet*— Gertrude Stein's version of *Giselle*.
Above: With Lord Gerald Berners, the composer of her ballet, who also created the stage sets. London 1937.
Top: Margot Fonteyn as the deserted Julia, Mary Honer as the bride, and Robert Helpman as the groom. Sadler's Wells Theatre, April 27, 1937. Photo by J. W. Debenham.

It was tomorrow which was yesterday and it was exciting, it was the first time I had ever been present when anything of mine had been played for the first time and I was not nervous but it was exciting, it went so very well. English dancers when they dance dance with freshness and agility and they know what drama is, they like to dance and they do know what drama is, it all went so very well, each time a musician does something with the words it makes it do what they never did do, this time it made them do as if the last word had heard the next word and the next word had heard not the last word but the next word.

After all why not.

I like anything that a word can do. And words do do all they do and then they can do what they never do do.

—*Everybody's Autobiography*

SYNOPSIS

The subject of this ballet is a provincial wedding in France at the beginning of the twentieth century. The scene is laid in the garden of a farmhouse near Bellay.

The ballet opens with the preparations for the wedding feast.

The guests arrive.

JOSEPHINE, a rather equivocal character, and her friends PAUL and JOHN. ERNEST hotly pursued by VIOLET (" Violet, oh will you ask him to marry you? "). Ernest is unwilling.

The slightly demented JULIA. A modern Giselle, she has been " ruined " by the rakish BRIDEGROOM. She is accompanied by her dog PEPE, a black and tan Mexican terrier. Pépé protects her from a would-be suitor.

Josephine is excessively devoted to Julia (" Not in any other language could this be written differently ").

The BRIDE appears to cries of " Charming ! Charming ! Charming ! "

Two BRIDESMAIDS dance together under the bridal veil.

A photograph is taken of the Wedding Group.

The festivities begin, interrupted from time to time by Julia, who is a source of embarrassment to the Bridegroom. Josephine goes too far, and is requested to leave the party. The Tango is danced by the Bridegroom and a chorus of his former mistresses, which includes most of the ladies present.

As night falls, the guests leave. (" Thank you. Thank you.")

Julia remains alone on the stage, disconsolate. Her faithful dog Pépé creeps up to her and tries to comfort her.

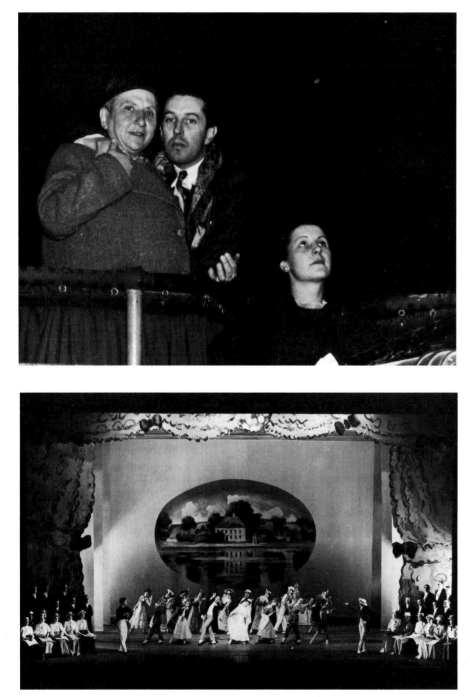

. . . I always do like to be a lion, I like it again and again, and it is a peaceful thing to be one succeeding.

—*Everybody's Autobiography*

And we were in London again and it is cheerful, even the ragged ones and the used up clothes are cheerful and the new clothes are very cheerful, Paris for the first time in all these years has been depressing, if you have what you wanted and it is not what you want it is naturally not encouraging, that is what they meant when they said that it turns to dust and ashes in your mouth, and Frenchmen have always been so occupied and now they have no occupation, well anyway either they will or they won't, and as Jean Saint-Pierre says every two years makes a generation why not every two months or two minutes why not. Well anyway we are liking it here and every one we know is excited about the ballet and we met Fred Ashton, who did the making a play of the Four Saints and who is now doing it again, so they all say we have not seen it, they all say it is very sad and everybody has to laugh and that is very nice.

We met Fred Ashton. I am always asking Alice Toklas do you think he is a genius, she does have something happen when he is a genius so I always ask her is he a genius, being one it is natural that I should think a great deal about that thing in any other one.

—*Everybody's Autobiography*

Top: With Frederick Ashton, the choreographer of her ballet, and the dancer Ninette de Valois(?), 1937.

Bottom: A later performance with the original sets.

205

The sun streaming in the window woke us early every morning. Once we were down on the terrace, Madame Roux would bring breakfast trays loaded under Miss Toklas' supervision. About the time we were through with coffee and our second cigarettes, Miss Stein would appear in a second-floor window and in her deep voice bid us good morning, tell us the latest news in the paper, ask whether we had had enough to eat, and suggest an outing for that day. The conversation could go on for an hour.

As she stood there statuesquely, perfectly framed by the window, her forearms on the sill, with a green tracery over the white wall below her, she was as impressive as Mussolini addressing his massed followers in Rome. The Duce needed the balcony of a magnificent Renaissance façade for his setting, however, and Miss Stein achieved the same effect by speaking from the bathroom.

She had breakfasted lightly in her room, reading the mail and the Paris *Herald,* which she preferred to French papers because for one reason the ink did not rub off on Miss Toklas' sheets. She surveyed not only her guests but the new day, and a sky with cottony clouds that needed only cherubs to make it a G. B. Tiepolo scene. By this time Miss Toklas, in a wide-brimmed straw hat and with a basket hooked over one arm, was out cutting bouquets for the house or trimming the roses, clove pinks, heliotrope, sweet alyssum and mignonette.

—W. G. Rogers,
When This You See Remember Me

On a mountain in Virginia stands a lonesome
pine.
Just below is the cabin home, Of a little girl of
mine.
Her name is June, and very very soon, She'll
belong to me.
For I know she's waiting there for me,
'Neath that lone pine tree.

Refrain:
In the Blue Ridge Mountains of Virginia, On the
trail of the lonesome pine.
In the pale moonshine our hearts entwine,
Where she carved her name and I carved mine;
Oh, June, like the mountains I'm blue
Like the pine I am lonesome for you.
In the Blue Ridge Mountains of Virginia, On the
trail of the lonesome pine.

—"On the Trail of the Lonesome Pine," lyrics by
Barrard Macdonald, music by Harry Carroll

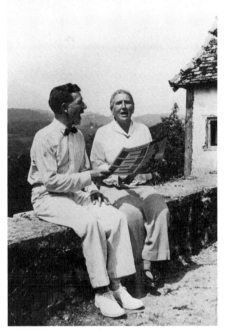

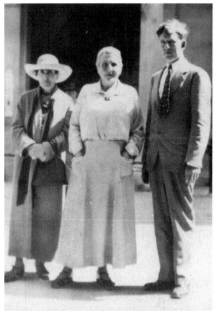

The Trail of the Lonesome Pine as a
song made a lasting appeal on
Gertrude Stein. Mildred Aldrich had it
among her records and when we spent
the afternoon with her at Huiry,
Gertrude Stein inevitably would start
The Trail of the Lonesome Pine on the
phonograph and play it and play it.
She liked it in itself and she had been
fascinated during the war with the
magic of the Trail of the Lonesome
Pine as a book for the doughboy. How
often when a doughboy in hospital
had become particularly fond of her,
he would say, I once read a great book,
do you know it, it is called The Trail of
the Lonesome Pine. They finally got a
copy of it in the camp at Nîmes and it
stayed by the bedside of every sick
soldier. They did not read much of it,
as far as she could make out some-
times only a paragraph, in the course
of several days, but their voices were
husky when they spoke of it, and

when they were particularly devoted
to her they would offer to lend her this
very dirty and tattered copy.

—*The Autobiography of Alice B. Toklas*

And then the Kiddie came other-
wise known as William Rogers. I
suppose there is something in a name
there was Billy the kid, and we had
William the Kiddie. All right he came.

After he was there while he was
there we took him everywhere. We
always had taken him everywhere.

—*Everybody's Autobiography*

Left page: Morning ceremony at the
bathroom window in Bilignin, 1937.
Left and center: Singing her favorite
song, "The Trail of the Lonesome Pine,"
with W. G. Rogers, "the Kiddie."
Above: On a "sentimental journey" to
Nîmes, 1937, with W. G. Rogers. Photo
by his wife, Mildred Weston.

It was a very hot italian day and we started as usual about noon, that being Gertrude Stein's favourite walking hour, because it was hottest and besides presumably Saint Francis had walked it then the oftenest as he had walked it at all hours. We started from Perugia across the hot valley. I gradually undressed, in those days one wore many more clothes than one does now, I even, which was most unconventional in those days, took off my stockings, but even so I dropped a few tears before we arrived and we did arrive. Gertrude Stein was very fond of Assisi for two reasons, because of Saint Francis and the beauty of his city and because the old women used to lead instead of a goat a little pig up and down the hills of Assisi. The little black pig was always decorated with a red ribbon. Gertrude Stein had always liked little pigs and she always said that in her old age she expected to wander up and down the hills of Assisi

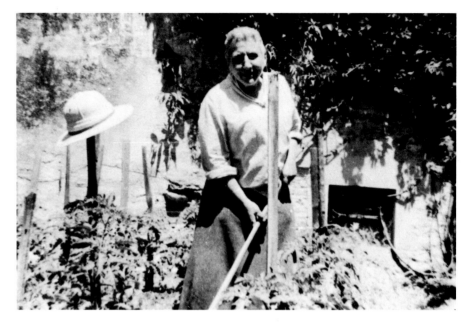

with a little black pig. She now wanders about the hills of the Ain with a large white dog and a small black one, so I suppose that does as well.

—*The Autobiography of Alice B. Toklas*

🔲 Left: At a Roman column near Bilignin.
Above and right page: Unpolitical tomatoes. All photos by Samuel M. Steward, 1937.

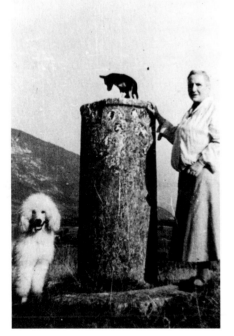

So I wandered with Basket and Pépé and I enjoyed myself and I took to gardening and it was a great pleasure I cut all the box hedges and we have a great many and I cleared the paths more or less well, the box hedges I did very well and then the weeds came up in the garden and we had corn the Kiddie who sends it to us says now we must not give it to any fascists but why not if the fascists like it, and we liked the fascists, so I said please send us unpolitical corn. . . .

—*Everybody's Autobiography*

Writers only think they are interested in politics, they are not really, it gives them a chance to talk and writers like to talk but really no real writer is really interested in politics.

—Answers to the *Partisan Review*

What is a loving tongue and pepper and more fish than there is when tears many tears are necessary. The tongue and the salmon, there is not salmon when brown is a color, there is salmon when there is no meaning to an early morning being pleasanter. There is no salmon, there are no tea-cups, there are the same kind of mushes as are used as stomachers by the eating hopes that makes eggs delicious. Drink is likely to stir a certain respect for an egg cup and more water melon than was ever eaten yesterday. Beer is neglected and cocoanut is famous. Coffee all coffee and a sample of soup all soup these are the choice of a baker. A white cup means a wedding. A wet cup means a vacation. A strong cup means an especial regulation. A single cup means a capital arrangement between the drawer and the place that is open.

—"Breakfast"

5 rue Christine
~~27 RUE DE FLEURUS~~

My dear Fay Ley

Merry Christmas and happy

New Year to you both, I like your

article about Picasso a lot, I do think

it gives a very true picture of him,

I've was in the country a long time

... you see by the above that we are moving, I guess 27 got so historical it just could not hold us any longer and so the landlord wanted to put his son in and we might have made a fuss but we were kind of pleased and now we are very pleased. . .

—Gertrude Stein to Sherwood Anderson, January 1938

A new letterhead, after the move to 5, rue Christine, in the *quartier* St. Germain, 1938.
Right page: With Alice B. Toklas and Basket in the new apartment. Photo by Cecil Beaton, 1938.

210

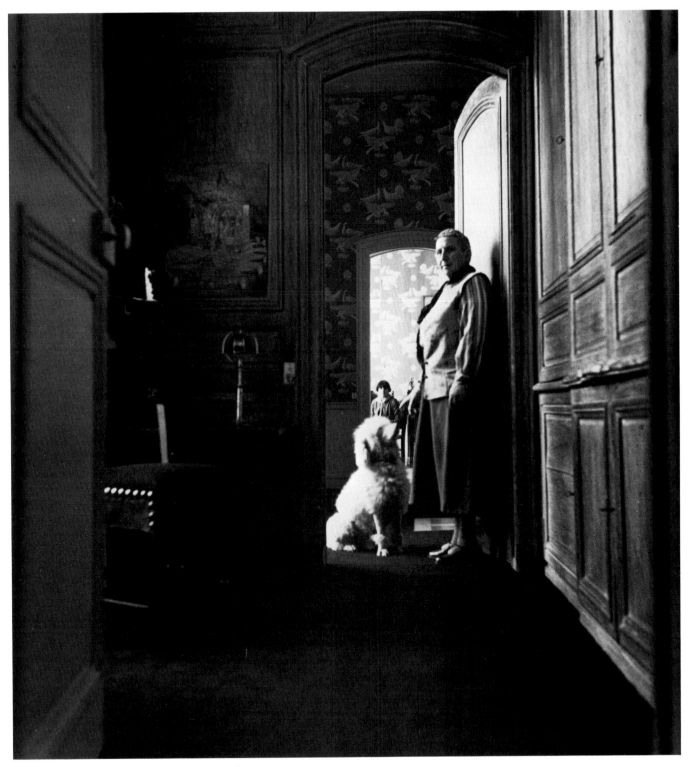

So from 1900 to 1930 those of us who lived in Paris did not live in picturesque quarters even those who lived in Montmartre like Picasso and Braque did not live in old houses, they lived in fifty year old houses at most and now we all live in the ancient quarter near the river, now that the twentieth century is decided and has its character we all tend to want to live in seventeenth century houses, not barracks of ateliers as we did then. The seventeenth century houses are just as cheap as our barracks of ateliers were then but now we need the picturesque the splendid we need the air and space you only get in old quarters. It was Picasso who said the other day when they were talking about tearing down the insalubrious parts of Paris but it is only in the insalubrious quarters that there is sun and air and space, and it is true, and we are all living there the beginners and the middle ones and the older ones and the old ones we all live in old houses in ramshackle quarters. Well all this is natural enough.

—*Paris France*

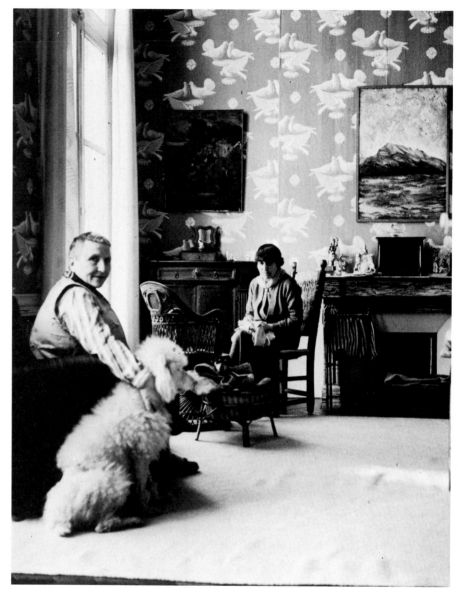

▧ Rue Christine with the American pigeon wallpaper (above) and the picture gallery in the hallway (right page, top). Photos by Cecil Beaton, 1938.

212

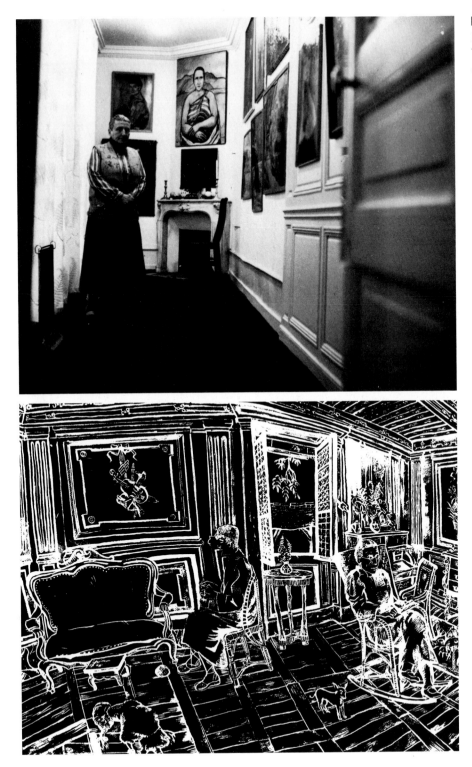

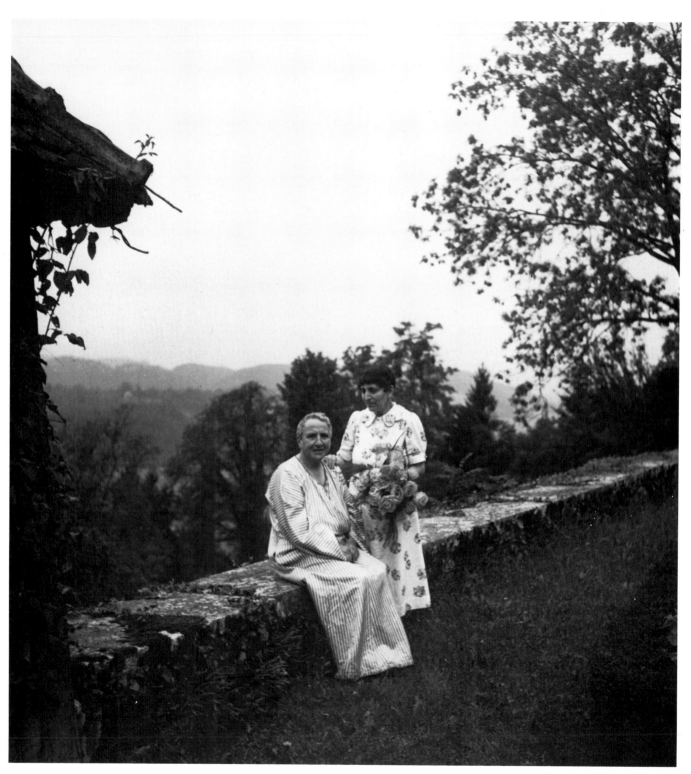

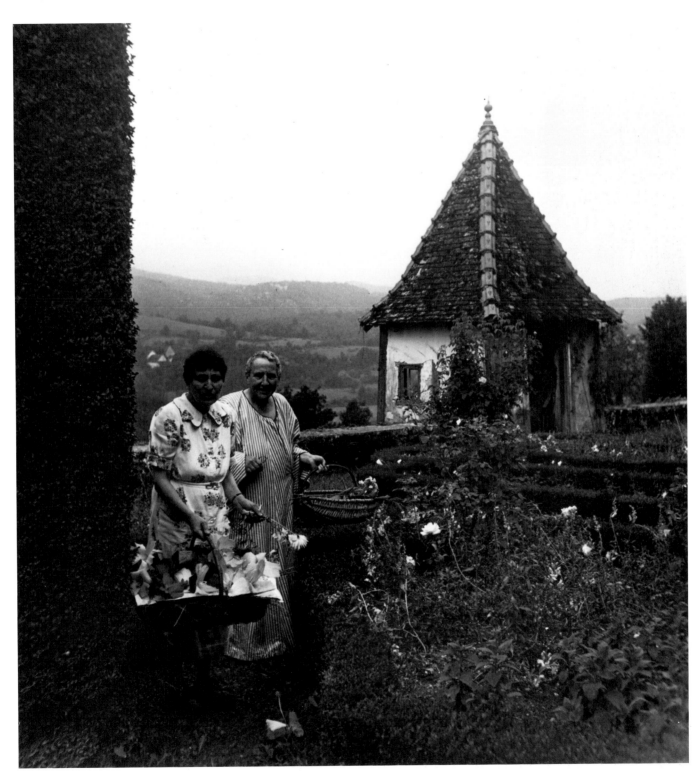

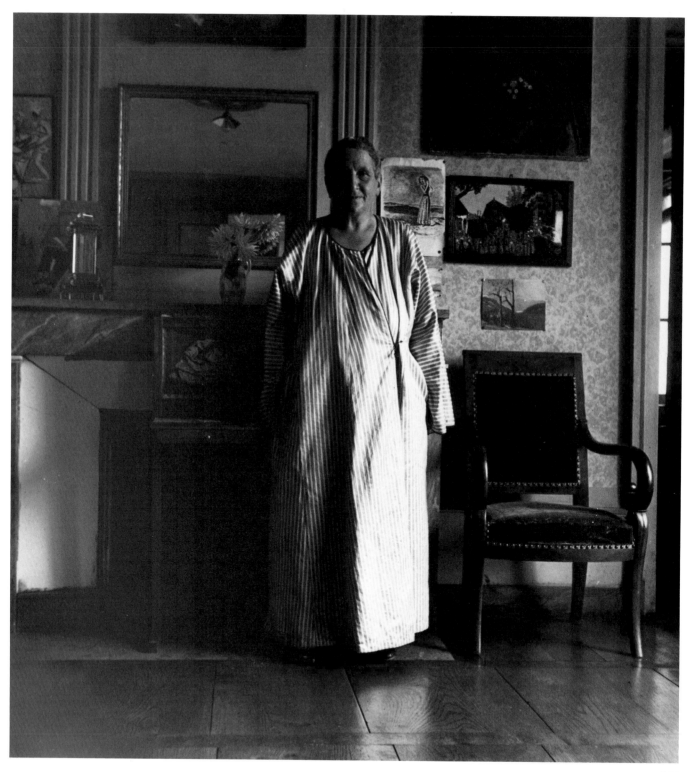

I took a piece of pork and I stuck it on a fork and I gave it to a curly headed jew jew jew. I want my little jew to be round like a pork, a young round pork with a cork for his tail. A young round pork. I want my little jew to be round like a young round pork. I do. . . .

. . . We murmur to each other, nightingales, we please each other with fruit trees we allow each other melons and we throw each other shoes. And pork. What do we think about pork and asparagus. What do we think about everything. It is necessary for us to know what we think. We think very well of butter and church cheese. We think very well of cracked church bells.

—"A Sonatina Followed by Another"

⊠ With Sir Francis Rose.

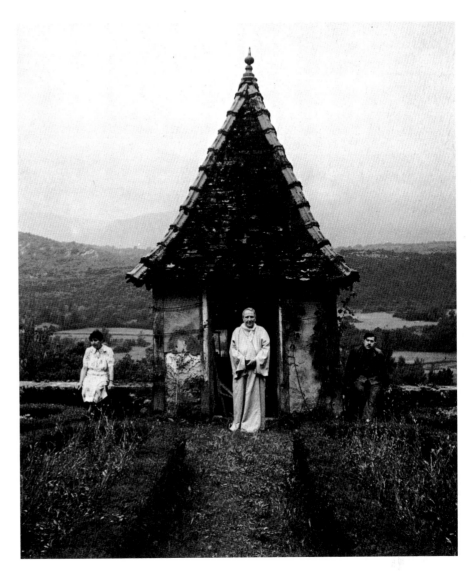

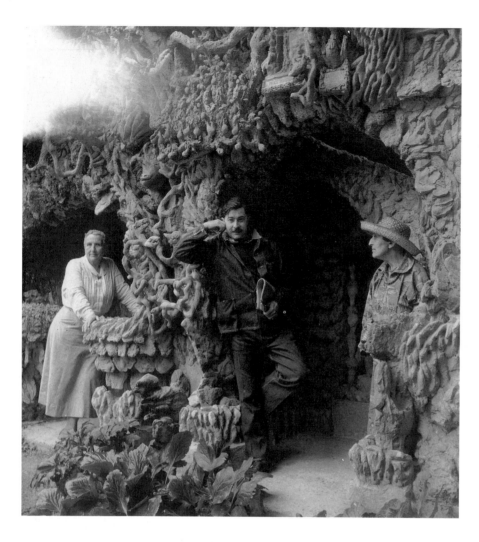

If you hear her snore
It is not before you love her
You love her so that to be her beau is
 very lovely
She is sweetly there and her curly hair
 is very lovely.
She is sweetly here and I am very near
 and that is very lovely.
She is my tender sweet and her little
 feet are stretched out well which is a
 treat and very lovely.
Her little tender nose is between her
 little eyes which close and are very
 lovely.
She is very lovely and mine which is
 very lovely.

—*Portraits and Prayers*

⬚ At the Palais Idéal of Facteur Cheval,
in Autrives, Provence, with and without
Sir Francis Rose. Photos by Cecil
Beaton, 1939.

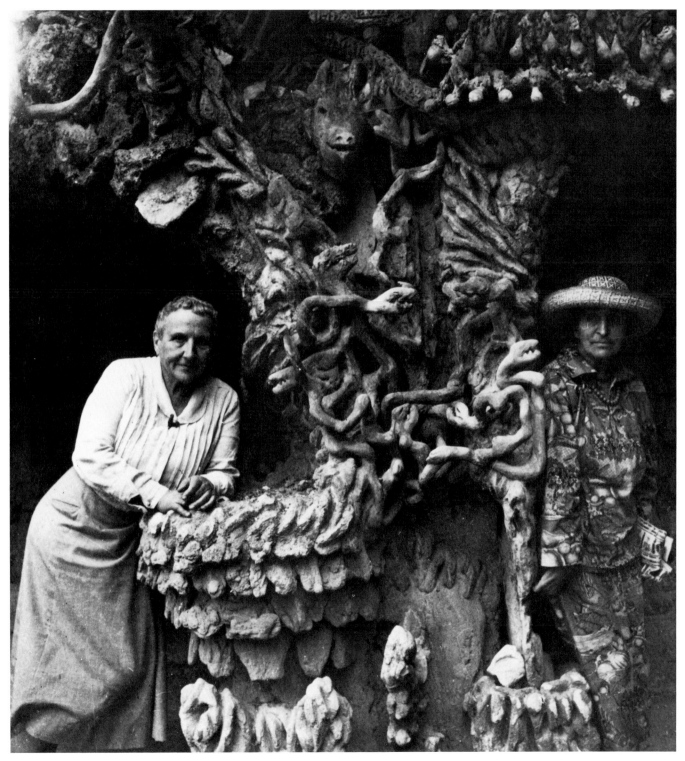

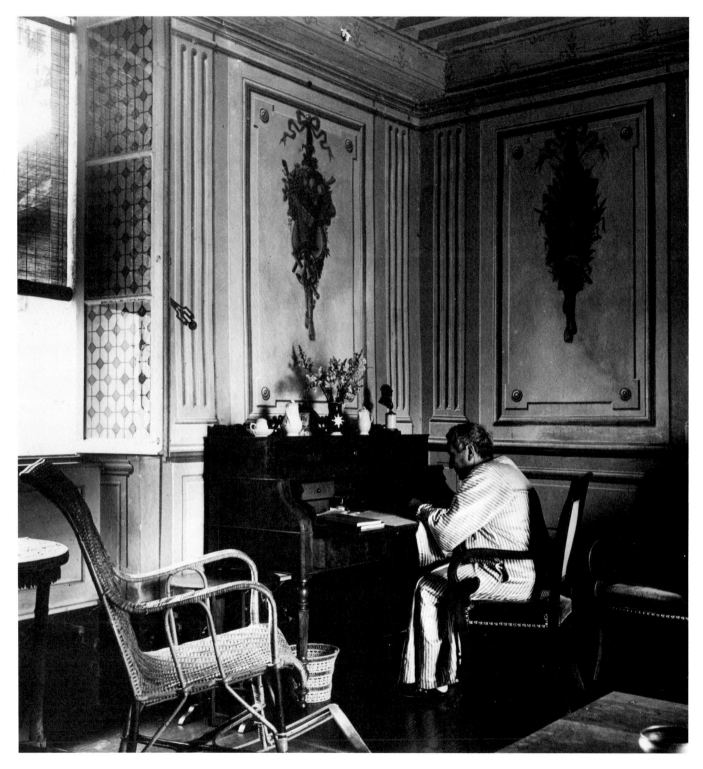

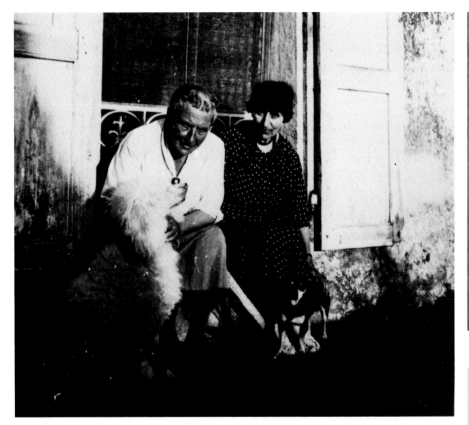

It is hard to go on when you are nearly there but not nearly enough to hurry up to get there.

— *The World Is Round*

⊞ Left page: At her desk in Bilignin. Photo by Cecil Beaton.
Above: The last summer before the war in which Gertrude Stein did not believe. Undated.
Top right: Sculpture of a soldier in the war of words, by Jacques Lipchitz, 1939.
Bottom right: A page from Gertrude Stein's children's book, *The World Is Round*, illustrated by Clement Hurd, 1939.

We talked about time about the passage of time about the dogs and what they did and was it the same as we did, and of course I was clear, Alice Toklas says and very often mistaken but anyway I am clear I am a good American, I am slow-minded and quickly clear in expression, I am certain that I see everything that is seen and in between I stand around but I do not wait, no American can wait . . .

— *Everybody's Autobiography*

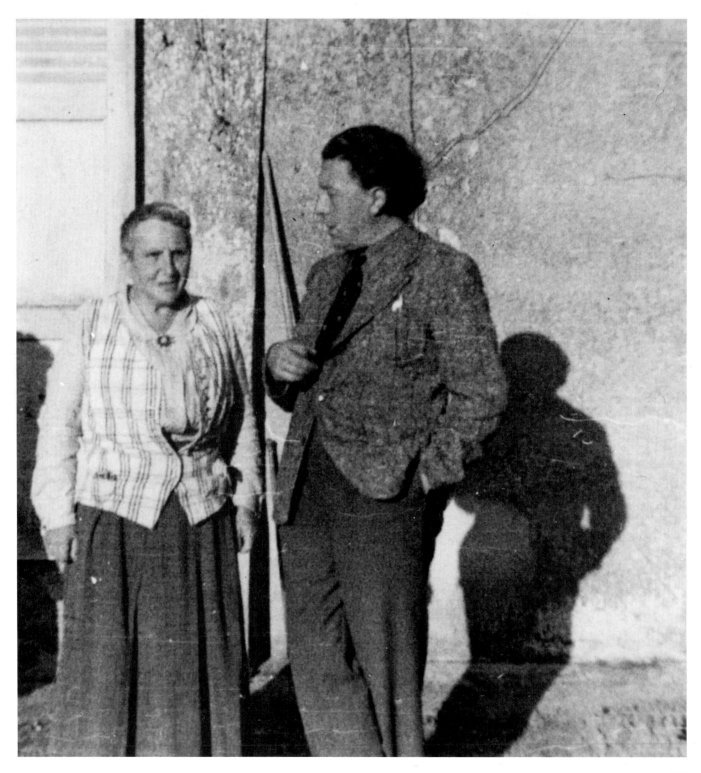

The surrealists still see things as
every one sees them, they compli-
cate them in a different way but the
vision is that of every one else, in
short the complication is the compli-
cation of the twentieth century but the
vision is that of the nineteenth
century. Picasso only sees something
else, another reality. Complications are
always easy but another vision than
that of all the world is very rare. That
is why geniuses are rare, to complicate
things in a new way that is easy, but to
see the things in a new way that is
really difficult, everything prevents
one, habits, schools, daily life, reason,
necessities of daily life, indolence,
everything prevents one, in fact there
are very few geniuses in the world.

—*Picasso*

⊠ Visit from André Breton, Bilignin,
1939. Photos by Samuel M. Steward.
Top right, from the left: Yves Tanguy and
Alice B. Toklas, a maid, Breton's wife and
daughter, Gertrude Stein, André
Breton, and Robert Matta.
Bottom right: The same. In the center,
Samuel M. Steward reads the maid's
palm.

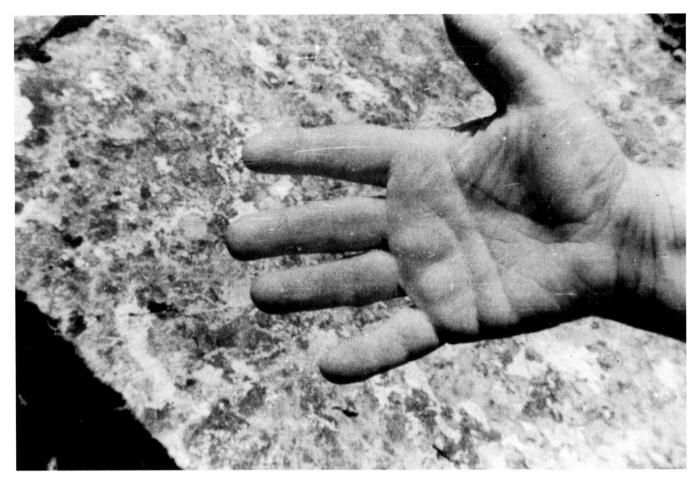

Palm-reading session, with and by
Samuel M. Steward, 1939.
Right page, bottom: Samuel M. Steward.

She was sitting on the low stone wall when I got there with my book and camera. I sat down beside her and she seized my right palm. "Are you righthanded Sammy, yes I seem to remember that you are," and with that she launched into a long and interesting reading, complaining about my "girdle of Venus" and the promiscuity it indicated: "That's the Eleven again I suppose," she said, "but they should really show up here on the side and they don't there's nothing there. I thought you said you'd just missed getting married by eleven women," she said severely.

"But I never had affairs with them," I said.

"No," Gertrude said, "there's really just one and a half." And then she complained about my crooked little finger. "It's the sign of a con man," she said.

"Maybe it's just that I broke it once," I said.

"Then you broke it being a con man," she laughed.

After she finished reading my hand, I looked at hers—at her insistence and against my will. I saw what was almost a man's hand, with "physical" fingers and one large affair mark—and a life

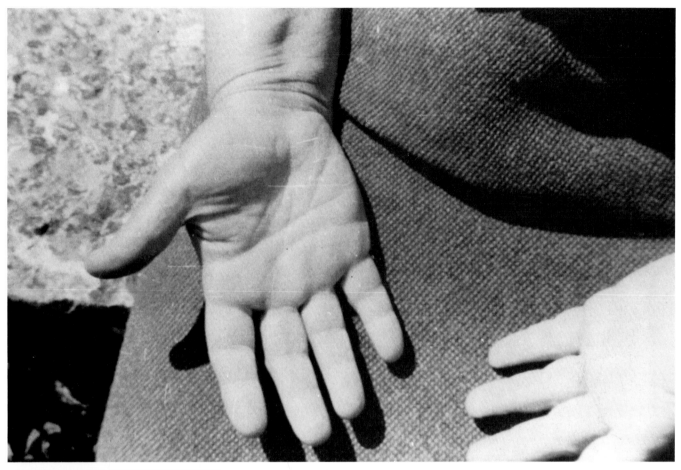

line that cut off dreadfully and sharply at a year or two past seventy—perhaps seventy right on the head. Between the ages of twenty and thirty-five there were many small cut-up lines, starts, and crosses, of struggle and confusion, and after that her "destiny line" went straight and sure—again to a point about seventy.

"You're holding things back now Sammy aren't you," Gertrude said in a stern tone. "You might as well tell me about the seventy thing, I can see it myself and that gives me six or seven more good years, but a lot, oh a very lot to be done, and the question is can I do it."

—Samuel M. Steward,
Dear Sammy: Letters from Gertrude Stein and Alice B. Toklas

Our dog's name is Basket and the French like that, it sounds well in French and goes very well with Monsieur, the children all call him Monsieur Basket more or less to rhyme with casquette.

That was the first Basket.

We did love the first Basket and he was shaved like a real poodle and he did fait le beau and he could say how do you do and he was ten years old and last autumn just after our return to Paris he died. We did cry and cry and finally every one said get another dog and get it right away.

Henry Daniel-Rops said get another as like Basket as possible call him by the same name and gradually there will be confusion and you will not know which Basket it is. They had done that twice with their little white Teneriffe which they call Claudine.

And then I saw Picasso, and he said no, never get the same kind of a dog again never, he said I tried it once and it was awful, the new one reminded me of the old one and the more he looked like him the worse it was. Why said he, supposing I were to die, you would go out on the street and sooner or later you would meet a Pablo, but it would not be I and it would be the same. No never get the same kind of a dog, get an Afghan hound, he has one, and Jean Hugo had said I could have one, but they are so sad, I said, that's all right for a Spaniard, but I don't like dogs to be sad, well he said get what you like but not the same, and as I went out he repeated not the same no not the same.

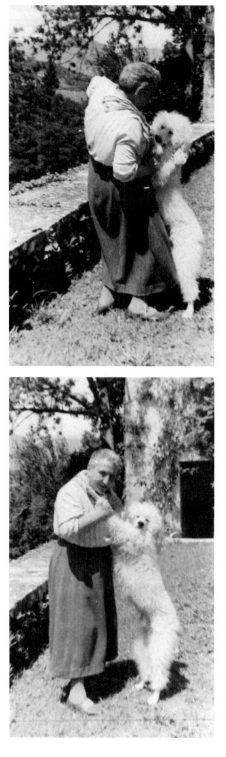

So we tried to have the same and not to have the same and there was a very large white poodle offered to us who looked like a young calf with black spots and other very unpleasant puppies with little pink eyes and then at last we found another Basket, and we got him and we called him Basket and he is very gay and I cannot say that the confusion between the old and the new has yet taken place but certainly le roi est mort vive le roi, is a normal attitude of mind.

I was a little worried what Picasso would say when he saw the new Basket who was so like the old Basket but fortunately the new Basket does stand on his legs in some indefinable way a little the way an Afghan hound stands on his although Basket the new Basket is pure poodle, and I pointed this out to Picasso when we and our dogs met on the street and that did rather reconcile him to it.

—*Paris France*

✴ Dance with Basket. Photos by Samuel M. Steward.

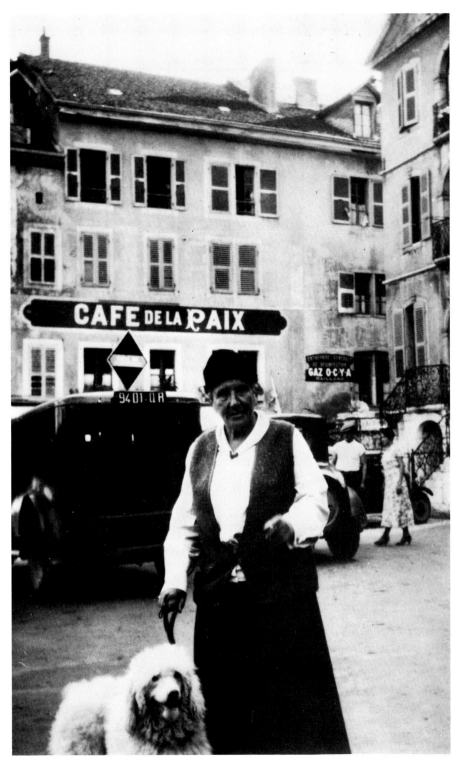

I once wrote and said what is the use of being a boy if you are to grow up to be a man what is the use and what is the use. But in France a boy is a man of his age the age he is and so there is no question of a boy growing up to be a man and what is the use, because at every stage of being alive he is completely a man alive at that time.

This accounts for the very curious relation of every french man to his mother. Just as he is always alive all the time and every moment of the time as a man so he is all his life continually a son dependent upon his mother. There is no break in that dependence even if a man is sixty years old and that in France very often does happen, the man is always dependent upon his mother, and so a frenchman is always a man because there is nothing inevitably different between being a boy and a man in a frenchman's life and he is always a son because he is always dependent upon his mother for his strength his morality, his hope and his despair, his future and his past. A frenchman always goes completely to pieces when his mother dies, he is fortunate if another woman has come into his life who is a mother to him.

—*Paris France*

▨ "Paris France is exciting and peaceful." Undated.

So the most striking thing about France is the family, and the terre, the soil of France. Revolutions come and revolutions go, fashions come and fashions go, logic and civilisation remain and with it the family and the soil of France.

They are so reasonable about that land, of course it has no value without men, and of course men cannot exist without family.

The family, any family has naturally the quality of the concentration of isolation. That is what makes a family, that is what makes war, so much war, it is that concentration of isolation.

—*Paris France*

Shooting at the country fair of Virieu-le-Grand. With the writer Henri Daniel-Rops and Alice B. Toklas.

The only personality I would like to write about for your catalogue is Paris, France, that is where we all were, and it was natural for us to be there. In the twentieth century we all did whether we knew it or not, we all did feel civilization logic and fashion.

For the first time since the eighteenth century, civilization was more important than progress, causes or intentions, logic was more important than sentiment, fashion more important than realism. And so we all lived in France because the French had always been civilized, logical and fashionable. And so we had to be there and we all were there.

—"We Moderns, 1920–1940"
Gertrude Stein to Frances Steloff

After all, anybody is as their land and air is. Anybody is as the sky is low or high. Anybody is as there is wind or no wind there. That is what makes a people, makes their kind of looks, their kind of thinking, their subtlety and their stupidity, and their eating and their drinking and their language.

—*What Are Masterpieces*

Last Years in France— World War II and Death 1939–1946

After all everybody, that is, everybody who writes is interested in living inside themselves in order to tell what is inside themselves. That is why writers have to have two countries, the one where they belong and the one in which they live really. The second one is romantic, it is separate from themselves, it is not real but it is really there.

—*Paris France*

1939 Gertrude Stein receives a warning from the American consulate to leave France, but she and Alice B. Toklas stay. Stein writes her homage to Paris, *Paris France* ("Paris France is peaceful and exciting").

1940 *Paris France* is published in London at the time of the German occupation of France. Worried about Stein's safety, W. G. Rogers advises her to return to lecture in the United States; Carl Van Vechten suggests going to Hollywood to follow the prospect of a film version of *The Autobiography of Alice B. Toklas*. On June 14, Paris is occupied. Gertrude Stein and Alice B. Toklas decide to wait out the war in Bilignin, surrounded by friends. Stein writes the novels *Ida* and *Mrs. Reynolds*, as well as *The Winner Loses: A Picture of Occupied France*.

1941–42 Concerned about France, Gertrude Stein sympathizes with Marshal Pétain's politics of the armistice. She makes an attempt at translating Pétain's *Paroles aux français*. During the occupation, Stein and Toklas's friend Bernard Faÿ intervenes with the Vichy régime in order to secure their protection. Stein and Toklas manage to survive the meager years thanks to their vegetable garden, to fishing with the help of an umbrella, to Alice's skill at cooking, and to Gertrude's black-market deals. Stein begins writing her third autobiographical book, *Wars I Have Seen*.

1943 The lease for Bilignin is canceled (in spite of Stein's attempt to sue). Gertrude Stein and Alice B. Toklas neglect another urgent official warning to leave France. They move to Le Colombier, a house in the nearby town of Culoz. The new house does not have a vegetable garden, and

Gertrude Stein undertakes frequent mile-long walks in order to find something to eat. They acquire a goat (named Bizerte, after the Allied victory). The young couturier Pierre Balmain tailors warm clothes and coats for the two women. The *Cézanne* portrait is being "eaten." In the summer, a German officer and his subordinates are billeted in their house, followed by Italian troops. Stein increasingly sympathizes with the maquis.

1944 Gertrude Stein's dog Pépé dies. At the end of August, the first American soldiers arrive in Culoz. The American press reports Gertrude Stein's "liberation." She writes a theater play about life in an occupied country, *In Savoy: A Play of the Resistance in France*. In mid-December, the two women return to Paris. Together with Picasso, they inspect the unharmed paintings at rue Christine. Short reconciliatory meeting with Hemingway, who is serving as a war correspondent in Paris.

1945 Hordes of GIs visit and beleaguer Gertrude Stein. In the spring, *Wars I Have Seen* appears and becomes one of her most successful books. Stein writes a long (unsuccessful) defense of her friend Bernard Faÿ, who is accused of collaboration. In June, she and Toklas tour American military bases in occupied Germany. They visit Hitler's country house in Berchtesgaden. Stein writes *Brewsie And Willie*, a critical portrait of GIs in Europe. In November, she reports on Pierre Balmain's first Paris fashion show in *Vogue*, "From Dark to Day." She starts a second opera libretto for Virgil Thomson, *The Mother of Us All*, about the suffragette Susan B. Anthony. Actress Katharine ("Kittie")

Cornell visits Paris on a theater tour for GIs and gives a reading of Stein's play *In Savoy* (the title is later changed to *Yes Is for a Very Young Man*). In November, while lecturing to GIs in Brussels, Gertrude Stein suffers a severe attack of intestinal problems, but she does not take it seriously.

1946 Gertrude Stein finishes her opera *The Mother of Us All*. *Yes Is for a Very Young Man* premieres in Pasadena. She buys a new car, her last Ford. In July, on the way to a vacation in Bernard Faÿ's country house, she suffers another intestinal attack. She is brought to the American Hospital in Neuilly, near Paris. Expecting surgical intervention, she makes her will on July 23. She leaves all her writings to Yale University, and her Picasso portrait to New York's Metropolitan Museum. Everything else is left to Alice B. Toklas and, after Toklas's death, to her nephew Allan Stein. The operation takes place on July 27, in the afternoon; the diagnosis of colon cancer is confirmed. A few hours later, at 6:30 P.M., Gertrude Stein dies under anaesthesia. She is seventy-two years old. On October 22, Gertrude Stein is received into her definitive grave in the Paris cemetery Père Lachaise, with a tombstone designed by Francis Rose. Ironically, her birthplace is misspelled "Allfghany" and her death date incorrectly reads "July 29, 1946."

1947 On July 29, Leo Stein dies in Florence.

1967 On March 7, Alice B. Toklas dies. She lies next to Gertrude Stein in Père Lachaise.

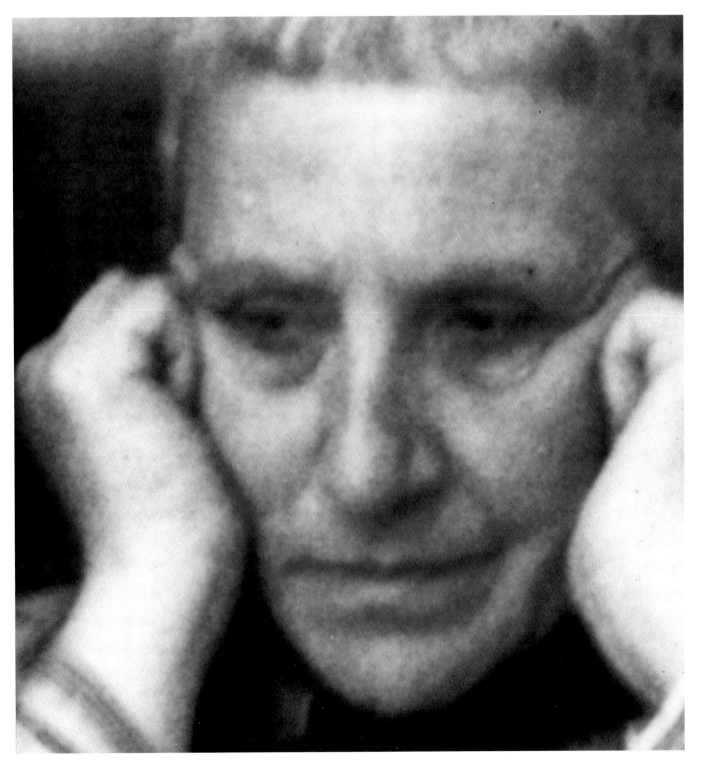

233

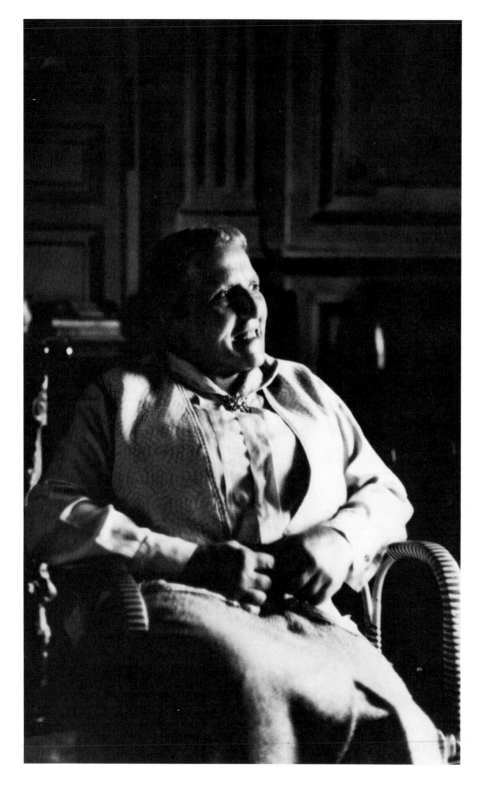

And so I am an American and I have lived half my life in Paris, not the half that made me but the half in which I made what I made.

—"An American and France"

Our old servant Hélène who was with us before the war for many years, learned from us that children should be raised differently and more hygienically and raise it in that way she did but all the same one day I heard her talking to her six year old little boy and saying you are a good little boy, yes mother he said, and you love your mother very much, yes mother he said, and you will grow up loving your mother she said, yes mother he said and then she said you will be grown up and you will leave me for a woman will you not, yes mother he said.

—*Paris France*

Living in the country to survive the war. Gertrude Stein, about sixty-five years old.
Right page: Afternoon coffee in the garden of their neighbor, Baroness Perlot(?). Undated.

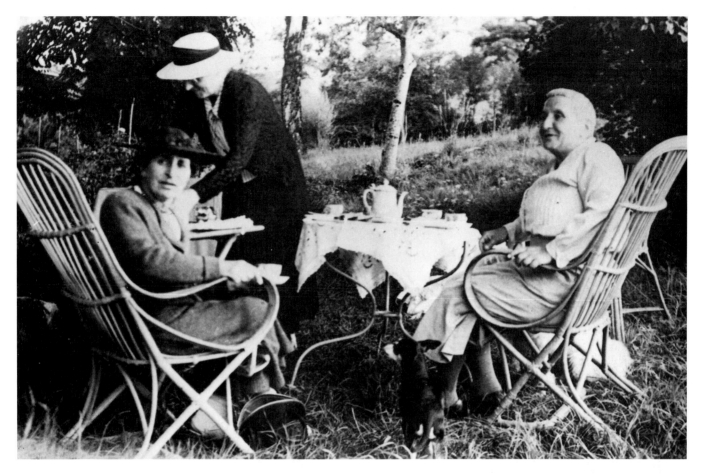

The relation of men to women and men to men and women to women in a state of being civilised has to be very much considered. Frenchmen love older women, that is women who have already done more living, and that has something to do with civilisation, they do not believe in comradeship really not with any one, they said in their revolution Egalité Fraternité Liberté, but these qualities should be left to war and politics, they are not human. Humanly speaking, Frenchwomen nor Frenchmen do not really interest themselves in intimacy, intimacy is something essentially uncivilised, civilisation makes young men interested in a woman of thirty and an interest in a spirit of equality with a very young woman is more or less a sign of senility, and senility is of course not civilised. . . .

. . . It is because of this element of civilization that Paris has always been the home of all foreign artists, they are friendly, the French, they surround you with a civilised atmosphere and they leave you inside of you completely to yourself.

—*Paris France*

An old French friend, Madame Pierlot once said to me she is now eighty-eight and she said that she is so much more flattered now than when she was a fascinating young woman. Fitzgerald once said to me it is easy to charm the old. But that is not the whole story it is easy for the old to charm.

—*Paris France*

The characteristic art product of a country is the pulse of the country, France did produce better hats and fashions than ever these last two years and is therefore very alive and Germany's music and musicians have been dead and gone these last two years and so Germany is dead well we will see, it is so, of course as all these things are necessarily true.

—*Paris France*

It could be a puzzle why the intellectuals in every country are always wanting a form of government which would inevitably treat them badly, purge them so to speak before anybody else is purged. It has always happened from the French revolution to-day. It would be a puzzle this if it were not that it is true that the world is round and that space is illimitable unlimited. I suppose it is that that makes the intellectual so anxious for a regimenting government which they could so ill endure.

—*Paris France*

⬚ "I do not like to fish in troubled waters but I do like to see the troubled water and the fish and the fisherman." Peasant disguise of a Jewish writer in occupied France. Undated.

Waiting for American soldiers.
Below: A chat with neighbours in
Bilignin, 1943.
Right: Undated

William James was of the strongest scientific influences that I had and he said he always said there is the will to live without the will to live there is destruction, but there is also the will to destroy, and the two like everything are in opposition, like wanting to be alone and when you are alone wanting to have company and when you have company wanting to be alone and liking wanting eternity and wanting a beginning and middle and ending and now in 1943 the thing that we know most about is the opposition between the will to live and the will to destroy, and when like with the Germans it is almost fifty fifty they do not mind they commit suicide. There was a farmer who once said to me he said it in 1941, he said they say it is Hitler, but it is not Hitler. I fought all the other war and I know what Germans are. They are a funny people. They are always choosing some one to lead them in a direction which they do not want to go. They cannot help

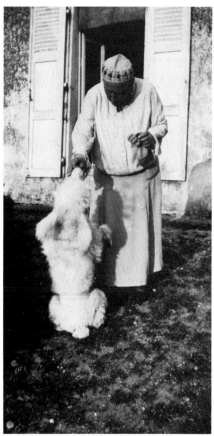

themselves they are not led, it is not the Kaiser, it is not Hitler, who leads them, it is they themselves who choose the man and really force him to lead them in a direction which they do not want to go. That is because the will to live and the will to destroy is fifty fifty which is what it ought not to be.

—*Wars I Have Seen*

Call it modern if you like but soldiers any quantity of them at any time can be carried across the ocean, any quantity of them at any time and now here in June 1943, we are waiting for them, waiting for them. . . .

—*Wars I Have Seen*

It was strange sitting there watching the people [going] up and down on the main street of Belley, like all country towns; there are always a good many people going up and down the main street of a country town, and now added to it were these familiar and unfamiliar German soldiers, familiar because we had seen their photographs in illustrated papers all winter and unfamiliar because we never dreamed we would see them with our own eyes.

They did not look like conquerors; they were very quiet. They bought a great deal, all sugar things, cakes and candies, all silk stockings, women's shoes, beauty products and fancy soaps, but always everlasting what the American soldiers in the last war called "eats"—that is, anything sweet—and anything that looked like champagne.

They went up and down, but they were gentle, slightly sad, polite; and their voices when they spoke—they did not seem to talk much—were low, not at all resonant.

Everything about them was exactly like the photographs we had seen except themselves; they were not the least bit like we thought they would be. They admired Basket II and said to each other in German, "A beautiful dog." They were polite and considerate; they were, as the French said, correct. It was all very sad; they were sad, the French were sad, it was all sad, but not at all the way we thought it would be, not at all.

The French, the girls and boys and the older men and older women, who also went up and down about their own affairs, had that *retenue* that is French—they neither noticed nor ignored the Germans. In all the three

weeks that the Germans were in Belley there was no incident of any kind.

When the Germans left, in Belley, in Yenne, in Lyon, and I imagine everywhere else in France, they thanked the mayors and congratulated them upon the extraordinary discipline of their populations. The Germans called it discipline, but it was not—it was the state of being civilized that the French call *retenue*.

—"The Winner Loses. A Picture of Occupied France"

I was taking a sixteen kilometer walk, I do do this very often and sometimes when I have bread to carry, I sometimes do have white bread and cake to carry I sometimes take an autobus. . . .

—*Wars I Have Seen*

We had recently quite a number of difficult moments. America had come into the war, our consul and vice-consul in Lyon with whom we had gotten very friendly because they had taken a summer home right near us and kept a white goat called Genevieve, and there we first found out that you could have goat's milk that did not taste of goat, had been interned first at Lourdes and then taken to Germany and now I went to Belley to say good-bye as we were moving. My lawyer said that everything was nicely arranged and we thanked each other and said what a pleasure it had all been, and then he said and now I have something rather serious to tell you. I was in Vichy yesterday, and I saw Maurice Sivain, Sivain had been sous-prefet at Belley and had been most kind and helpful in extending our privileges and our occu-

pation of our house, and Maurice Sivain said to me, tell these ladies that they must leave at once for Switzerland, to-morrow if possible otherwise they will be put into a concentration camp. But I said we are just moving. I know he said. I felt very funny, quite completely funny. But how can we go, as the frontier is closed, I said. That he said could be arranged, I think that could be arranged. You mean pass by fraud I said, Yes he said, it could be arranged. I felt very funny. I said I think I will go home and will you telephone Madame d'Aiguy to meet me. He said shall I walk home with you, I did feel very funny, and I said no I will go home and Madame d'Aiguy will come down to see you and arrange and I went home. I came in, I felt a little less funny but I still did feel funny, and Alice Toklas and Madame d'Aiguy were there, and I said we are not moving to-morrow we are going to Switzerland. They did not understand that and I explained and then they did understand, and Madame d'Aiguy left to go and see the lawyer and arrange and Alice Toklas and I sat down to supper. We both felt funny and then I said. No, I am not going we are not going, it is better to go regularly wherever we are sent than to go irregularly where nobody can help us if we are in trouble, no I said, they are always trying to get us to leave France but here we are and here we stay. What do you think, I said, and we thought and I said we will walk down to Belley and see the lawyer and tell him no. We walked down to Belley it was night it was dark but I am always out walking at night, I like it, and I took Alice Toklas by the arm because she has not the habit of walking at night and we

238

got to Belley, and climbed up the funny steps to the lawyer, and I said I have decided not to go. Madame d'Aiguy was still there and she said perhaps it was better so, and the lawyer said perhaps we had better go and then he said he had a house way up in the mountains and there nobody would know, and I said well perhaps later but now I said to-morrow we are going to move to Culoz, with our large comfortable new house with two good servants and a nice big park with trees, and we all went home, and we did move the next day.

—*Wars I Have Seen*

⊠ Walking miles for something to eat.

In spite of their sumptuous installation in a castle with a terraced garden running down to the valley, I discovered that even in the unoccupied zone, life was far from easy for them. Both at Biliguin (sic) and at Culoz the two famous Cézanne and Picasso portraits . . . had always hung face to face on opposite walls. One day I noticed that the Cézanne portrait was missing.

I asked Alice where it was, but she changed the subject. Being obstinate, I questioned Gertrude, who was less reserved.

'How do you think we eat?' she demanded, increasing the tempo of her rocking-chair. 'We are eating the Cézanne.'

—Pierre Balmain,
My Years and Seasons

He used to come over on his bicycle; we were many miles away, but nobody minded that, and the winter was cold and we were cold, and he made us some nice warm suits and a nice warm coat, and Alice Toklas insists that one of her suits was as wonderful as any he was showing at his opening, and there was no reason why not, after all, didn't he design it, and didn't he come over on his bicycle to oversee, and was it not as it all just is in dark days? There are bright spots. . . .These were nice days in those dark days, and then Pierre used to go to and fro from Paris, and he brought us back a breath of our dear Paris and also darning cotton to darn our stockings and our linen, that was Pierre.

—"From Dark to Day"

CULOZ. - Château du Colombier

And now it is 1943 and there is no milk and we keep a goat and I walk the goat and I like the goat, goats are very willful and I have found out why we like flowers. Because goats pick flowers to eat, and children pick flowers because animals pick flowers to eat and children pick flowers like that.

—*Wars I Have Seen*

▨ The new country house in Culoz, 1943.

240

**Press release, Friday,
September 29, 1944:**

Gertrude Stein safe, safe, is safe—
southeastern France . . . Gertrude
Stein, right, famous American
authoress renowned for her repetitive
form of writing, with her biographer
and companion, Alice B. Toklas, and
their pet dog, walking down a street of
the village in the mountains of south-
eastern France in which they lived in
self-imposed isolation since the Nazi
occupation. When Allied Troops took
over the women hailed them with joy
and a hearty meal.

American press photo: Gertrude
Stein and Alice B. Toklas with Basket, in
Culoz, 1944.

And now at half past twelve to-day on the radio a voice said attention attention attention and the Frenchman's voice cracked with excitement and he said Paris is free. Glory hallelujah Paris is free, imagine it less than three months since the landing and Paris is free. All these days I did not dare to mention the prediction of Saint Odile, she said Paris would not be burned the devotion of her people would save Paris and it has vive la France. I cant tell you how excited we all are and now if I can only see the Americans come to Culoz I think all this about the war will be finished yes I do.

—Wars I Have Seen

How we talked that night, they just brought all America to us every bit of it, they came from Colorado, lovely Colorado, I do not know Colorado but that is the way I felt about it lovely Colorado and then everybody was tired out and they gave us nice American specialties and my were we happy, we were, completely and truly happy and completely and entirely worn out with emotion. The next morning while they breakfasted we talked some more and we patted each other and then kissed each other and then they went away. Just as we were sitting down to lunch, in came four more Americans this time war correspondents, our emotions were not yet exhausted nor our capacity to talk, how we talked and talked and where they were born was music to the ears Baltimore and Washington D. C. and Detroit and Chicago, it is all music to the ears so long long long away from the names of the places where they were born. Well they have

asked me to go with them to Voiron to broadcast with them to America next Sunday and I am going and the war is over and this certainly this is the last war to remember.

—Wars I Have Seen

I said that I had begun by saying that after all to-day, America was the oldest country in the world and the reason why was that she was the first country to enter into the twentieth century. She had her birthday of the twentieth century when the other countries were still all either in the nineteenth century or still further back in other centuries, now all the countries except Germany, all trying to be in the twentieth century, so that considering the world as twentieth century America is the oldest as she came into the twentieth century in the eighties before any other country had any idea what the twentieth century was going to be.

—Wars I Have Seen

▣ "Gloria hallelujah Paris is free." Greeting the American troops from her window at rue Christine.
Left: The Allied parade on the Champs Elysées.

242

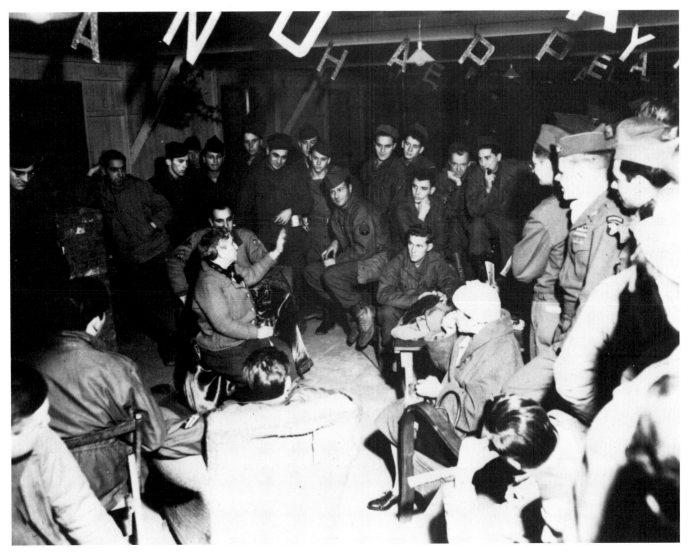

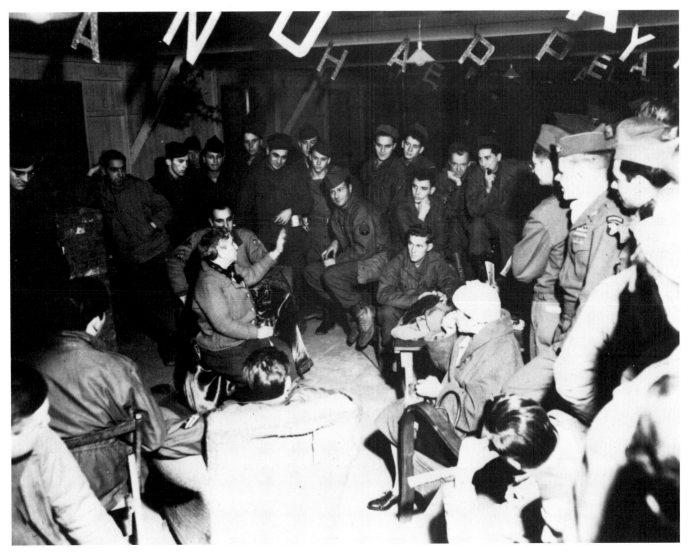⌗ New Year's celebration with GIs, 1944/45.

They used all of them to want to know how we managed to escape the Germans and gradually with their asking and with the news that in the month of August the Gestapo had been in my apartment in Paris to look at everything, naturally I began to have what you might call a posthumous fear. I was quite frightened. All the time the Germans were here we were so busy trying to live through each day that except once in a while when something happened you did not know about being frightened, but now somehow with the American soldiers questions and hearing what had been happening to others, of course one knew it but now one had time to feel it and so I was quite frightened, now that there was nothing dangerous and the whole American army between us and danger. One is like that.

—*Wars I Have Seen*

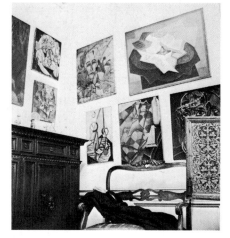

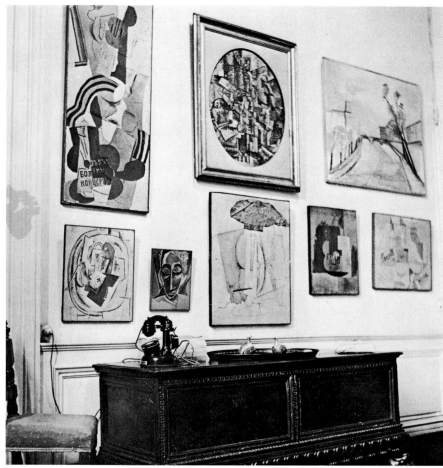

F ortunately as far as I could see all the pictures on the walls were unhurt though several of the small Picasso heads had been thrown on the floor. We put them back in their places and none are harmed. . . . But it's a miracle that your collection is still there for about 2 weeks before the Boches left 4 men of the Gestapo came, demanded the key of the concierge who protested in vain that you were American. The young girl who is secretary in the Bureau Weil heard steps overhead, rushed up, banged on the door until they opened it, pushed in past them and asked by what right they were there—that the proprietor was American, that she had charge of the house. They tried to put her out but she stayed. They were lashing themselves into a fury over the Picassos saying they would cut them to pieces and burn them. 'De la saloperie juive, bon à bruler.' The big pink nude 'cette vache.' They recognised your Rose portrait—they had a photo of you with them—and the other Rose heads in the long gallery, 'Tous des juifs et bon à bruler.' The girl rushed downstairs to her office, tele-phoned the police and in 10 minutes there was the Commissaire and 30 agents before the door much to the excitement of the street. By this time they—the G.s—were trying on your Chinese coats in your bedroom. The Commissaire asked them for their orders of perquisition which they had neglected to bring with them and they had to go but taking the key with them. So she waited before the door until a menuisier could be found to change the lock.

—Catherine Dudley, a neighbor, to Gertrude Stein

⊞ The paintings at rue Christine. A later photo of the unchanged apartment. Right page: Back in Paris, 1945. Photo by Cecil Beaton.

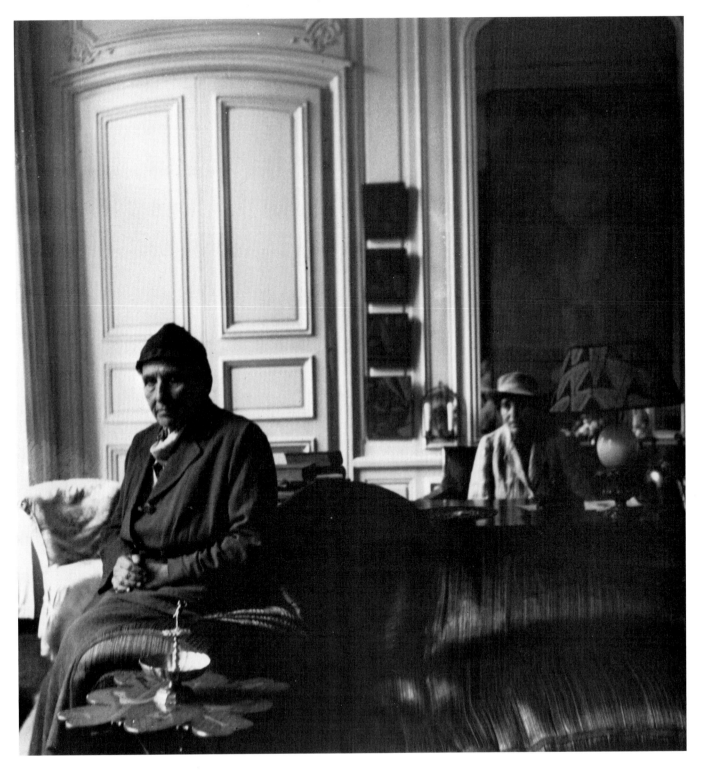

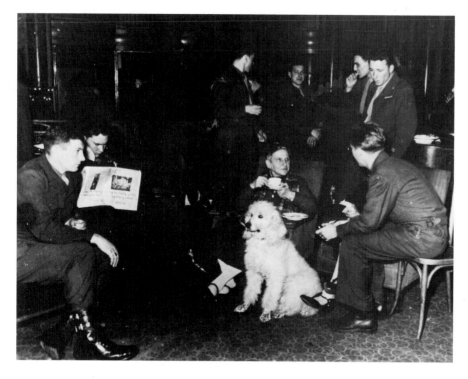

When General Osborne came to see me just after the victory, he asked me what I thought should be done to educate the Germans. I said there is only one thing to be done and that is to teach them disobedience, as long as they are obedient so long sooner or later they will be ordered about by a bad man and there will be trouble. Teach them disobedience, I said, make every German child know that it is its duty at least once a day to do its good deed and not believe something its father or its teacher tells them, confuse their minds, get their minds confused and perhaps then they will be disobedient and the world will be at peace. The obedient peoples go to war, disobedient peoples like peace, that is the reason that Italy did not really become a good Axis, the people were not obedient enough, the Japs and the Germans are the only really obedient people on earth and see what happens, teach them disobedience, confuse their minds, teach them disobedience, and the world can be peaceful.

General Osborne shook his head sadly, you'll never make the heads of an army understand that.

—"Off We All Went to See Germany"

▨ Proposal to the general: Teaching the Germans disobedience.

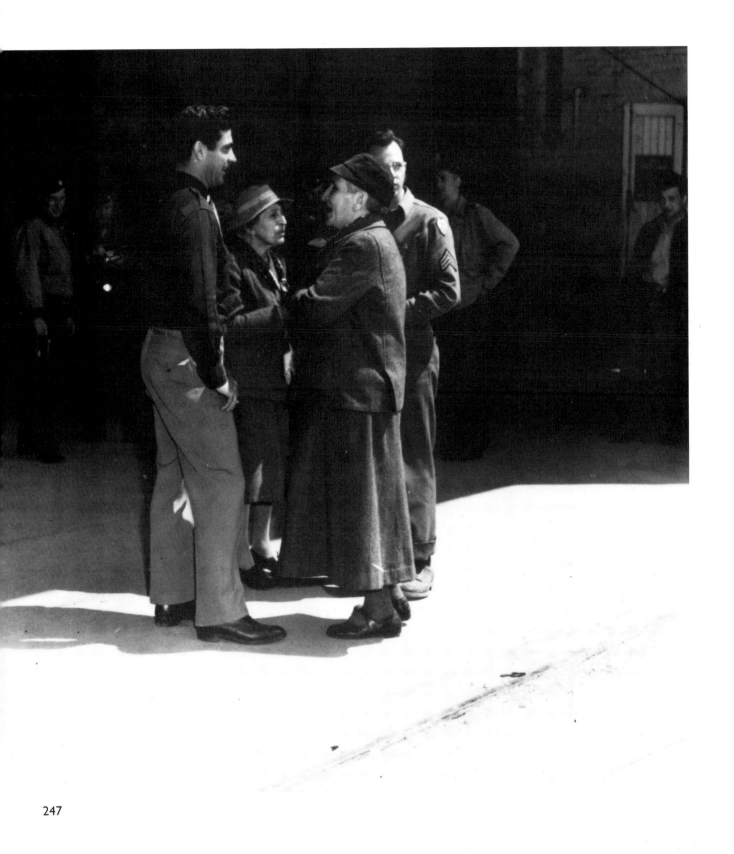

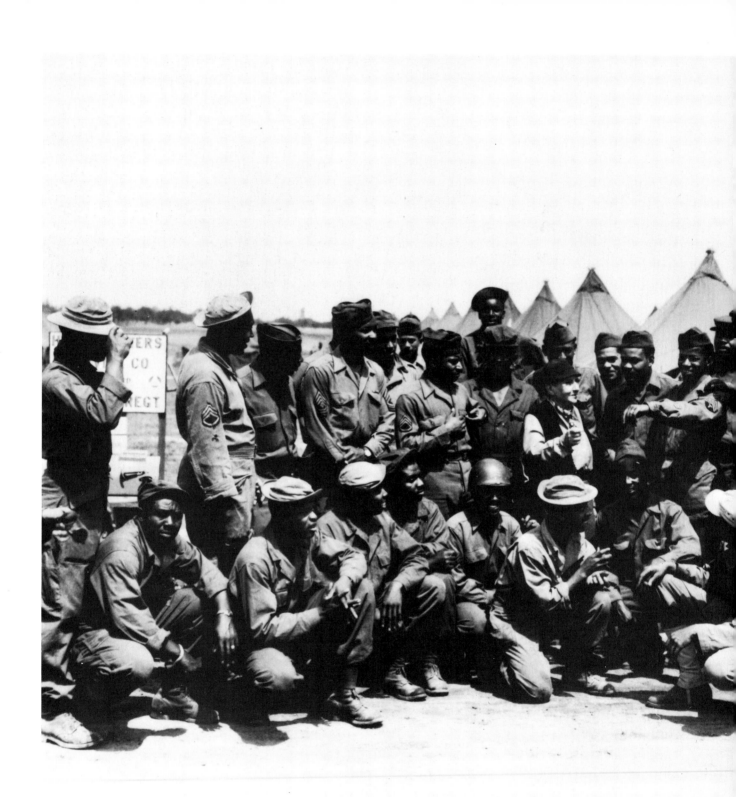

I know they do not want you to say Negro but I do want to say Negro. I dislike it when instead of saying Jew they say Hebrew or Israelite or Semite, I do not like it and why should a Negro want to be called colored. Why should he want to lose being a Negro to become a common thing with a Chinaman or a Japanese or a Hindu or an islander or anything any of them can be called colored, a Negro is a Negro and he ought to like to be called one if he is one, he may not want to be one that is all right but as long as he cannot change that why should he mind the real name of them. Ulysses Grant says in his memoirs all he learned when he was at school was that a noun is the name of anything, he did not really learn it but he heard it said so often that he almost came to believe it. I have stated that a noun to me is a stupid thing, if you know a thing and its name why bother about it but you have to know its name to talk about it. Well its name is Negro if it is a Negro and Jew if it is a Jew and both of them are nice strong solid names and so let us keep them.

—*Everybody's Autobiography*

▨ Visiting GIs in occupied Germany.

. . . these G.I.'s kept pinup girls all over. The walls of their barracks—like religious icons. They idealized women, but when they walked the streets of Paris, many of them would be drunk and would leer at and insult almost every woman they met. American boys are virginal, for only virgins would act that way. They liked the German women. When they made love to the German women, the German women did all the work, like the cows they did all the work.

— Gertrude Stein to a reporter

▨ The avant-garde author in the "chow line."
Right page: In a military airplane over Germany, summer 1945.

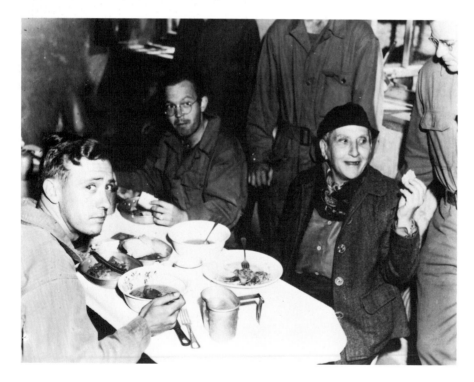

I always remember during the war being so interested in one thing in seeing the American soldiers standing, standing and doing nothing standing for a long time not even talking but just standing and being watched by the whole French population and their feeling the feeling of the whole population that the American soldier standing there and doing nothing impressed them as the American soldier as no soldier could impress by doing anything. It is a much more impressive thing to any one to see any one standing, that is not in action than acting or doing anything doing anything being a successive thing, standing not being a successive thing but being something existing. That is then the difference between narrative as it has been and narrative as it is now. And this has come to be a natural thing in a perfectly natural way that the narrative of to-day is not a narrative of succession as all the writing for a good many hundreds of years has been.

—*Narration*

And then we all climbed into our transport, that is our cars and off we went to Hitler. That was exciting. It was exciting to be there, the other houses were bombed but Hitler's was not it was burned but not down and there we were in that big window where Hitler dominated the world a bunch of GIs just gay and happy. It really was the first time I saw our boys really gay and careless, really forgetting their burdens and just being foolish kids, climbing up and around and on top, while Miss Toklas and I sat comfortably and at home on garden chairs on Hitler's balcony. It was funny it was completely funny, it was more than funny it was absurd and yet so natural. We all got together and pointed as Hitler had pointed but mostly we just sat while they climbed around. . . .

That evening I went over to talk to the soldiers, and to hear what they had to say, we all got very excited, Sergeant Santiani who had asked me to come complained that I confused the minds of his men, but why shouldn't their minds be confused, gracious goodness, are we going to be like the Germans, only believe in the Aryans that is our own race, a mixed race if you like but all having the same point of view. I got very angry with them, they admitted they liked the Germans better than the other Europeans. Of course you do, I said, they flatter you and they obey you, when the other countries don't like and and say so, and personally you have not been awfully ready to meet them halfway, well naturally if they don't like you they show it, the Germans don't like you but they flatter you, dog gone it, I said I bet you Fourth of July they will all be putting up our flag, and all you big babies will

just be flattered to death, literally to death, I said bitterly because you will have to fight again. Well said one of them after all we are on top. Yes I said and is there any spot on earth more dangerous than on top. You don't like the Latins, or the Arabs or the Wops, or the British, well don't you forget a country can't live without friends, I want you all to get to know other countries so that you can be friends, make a little effort, try to find out what it is all about. We all got very excited, they passed me cognac, but I don't drink so they found me some grapefruit juice, and they patted me and sat me down, and there it all was.

The next morning the sergeant came over to say goodbye and gave me a card, which said to Gertie, another Radical. Bless them all.

—"Off We All Went to See Germany"

⊠ Visiting Hitler's country house in Berchtesgaden.

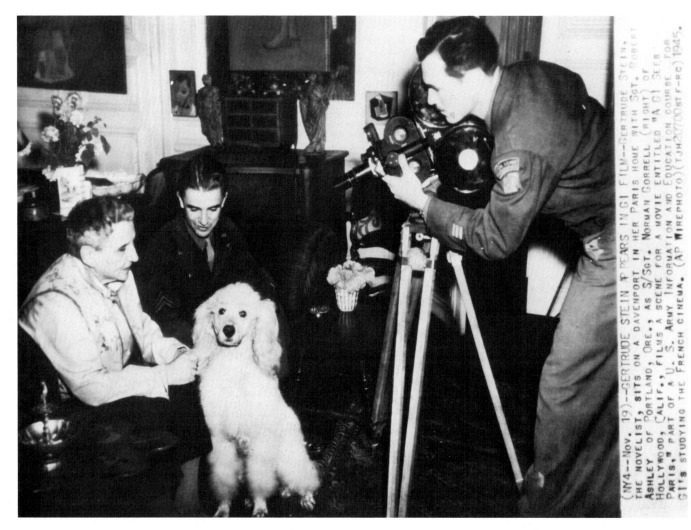

(NY4--Nov. 19)--GERTRUDE STEIN ‡PEARS IN GI FILM--GERTRUDE STEIN, THE NOVELIST, SITS ON A DAVENPORT IN HER PARIS HOME WITH SGT. ROBERT ASHLEY OF PORTLAND, ORE., AS S/SGT. NORMAN GORRELL (RIGHT) OF HOLLYWOOD, CALIF., FILMS A SCENE FOR A MOVIE ENTITLED "A GI SEES PARIS," PART OF A U.S. ARMY INFORMATION AND EDUCATION COURSE FOR GI's STUDYING THE FRENCH CINEMA. (AP WIREPHOTO)(TJH2/7)(OST-RC)1945.

She said to me once: "Everyone when they are young has a little bit of genius, that is they really do listen. They can listen and talk at the same time. Then they grow a little older and many of them get tired and they listen less and less. But some, a very few continue to listen. And finally they get very old and they do not listen any more. That is very sad; let us not talk about that." This book is by an impassioned listener to life. Even up to her last years she listened to all comers, to "how their knowing came out of them." Hundreds of our soldiers, scoffing and incredulous but urged on by their companions, came up to Paris "to see the Eiffel Tower and Gertrude Stein." They called and found bent upon them those gay and challenging eyes and that attention that asked nothing less of them than their genius. Neither her company nor her books were for those who have grown tired of listening. It was an irony that she did her work in a world in which for many reasons and for many appalling reasons people have so tired.

—Thornton Wilder,
introduction to *Four in America*

254

And all the time was I right when I said I was losing knowing what the human mind is. Anybody can know what human nature is and that it is not interesting. Anybody can begin to come to know what money and romanticism is.

Master-pieces have no finishing in them and what anybody can say is what anybody can know and what anybody can know is what anybody can know is what anybody can see but human nature and war and storms have a beginning and an ending as they begin they end and as they end they begin and therefore they are not interesting and money and romanticism they do not end and they do not begin but they do not exist and therefore they are not anything although any one can feel that way about them and therefore although they are not anything they are interesting.

—The Geographical History of America

⊠ Left page: Paris, November 4, 1945. Interview for the film *A GI Sees Paris*. Right: Listening until the end of her life. Top: With WAACs, members of the Women's Army Auxiliary Corps. Bottom: With the actress Katharine ("Kitty") Cornell, who had served Gertrude Stein a "superlative lemon pie" in New York, 1945.

When Pierre Balmain came to Paris to establish himself after the war, Gertrude and I went to his first showing. Pierre had made earlier a suit for Gertrude Stein, and a suit and coat for me. When we went to his collection I said to her, For God's sake, don't tell anybody that we're wearing Pierre's clothes. We look too much like gypsies. Why not? said Gertrude, they're perfectly good clothes.

—Alice B. Toklas,
What Is Remembered

I opened with a mannequin wearing a pair of grey flannel slacks, low-heeled brown suede shoes, and a loose brown homespun jacket like that of a Breton sailor. With her, on a lead, was my own pet Airedale, Sandra.

What followed was inevitable. Sandra saw Gertrude Stein's poodle at the same moment that Basket saw the Airedale. There was a furious battle, before Gertrude, myself, the mannequin and some of the salesgirls succeeded in separating the dogs. But the dog-fight had caused amusement and set a note of informality which probably helped the show get off to a good start. . . . *Vogue* invited Gertrude Stein to do a special feature on the showing—the only fashion article which she ever wrote in her life.

—Pierre Balmain,
My Years and Seasons

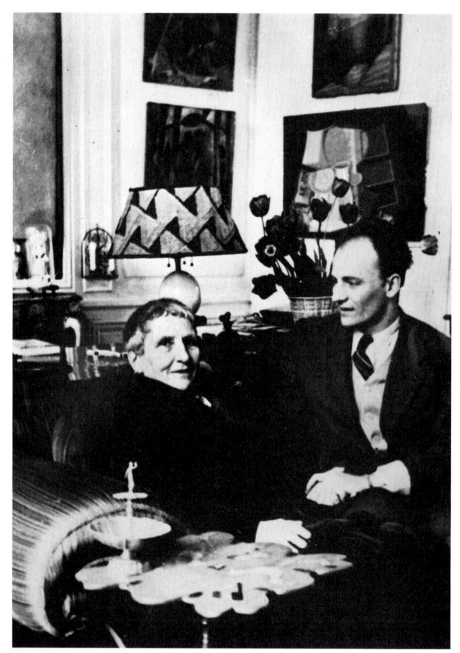

▨ Gertrude Stein and her couturier, Pierre Balmain. Photo by Cecil Beaton, 1945.

Well Marie Laurencin and I we had not met for so many years and we met and she said she would like to paint Basket the poodle and we met and we liked her painting Basket, she likes to paint white or brown dogs and dogs with long hair, she does not paint short-haired dogs or black dogs, I assure you I really do assure you that any painter paints the color that they are really and truly. Remember that.

And so Basket was posing very well, from time to time to be sure I had to support his chin, dogs have a tendency to find their heads get heavy and to have to have their chin supported. Well while the painting was going on young people came in. Young people like old people, they do, they do not like middle-aged people, not generally

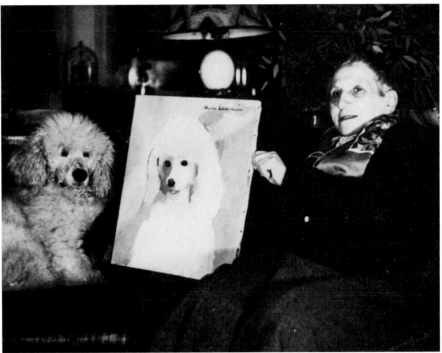

but they do like old people and that is all right it is mutual, old people like them. There is a natural affiliation between age and youth, which there is not with middle age and youth or middle age and age. All right, young people like us and they come to see us and they like to listen to us. And so while Basket was having his portrait painted the young men and women came and sat around and they asked about Guillaume Apollinaire and that was natural enough, and Marie talked and I talked and gradually as we talked we realized that it was not the people that we had known that had formed us but the streets of Paris, the Paris that is made of streets and rivers and islands and hills and people pushing things along or pulling things along and wagons and markets and fruits and

vegetables and mist and trees and buildings, and long streets in the dark, and short streets and squares in the light, and everything that makes Paris what it is.

—"Raoul Dufy"

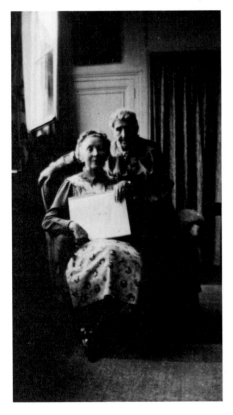

▧ Above: Portrait and model, painted by Marie Laurencin, 1946.
Left: The artist.

There was of course science and
evolution and there were of course
the fact that stars were worlds and that
space had no limitation and still if
civilizations always came to be dead of
course they had to come to be dead
since the earth had no more size than
it had how could other civilizations
come if those that were did not come
to be dead but if they did come to be
dead then one was just as good as
another one and so was science and
progress interesting that is was it excit-
ing but after all there was evolution
and James' the Will to Live and I I had
always been afraid always would be
afraid but after all was that what it was
to be not refusing to be dead although
after all every one was refusing to be
dead.

—*Everybody's Autobiography*

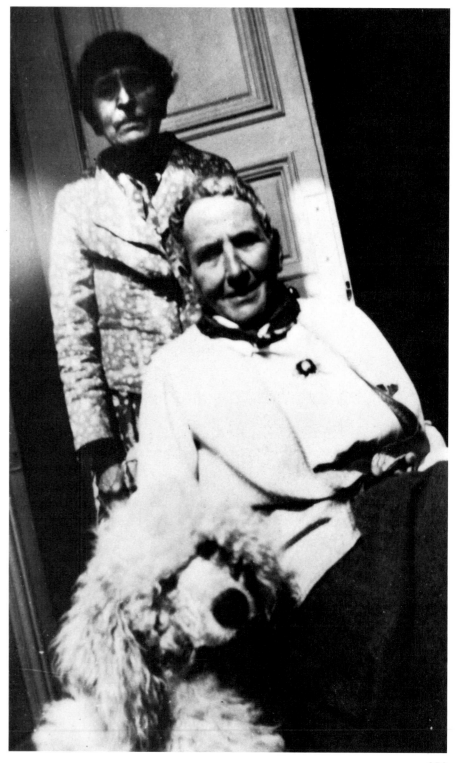

"Little or big young or old dog or
man." 1946.

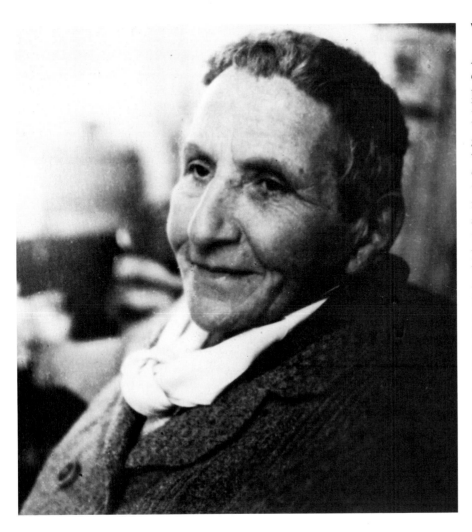

W ell like it or not everybody has to do something to fill the time. After all human beings have to live dogs too so as not to know that time is passing, that is the whole business of living to go on so they will not know that time is passing, that is why they get drunk that is why they like to go to war, during a war there is the most complete absence of the sense that time is passing a year of war lasts so much longer than any other year. After all that is what life is and that is the reason there is no Utopia, little or big young or old dog or man everybody wants every minute so filled that they are not conscious of that minute passing. It's just as well they do not think about it you have to be a genius to live in it and know it to exist in it and and express it to accept it and deny it by creating it. . . .

—*Everybody's Autobiography*

⧈ "If things do not take long it makes life too short." 1946.

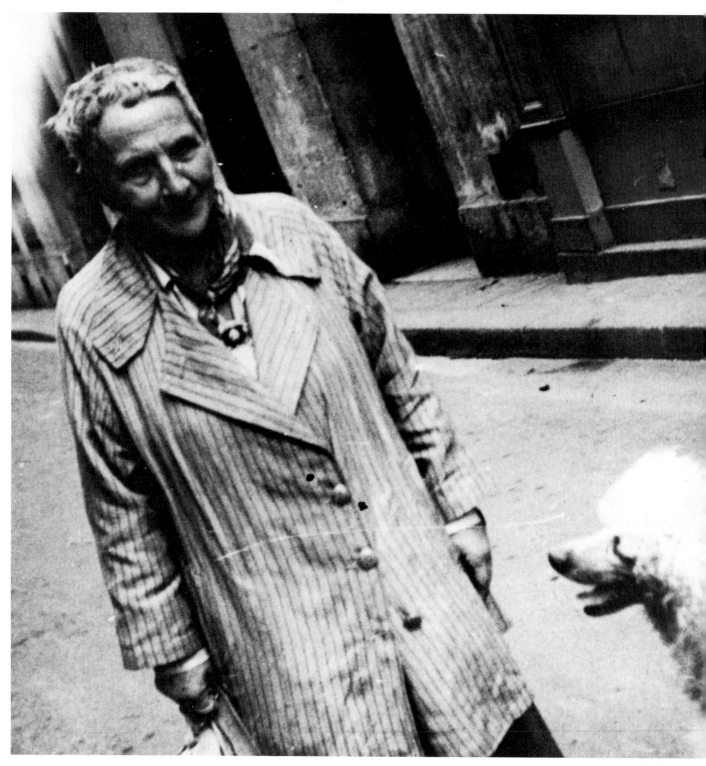

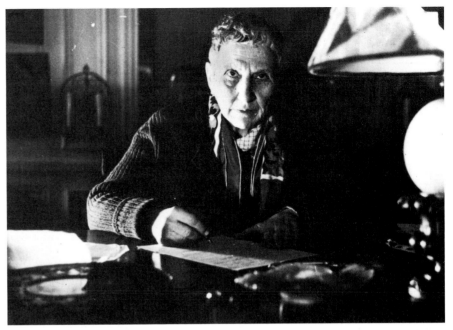

It is a rather curious thing that it should take a hundred years to change anything that is to change something, it is the human habit to think in centuries and centuries are more or less a hundred years and that makes a grandfather a grandmother to a grandson or a granddaughter if it happens right and it often does about happen right. It is the human habit to think in centuries from a grandparent to a grandchild because it just does take about a hundred years for things to cease to have the same meaning that they had before, it is a curious thing a very curious thing that everything is a natural thing but it is it is a natural thing and it being a natural thing makes it a curious thing a very curious thing to almost anybody's feeling.

—*Narration*

I like to read detective and mystery stories, I never get enough of them but whenever one of them is or was about death rays and atomic bombs I never could read them. What is the use, if they are really as destructive as all that there is nothing left and if there is nothing there nobody to be interested and nothing to be interested about.

—*Reflection on the Atomic Bomb*

Left: Thinking in centuries. A walk in the *quartier*, 1946.
Above: At her desk until the last moment.

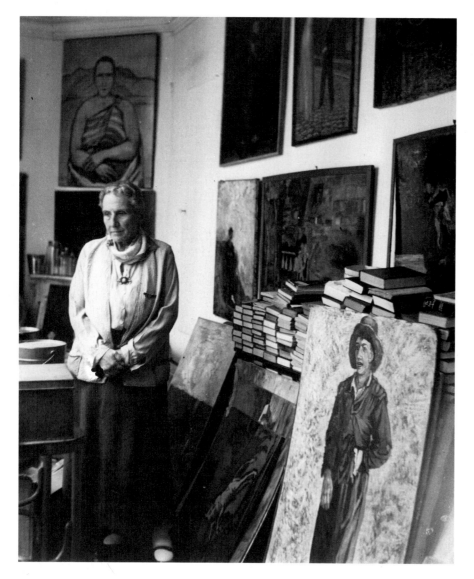

. . . I just tell you and though I dont sound like it I've got plenty of sense, there aint any answer, there aint going to be any answer, there never has been any answer, that's the answer.

—*Brewsie and Willie*

Supposing no one asked a question. What would be the answer.

—"Near East or Chicago"

By this time Gertrude Stein was in a sad state of indecision and worry. I sat next to her and she said to me early in the afternoon, What is the answer? I was silent. In that case, she said, what is the question? Then the whole afternoon was troubled, confused and very uncertain, and later in the afternoon they took her away on a wheeled stretcher to the operating room and I never saw her again.

—Alice B. Toklas,
What Is Remembered

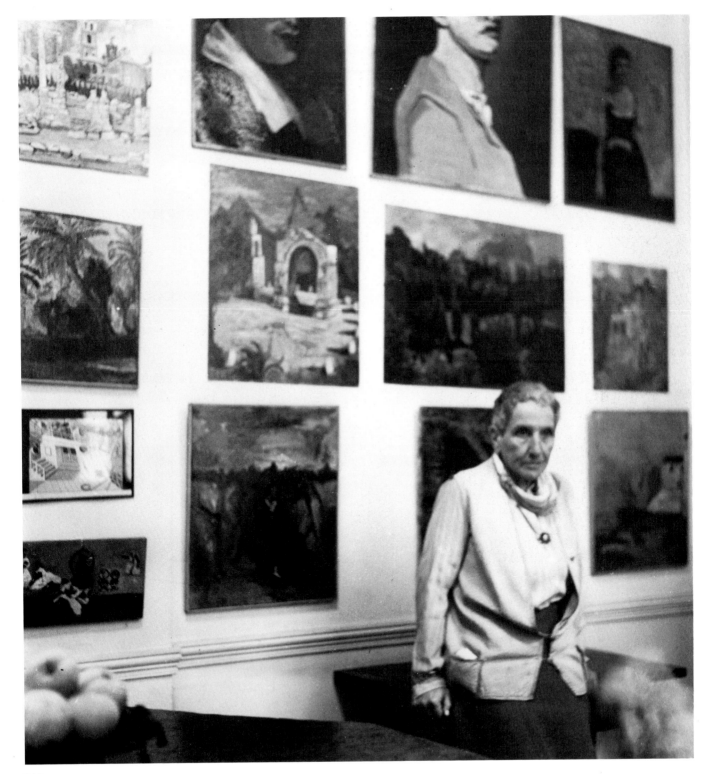

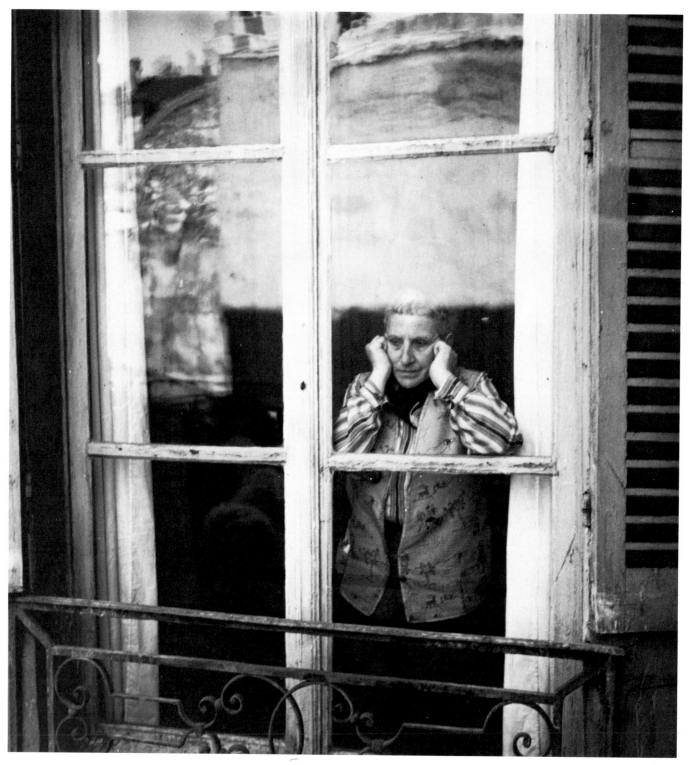

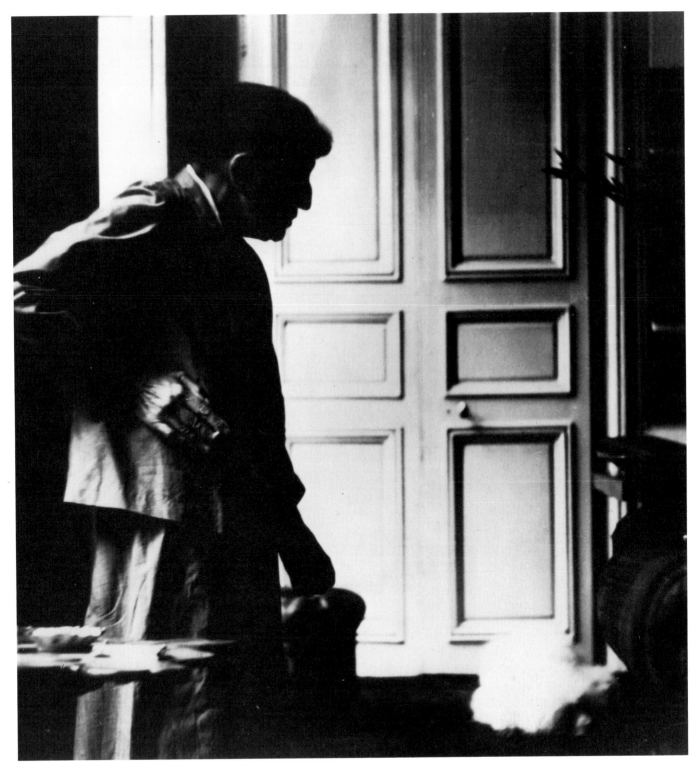

Left: The American Hospital in Neuilly near Paris, where Gertrude Stein died on July 27, 1946.
Below: Tombstone with errors, in the Paris cemetery Père Lachaise. Gertrude Stein's birthplace is misspelled and the date of her death confused with that of her brother Leo.
Photos by Samuel M. Steward.

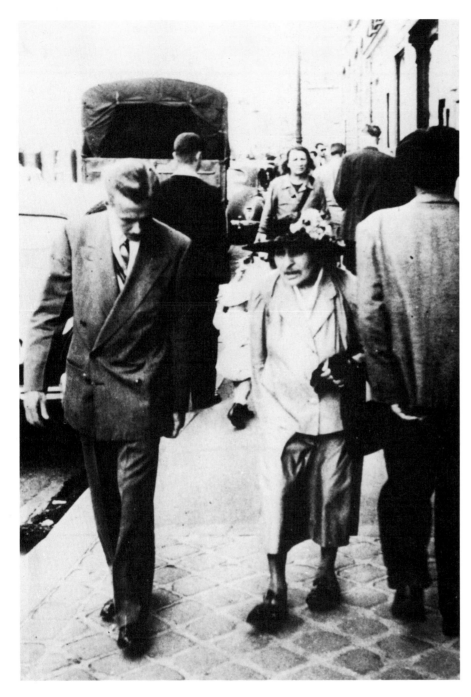

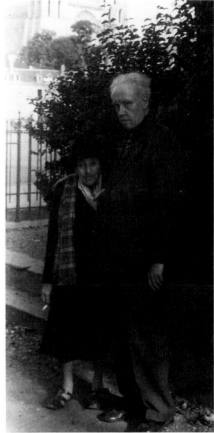

Friendship beyond death. Above right: The two literary executors, Alice B. Toklas and Carl Van Vechten (photo by John Breon, 1949).
Left: with Samuel M. Steward in Paris, 1954.

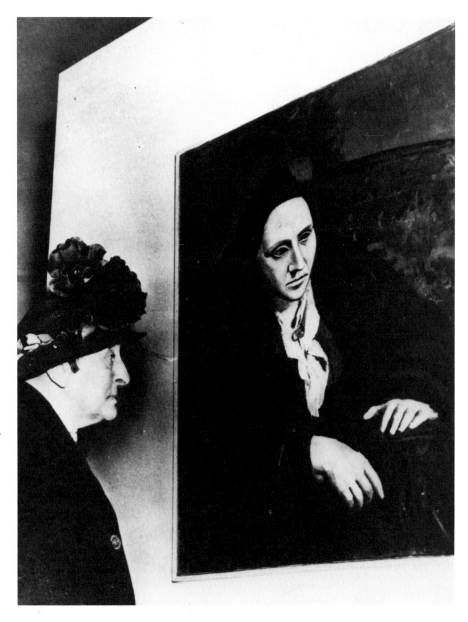

▨ Picture at an exhibition. Paris, 1955.

Sources for Quotes

Note: Works by Gertrude Stein are cited by abbreviation from the list below or by title. All other sources are cited by the author's last name. Full bibliographical information is provided for both primary and secondary sources in the select bibliography that follows this section (page 273).

Abbreviations

ABT	*The Autobiography of Alice B. Toklas*
EA	*Everybody's Autobiography*
FERN	*Fernhurst, Q.E.D., and Other Early Writings*
GHA	*The Geographical History of America*
GS	*Gertrude Stein on Picasso*
HWW	*How Writing Is Written*
LA	*Lectures in America*
MA	*The Making of Americans*
MPG	*Matisse, Picasso and Gertrude Stein*
PF	*Paris France*
RM	*"The Radcliffe Manuscripts"*
TL	*Three Lives*
WAM	*What Are Masterpieces*
WARS	*Wars I Have Seen*

p. 1 WARS, 17
p. 4 MA, 53; MA, 143
p. 5 ABT, 69
p. 6 WARS, 3; Amelia Stein quoted in Sprigge, 15–16; MA, 44–5; Rachel Keyser quoted in Hobhouse, 3; EA, 70
p. 7 WARS, 4–5
p. 8 MA, 45
p. 9 EA, 135; ABT, 74
p. 10 WARS, 12
p. 13 MA, 46–7; Gertrude Stein to Robert Bartlett Haas, unpublished
p. 15 EA, 118
p. 18 "The Great Enigma," in RM, 123
p. 19 ABT, 75
p. 20 EA, 70
p. 21 Helen Bachrach quoted in Sprigge, 22–3; EA, 72
p. 22 ABT, 79
p. 23 "A Transatlantic Interview," in A Primer, 34; EA, 266–67
p. 24 "The Temptation," in RM, 154–55; "The Great Enigma," in RM, 124–25
p. 27 "Fernhurst," in FERN, 19–20; PF, 12–13; ABT 83
p. 28 "A Transatlantic Interview," in A Primer, 17
p. 29 MA, 295
p. 30 ABT, 82–3; RM, 141
p. 31 Q.E.D., in FERN, 102; Q.E.D., in FERN, 65
p. 33 MA, 436–37
p. 36 MA, 348; MA 289
p. 38 EA, 72
p. 40 Luhan, 327; the husband of one of Gertrude Stein's cousins quoted in Sprigge, 36–7; LA, 138
p. 42 ABT, 52–3
p. 43 TL, 102–3
p. 44 ABT, 42–3
p. 45 ABT, 9
p. 46 ABT, 46

p. 47 ABT, 45–6; ABT, 49; "Picasso," in GS, 14; ABT, 12

p. 48 ABT, 6

p. 49 ABT, 41–2

p. 50–1 HWW, 156

p. 51 ABT, 15

p. 52 ABT, 10–11

p. 53 ABT, 17–18

p. 54 Toklas, 26; MA, 485

p. 55 MA, quoted in Hobhouse, 80

p. 56 Leo Stein, 149; EA, 76; EA 77; MA, 459

p. 57 "Ada," in Geography and Plays, 13–14

p. 60 ABT, 4–5

p. 62–3 Luhan, 324

p. 64 ABT, 16; "Farragut," in Useful Knowledge, 15; Toklas, 44

p. 65 "Didn't Nelly," in As Fine As Melanctha, 223; "A Long Gay Book," in MPG, 21

p. 66 ABT, 119; ABT, 90

p. 67 Picasso, in GS, 14–15; "Memories of Gertrude Stein," unpublished, quoted in Sprigge, 164; Leo Stein to Mabel Weeks, in Leo Stein, 102; Toklas, 148

p. 70 Leo Stein, 100; Leo Stein to Mabel Weeks, in Leo Stein, 84

p. 71 "Name of Flowers," in Bee Time Vine, 217

p. 72 ABT, 136; "One," in Geography and Plays, 199–200

p. 73 ABT, 70; Fifield, quoted in Hobhouse, 94

p. 74 "A Long Gay Book," in MPG, 104; "Poetry and Grammar," in LA, 235

p. 75 ABT, 156; Tender Buttons, 27

p. 76 ABT, 170; "Picasso," in GS, 79; "Portraits and Repetition," in LA, 183

p. 78 Greenfield, 2; "Photograph, A Play in Five Acts," in Last Operas and Plays, 222

p. 79 ABT, 149; ABT, 72

p. 80 ABT, 162; ABT, 172; ABT, 173

p. 81 ABT, 184–85; ABT, 174

p. 82 ABT, 185

p. 83 ABT, 116

p. 84 EA, 148; "The King or Something," in Geography and Plays, 122–23

p. 85 EA, 52

p. 88 ABT, 112; Hemingway, 28

p. 89 Hemingway, 14, 15–16

p. 90 ABT, 214

p. 91 ABT, 215; ABT, 219–20

p. 92 ABT, 216–17; "A Valentine for Sherwood Anderson," in Portraits and Prayers, p. 152; "A Conversation with Gertrude Stein," in Atlantic Monthly, 156, August 1935

p. 93 ABT, 76–7; ABT 197–98; EA, 316

p. 95 Faÿ, 91; WARS, 3; ABT, 87

p. 96 ABT, 138

p. 97 A Novel of Thank You, 246; ABT, 211

p. 98–9 ABT, 200–2

p. 99 A Book Concluding with As a Wife Has a Cow a Love Story [unnumbered pages]

p. 102 ABT, 191; EA, 251

p. 103 Rogers, 111; ABT, 206; ABT, 233

p. 104 Acton, 161–62

p. 106–7 ABT, 234–35

p. 107 ABT, 235; ABT, 211–12

p. 108 Pavel Tchelitchev, quoted in Sprigge, 139

p. 109 EA, 85–6

p. 111 ABT, 55

p. 112 ABT, 250; ABT, 224–25; ABT, 70

p. 114 Imbs, 102

p. 116 ABT, 247

p. 117 Narration, 15

p. 121 ABT, 228–29; EA, 109

p. 122 ABT, 246

p. 123 ABT, 238; An Acquaintance with Description, in Dydo, Gertrude Stein, 524

p. 124 ABT, 229

p. 125 ABT, 247–48

p. 126 Toklas, 124

p. 127 ABT, 83; "Patriarchal Poetry," in Bee Time Vine, 263–64; Thomson, quoted in Sprigge, 140

p. 128 Stein to W. G. Rogers, quoted in Rogers, 75

p. 129 EA, 90

p. 130 ABT, 77

p. 132 ABT, 241–42; ABT, 242; Toklas, 136–37; ABT, 243

p. 133 Thomson, 171

p. 134 ABT, 228; ABT, 231

p. 134–35 ABT, 244

p. 135 ABT, 248; ABT, 245–46

p. 136 EA, 48–9; ABT, 248

p. 137 Narration, 22–3

p. 138 EA, 98; EA, 84; EA, 70; "Memories of Gertrude Stein," in Vogue, January 1971

p. 139 ABT, 251–52

p. 140 From the foreword to the Italian edition of ABT, Turin, Einaudi, 1938

p. 141 EA, 40

p. 142 "A Lyrical Opera," in Operas and Plays, 51; "A Sonatina," in Bee Time Vine, 4; "The Question of

Identity," in GHA, 72, 77; "A Long Gay Book," in MPG, 74

p. 144 "And Now," in HWW, 63; EA, 47

p. 145 EA, 64

p. 146 EA, 84; EA, 101–2

p. 147 *Blood on the Dining-Room Floor*, 50

p. 149 EA, 91

p. 152 EA, 101; EA, 112; Thomson, *Selected Letters*, 112–13

p. 154 "Counting Her Dresses," in *Geography and Plays*, 276–77

p. 155 EA, 167–68; *Stanzas in Meditation and Other Poems*, 151

p. 156 Rogers, 122–29

p. 157 *A Book Concluding with As a Wife Has a Cow a Love Story*, 13

p. 158 EA, 173–74

p. 159 "Van or Twenty Years After," in LA, 157

p. 160 EA, 174–75

p. 161 EA, 122–23; LA, 11

p. 162 "Counting Her Dresses," in *Geography and Plays*, 283–84

p. 163 "I Came and Here I Am," *Cosmopolitan*, February 1935

p. 164 *Four in America*, v–vi

p. 166 EA, 190–91

p. 167 *Picasso*, in GS, 76

p. 168 EA, 205–7

p. 170 EA, 213

p. 171 "Portraits and Repetition," in LA, 184

p. 172–73 EA, 201–3

p. 174–75 LA, 231–34; EA, 215

p. 176 Stein to Van Vechten, quoted in Sprigge, 193–94

p. 177 EA, 286; EA, 196

p. 178 Lecture at Wesleyan, quoted in Rogers, 140–41

p. 179 EA, 198; "A Little Love," in *Stanzas in Meditation*, 277

p. 180 Toklas to Crager, unpublished

p. 181 EA, 218–19; EA, 3–4

p. 182 EA, 282–83

p. 183 "A Translatlantic Interview," in *A Primer*, 31

p. 184 EA, 227; "A Conversation with Gertrude Stein," in *Atlantic Monthly*, 156, August 1935

p. 185 EA, 288; EA 289

p. 186 "Poetry and Grammar," in LA, 221

p. 187 EA, 291–92

p. 188 EA, 50; EA, 233

p. 190 EA, 297

p. 191 Rogers, 152

p. 193 EA, 21–2

p. 196 EA, 31–2; Tzara, in *transition*, February 1935

p. 200 GHA, 193; EA, 259–60

p. 201 WAM, 94

p. 202 EA, 307; *Picasso*, in GS, 68–9; EA, 37

p. 203 EA, 132; EA, 133

p. 204 EA, 193–94; EA, 317

p. 205 EA, 318; EA, 315

p. 206 Rogers, 103–4

p. 207 ABT, 239; EA, 159

p. 208 ABT, 88–9; EA, 309; "Answers" in HWW, 55

p. 209 "Breakfast," in *Tender Buttons*, 42

p. 210 Stein to Anderson, in *Sherwood Anderson/Gertrude Stein*, 106–7

p. 212 PF, 17–18

p. 217 "A Sonatina," in *Bee Time Vine*, 13–14

p. 218 *Portraits and Prayers*, 240

p. 221 *The World Is Round*, 84; EA, 301

p. 223 *Picasso*, in GS, 65

p. 224–25 Steward, 62–63

p. 226 PF, 69–71

p. 227 PF, 26–27

p. 228 PF, 101

p. 230 Gertrude Stein to Frances Steloff, in "We Moderns," 1939, 3 (Frances Steloff's book catalog); WAM, 62

p. 231 PF, 2

p. 234 "An American and France," in WAM, 62; PF, 16

p. 235 PF, 39, 56–7; PF, 65–6

p. 236 PF, 36; PF, 65

p. 237 WARS, 63–4; WARS, 39

p. 238 "The Winner Loses," in *Atlantic Monthly*, November 1940; WARS, 99

p. 238–39 WARS, 49–51

p. 240 Balmain, 75–6; "From Dark to Day," in *Vogue* (London), November 1945; WARS, 34

p. 242 WARS, 237; WARS, 246; WARS, 357–58

p. 243 WARS, 254–55

p. 244 Dudley to Stein, quoted in Sprigge, 254–55

p. 246 "Off We All Went," in *Life*, August 6, 1945

p. 249 EA, 199–200

p. 250 Stein quoted in Brinnin, 394

p. 251 *Narration*, 19–20

p. 252–53 "Off We All Went," in *Life*, August 6, 1945

p. 254 *Four in America*, xxvii

p. 255 GHA, 194–95

p. 256 Toklas, 171; Balmain, 95–6

p. 257 "Raoul Dufy," in *Reflection on the Atomic Bomb*, 69–70

p. 258 EA, 242–43

p. 259 EA, 281

p. 261 *Narration*, 1; *Reflection on the Atomic Bomb*, 161

p. 262 *Brewsie and Willie*, 30; "Near East or Chicago," in *Useful Knowledge*, 51; Toklas, 173

Select Bibliography

The following is a list of works by Gertrude Stein and other authors quoted and mentioned in this book. For works by Gertrude Stein, years in parentheses indicate the dates of a work's genesis or composition and the date of its first publication. (The dating follows Bruce Kellner's study, *A Gertrude Stein Companion*.)

Works by Gertrude Stein

An Acquaintance with Description (1926: 1929). London: Seizen Press, 1929. For quotations, see *Gertrude Stein. A Stein Reader*.

As Fine As Melanctha (1914–1930: 1954). New Haven: Yale University Press, 1954.

The Autobiography of Alice B. Toklas (1932: 1933). New York: Random House, 1936.

Bee Time Vine (1913–1927: 1953). New Haven: Yale University Press, 1953.

Blood on the Dining-Room Floor (1933: 1948). Pawlet, Vt.: Banyan Press, 1948.

A Book Concluding with As a Wife Has a Cow a Love Story (1923: 1926). Paris: Daniel-Henry Kahnweiler, 1926.

Brewsie And Willie (1945: 1946). New York: Random House, 1946.

Everybody's Autobiography (1936: 1937). New York: Random House, 1937.

Fernhurst, Q.E.D., and Other Early Writings (1903–1905: 1971). Ed. Leon Katz. New York: Liveright, 1971.

Four in America (1931–1933: 1947). New Haven: Yale University Press, 1947.

Four Saints in Three Acts (1927: 1934). New York: Random House, 1934.

The Geographical History of America or The Relation of Human Nature to the Human Mind (1935: 1936). New York: Random House, 1936.

Geography and Plays. Boston: The Four Seas Company, 1922.

Gertrude Stein. A Stein Reader. Ed. Ulla Dydo. Evanston, Ill.: Northwestern University Press, 1994.

Gertrude Stein on Picasso (1909–1938: 1970). Ed. Edward Burns. New York: Liveright, 1970.

How Writing Is Written (1928–1945: 1974). Ed. Robert Bartlett Haas. Los Angeles: Black Sparrow Press, 1974.

Last Operas and Plays (1920–1946: 1949). New York: Rinehart, 1949.

Lectures in America (1934: 1935). New York: Random House, 1935.

The Making of Americans (1903–1911: 1925). Paris: Contact Editions, 1925.

Matisse, Picasso and Gertrude Stein with Two Shorter Stories (1909–1912: 1933). Paris: Plain Edition, 1933.

Narration (1935: 1935). Chicago: University of Chicago Press, 1935.

A Novel of Thank You (1925–1926: 1958). New Haven: Yale University Press, 1958.

Operas and Plays (1913–1931: 1932). Paris: Plain Edition, 1932.

Painted Lace (1914–1927: 1955). New Haven: Yale University Press, 1955.

Paris France (1939: 1940). New York: Charles Scribner's Sons, 1940.

Picasso (1938: 1938). London: Batsford, 1938. For quotations, see *Gertrude Stein on Picasso*.

Portraits and Prayers (1909–1931: 1934). New York: Random House, 1934.

A Primer for the Gradual Understanding of Gertrude Stein (1895–1946: 1971). Ed. Robert Bartlett Haas. Los Angeles: Black Sparrow Press, 1971.

"The Radcliffe Manuscripts" (1894–1895: 1949). In Rosalind S. Miller, *Gertrude Stein. Form and Intelligibility*. New York: Exposition Press, 1949.

Reflection on the Atomic Bomb (1913–1946: 1973). Ed. Robert Bartlett Haas. Los Angeles: Black Sparrow Press, 1973.

Sherwood Anderson / Gertrude Stein: Correspondence and Personal Essays. Ed. Ray Lewis White. Chapel Hill, North Carolina: University of Carolina Press, 1951.

Stanzas in Meditation and Other Poems (1929–1933: 1956). New Haven: Yale University Press, 1956.

Tender Buttons (1912: 1914). New York: Claire Marie, 1914.

Three Lives (1903–1906: 1909). New York: The Grafton Press, 1909; For quotations, see Signet Classics, 1985.

Useful Knowledge (1915–1926: 1928). London: The Bodley Head, 1928.

Wars I Have Seen (1943–1944: 1945). New York: Random House, 1945.

What Are Masterpieces (1913–1936: 1940). Los Angeles: The Conference Press, 1940.

The World Is Round (1938: 1939). New York: Scottbooks, 1939.

Works by Other Authors

Acton, Sir Harold. *Memoirs of an Aesthete*. London: Hamish Hamilton, 1984.

Balmain, Pierre. *My Years and Seasons*. New York: Doubleday, 1965.

Bridgman, Richard. *Gertrude Stein in Pieces*. New York: Oxford University Press, 1970.

Brinnin, John Malcolm. *The Third Rose: Gertrude Stein and Her World*. Boston: Little, Brown, 1959.

Faÿ, Bernard. *Les Précieux*. Paris: Librairie Académique Perrin, 1966.

Four Americans in Paris. New York: Museum of Modern Art, 1970.

Greenfield, Howard. *Gertrude Stein: A Biography*. New York: Crown, 1973.

Hemingway, Ernest. *A Moveable Feast*. New York: Scribner's, 1964.

Hobhouse, Janet. *Everybody Who Was Anybody*. New York: Putnam, 1975.

Imbs, Bravig. *Confessions of Another Young Man*. New York: Henkle-Yewdale, 1936.

Kellner, Bruce (Ed.). *A Gertrude Stein Companion*. New York: Greenwood Press, 1988.

Luhan, Mabel Dodge. *European Experiences*. New York: Harcourt Brace, 1935.

Orenstein, Gloria F. *Reflowering of the Goddess*. New York: Teachers College Press, 1990.

Rather, Lois. *Gertrude Stein and California*. Oakland, Ca.: Rather Press, 1974.

Rogers, W. G. *When This You See Remember Me: Gertrude Stein in Person*. New York: Rinehart, 1948.

Simon, Linda. *The Biography of Alice B. Toklas*. New York: Doubleday, 1977.

Sprigge, Elizabeth. *Gertrude Stein: Her Life and Work*. New York: Harper, 1957.

Stein, Leo. *Journey into the Self: Being the Letters, Papers and Journals of Leo Stein*, ed. Edmund Fuller. New York: Crown, 1950.

Steward, Samuel M. *Dear Sammy: Letters from Gertrude Stein and Alice B. Toklas*. Boston: Houghton Mifflin, 1977.

———*Parisian Lives*. New York: St. Martin's Press, 1984.

Thomson, Virgil. *Virgil Thomson*. New York: Knopf, 1966.

———*Selected Letters of Virgil Thomson*. Ed. Tim Page and Vanessa Weeks Page. New York: Summit Books, 1988.

Toklas, Alice B. *What Is Remembered*. New York: Holt, Rinehart and Winston, 1963.

Credits

Photographs

Courtesy The Bancroft Library: Page 10 top, 13, 14, 21 top, 28 all, 29 right, 39 bottom, 49 left, 54 top, 60, 61 left, 63 both, 64 left and bottom, 65 left, 75 left, 82 both, 99 right, 122 right, 123 right, 125 both, 127 bottom, 141 top, 157 left, 181, 187 both, 195, 204 top, 208 both, 209 both, 211 bottom, 222, 223 both, 224, 225 top, 226 both, 228–29, 254, 266 top, 267 left.

Private Collections: 47 right, 61 right, 72, 91, 124 bottom, 182 left, 225 bottom, 237 left, 240.

National Archives: 242 bottom.

The Baltimore Museum of Art: Cone Archives: 37, 44, 45, 48, 51, 52, 53, 71 right top and bottom, 79 bottom.

© 1978 Imogen Cunningham Trust: 186 both.

The Addison M. Metcalf Collection of Gertrude Steiniana, Denison Library, Scripps College: 70, 75, 91 bottom, 96 both, 102 left, 111, 127, 132, 135 left and top right, 140, 157 right, 179 right, 180 all, 196, 204 left and bottom, 205 bottom, 210, 221 bottom right, 244 both.

Arche Archiv (Hamburg): 23 bottom, 39 top right and left, 44 bottom, 46 left, 49, 54 left, 56 left, 66, 67 both, 70 center and right columns, 71 left top and bottom, 75 right, 79 top, 88 top left and bottom, 91 top, 92 bottom, 93 bottom, 95, 97 bottom left, 98 left, 100 center column and right, 101 all, 104, 105, 106 both, 128 both, 130 bottom, 142 both, 172, 178 right top and bottom, 179 left, 182 right top and bottom, 183 left top and bottom, 190 left, 192, 202, 203 right, 207 right.

San Francisco History Room, San Francisco Public Library: 10 left bottom, 18 top, 185.

The Carnegie Library of Pittsburgh, Pennsylvania Department: 5 both.

The Ernest Hemingway Foundation (d.b.a. The Hemingway Society): 88 left, 90 bottom.

The New York Public Library, the Research Collections: 32.

The Enoch Pratt Library, Maryland Department: 27 both.

Billy Klüver and Julie Martin Archive: 90 top.

University of California, Los Angeles, Department of Special Collections: 268.

Courtesy of Sotheby's, London, Cecil Beaton Archive: All photos by Cecil Beaton.

Text

Acknowledgments

First and foremost, I would like to thank Calman A. Levin and the Gertrude Stein Estate, as well as Patricia Willis, Curator of American Literature at the Beinecke Rare Books and Manuscript Library, Yale University, for their generosity. Without their understanding and support this book could not have been made. The patience, precision, and intuition of Stephen Jones in locating and identifying photographic materials at the Beinecke Library has often come close to the miraculous.

I am also grateful to the Bancroft Library at the University of California, Berkeley—to its late director, James Hart, its retired curator, Larry Dinnean, its interim director, Peter E. Hanff, to Richard Ogar and the staff, for their sustained encouragement and help. James Hart pointed out the photographic treasures in works by Edward Burns (in particular *Gertrude Stein on Picasso*) and in *Four Americans in Paris* (published by the New York Museum of Modern Art), works to which I am indebted for their inspiration. He also directed me to newspaper research following the lead of Lois Rather in her lovely, little-known book *Gertrude Stein and California* and to the "Steiniana" of Scripps College.

Heartfelt thanks to Judy Harvey Sahak at the Ella Strong Denison Library (Scripps College, Claremont) for her enthusiasm and the expertise with which she guided me through the "Steiniana" of the Addison M. Metcalf Collection.

Extraordinary support came from Lydia Cresswell-Jones and the Cecil Beaton Archive at Sotheby's, London; from Patricia Flynn and Random House; and from Jean-Marc Gutton at ADAGP (Société des auteurs dans les arts graphiques et plastiques) and Elisabeth Weisberg at ARS (Artists' Rights Society) into whose helpful hands my project was placed by Lucien Treillard. I am also deeply grateful to Julie Martin and Billy Klüver, to Nancy Press and the Cone Collection at the Baltimore Museum of Art, to Elisabeth Partridge and the Imogen Cunningham Trust, and to Robert Lewis and The Hemingway Society.

I would like to acknowledge two of my earliest sources of inspiration: A special eye-opener to Stein's eroticism was Linda Simon's work *The Biography of Alice B. Toklas*. At the same time, at the end of the seventies, my Paris talks with Gloria Feman Orenstein and her essay "Decoding the Amusing Muse" (recently published in *Reflowering of the Goddess*) enlightened me on Stein's clever subversion of the European salon tradition, and on the Jewish, lesbian, and perhaps even matriarchal subtexts in Stein's work.

The late Samuel M. Steward (alias Phil Andros) followed the development of my project from start to

almost finish, and in the process, became a friend. He was a true *combattant* in my struggle for an American edition of my book. I was able to share the news of a happy ending with him just in time before his death. Sam's *roman à clef Parisian Lives* had initially shown me the way to *Dear Sammy: Letters from Gertrude Stein and Alice B. Toklas* with his snapshots and memories. He turned out to be a neighbor in Berkeley and a rare source of information on Gertrude, Alice, and their private life. His literary executor, Michael Williams, now has taken over with the same generous spirit. Thanks to him, too.

Through Sam I met Paul Padgette whose expertise as a Stein collector and editor of Carl Van Vechten made him a veritable Sherlock Holmes in identifying photos and detecting errors, both in my manuscript and in earlier biographies of Gertrude Stein. Paul provided me with a youth photo of Carl Van Vechten and pointed me toward Bruce Kellner's superb study, *A Gertrude Stein Companion*. Bruce Kellner pointed out factual and artistic errors in the German edition and made me discover what became one of my favorite Stein quotations, "I will be well welcome when I come . . ." His work, together with Richard Bridgman's study *Gertrude Stein in Pieces*, was the unfailing academic fundament on which to ground my research.

Paul Padgette also provided me with an introduction to the Stein specialist and former curator of the Collection of American Literature at Yale University, Donald Gallup, who kindly identified a photo for me and gave me much-needed encouragement for my work.

I also want to warmly thank Robert B. Haas who made his vast experience with the work of Gertrude Stein available to me in a series of inspiring letters across the Atlantic and who was unfailing in his support. One of his recent letters added the surprise of an unknown photograph that was a most pleasurable addition to my American edition.

Another equally unknown photograph came from Belley, in France, from a former neighbour of Gertrude Stein. I thank the painter Gesine Probst for her transmission of this discovery, made during a journalistic pilgrimage through the places of Gertrude Stein's country life in France.

Finally, I am grateful to Helmut Frielinghaus whose friendship and rich experience in the European world of books made him an unerring guide and adviser from the start. I am grateful to the clear-sighted readers of my manuscript: Terry Castle, Kate Delos, Tobey Hiller, Jaimee Karroll, Louise Kollenbaum, Shana Penn, Amy Rennert, and Rena Rosenwasser. The passion for detail and the intelligence of my editor, Julia Boss, and my managing editor, Cheryl Friedman, made the process of publication as much a pleasure as there can be.

My publisher, Elisabeth Scharlatt, and my agent, Diane Cleaver, both firmly believed in a project that, in the course of several years, was repeatedly threatened by dramatic adversities. Both stood by me like rocks against all odds of cross-Atlantic publishing. The same, and more, can be said about Kim Chernin to whom this book is dedicated and who, in the midst of the storm, reminded me when to stop and when to go on. It should also be said about Zelda, who nudged me whenever I failed, alas, to keep a pigeon on the grass.

Biographical Note

Renate Stendhal, a writer, editor, and translator, was born and raised in Germany. She lived in Paris for twenty years as a cultural correspondent for German radio and press. She has translated into German the works of Gertrude Stein, Audre Lorde, Adrienne Rich, and others, and she is the co-author (with Kim Chernin) of *Sex and Other Sacred Games*. She works as a consultant for creativity and writing in Berkeley, California.

To arrange public appearances, please contact:
Jaimee Karroll, Representative
1563 Solano Ave, Suite 344,
Berkeley, CA 94707
Tel: (510) 527-9969
Fax: (510) 527-3014

INDEX